# Boston

## SPIRIT OF PLACE
### CAPE ANN TO CAPE COD

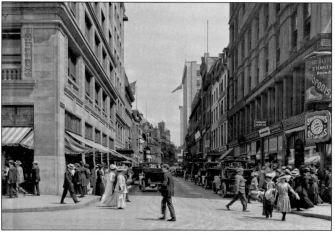

*A man sits alone with a book. The whole world around him grows silent.*
*A voice so secret it can't be heard, just felt. is whispering to him*
*and leading him deep into the world of the greatest wonder and power. His own imagination*

Morley Callaghan "*My Love for Miracles of the Imagination,*" More than Words Can Say. (1990)

MAGIC LIGHT PUBLISHING

# Boston
## SPIRIT OF PLACE
## CAPE ANN TO CAPE COD

By: John McQuarrie with Robert Allison, Lawrence DiCara and Doug Most
Introduction by: Mayor Martin J. Walsh

Copyright: 2014 John McQuarrie

Published by: Magic Light Publishing
John McQuarrie Photography
192 Bruyere Street
Ottawa, Ontario
K1N 5E1
(613) 241-1833
FAX: 241-2085
e-mail: mcq@magma.ca
www.magiclightphoto.ca

Design:      John McQuarrie
Printing:    Friesens, Altona Manitoba Canada, friesens.com

Library and Archives Canada Cataloguing in Publication

McQuarrie, John, 1946-, author
     Boston, spirit of place : Cape Ann to Cape Cod / John McQuarrie.

ISBN 978-1-894673-69-3 (bound).--ISBN 978-1-894673-70-9 (pbk.)

     1. Boston (Mass.)--History.  2. Boston (Mass.)--History--Pictorial works.  I. Title.

F73.B68 2014          974.4'61          C2014-905803-9

Front Cover: Aerial View of Boston Harbor
Title page: Tremont Street at Temple Place, c1910
Back Cover: State Street c1906 and today

# CONTENTS

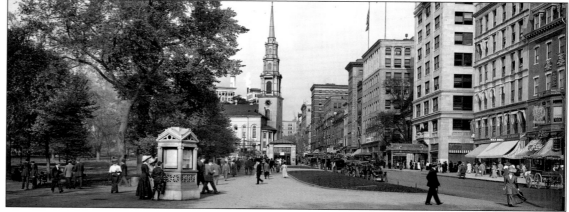

*View of Tremont Street c1910, looking to the north past the entrance to Park Street subway station*

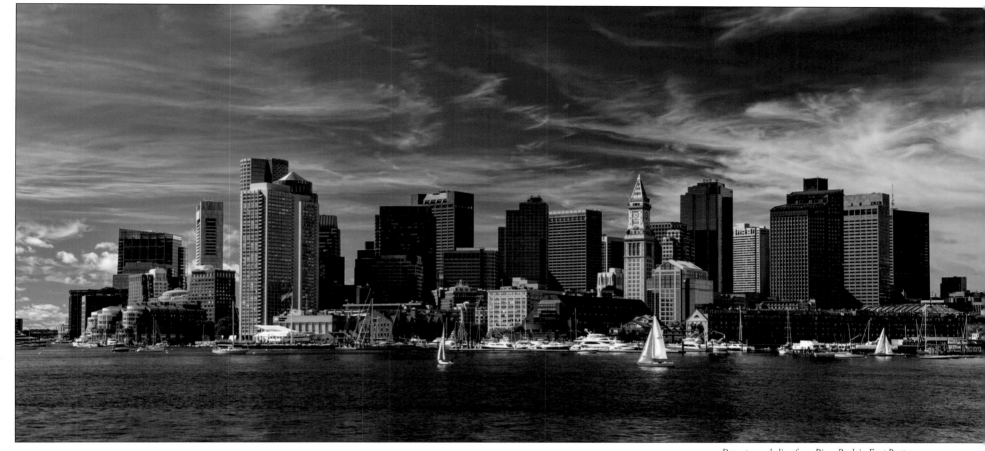

*Downtown skyline from Piers Park in East Boston*

*Cape Cod sunset*

MAYOR WALSH'S INTRODUCTION WAS TO HAVE APPEARED HERE. THIS SPACE WAS held right up to press time but the Introduction, arranged through the mayor's Press Secretary Kate Norton—in a telephone conversation on July 9th 2014, and later confirmed in an email from Miss Norton on July 22nd—had not materialized by September 4th, when this book went on press. Repeated telephone calls and emails were not returned throughout the month of August and concern mounted, particularly given that thousands of covers and jackets had already been printed with the fact of the mayor's introduction noted. I have never been able to get through to Mr. Walsh personally, but strongly suspect his office did not disclose our interest in having the mayor involved in this book. A draft of this page was sent to the Mayor's Office the morning of August 29th. Given Mr. Walsh's obvious love for his city, I am bitterly disappointed to have to include this note here.

John McQuarrie
Publisher

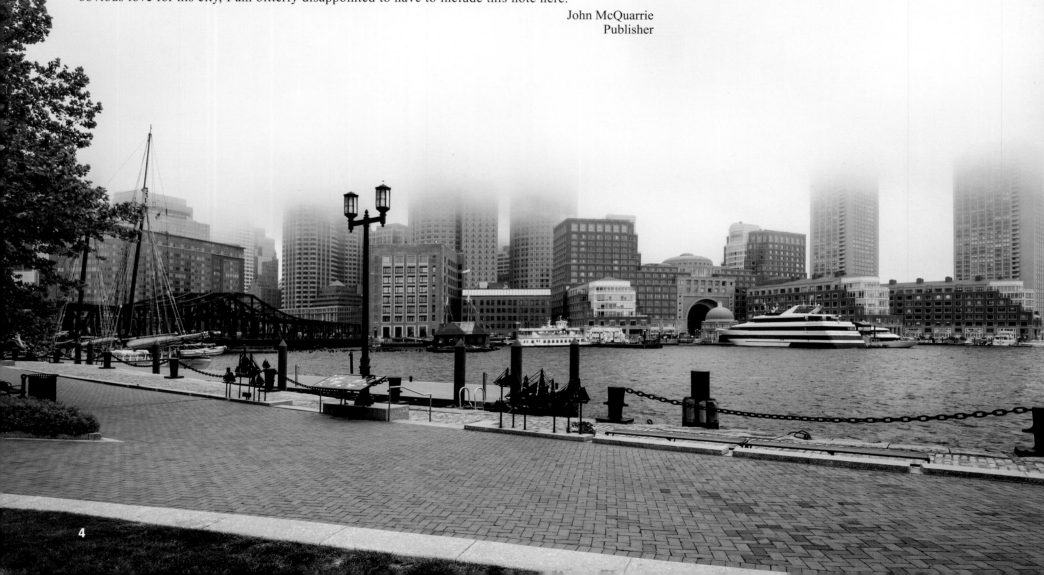

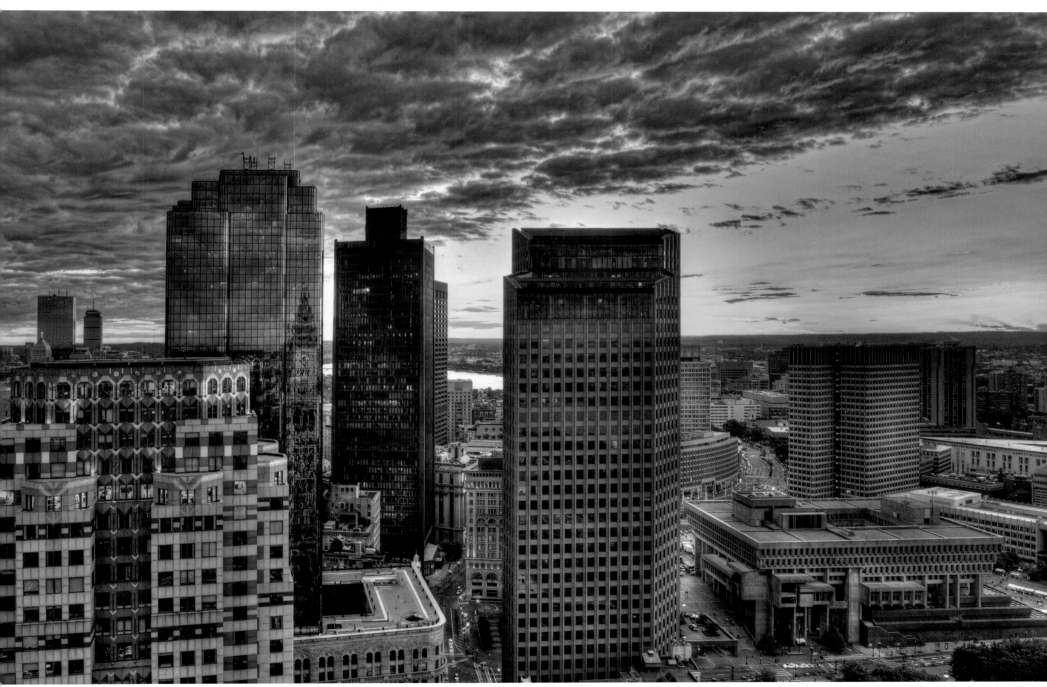

*(left) View of Rowes Wharf area in Boston from the Courthouse Docks in South Boston's Seaport District.*

*Sunset view to the west from the observation deck of the Marriott Custom House tower. (Left to right) 75 State Street, Exchange Place, One Boston Place, 60 State Street, Boston City Hall and JFK Federal Building*

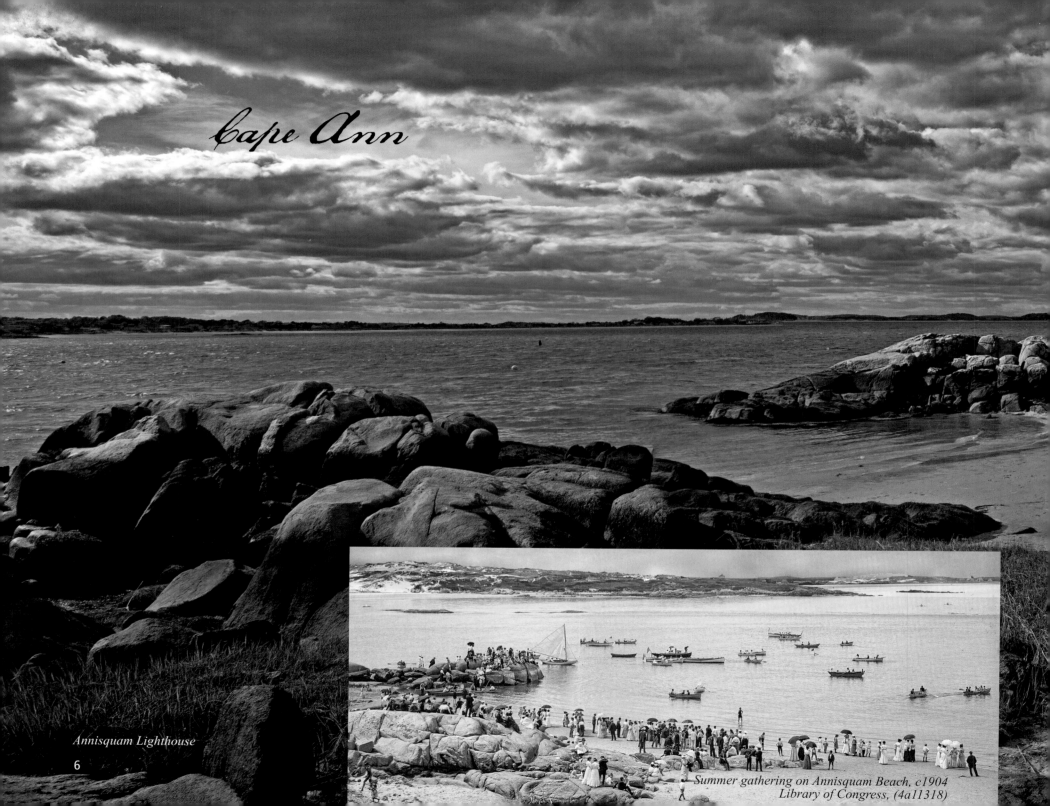

# Cape Ann

Annisquam Lighthouse

6

*Summer gathering on Annisquam Beach, c1904*
*Library of Congress, (4a11318)*

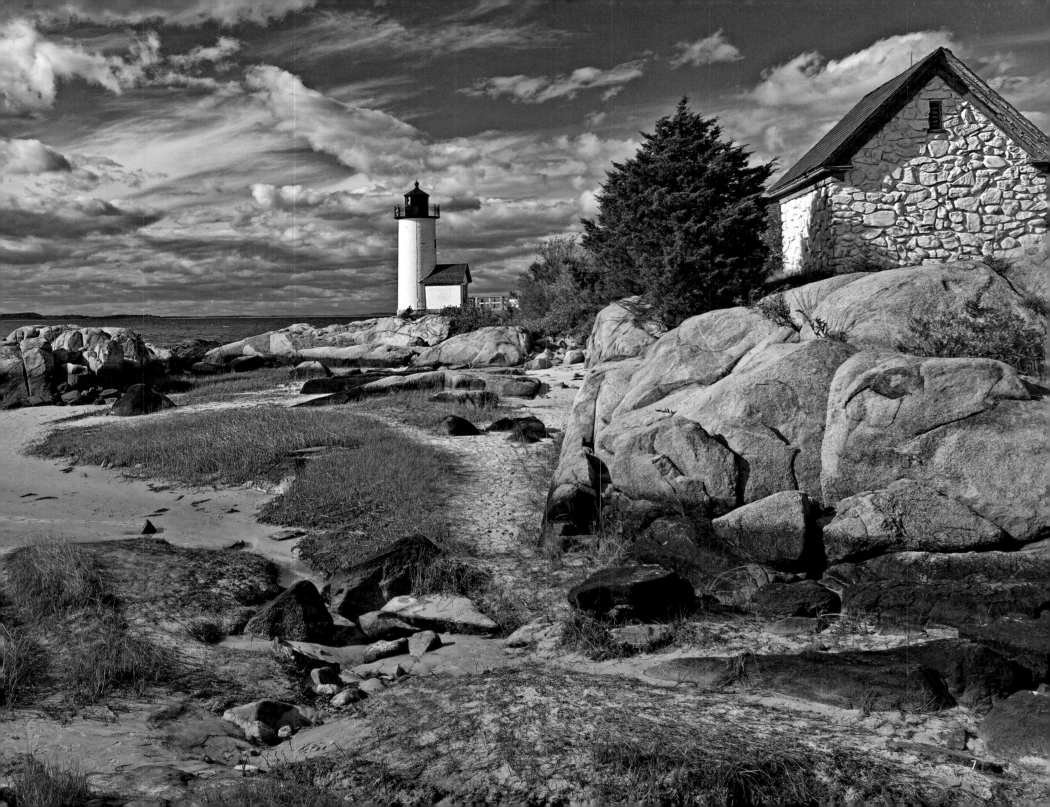

# Gloucester

GLOUCESTER'S DEEPWATER HARBOR ATTRACTED A GROUP OF Englishmen from the Dorchester Company, who landed here in 1623 to fish and to establish a settlement. It was one of the first English settlements in what would become the Massachusetts Bay Colony, and predates both Salem (1626) and Boston (1630). By the late 19th Century, Gloucester was a record-setting port for fisheries under sail.

Life in this first settlement was harsh, and it was short-lived. Around 1626, the place was abandoned, and the people removed themselves to Naumkeag (what is now Salem), where more fertile soil for planting was to be found.

At some point in the following years—though no record exists—the area was slowly resettled. The town was incorporated in 1642. It is at this time that the name Gloucester first appears on tax rolls. The town took its name from the city of Gloucester in southwest England.

Early industry included subsistence farming and logging. Because of the poor soil and rocky hills, Cape Ann was not well suited for farming on a large scale. Small family farms and livestock provided the bulk of the sustenance to the population. Fishing, for which the town is known today, was limited to close to shore, with families subsisting on small catches as opposed to the great bounties yielded in later years. The fisherman of Gloucester did not command the Grand Banks until the mid-18th Century.

Trade was conducted with Surinam, China, Europe and India. The most lucrative was the trade with the Dutch colony of Surinam. It made fortunes for many sea captains, but also brought shame to some local families because slaves were part of the trade, along with rum, molasses and dried fish.

The city remained a fishing center as waves of immigrants, primarily from Nova Scotia, Sicily and Portugal—came to fish the waters off Cape Ann.

*Panorama of Gloucester Harbor looking to the northwest from above East Main Street, over Rocky Neck towards the downtown 'skyline', c1905*
*Library of Congress, (photomerge: 4a06957_4a06958_4a06959 and 4a06960)*

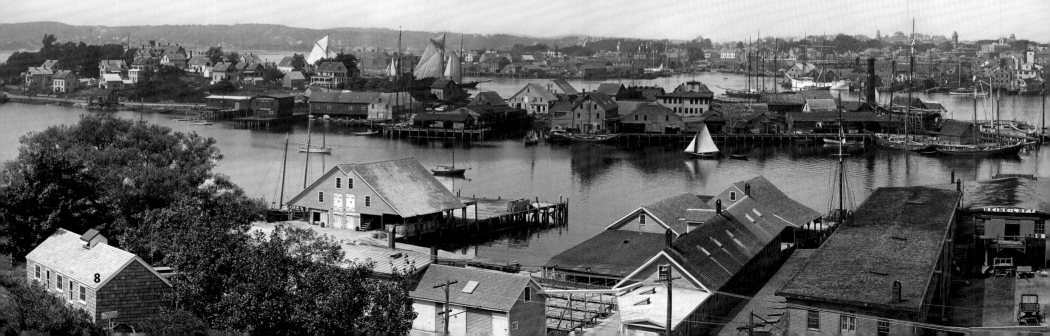

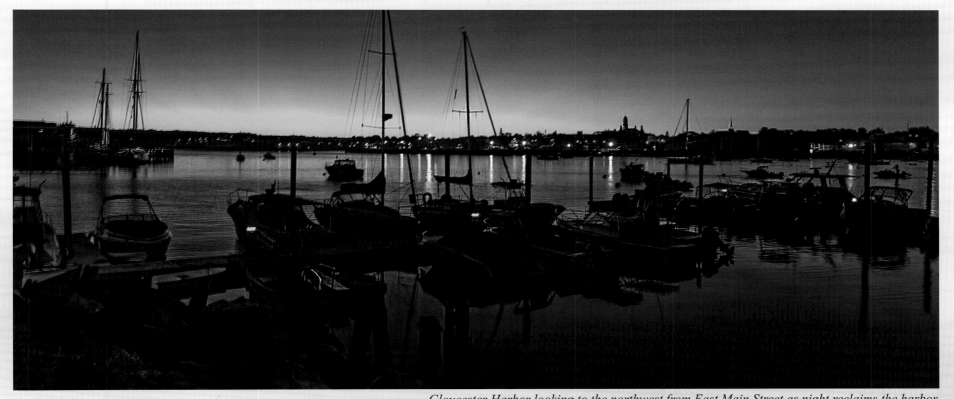

*Gloucester Harbor looking to the northwest from East Main Street as night reclaims the harbor. The pair of church steeples visible in the archival view can be seen in this 21st–Century twilight photograph above.*

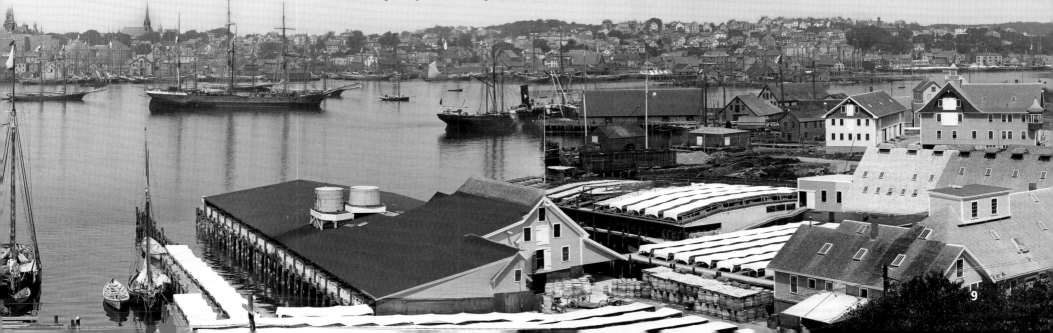

9

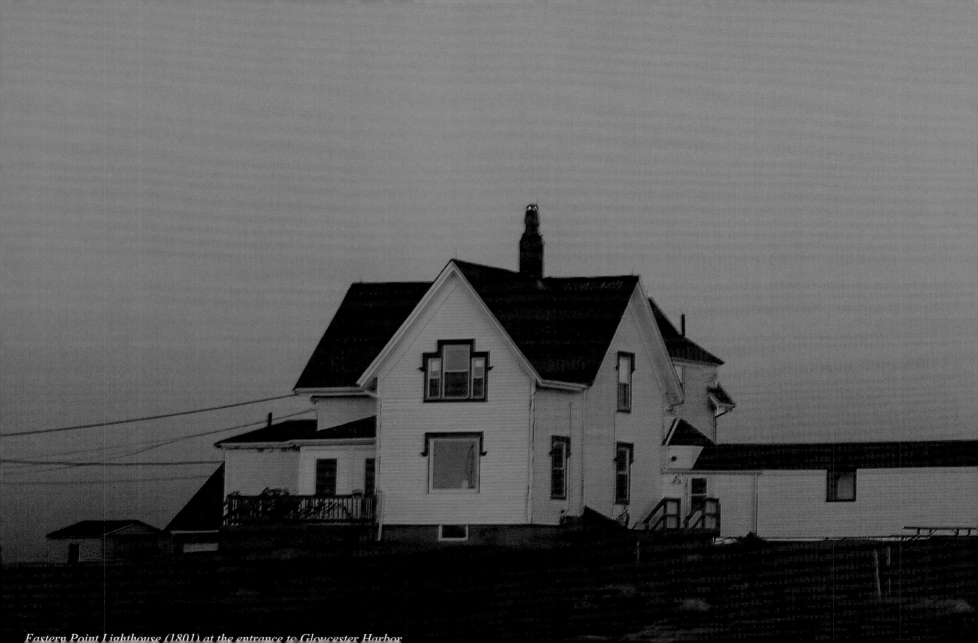
*Eastern Point Lighthouse (1801) at the entrance to Gloucester Harbor*

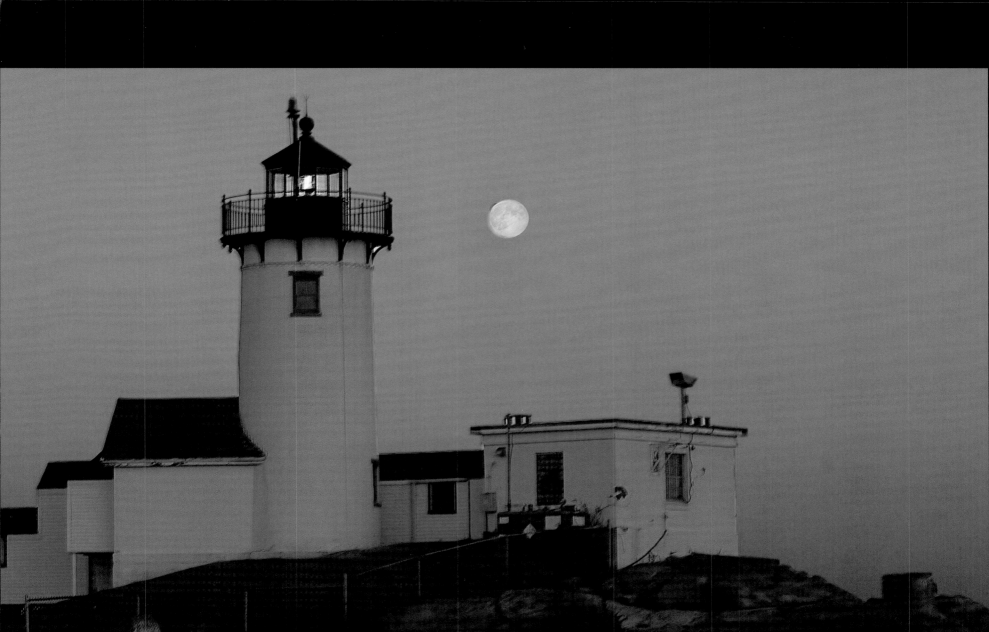

*Traditional wooden dories built, and on display, at the Gloucester Maritime Haritage Center on the city's historic waterfront.* www.maritimegloucester.com

The town was an important shipbuilding center, the first schooner reputedly built there in 1713. The community developed into an important fishing port, largely due to its proximity to Georges Bank and other fishing banks off the east coast of Nova Scotia and Newfoundland. Besides catching and processing seafood, Gloucester is also a center for fish research. Seafaring and fishing have been, and still are, very dangerous undertakings. In its almost 400-year history, Gloucester has lost over 10,000 men to the Atlantic Ocean. The names of all of the known lost are painted on a huge mural in the main staircase at City Hall, and also on Fishermen's Memorial Cenotaph. The list has continued to lengthen despite increased safety requirements.

*Schooner* Ardelle *about to enter the open Atlantic Ocean as she approaches the Dog Bar Breakwater, which extends about one half mile into the mouth of the outer harbor.*

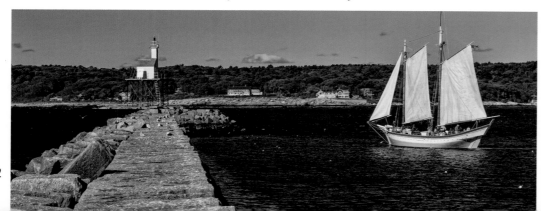

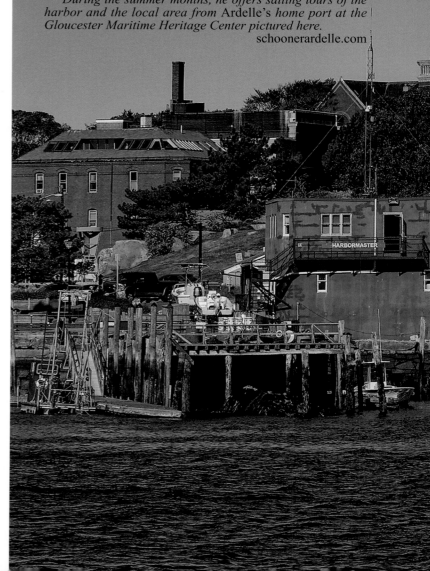

*This exquisite schooner was the sixth vessel to emerge from the Burnham Boatyard, located on an island marsh overlooking the Essex river basin, a few miles west of Gloucester. It has been the site of shipbuilding in Essex for four centuries, and home to the Burnham family for all those years. Harold Burnham built this 50-foot, double-sawn frame schooner* Ardelle, *named after his grandmother and his daughter Perry Ardelle.*

*During the summer months, he offers sailing tours of the harbor and the local area from* Ardelle's *home port at the Gloucester Maritime Heritage Center pictured here.*

schoonerardelle.com

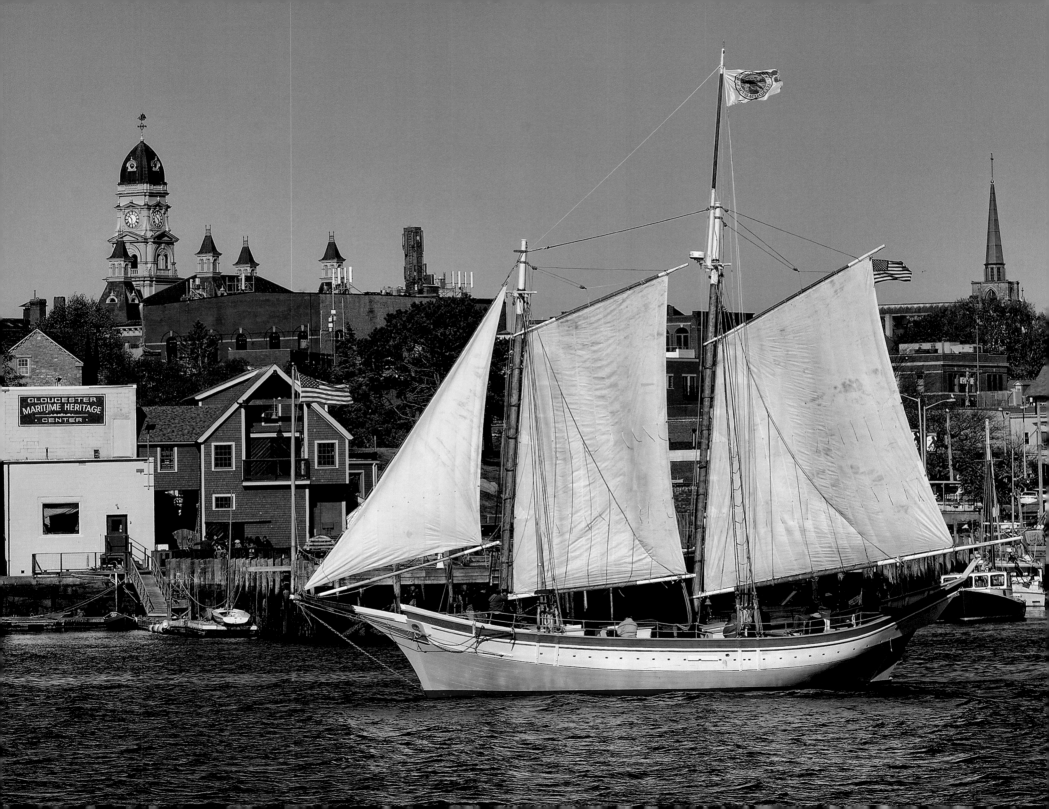

# A Brief History of Cod Fishing

Jennifer Kennedy

THE COD'S IMPORTANCE TO AMERICAN HISTORY IS UNDENIABLE. IT WAS cod that attracted Europeans to North America for short-term fishing trips, and eventually enticed them to stay. Certainly no other fish was as formative in the settlement of the eastern coast of North America, and in forming the booming fishing towns of New England and Canada. The cod became one of the most sought-after fish in the North Atlantic, and it was its popularity that caused its enormous decline and precarious situation today.

Long before Europeans arrived and discovered America, Native Americans fished along its shores, using hooks they made from bones and nets of natural fibers. The Vikings and Basques were some of the first Europeans to travel to the coast of North America to harvest and cure cod. Cod was dried until it was hard, or cured using salt, so that it was preserved for a long period of time. Eventually, explorers such as Columbus and Cabot discovered the "New World". Descriptions of the fish indicate that cod were as big as men, and some say that fishermen could scoop the fish out of the sea in baskets. Europeans concentrated their cod fishing efforts in Iceland for a while, but as conflicts grew, they began fishing along the coast of Newfoundland and New England.

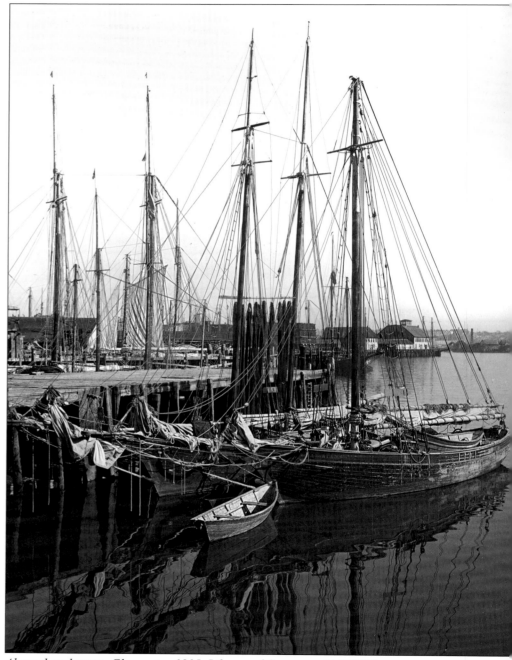

*Along the wharves, Gloucester, 1905  Library of Congress, (4a30222)*

In the early 1600s, John Smith charted out New England. When determining where to flee, the Pilgrims studied Smith's map and were intrigued by the label Cape Cod. They were determined to profit from fishing, although according to Mark Kurlansky, in his book *Cod: a Biography of the Fish That Changed the World*, they knew nothing about fishing, and while the Pilgrims were starving in 1621, there were British ships filling their holds with fish off the New England coast.

Believing they would receive blessings if they took pity on the Pilgrims and assisted them, the local Native Americans showed them how to catch cod and use the parts not eaten as fertilizer. They also introduced the Pilgrims to quahogs, "steamers," and lobster, which they eventually ate in desperation. Negotiations with the Native Americans led to our modern-day celebration of Thanksgiving, which would not have occurred if the Pilgrims had not sustained their stomachs and farms with cod.

The Pilgrims eventually established fishing stations in Gloucester, Salem, Dorchester, and Marblehead, Massachusetts, and in Penobscot Bay, in what is now Maine. Cod were caught using handlines, with larger vessels sailing out to fishing grounds and then sending two men in dories to drop a line in the water. When a cod was caught, it was pulled up by hand.

Fish were cured by drying and salting, and marketed in Europe. Then a 'triangle trade developed linking cod to slavery and rum. High-quality cod was sold in Europe, with the colonists purchased European wine, fruit and other products. The traders then went to the Caribbean, where they sold a low-end cod product called "West India cure" to feed the burgeoning slave population, and bought sugar, molasses (used to make rum in the colonies), cotton, tobacco, and salt. Eventually New Englanders also transported slaves to the Caribbean. But cod fishing continued and made the colonies prosperous.

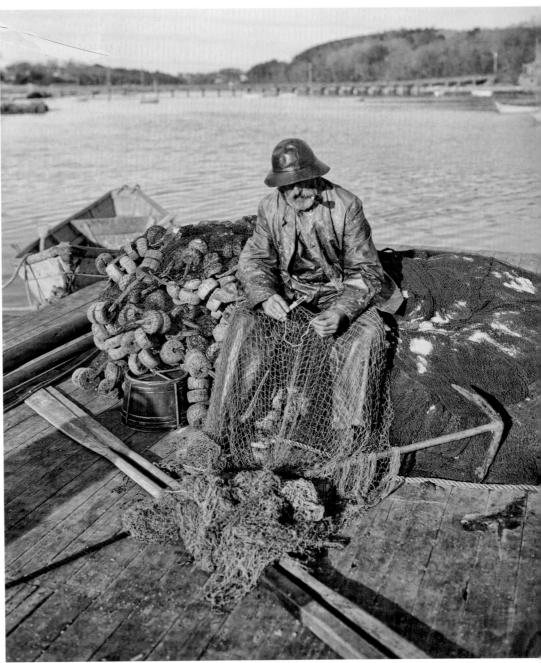

*Fisherman repairing nets, Gloucester, c1905-1910  Library of Congress, (4a17487)*

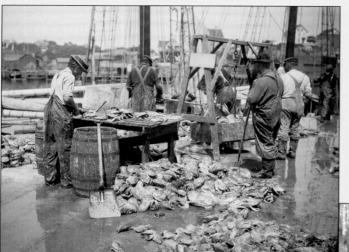

In the 1920s and 1930s, more sophisticated and effective tools, such as gillnets and draggers were used. Commercial cod catches increased throughout the 1950s. Fish processing techniques also expanded. Freezing techniques and filleting machinery eventually led to the development of fish sticks, marketed as a healthy convenience food. Factory ships started catching fish and freezing it out at sea. Technology improved and fishing grounds became more competitive. In the U.S., the *Magnuson Act* of 1976 prohibited foreign fisheries from entering the exclusive economic zone (EEZ) – 200 miles around the U.S. In the absence of foreign fleets, the optimistic U.S. fleet expanded, causing a steeper decline in fisheries.

*Cleaning cod on the Gloucester docks, (c1900-1915)*
*Library of Congress, (4a27648 above and 4a27647)*

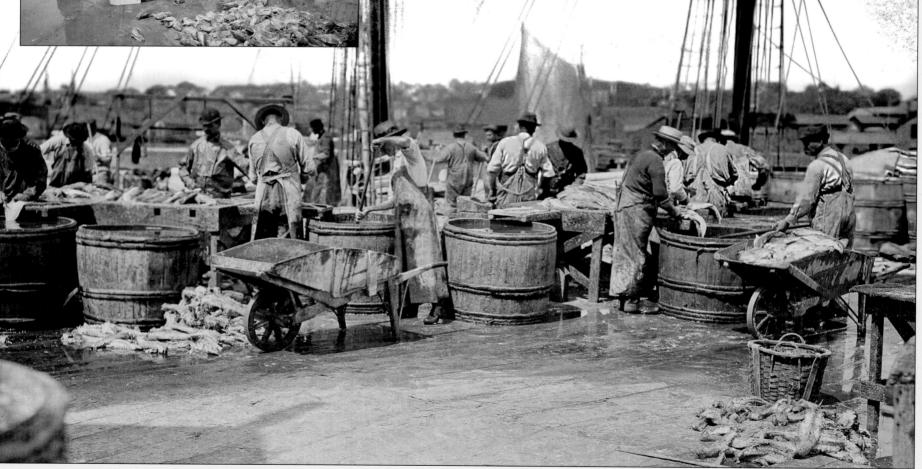

Today, New England cod fishermen face strict regulations on their catch. The commercial cod catch has decreased greatly since the 1990s because of these regulations. This has led to a rebound in cod populations. According to NMFS, cod stocks on Georges Bank and the Gulf of Maine are rebuilding to target levels, and the Gulf of Maine stock is no longer considered overfished.

Jennifer Kennedy
Executive Director, Blue Ocean Society for Marine Conservation
www.about.com

*Fishing boats in Gloucester Harbor at sunrise.*

*Schooner* Mary G. Powers *unloading catch to a group of what appear to be eager buyers on Boston's T-Wharf, c1900-1910. Library of Congress, (4a17225)*

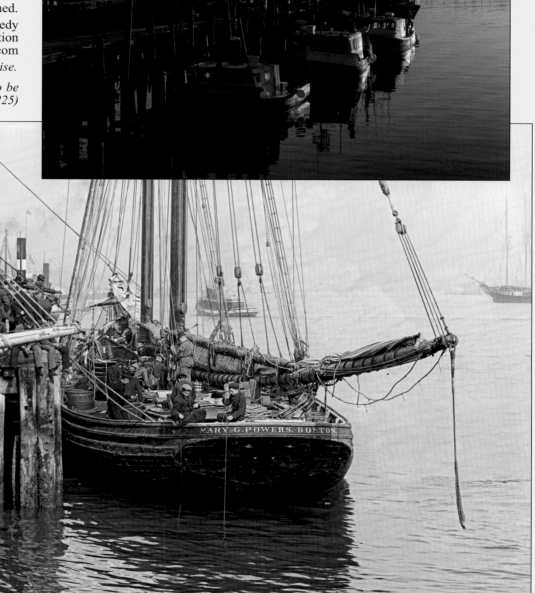

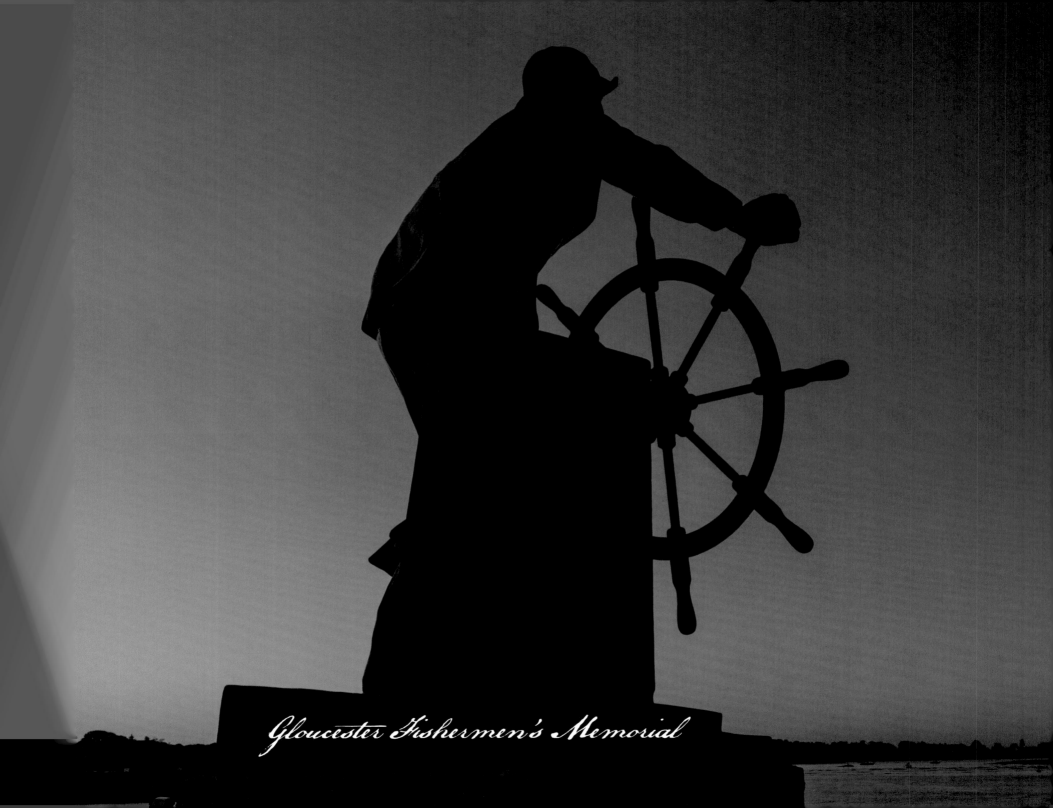

Gloucester Fishermen's Memorial

*"For nearly four centuries the history of Gloucester has been the story of America's greatest fishing port.*

*"With this memorial, we commemorate the lives and the legacy of those who died at sea while fishing. Their legacy came at a tremendous cost: the loss of over 5300 men. Some were overtaken by the howling winds and mountainous seas of a catastrophic northeaster. Some met their fate in the solitude of a small dory gone astray from the schooner that brought them to the banks. Some ships collided in storms and tragically sank. Others were run down by steamers in shipping lanes.*

*"These courageous men have been known by names other than fishermen. They were father, husband, brother, son. They were known as the finest kind. Their lives and their loss have touched our community in profound ways. We remain strengthened by their character, inspired by their courage and proud to call them Gloucestermen.*

*"They that go down to the sea in ships, that do business in great waters; These see the works of the Lord, and his wonders in the deep. Psalm CVII, 23-24"*

Portions of inscription on the memorial's brass plaque.

**Gloucester Fishermen's Memorial** *(also known as: "Man at the Wheel" statue or "Fishermen's Memorial Cenotaph") is a historic memorial cenotaph sculpted in 1925 by Leonard F. Craske.*

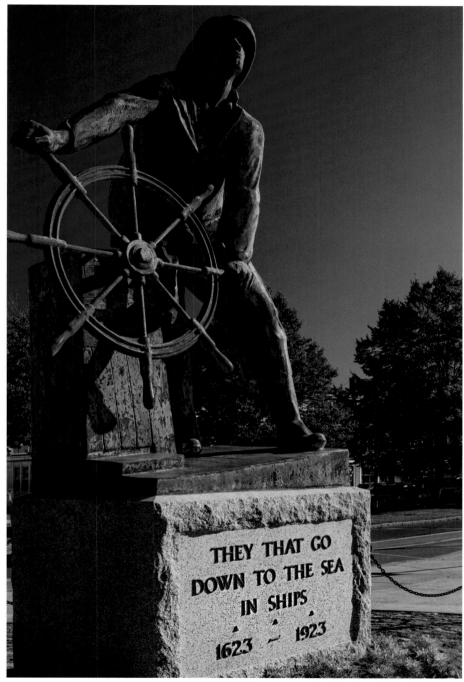

*Gloucester Fishermen's Memorial.*

19

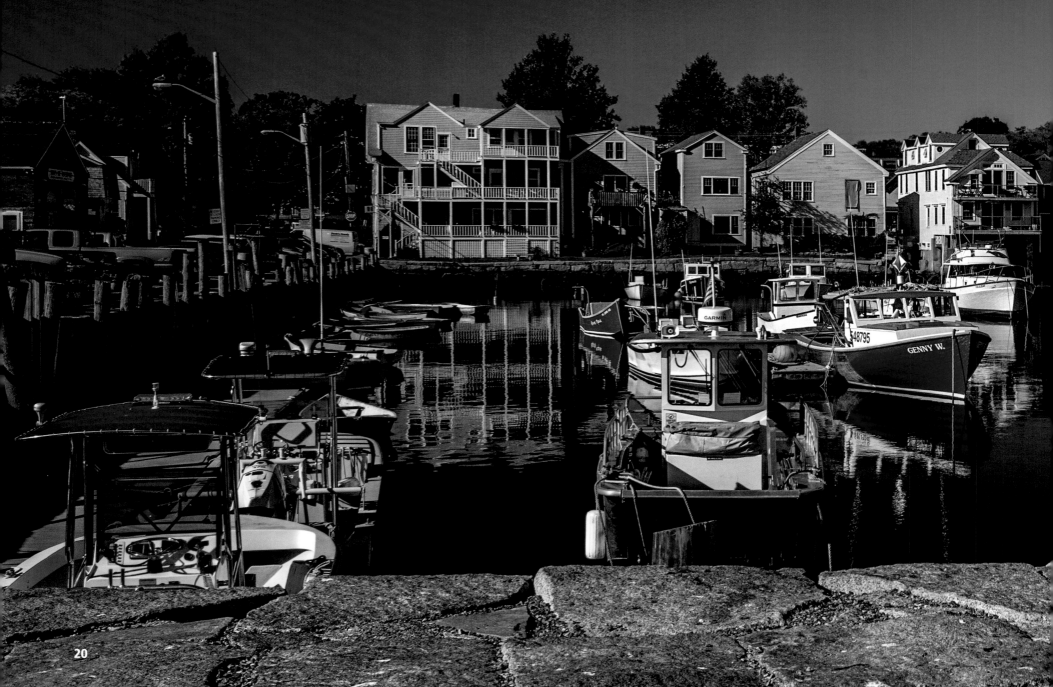

Rockport

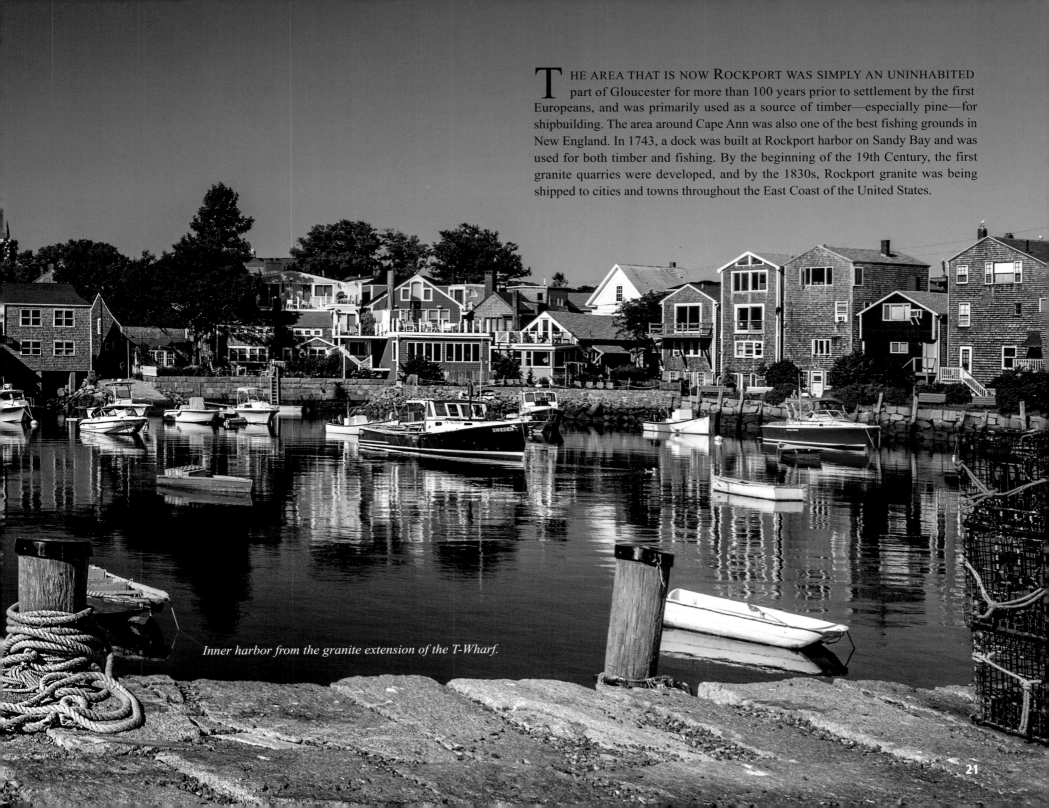

THE AREA THAT IS NOW ROCKPORT WAS SIMPLY AN UNINHABITED part of Gloucester for more than 100 years prior to settlement by the first Europeans, and was primarily used as a source of timber—especially pine—for shipbuilding. The area around Cape Ann was also one of the best fishing grounds in New England. In 1743, a dock was built at Rockport harbor on Sandy Bay and was used for both timber and fishing. By the beginning of the 19th Century, the first granite quarries were developed, and by the 1830s, Rockport granite was being shipped to cities and towns throughout the East Coast of the United States.

*Inner harbor from the granite extension of the T-Wharf.*

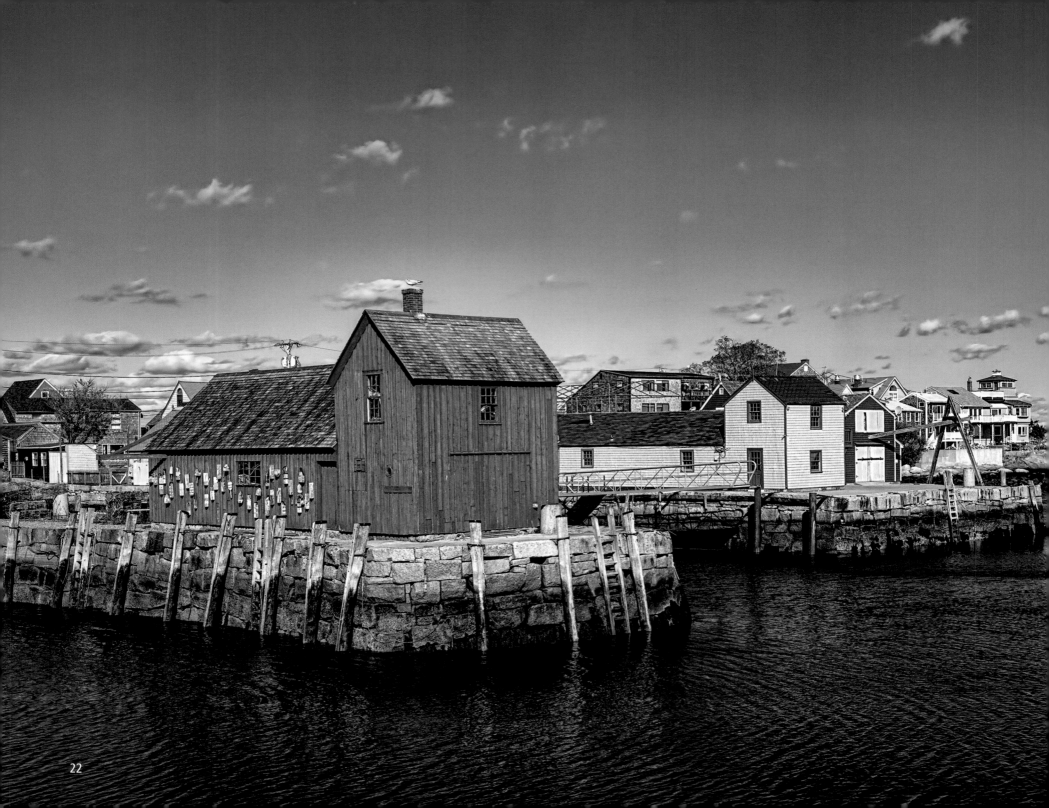

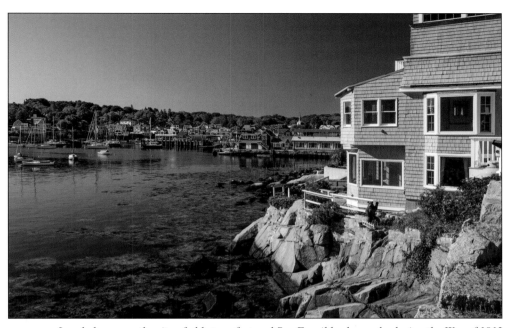

*Lovely house on the site of old stone fort and Sea Fencibles barracks during the War of 1812*

For a memory that will last longer than most, may I suggest you time your visit to Rockport's T-Wharf for noon. As you are about to walk onto the wharf, stop in at Ellen's Harborside for a take-out serving of her delectable fat-belly fried clams and carry on down to the granite part of the pier pictured on the previous page. You will enjoy that same view, and if you turn around, you will see a part of the town known affectionately as Bearskin Neck (left). Lots of little shops, galleries and more good eats. And from the traffic circle at the end of the road, you can look out to the Straitsmouth Island Lighthouse (1835) If your eyesight is up to it, Spain and France are just over the Atlantic horizon.

*Straitsmouth Island Lighthouse(1835)*

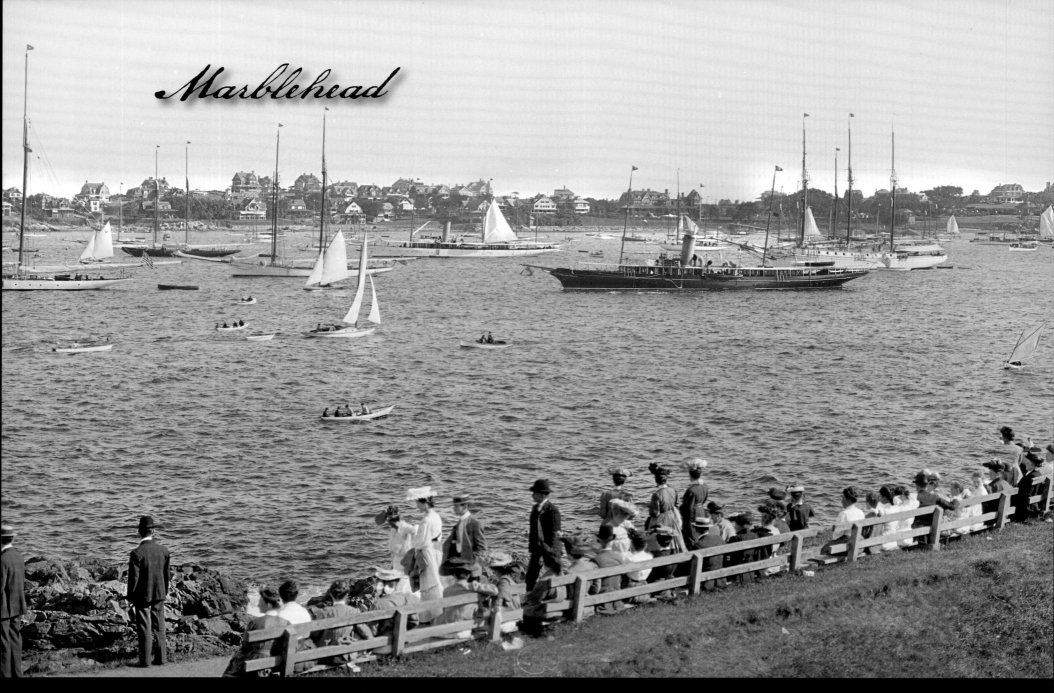

*Marblehead*

Spectators in their Victorian finery enjoying a yachting event from the shores of Fort Sewal. The Eastern Yacht Club (EYC) clubhouse can be seen over the stack of the black steam yacht Colonia on the far shore of Marblehead Harbor.
*New York Yacht Club Fleet, August 1902*
*Library of Congress, (photomerge: 4a06968 and 4a06969)*

t is Sunday, August 10, 1902 and, according to Joseph E. Garland in his book; The Eastern Yacht Club – A History from 1870-1985 he writes; "The harbormaster counted 1,047 craft of all kinds in the harbor. Monday was Regatta Day. The public came by the tens of thousands to catch a view from every vantage point on the shore. In this photograph the crowd is on the grounds of Fort Sewal. " Most of the vessels are from the New York Yacht Club and it was a huge event.

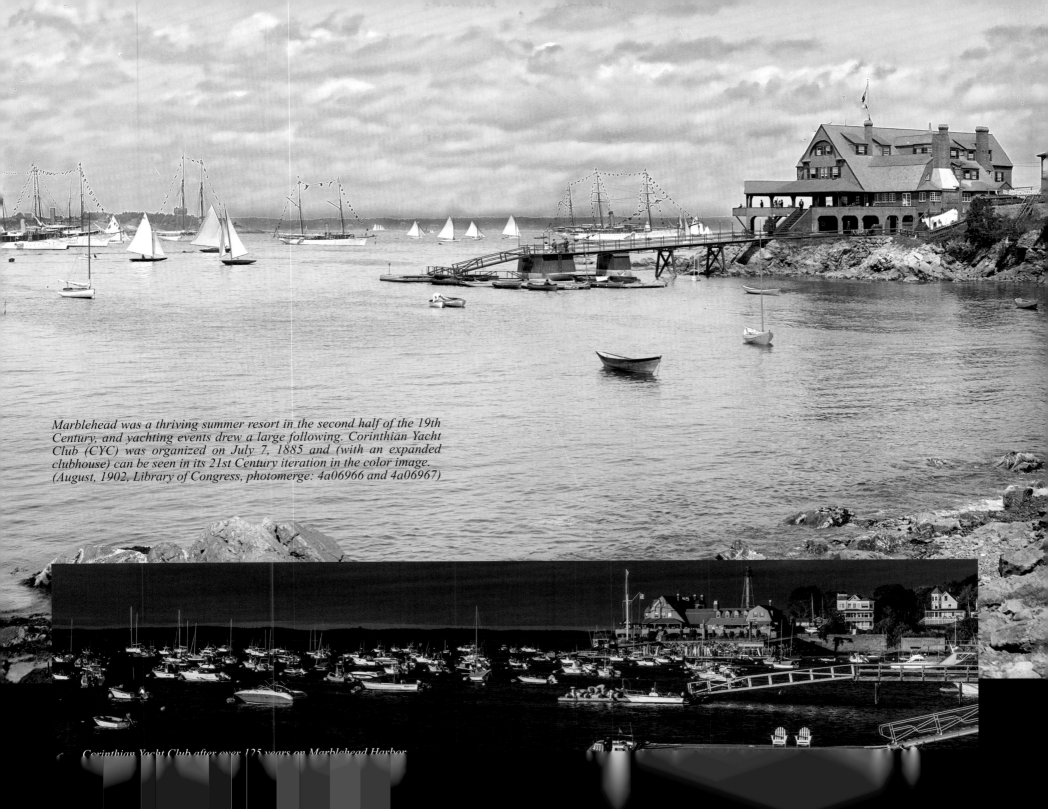

Marblehead was a thriving summer resort in the second half of the 19th Century, and yachting events drew a large following. Corinthian Yacht Club (CYC) was organized on July 7, 1885 and (with an expanded clubhouse) can be seen in its 21st Century iteration in the color image. (August, 1902, Library of Congress, photomerge: 4a06966 and 4a06967)

Corinthian Yacht Club after over 125 years on Marblehead Harbor.

# Salem

WHEN THE UNITED STATES WAS YOUNG, SHIPS FROM Salem helped to build the new nation's economy by carrying cargo back and forth from the West to Asia. The historic buildings, wharves, and reconstructed tall ship at this nine-acre National Park tell the stories of the sailors, Revolutionary War privateers, and merchants who brought the riches of the world to America.

From its founding in 1626 through the late 19th Century, Salem looked to the sea for its livelihood. The city's peak years came between the Revolutionary War and the War of 1812, when Salem's shipbuilders, merchants and mariners opened new ports of trade for America in Asia and other parts of the world. The wealth they created boosted the economy of the new nation and made Salem the sixth largest city in America in 1790.

Today you can recall Salem's maritime past by visiting the nine historic buildings and the replica tall ship at the site, or walk down the three historic wharves.

The Salem East Indiaman *Friendship* was launched in 1797. She made 15 voyages during her career to Batavia, India, China, South America, the Caribbean, England, Germany, the Mediterranean, and Russia, trading local products like dried cod fish and timber for pepper, spices, sugar, coffee, silk, tea and other exotic goods. Built for the Salem mercantile firm Waite and Peirce in the South River shipyard of Enos Briggs, she ended her activities as an American merchant vessel when she was captured as a prize of war by the British Sloop of War HMS *Rosamond* in September 1812.

The replica of *Friendship* was built by the National Park Service using modern materials and construction methods while retaining the appearance of the original ship. Today, Friendship of Salem sails to nearby ports, helping to bring the region's maritime heritage to life.

*Sail Loft, Derby Wharf and the replica ship* Friendship of Salem
*Salem Maritime National Historic Site (NHS)*

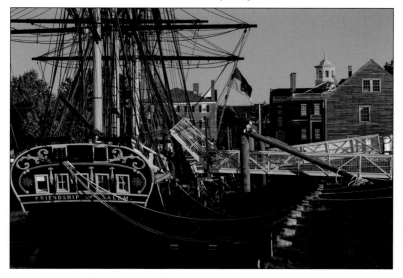

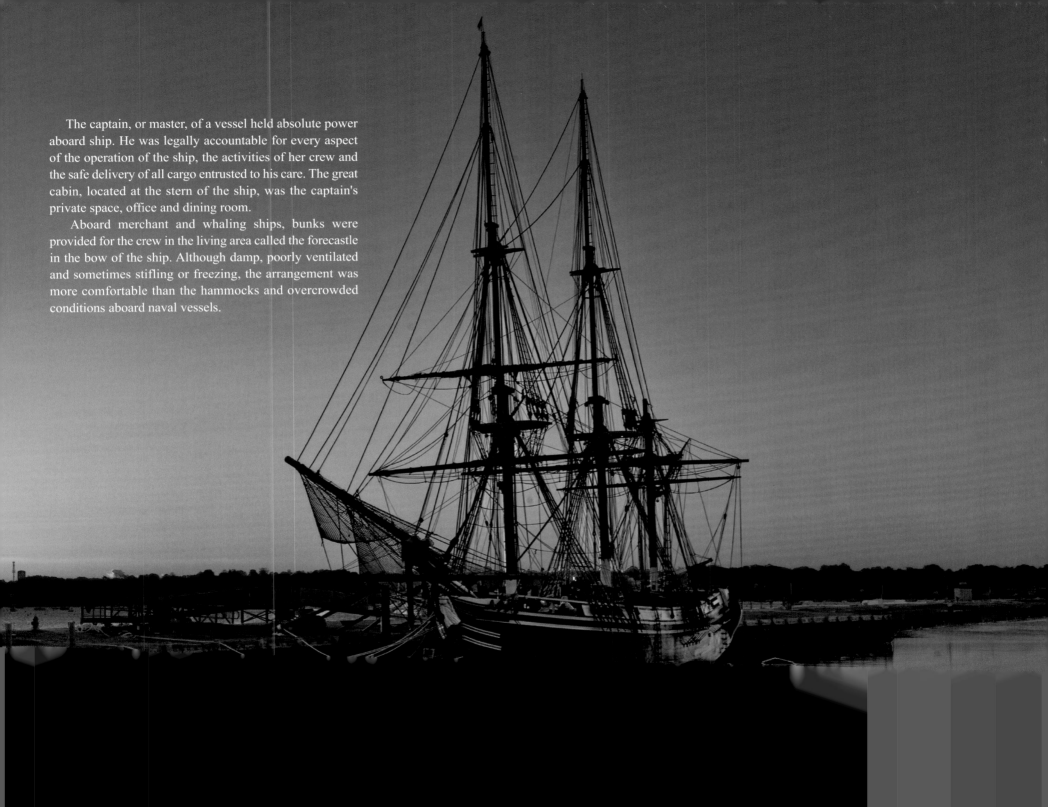

The captain, or master, of a vessel held absolute power aboard ship. He was legally accountable for every aspect of the operation of the ship, the activities of her crew and the safe delivery of all cargo entrusted to his care. The great cabin, located at the stern of the ship, was the captain's private space, office and dining room.

Aboard merchant and whaling ships, bunks were provided for the crew in the living area called the forecastle in the bow of the ship. Although damp, poorly ventilated and sometimes stifling or freezing, the arrangement was more comfortable than the hammocks and overcrowded conditions aboard naval vessels.

BOSTON'S INTERNATIONAL TRADE OWED MUCH TO THE INGENUITY AND technical skill of men like Donald McKay. From his East Boston shipyard, McKay and his workmen launched some of the fastest sailing vessels ever built. McKay's ships—the *Flying Cloud*, *Sovereign of the Seas* and *Great Republic*—were designed for both speed and cargo, to carry goods from Boston to California around Cape Horn, and to bring back gold from California to Boston. But the very nature of the clipper's success––the fact that Bostonians were perfecting clipper ships when steam power was rendering sails obsolete—ultimately prevented Boston's further advance. New York, with canals linking the city to the interior, ultimately became the nation's financial capital.

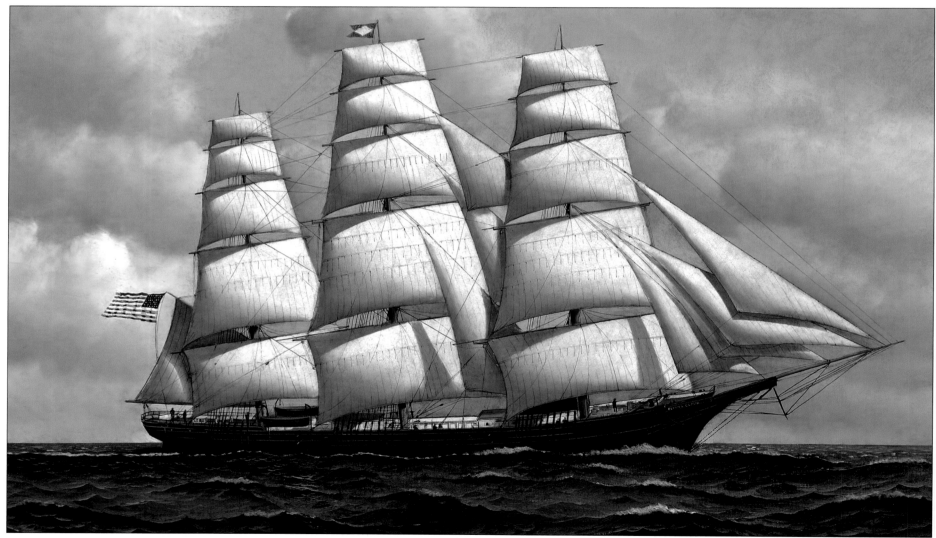

*Launched in 1851 with a 225-foot deck length and a tonnage of 1,782,* Flying Cloud *spent her early years on the New York to San Francisco trade via Cape Horn. Her maiden voyage set a record for the run which her fourth voyage improved to 89 days and 8 hours, anchor to anchor, a time never bettered and still standing for that route. She spent her final years in the timber trade until being wrecked on Beacon Island bar, outside St. John's, Newfoundland, in 1874.*

*The American clipper ship* Flying Cloud *at sea under full sail.*
Antonio Jacobsen/1913, Oil on cardboard,

The clipper ship Sovereign of the Seas *(below)*, launched in 1852, influenced the design of all future clippers. With her 200-foot main mast and over 12,000 yards of sail, she reported the highest rate of speed ever achieved by a sailing ship–22 knots, allowing her to break the record from New York to Liverpool, making the run in 13 days, 13 ½ hours.

,Launched on October 4, 1853 the Great Republic *(right)* is noteworthy as the largest wooden clipper ship ever constructed. She required 1,500,000 feet of pine, 2,056 tons of white oak, 336 tons of iron, and 56 tons of copper—about three times as much pine as was typically required for a large clipper ship. She sailed in ballast from Boston to New York, where in December 1853 her first cargo was loaded.

*The Yankee Clippers*

*Great Republic,* Jack Spurling

*Find a swift Yankee clipper,*
*here is freight for you,*
*black-bellied clipper,*
*Up with your anchor, shake out your sails,*
*steer straight toward Boston bay.*

*Leaves of Grass,* Walt Whitman

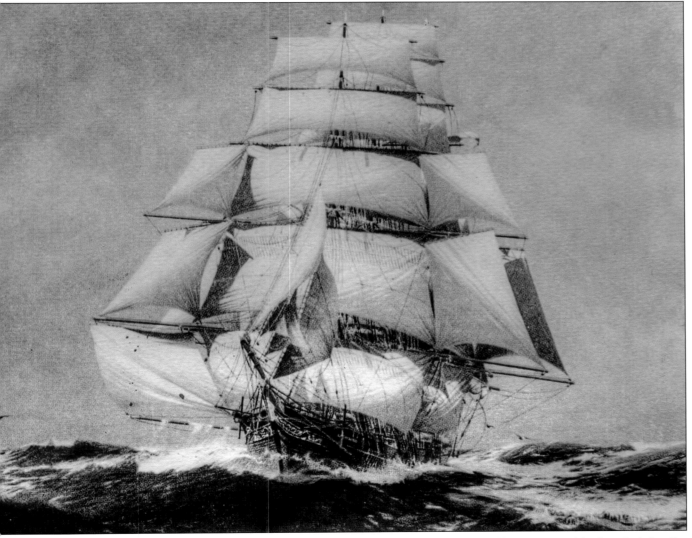

The Romance of Sail, Clipper Ship *Sovereign of the Seas,* Jack Spurling

# In The Beginning

**Robert J. Allison**

from: *A Short History of Boston*

FROM THE END OF LONG WHARF, YOU CAN SEE TEN THOUSAND YEARS OF HISTORY. On the islands of the harbor, created by the glaciers that shaped New England's coast, the Massachusett people fished and farmed. They called this harbor Quonehassit, and it gave them oysters, clams, cod, and occasionally a whale.

Across these waters the English began to come in the 1620s, trading with the Massachusett and others, and then opening their own trade with the rest of the world. The English built Long Wharf and the town of Boston around it. When the town's people resisted laws passed by the British to govern them, troops landed on Long Wharf to enforce the law, and on March 17, 1776, the British forces sailed from Long Wharf, leaving Bostonians to govern themselves.

The city of Boston, its gleaming towers and crowded neighborhoods, is the result of successful trade and revolution. To the airport across the harbor still come thousands of immigrants to make new lives in the New World.

Quonehassit today is a different world from the one the Massachusett called home. The land has changed, and the harbor has changed. For three centuries the people of Boston dumped their garbage in it, and by the 1950s it was an open sewer. But today, thanks to a massive cleanup, it is one of the world's cleanest harbors. Like the Massachusett who stood on its marshy shores, you might see a porpoise or a seal breaking its surface.harbor and building elaborate fish weirs, nets that trapped fish swept in at high tide. Recent archaeological work on Spectacle Island has uncovered

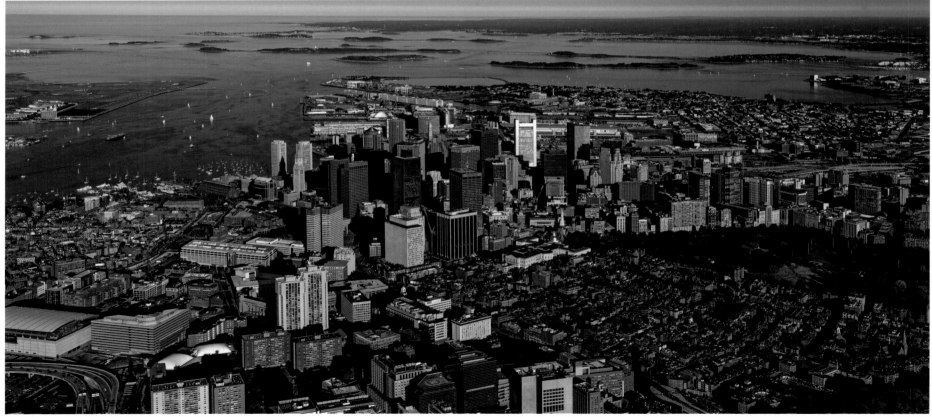

*Aerial view of downtown Boston, the North End, Beacon Hill, the Seaport District and the Harbour Islands.*

shell middens, tremendous piles of clamshells left over hundreds of years by the Massachusett. In the winter, the Massachusett retired up the Neponset River to the Blue Hills, or up the Charles and Mystic Rivers to the north and west (their name, Massachusett, means "people of the great hills"). They hunted deer and other animals. They grew corn, beans, squash and tobacco, trading with the Wampanoag and Pequot to the south and west, the Nipmuck and Abenaki to the north. When English, French and Dutch traders began to arrive, they traded with them as well.

In 1624 Samuel Maverick built a trading post at Noddle's Island, almost directly across the harbor from where you stand at the end of Long Wharf. Maverick traded with the surviving Massachusett and others for furs and corn, which he then traded to fishermen and others venturing into the area, including the English who started a colony at Plymouth in 1620. By 1626 Maverick had a new neighbor, William Blackstone, a minister in the Church of England. Blackstone had come to the New World as the chaplain of an attempted colony at Wessagusset, which later became Weymouth. When the expedition failed, Blackstone decided to stay in the New World. He left Weymouth for Quoneassit and built his house across the harbor from Maverick, on the peninsula the Massachusett people called "place of clear waters," or Shawmut, for its fine fresh spring water. Maverick and Blackstone, Nanepashermet and Chicatabot—all lived peacefully along the marshy shores of Quoneassit. In 1630, a larger group of Europeans arrived.

John Winthrop, an English lawyer, along with several hundred followers of the Puritan way, left England to found a religious commonwealth—a community sharing in a common endeavor—in the New World. They believed England had grown corrupt and decadent, and the Church of England, despite having broken with the Roman Catholic Church a century earlier, still maintained too many of its rituals and traditions. Winthrop and his followers wanted to form their own individual relationships with God, doing so as members of a community of saints.

In April 1630 the expedition of more than a thousand men, women, and children gathered in Southampton, England. The Reverend John Cotton, one of the leading Puritan ministers of the day, preached a farewell sermon to the multitude. They sailed off with a charter authorizing them, as the Massachusetts Bay Company, to plant a colony somewhere between the Merrimack and the Neponset Rivers.

After landing at Naumkeag (now Salem), where most of the original settlers had already died, Winthrop set out to find a more congenial place for his colony. He ventured south and, in Quonehassit, found what he was looking for. He met with Blackstone and Maverick, and at Mishawum found remnants of a great house, built by the Naumkeag expedition, which he converted into a dwelling The others followed, and by the end of summer nearly a thousand people crowded into this new settlement. They changed the name of Misawum to Charlestown, for the king, and the site of this first settlement today is City Square and Paul Revere Park.

*Charlestown's City Square and Paul Revere Park, so named to commemorate the famous ride that started here.*

Maverick stayed on Noodle's Island, both a friend and a rival to Winthrop and the Puritans, trading with the native people and entertaining more exuberantly than the Puritans approved As with Blackstone, who gave his name to a river, Maverick left his name behind. Maverick Square in East Boston is roughly the site of his Noodle's Island home; one descendant died in the Boston Massacre, and another ventured out to Texas, where he chose not to brand his cattle, which marked them as not belonging to anyone else. Maverick still means one who does not fit in with the established orthodoxy, whether of cattle or religious doctrine.

Winthrop named the settlement Boston, for the English town from which many had come. Standing on the end of Long Wharf, looking back toward the city, one can imagine the settlement by looking left, to the towers on the East India Wharf, just past the Aquarium. The shoreline curved inward, to the fleck of gold on top of the Old State House, in a straight line up Long Wharf and State Street, and from that point curved outward again, to the right, toward the granite blocks of Commercial Wharf. Atlantic Avenue marks approximately the boundary between the tidal flats, which were marshy ground at low tide, and the deeper waters of the harbor. Dock Square, in front of Faneuil Hall, became the settlement's center. Buildings spread to the northeast, along the shore of what became the North End, and to the southeast, in what then was the South End.

Beyond the settlement to the west rose the three peaks of the Trimount. The eastern peak was named Mount Cotton for clergyman John Cotton, who built his house on it after arriving in the mid-1630s; the center peak was Beacon Hill, the tallest point on the peninsula, from which a beacon could be shone warning of attacks or other calamities; the western-most was called Mount Whoredom for the illicit activities taking place on its slopes. Today Mounts Cotton and Whoredom are leveled, their ground used to fill the Mill Pond and Charles Street, respectively, and Beacon Hill itself is reduced and smoothed.

The name Trimount lives on in Tremont Street, which runs from the foot of Beacon Street along Boston Common and into the South End.

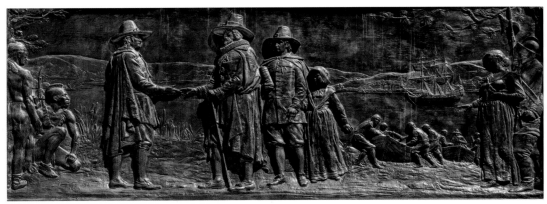

*In the Tercentenary Monument on Boston Common, William Blackstone greets John Winthrop.*
*Here, the model for Blackstone was James Michael Curley.*
*City's skyline bathed in beautiful May sunshine as Boston Harbor Cruises' tour boat* Rookie *enters the frame.*

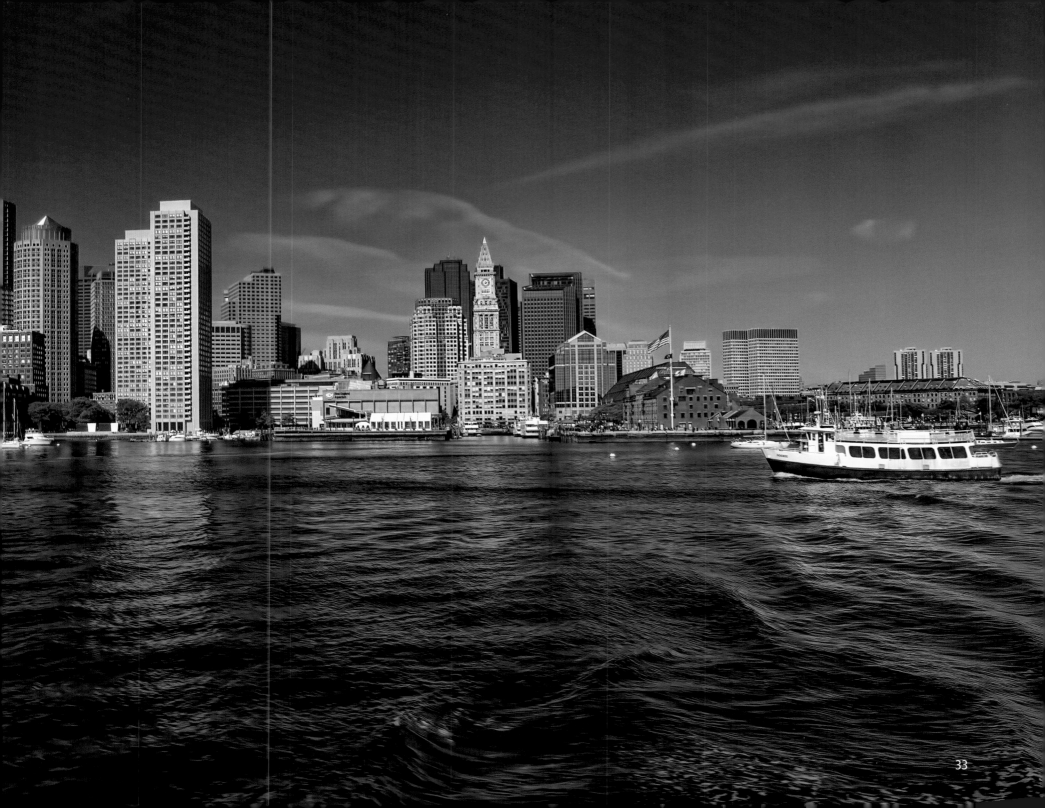

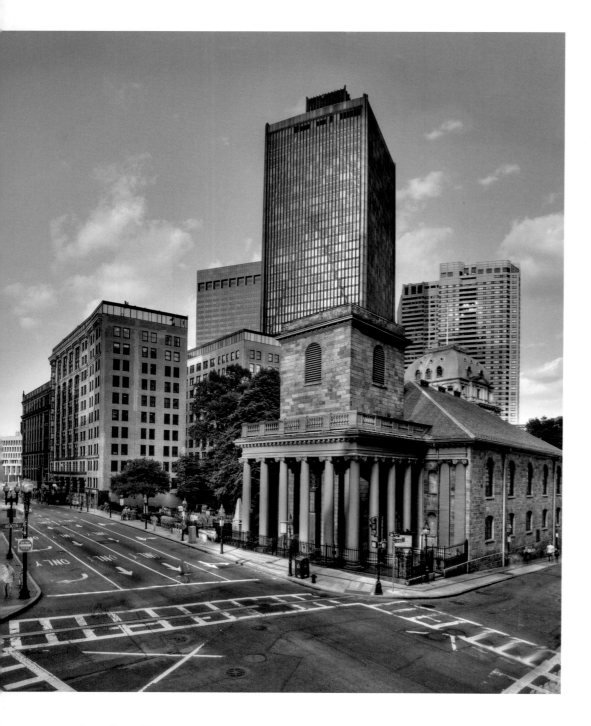

The colonists learned to fish, raise cattle and hogs, cut down timber and build ships. The Massachusetts Bay Colony thrived by combining all of these activities, building barrels to pack their salted codfish, pork and beef, and loading these goods onto ships to trade in Barbados and Jamaica. On those West Indian islands, African slaves produced sugar. The Massachusetts ships brought salted meat and codfish to feed the slave laborers, taking molasses in return . The molasses was brought back to Boston, refined into either sugar or rum, and then shipped to Europe or Africa, to be traded for manufactured goods or for more slaves for the West Indies. Massachusetts thrived not so much through producing codfish and ships as through selling goods in this trans-Atlantic trade. Edward Randolph noted in 1676 that "Boston may be esteemed the mart town of the West Indies."

At the end of the seventeenth Century the British government began to see the importance of its colonies. This meant closer attention from London, which did not please the Bostonians. King James II, in the late 1680s, tried to consolidate Massachusetts with the other New England colonies into the Dominion of New England, which would be governed from New York. Edmund Andros, New York's royal governor, would now also govern New England. Andros angered the Puritan hierarchy when he declared his intention to build an Episcopal church, King's Chapel, on a portion of the Old Burying Ground on Tremont Street.

The Bostonians arrested Governor Andros as a usurper and sent minister Increase Mather to England to plead their case Fortunately for them, Parliament deposed King James in what the British called the Glorious Revolution. In his place, Parliament installed Queen Mary, a Protestant daughter of James II, and her husband, Prince William of the Netherlands. Thanks to Increase Mather's lobbying, William and Mary granted a new charter to the Massachusetts Bay Colony, guaranteeing self-government but making the governor a royal, rather than a local, appointee.

*Kings Chapel on Tremont Street today and, c1905. (Library of Congress 4a23394) King's Chapel was organized as an Anglican congregation at a meeting in Boston's Town House, the city hall of the day, on June 15, 1686. Its first house of worship was a small wooden meeting house at the corner of Tremont and School Streets, where the church stands today. It was dedicated on June 30, 1689.*

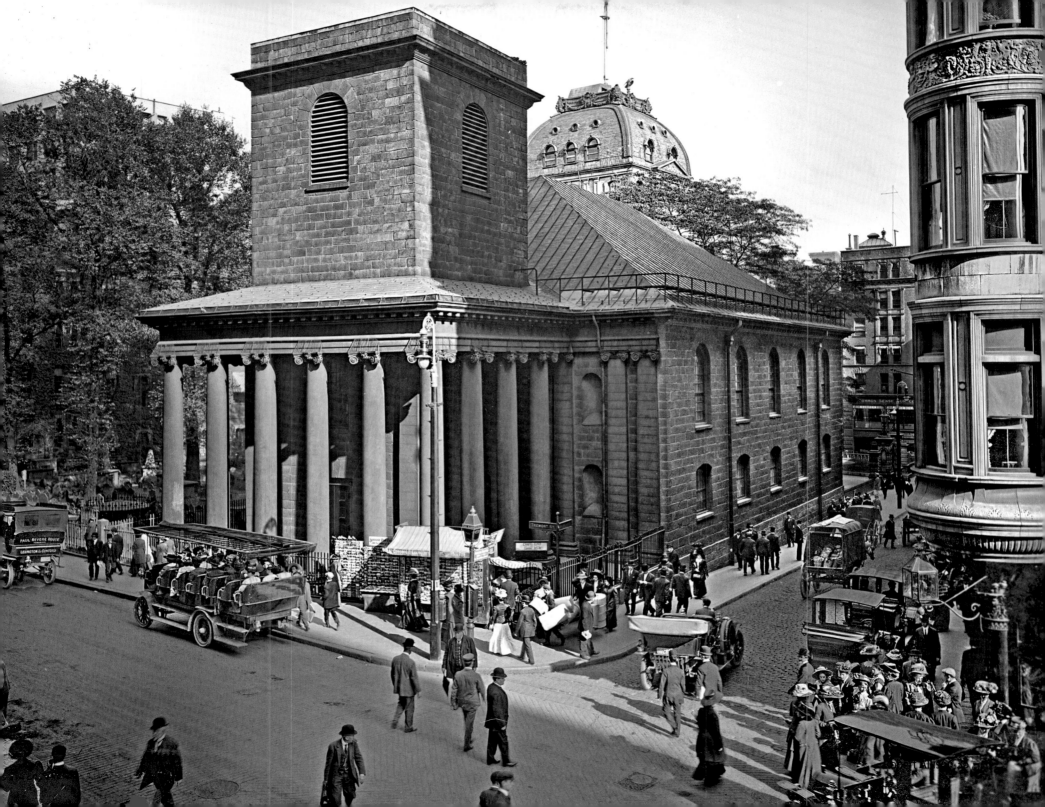

# *Road to Revolution*

**Robert J. Allison**

from *A Short History of Boston*

AT THE HEAD OF LONG WHARF IN 1657, THE TOWN BUILT A CENTRAL marketplace, thanks to the bequest of merchant Robert Keayne. Here on the ground floor, people coming to town to sell their goods could dry off in rainy weather or warm up in cold weather. On the upper floor, the town elders could confer and the courts could sit. It burned in 1711 but was quickly replaced by a new brick town house, with a market on the ground floor and town and provincial offices and meeting rooms upstairs. This served as the seat of Massachusetts government from 1713 until 1976, and today, as the Old State House, it is the second oldest public building in the nation. The Town House stood at the center of Boston's commercial world, on Long Wharf. From the balcony of the Council Chamber, from where he read royal Proclamations, the governor could watch ships preparing to carry the British flag to all parts of the world.

Here in 1748 Governor William Shirley was meeting with his council when they heard an angry mob outside surrounding the building. This crown had marched up Long Wharf, escorting a detachment from the British warship Preston. These British sailors had been sent ashore to impress into the Royal Navy any able-bodied men they could find. The Royal Navy treated its sailors brutally and therefore found it difficult to enlist men, who were better paid, fed, and treated in the merchant service. Under British law, a naval commander could impress into service any British subject anywhere in the world.

The men and women in the Boston mob permitted the British officers to go inside and meet with the governor. But while Shirley met the press gang he could hear the Bostonians outside demanding that he send the Preston and its press gang away. Shirley recognized that British warships might come and go, but he would have to live with the men and women outside. He sent the press gang away empty-handed. While British ships would impress sailors in other ports in the American colonies, none would ever again try to do so in Boston–despite the need for men to fight the Seven Years' War, which began in 1756.

After the Seven Years' War (called by Americans the French and Indian War) ended in 1763, the British government tried to raise revenue by taxing the American colonists. The *Stamp Act* of 1765 imposed a small tax on all printed documents. In Boston, Andrew Oliver signed on to sell the stamps. Little did he know that by agreeing to uphold the law of the empire, he would help trigger the empire's end in America. On the night of August 14, 1765, a mob descended on Oliver's Long Wharf office. Believing that Oliver was storing the stamps inside, the mob broke in and, not finding the stamps, tore down

the shop and threw it into the harbor. A day later, Oliver was invited to visit the South End tavern where the mob's leader, Ebenezer Macintosh, a shoemaker, held court. Escorted by a group of citizens, Oliver arrived at the large elm in front of the tavern to see his own effigy hanging by its neck. Oliver was asked if he would like to continue as tax agent. Fearing that the mob would not be satisfied with simply hanging his effigy, Oliver resigned.

In Parliament, some wanted to punish the Bostonians for their destructive protests. Others sympathized. Isaac Barre, a member of Parliament, argued that the colonists were asserting their rights as Englishmen not to be taxed without their consent. The protestors were not lawless mobs, Barre insisted, but the "freeborn sons of liberty," seeking to preserve their liberties as English men and women. The term "Sons of Liberty" stuck, and the elm from which they hung Oliver's effigy became the Liberty Tree. As with the mob that blocked the Preston crew's attempt to impress Bostonians, the Sons of Liberty resisted any attempt to establish an arbitrary, tyrannical government.

These attempts continued, however. In 1767 Parliament, insisting it did have the power to tax all subjects of the British empire, created a new system of taxes. Knowing that collecting these taxes in Boston would be difficult, Governor Francis Bernard requested two regiments of troops, who arrived at Long Wharf in October 1768.

The arrival of troops made a tense situation explosive. The soldiers, dressed in the uniforms of the 14th and 29th Regiments, arrived as the town struggled through a postwar recession. Many of these men, poorly paid Irish Catholics, had brought their wives and children along and now were competing for jobs and housing with Bostonians at the bottom of the town's economic ladder. Business had boomed

during the war, but now Boston struggled. Matters were not helped by the new taxes Parliament had imposed, nor by town leaders like Samuel Adams calling for a boycott of British goods to protest those taxes. By early 1770, trade was stalled, and some merchants hoped either to evade the taxes by smuggling or simply to accept the taxes and sell British goods.

*Michael Szkolka, dressed as a Captain in the British 1st Foot Guards, now the Grenadiers, enjoying a pint in the Green Dragon Tavern after a day of entertaining visitors and locals with tales of Colonial Boston's history.*

All of these factors—religious, economic and political—made it impossible for the soldiers to fulfill their mission of preventing disorder in the tense town. These tensions erupted on March 5, 1770, when an angry mob surrounded a company of British troops outside the Town House. The soldiers opened fire; four men fell dead and seven were wounded (one of whom died the following week).

Samuel Adams saw this as an inevitable consequence of using armed troops to enforce the law in a community and demanded that the troops be removed. They were sent to Castle Island. Adams organized a public funeral for the victims, all of them mourned together at Faneuil Hall. From Faneuil Hall, 10,000 mourners followed the four caskets through the narrow streets to the Granary Burying Ground, where the four men were buried. Thirty-three years later, Samuel Adams would be buried beside them.

Artist Henry Pelham painted the riot scene, calling it *The Fruits of Arbitrary Power*, and coppersmith Paul Revere made an engraving of the massacre on King Street. As the soldiers awaited trial, the town of Boston sent Revere's drawing and its own report on the event to England, demanding that the troops be removed farther away than Castle Island. Samuel Adams's cousin John defended the soldiers, who were tried for murder, and all but two were acquitted. Those two were branded on their thumbs. All the troops left Boston in 1771.

Boston remained quiet until 1773. That year, several seemingly unrelated events converged to renew the conflict. Thomas Hutchinson, who had become governor when Bernard was recalled, wanted the Assembly to meet in Cambridge, beyond Boston's influence. The Assembly, under the leadership of its clerk, Samuel Adams, began moving to recall Hutchinson, just as they had forced Governor Bernard out four years earlier. Halfway across the globe, the British East India Company had bankrupted itself in conquering India. To ease the company's distress, Parliament had given it a monopoly on all the tea sold in the British Empire. Parliament also designated the merchants in each port who would be permitted to sell the tea. In Boston, two of the three designated merchants were Thomas Hutchinson's sons, Elisha and Thomas jr.

When the *Dartmouth* docked at Griffin's Wharf in November, the Sons of Liberty quickly surrounded it, keeping the tea from being unloaded. Samuel Adams organized mass meetings, first in Faneuil Hall and then in the Old South Meeting House, to protest the arbitrary power Parliament exercised. Finally, on December 16, 1773, about one hundred men dressed as Mohawk Indians streamed out of taverns and Masonic meetings along the South End waterfront, and within an hour had dumped all of the tea into the harbor. More than £9,000 sterling (worth more than $1.5 million today) was destroyed, in what became known

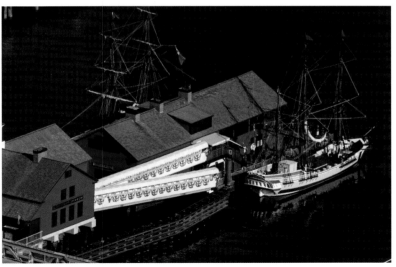

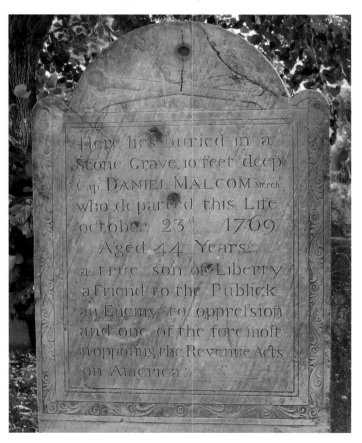

*Just before the Battle of Bunker Hill, British soldiers occupied Copp's Hill, and found sport in firing muskets at the gravestones. Their favorite target was that of Daniel Malcom, a sea captain and Patriot who strongly opposed the Revenue Acts. The Americans considered the Revenue Acts taxation without representation. The bullet marks are clearly visible in several place on Malcom's gravestone.*
*(Craig Dilley Photo)*

*Boston Tea Party Ships and Museum at the center of the Congress Street bridge over Fort Point Channel.*

as "the destruction of the tea" and later "the Boston Tea Party." In other port cities, the locals either impounded the tea or forced it to be sent back to England.

When Parliament heard what had happened, it closed Boston Harbor, suspended the Massachusetts government, and sent General Thomas Gage, commander in chief of British forces in North America, to govern the rebellious province. Parliament hoped to isolate Boston and Massachusetts and was certain the other colonies would fall into line. But Samuel Adams, behind-the-scenes leader of the Boston town meeting and clerk of the Massachusetts Assembly, had already prepared a network: a Boston Committee of Correspondence to communicate with other Massachusetts towns and a Committee of Correspondence in the Assembly to communicate with other colonies. By the time the British government shut down Massachusetts commerce and government, Adams had created a network throughout the other colonies that he hoped would come to his province's support.

In September 1774, Samuel and John Adams, along with John Hancock, set out for Philadelphia for the first meeting of a Continental Congress. The big question was, would the other colonies support Massachusetts? Or would they follow Parliament in seeing Massachusetts as a particularly troubling place, one whipped into a frenzy by Adams and other radical leaders? While the Congress hoped to reconcile the colonies with the empire, the Congress also was determined to support Massachusetts in her extremity. After all, the delegates reasoned, if Parliament could suspend the Massachusetts government and close Boston Harbor, it could also suspend their governments and close their ports.

As General Gage and his troops occupied the town of Boston, a new government—or actually the old government—emerged in the rest of the province. People in the towns continued to elect their own magistrates, tax collectors, and delegates to the Assembly, even as Gage declared that only he could appoint local officials and that the Assembly had no business meeting at all. By early 1775, two governments operated in Massachusetts. Officially, Gage was the governor, but his power extended only to the areas controlled by his troops In the rest of the province, voters at town meetings appointed local committees of safety to govern the towns and also sent delegates to a provincial Congress to govern Massachusetts. Men and women in Massachusetts who remained loyal to the British Crown found they had to leave their homes for Boston to put themselves under Gage's protection, while Bostonians whose loyalty remained with their home province fled from the town. Boston's population shrank from about 15,000 to fewer than 5,000, and Gage and his troops found themselves prisoners in the town they occupied as, throughout New England, militia forces now swarmed into Cambridge and Roxbury to keep the British in Boston.

*Here a Continental Army officer in the early part of the war bids farewell to his family at their modest homestead as his regiment departs for active service. His wife is presenting him with a silver-hilted sword and her wish that he may return soon and safely, although, it may be some time until they're reunited. As with all Troiani paintings, attention to the most trivial historical details (such as the green arsenic dyed ivory grips on the sword) is unrivaled.*
Don Trioni, *Answering Liberty's Call*

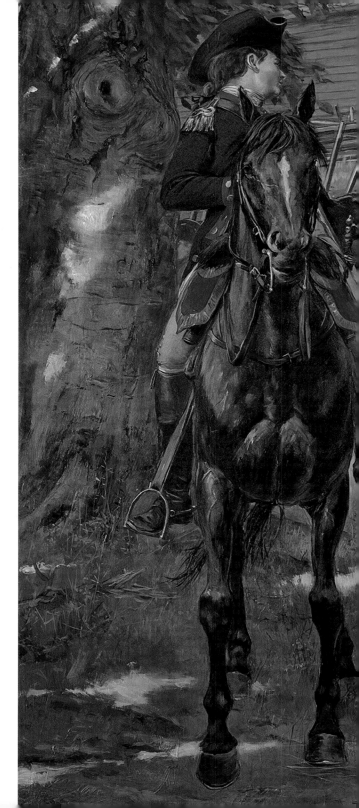

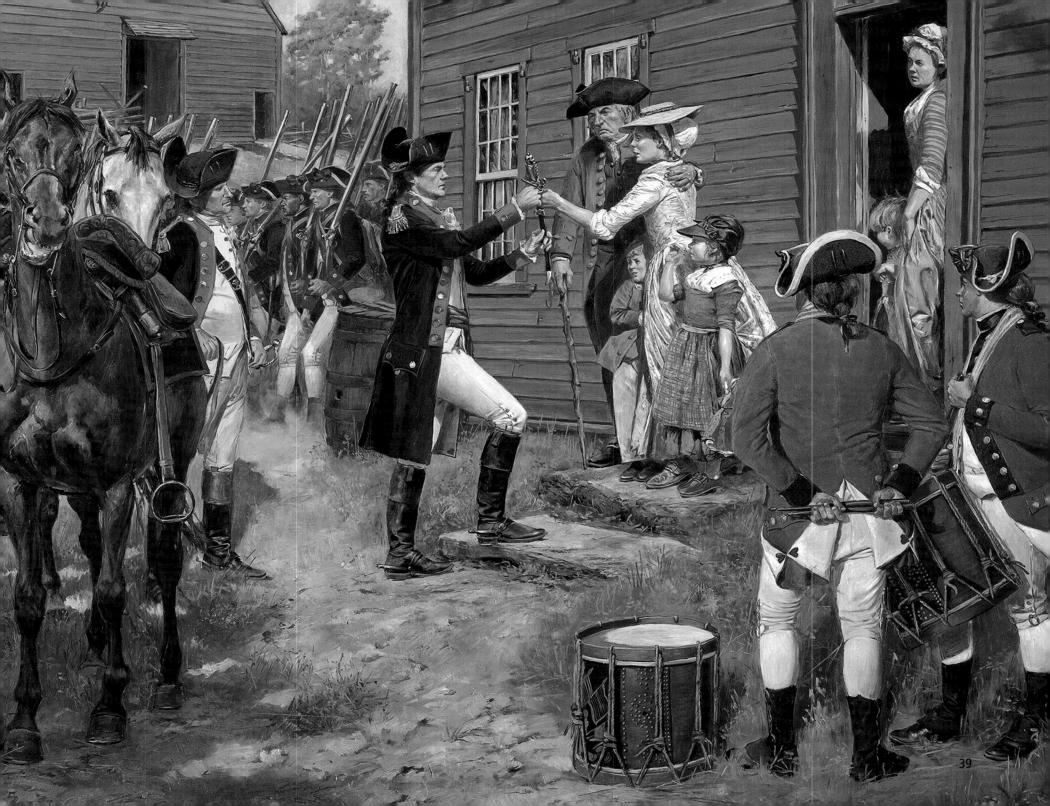

# Revolution

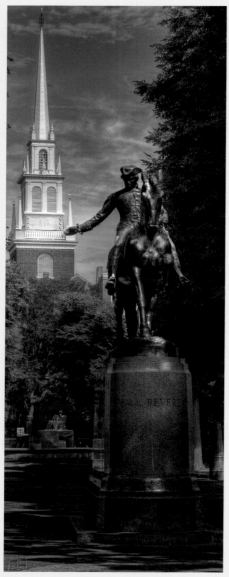

*Paul Revere Mall with an equestrian statue of the famous patriot and the Old North Church in the North End.*

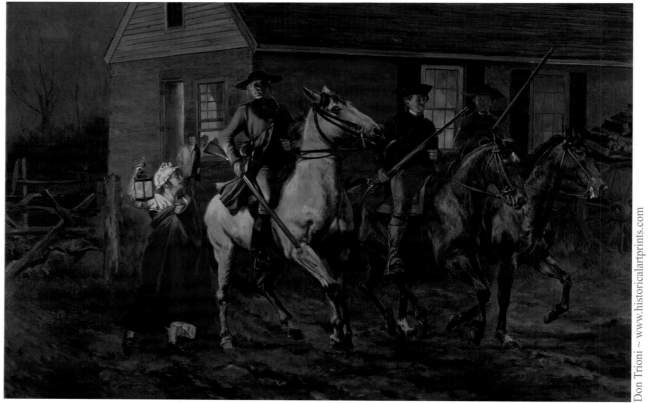

*In the pre-dawn hours of April 19th, 1775, an alarm was spreading through the Massachusetts countryside that British regulars were on the march towards Concord. As the word reached Westford and the other surrounding towns, men grabbed their muskets and swords, said goodbye to their loved ones, and rushed to answer the call to arms. In advance of the rest of the Town of Westford's Minutemen and Militia companies, three men left that morning on horseback for the ten-mile trek to Concord. Sgt. Joshua Parker said goodbye to his wife Hannah, while his three children, Joshua jr., Mary, and Patty, awoken by the commotion looked on, probably not understanding the gravity of what was to come. All three men said goodbye and rode off, not knowing if or when they would return, or that they would be witness to great events soon to come that day in Concord, and along the road back to Boston.*

Don Trioni, *Departure Of The Minutemen – Westford Responds April 19, 1775*

Massachusetts Colony was a hotbed of sedition in the spring of 1775. As tensions grew between the colonies and British Parliament on issues of taxation, Great Britain responded to colonial protests such as the Boston Tea Party by closing Boston's port and restricting the colonists' treasured right to self-rule.

Preparations for conflict with the Royal authority had been underway throughout the winter with the production of arms and munitions, the training of militia (including the minutemen), and the organization of defenses.

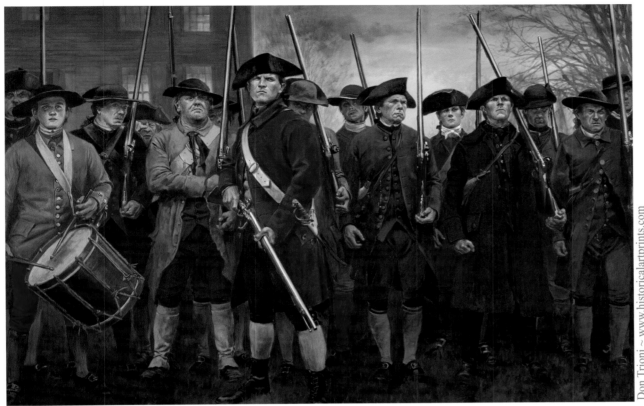

*At about midnight on April 19th, 1775, Boston silversmith and patriot alarm rider Paul Revere rode into the town of Lexington, Massachusetts to alert Samuel Adams and John Hancock along with local Minute and Militia companies along the way, that British Regulars were on the march to Concord. By 2:00 a.m., 45-year old Capt. John Parker had formed his militia company of about 130 men on the Lexington Common, and ordered them to load their muskets. Unknown to Parker, there were actually some 700 elite British light infantry and grenadiers on the march to Concord, which would take them past the town common. Finally, at about 5:00 a.m., word did come back to Parker that the regulars were close. He ordered the young William Diamond to beat his drum and assemble the militia. Some 77 men hastily formed on the common facing the road to Concord in two ranks. As the British light infantry companies came onto the common at the double quick march, Major Pitcairn rode onto the common calling on his troops not to fire, but to surround and disarm the assembled militia, and also ordered the rebels to "Lay down your arms and disperse". A shot rang out, and the opening volley of the American Revolution had begun on a New England town green.*

Don Trioni, *Lexington Common – 19th of April 1775*

In April, General Thomas Gage, military governor of Massachusetts, decided to counter these moves by sending a force out of Boston to confiscate weapons stored in the village of Concord and capture patriot leaders Samuel Adams and John Hancock, reported to be staying in the village of Lexington. His orders to Lt.-Col. Smith, the British officer who was to lead the expedition, along with a fascinating eye-witness account from a militiaman on the Green, are reproduced at right.

"*Sir: Having received intelligence, that a quantity of Ammunition, Provision, Artillery, Tents and small arms, have been collected at Concord, for the Avowed Purpose of raising and supporting a Rebellion against His Majesty, you will march with the Corps of Grenadiers and Light Infantry, put under your command, with the utmost expedition and secrecy to Concord, where you will seize and destroy all Artillery, Ammunition, Provision, Tents, Small Arms, and all military stores whatever. But you will take care that the Soldiers do not plunder the inhabitants, or hurt private property.*"

And the following excerpt from a sworn affidavit by Sylvanus Wood, one of the militiamen who stood with Captain Parker that spring morning:

"*...They there halted. The officer then swung his sword, and said, "Lay down your arms, you damned rebels, or you are all dead men.' Some guns were fired by the British at us but no person was killed or hurt, being probably charged only with powder. Just at this time, Captain Parker ordered every man to take care of himself. The company immediately dispersed; and while the company was dispersing and leaping over the wall, the second platoon of the British fired and killed some of our men. There was not a gun fired by any of Captain Parker's company, within my knowledge...*"

www.eyewitnesstohistory.com/lexington.htm

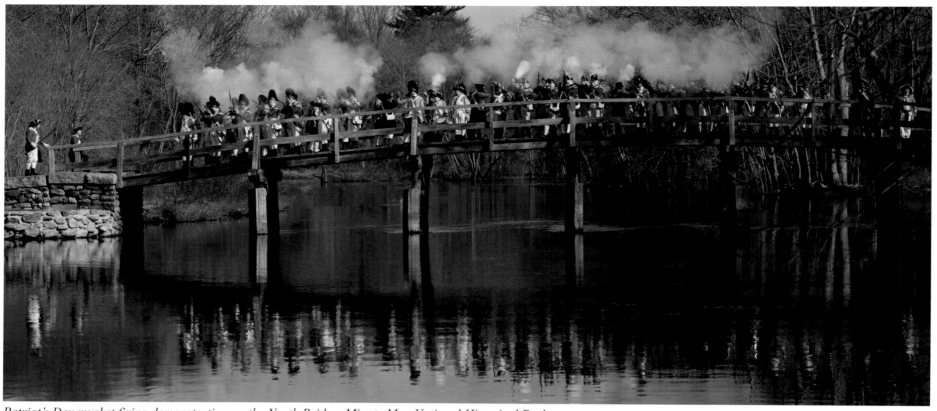

*Patriot's Day musket firing demonstration on the North Bridge, Minute Man National Historical Park*

Under great pressure from his superiors in England to bring Massachusetts back under control of the lawful government, General Gage sent the troops to Concord in the hopes that by doing so, he could convince the colonists to back down, and thus avoid an armed rebellion.

In his orders to Lt.-Colonel Smith, commander of the British expedition to Concord, Gage directed him to take control of the two bridges in town, the South Bridge and the North Bridge. "You will observe...that it will be necessary to secure the two bridges as soon as possible..." Securing the bridges was necessary to prevent rebels from slipping across from remote parts of town to threaten the mission. Also, Lt.-Colonel Smith sent seven companies across the North Bridge with orders to search for supplies and artillery known to be hidden at Barrett's farm, about a mile west of the bridge.

At that time, the the colonial militia, with over 400 men, occupied the high ground (now the site of the North Bridge Visitor Center) overlooking the bridge. If they were to swoop down and take the bridge, the British soldiers at Barrett's farm would be cut off. Therefore, the British left three companies (about 96 men) at the bridge to guard it. It would prove not to be enough.

Sometime after 9:00 a.m. the militiamen, believing the town was being set on fire, marched down upon the bridge. According to one British officer, they did so "in a very military manner."

Hopelessly outnumbered by the advancing militia, the British pulled back to the east side of the bridge. According to one British officer, "Captain Laurie made us retire to this side of the bridge, which by the bye he ought to have done at the first for the rebels were so near..."

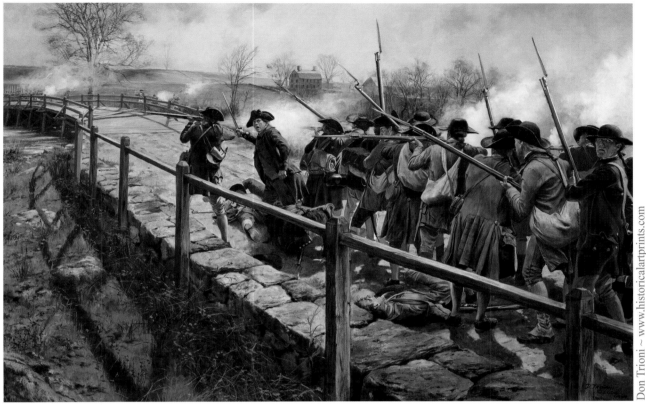

Don Trioni ~ www.historicalartprints.com

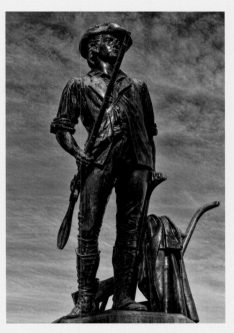

*Here the Minutemen led by Maj. John Buttrick face three companies of British Light Infantry across the wooden bridge near Concord, Mass. The Acton Company, armed with muskets and bayonets, was in the lead as the British opened fire without warning after being warned to stop removing planks from the bridge. Buttrick yelled to his men, "Fire, fellow soldiers, for god sake, fire!" The fire of the regulars had killed Capt. Davis and Pvt. Abner Hosmer and wounded a few others. Drawn up in column in the roadway before the bridge, the few Americans that could aim without hitting their neighbor heeded Buttrick's command and returned fire. As the Americans deployed and more guns were brought to bear, the British lights withdrew in a panic towards the safety of a column of grenadiers that had marched out of town to reinforce them. As the Redcoats evacuated Concord and its environs, they were followed and flanked by a swarm of angry, buzzing Americans from the nest they had disturbed and were stung badly on their retreat back into Boston, with some 73 British officers and men killed, another 174 wounded, and some 26 missing or captured. April 19th began what would lead to eight years of bloody conflict that would result in the 1783 Treaty of Paris and creation of a new nation, the United States of America.* Don Trioni, *Concord Bridge – 1775*

*The Concord Minuteman Statue by Daniel Chester French was created for the 100th anniversary of the battle (1875).*

*By the rude bridge that arched the flood,*
*Their flag to April's breeze unfurled;*
*Here once the embattled farmers stood,*
*and fired the shot heard round the world.*

*The Concord Hymn,* Walt Whitman, 1837

*At Concord's North Bridge, the colonial militia fired upon the British Army in defiance of the British Crown. Here, the British Army suffered its first fatalities of the war. The events that day launched the American War for Independence.*

# *Bunker Hill*

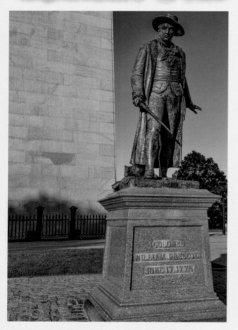

Colonel William Prescott commanded the Colonial forces at the Battle of Bunker Hill. This over-life-sized bronze statue shows him with his sword—the symbol of command—in his right hand. With his left hand, he signals his troops to hold their fire, waiting for the enemy to draw nearer. The statue is the work of the American sculptor William Wetmore Story. It was erected beside the monument in 1881.

*"Don't fire until you see the whites of their eyes."*
*It is uncertain who said it there, since various accounts attribute it to Prescott, Putnam, Stark or Gridley, and it may well have been said first by one, and repeated by the others.*

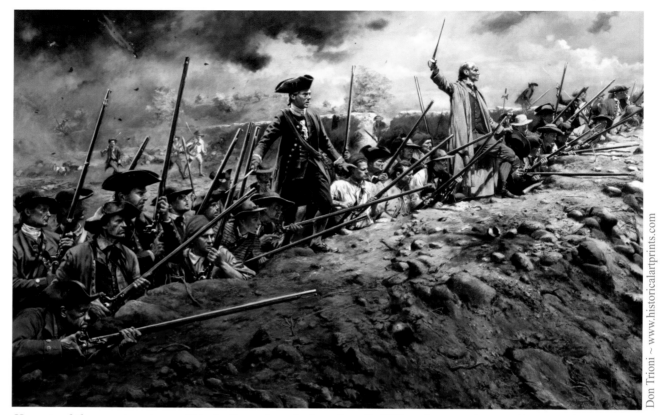

*Here stand the raw American militia in the main redoubt at Breed's Hill as they are about to fire upon the seemingly endless advancing ranks of British regulars. Colonel Prescott stands on the works with his sword ready to give the famous command that would reshape American history forever.* Don Trioni, *Bunker Hill – 1775*

"Don't fire until you see the whites of their eyes!" This legendary order has come to symbolize the conviction and determination of the ill-equipped American colonists facing powerful British forces during the famous battle fought on this site on June 17, 1775. The battle is popularly known as "The Battle of Bunker Hill" although most of the fighting actually took place on Breed's Hill, the site of the existing monument and exhibit lodge. The Battle of Bunker Hill pitted a newly formed and inexperienced colonial army against the more highly trained and better equipped British. Despite the colonial army's shortcomings, it was led by such capable men as Colonel William Prescott, Colonel John Stark and General Israel Putnam, who had experience fighting alongside the British in the French and Indian War.

Although the British Army ultimately prevailed in the battle, the colonists greatly surprised the British by repelling two major assaults and inflicting great casualties. Out of the 2,200 British ground forces and artillery engaged at the battle, almost half (1,034) were counted afterwards as casualties

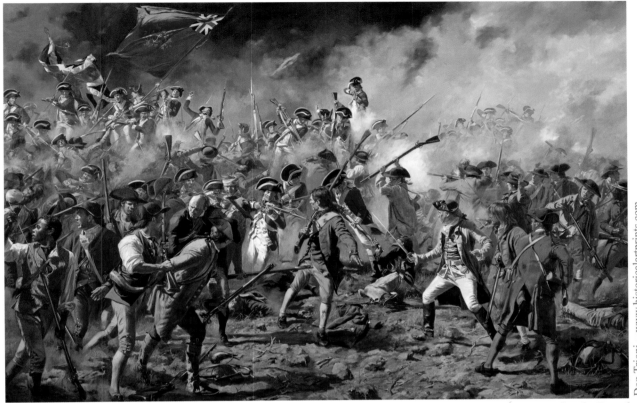

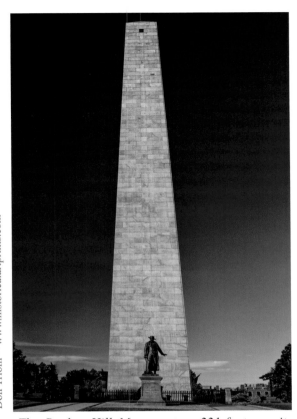

*Here we see the latter phase of the epic battle of June 17, 1775. After appalling losses in two previous assaults, the British push forward in a third attempt to storm the American position on Breed's Hill. As the patriots' ammunition runs out, the British Marines and 47th Regiment of Foot pour over the earthen walls in a furious rage. The Americans are forced back out of their redoubt in one of the most brutal hand-to-hand fights of the war. Giving ground only in the face of overwhelming force, President of the Massachusetts Provincial Congress, Dr. Joseph Warren is shot dead by a British officer.*

Don Trioni, *The Redoubt – 1775*

*The Bunker Hill Monument, a 221-foot granite obelisk, stands on Breed's Hill today. On June 17, 1825, the 50th anniversary of the battle, the cornerstone of the monument was laid by the Marquis de Lafayette with an address delivered by Daniel Webster.*

(both killed and wounded). The casualty count was the highest suffered by the British in any single encounter during the entire war. General Clinton remarked in his diary that "A few more such victories would have shortly put an end to British dominion in America," while his counterpart, General Nathanael Green wrote; "I wish we could sell them another hill at the same price we did Bunkers Hill." The colonists lost between 400 and 600 combined casualties, including popular patriot leader and newly elected Major-General Dr. Joseph Warren, who died during the retreat from the redoubt. The defenders had run out of ammunition, reducing the battle to close combat. The British had the advantage once they entered the redoubt, as their troops were equipped with bayonets on their muskets while most of the colonists were not. Colonel Prescott, one of the last colonists to leave the redoubt, parried bayonet thrusts with his ceremonial sabre.

In 1823, a group of prominent citizens formed the Bunker Hill Monument Association to construct a more permanent and significant monument to commemorate the famous battle. The present monument was finally completed in 1842 and dedicated on June 17, 1843, in a major national ceremony. The exhibit lodge was built in the late 19th Century to house a statue of Dr. Warren.

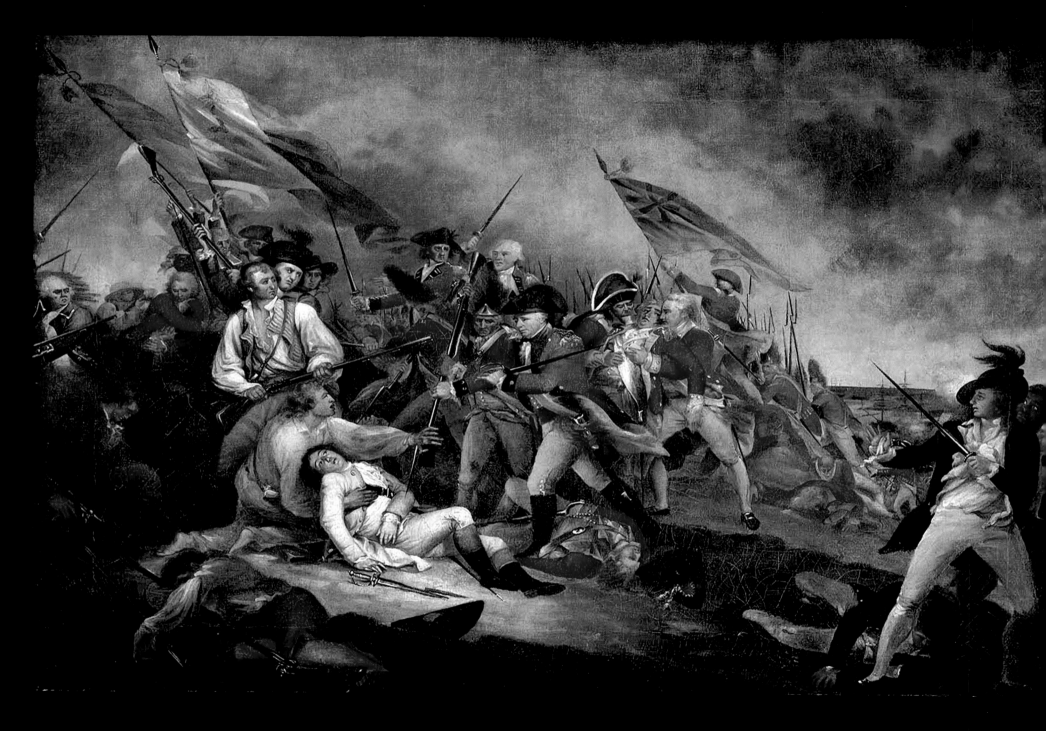

Artist John Trumbull (1756–1843) was in the colonial army camp at Roxbury, Massachusetts on June 17, 1775, the day of the Battle of Bunker Hill. He watched the battle unfold through field glasses, and later decided to depict one of its central events. Joseph Warren, a popular and influential Massachusetts politician and member of the colony's Committee of Safety, had just been elected a major general, but volunteered to serve under Colonel William Prescott in the defense of the redoubt as a simple rifleman. This redoubt was the target of three British attacks, of which the first two were repulsed. The third attack succeeded, in part because the defenders had run out of ammunition. Warren was struck by a musket ball during the evacuation of the redoubt and died shortly after.

The central focus of the painting is Warren's body, dressed in white, and John Small, a British major, dressed in a redcoated uniform. Small, who had served with colonial general Israel Putnam during the French and Indian War, is shown preventing a fellow British soldier from bayoneting Warren's body. General Israel Putnam is the colonial officer on the far left of the painting. Behind Major Small is British Major John Pitcairn, falling back dying in his son's (Lieutenant Pitcairn's) arms.

The foreground is littered with bodies from both sides of the conflict, and the background includes clusters of colonial and British troops carrying flags; Boston Harbor is also visible in the distance, although the sky is partially obscured by smoke (which rose from Charlestown, having been torched by the British).

Lieutenant-Colonel Moses Parker of Chelmsford is depicted sitting wounded to the left of Warren, and Colonel Thomas Gardner can be seen lying on the ground (lower right). Both Gardner and Parker were taken prisoner and both died in early July in Boston. The artist depicted seven additional combatants in his painting which gives this stylistic image a solid grounding in events of that day and stands as one of the first depictions of the American Revolution.

*The Death of General Warren at the Battle of Bunker's Hill, June 17,1775.*
*Called in his day the "patriot-artist," John Trumbull served in the Continental Army from 1775 to 1777 and became known for his images of the Revolutionary War. Trumbull painted several versions of the subject, including the one in the Museum of Fine Arts, Boston (dated between 1815 and 1831) which was commissioned by the Warren family and passed down through five generations until being given to the MFA in 1977, a gift of Howland S. Warren.*

Interesting to note that, while the painting shows both American and British soldiers. it does not portray the "redcoat" as the awful enemy. Rather it depicts the battle as affecting both armies. In presenting the British army this way, Trumbull is saying that the recoats were also normal people. Perhaps this explains why, when Congress commissioned him to paint four murals for the Capitol in 1817, they did not ask for his Bunker Hill painting to be one of the four. Even after this project, Trumbull was not known as one of the great American painters. However, without Trumbull, the heroism of Joseph Warren might have gone even more overlooked than it is today.

In describing the painting for a catalogue of his works, Trumbull explained why he chose to emphasize British Major Small's role, saying that Small, whom he apparently encountered in London, "was equally distinguished by acts of humanity and kindness to his enemies, as by bravery and fidelity to the cause he served."

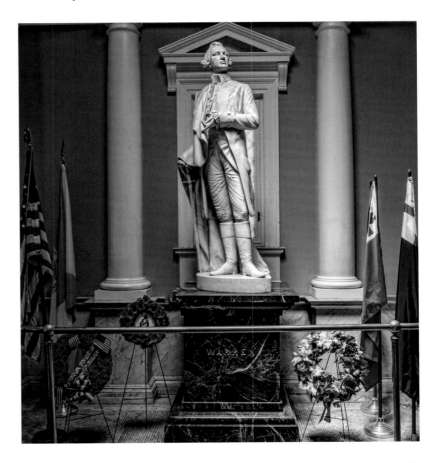

*Statue of Doctor Warren housed in the Exhibit Hall at the base of the Bunker Hill Monument.*

In the early winter months of 1776, Henry Knox, formerly a Boston bookseller, brought to Cambridge 59 cannon captured at Fort Ticonderoga on Lake Champlain. Knox and 80 teams of oxen had pulled the cannon 300 miles on sleds across Vermont, New York, and Massachusetts. Washington placed the cannon at strategic points, but he still did not have command of the town, the fleet, or the fort at Castle Island. He ordered the batteries at Cambridge to open fire on the town, diverting the British into thinking the attack would come from the north. Meanwhile Washington had batteries built on Dorchester Neck, now South Boston. On the night of March 3, the cannon were quietly taken through Roxbury to Dorchester Neck and placed on these strategic heights overlooking Boston, the harbor, and Castle Island. Washington had surrounded the British.

On March 17, 1776, General Gage realized he could no longer hold Boston. His troops marched to Long Wharf, boarded the British fleet, and sailed away. Never again would hostile troops march in the town of Boston. General Washington led his own troops into the town by way of Boston Neck, and townspeople who had evacuated during the occupation began streaming back. They found that fences, shutters, and furniture had been used for kindling that the Liberty Tree had been chopped down, and that Faneuil Hall had been used as a barracks and the Old South Meeting House as a riding school.

Boston slowly began to revive, and from the balcony of the Town House (Old State House), where royal governors had proclaimed the King's will, on July 18, 1776, citizens—no longer subjects—gathered in King Street to hear the Declaration of Independence read. Shortly after this, King Street became State Street. When in 1789 Washington returned as president of the United States, the long road connecting Boston to Roxbury became Washington Street.

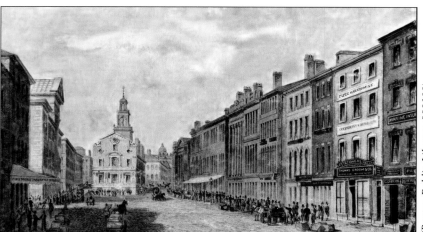

*(Boston Public Library, 000100)*

*View to the west up State Street to the Old State House, c1842)*
*Historic balcony of the Old State House where so many pivotal events of American history have unfolded for her citizens gathered below.*

48  Robert Allison

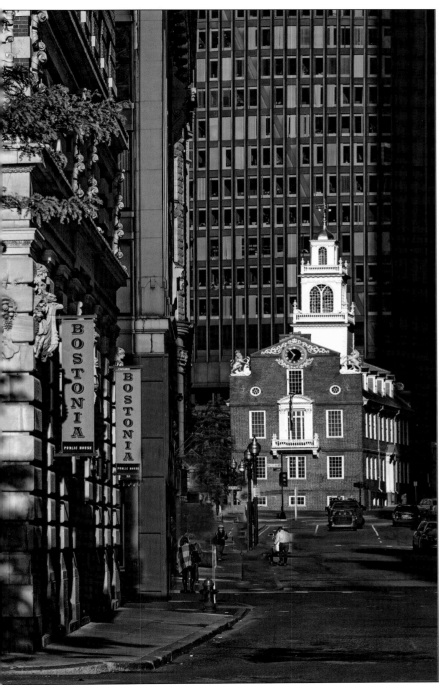

*View to the west up State Street from India Street to the Old State House today.*

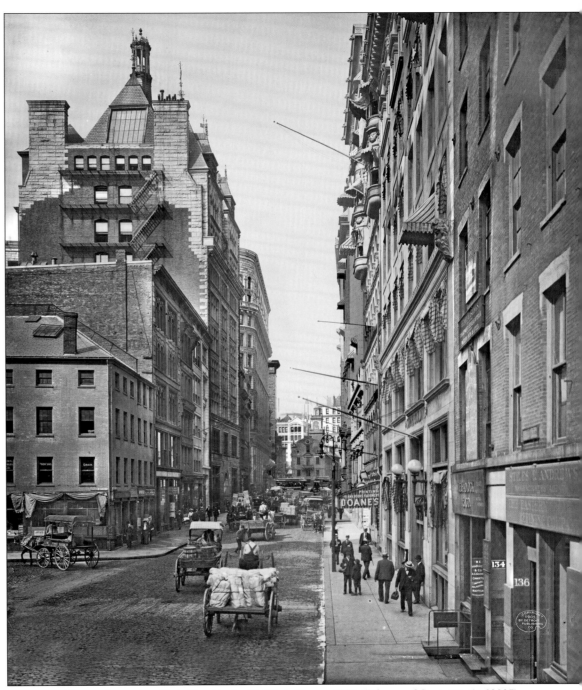

*View to the west up State Street to the Old State House, 1904. (Library of Congress, 4a 12837)*

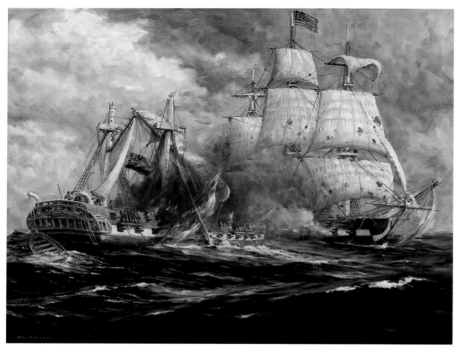

*Captain Issac Hull and* Constitution *force the surrender of the frigate* Guerriere.

## Constitution & The War of 1812

AFTER INDEPENDENCE, BRITAIN NO LONGER PROTECTED AMERICAN commerce. British ports in the West Indies, once the most lucrative ports for Boston, now were closed to American trade. In the Mediterranean, Britain encouraged Algerian pirates to attack American ships. With their two main outlets shut off, Bostonians sought other markets. In 1787, a group of Boston investors sent the *Columbia* to China, carrying a load of ginseng. It returned with a cargo of tea. The trade had its financial origins in Boston, but the trade quickly became one between China and the Pacific Northwest, with furs purchased from Indians along the Columbia River being sold in China for tea or silver. Ultimately the silver found its way to Boston where the wealth of the China Trade created new fortunes. In Canton, China, Boston was thought to be a large and prosperous country of its own, and south of the Blue Hills the Indian village of Ponkapoag was renamed Canton in recognition of these new trading ventures.

In the 1790s, the Washington administration determined to protect American trade by building a navy. Edmund Hartt's North End shipyard began building the USS *Constitution* in 1793. By the time the ship was launched four years later, the United States and Algiers had made peace, but France was now at war with the Americans. Shortly after the French war ended in 1800, Tripoli declared war on the United States. In response, *Constitution* sailed for the Mediterranean as flagship of the American forces under Captain Edward Preble and won peace from Tripoli in 1805. When the United States and England went to war in 1812, *Constitution* again sailed, this time under command of Isaac Hull. Hull encountered a British frigate, the *Guerriere*, southeast of Nova Scotia. The men in the British navy were experienced at war, having fought for nearly 20 years. In hundreds of engagements with enemy ships, the British had lost only five. But Hull and *Constitution* forced *Guerriere* to surrender.

No one knows if he was American or British, but during the battle a sailor who saw British cannonballs bounce off *Constitution's* hull called out, "Huzza!. Her sides are made of iron!" The ship's sides are actually made of wood—an outer layer of white oak and a frame of live oak, hardy wood from Georgia and Florida, which resists rot as well as cannonballs. Victorious, *Constitution* returned to Boston with her prisoners and a new nickname—*Old Ironsides*.

Bostonians celebrated this victory, but one of the war's most crushing defeats happened just off Boston Light. In the twilight hours on the first of June 1813, Bostonians could hear the thunder of cannon as the frigate *Chesapeake* fought the Brigish frigate *Shannon*. Captain James Lawrence was bold and daring, but his men were poorly trained, and many had spent their last night on shore celebrating. *Shannon* systematically and effectively cut *Chesapeake* apart, though Lawrence held his position until he was hit by a British shot. As he was carried below he gave a final order: "Don't give up the ship!" But without him the battle went badly. In the moments before he died, he was stunned to learn that his men had indeed given up the ship. Vessel, crew, and Captain Lawrence's body were taken to Halifax, where the British honored his valor with a hero's funeral before returning his body to Salem (and finally to New York). Thought the *Chesapeake's* timbers now frame an English mill, Lawrence's final words remain the motto of the U.S. Navy.

Named by President George Washington after the Constitution of the United States of America, USS *Constitution* is the world's oldest commissioned naval vessel afloat. *Constitution* is most famous for her actions during the War of 1812 against Great Britain, when she captured numerous merchant ships and defeated five British warships: HMS *Guerriere, Java, Pictou, Cyane* and *Levant.* The battle with *Guerriere* earned her the nickname of "*Old Ironsides*" and public adoration that has repeatedly saved her from scrapping. She continued to serve as flagship in the Mediterranean and African squadrons, circling the world in the 1840s. *Constitution* sailed under her own power for her 200th birthday in 1997, and again in August 2012, to commemorate the 200th anniversary of her victory over *Guerriere.*

*Constitution's* stated mission today is to promote understanding of the Navy's role in war and peace through educational outreach, historic demonstration, and active participation in public events. As a fully commissioned US Navy ship, her crew of 60 officers and sailors participate in ceremonies, educational programs, and special events while keeping the ship open to visitors year round and providing free tours. The officers and crew are all active-duty US Navy personnel and the assignment is considered special duty in the Navy. Traditionally, command of the vessel is assigned to a Navy Commander. *Constitution* is berthed at Pier 1 of the former Charlestown Navy Yard, at one end of Boston's Freedom Trail.

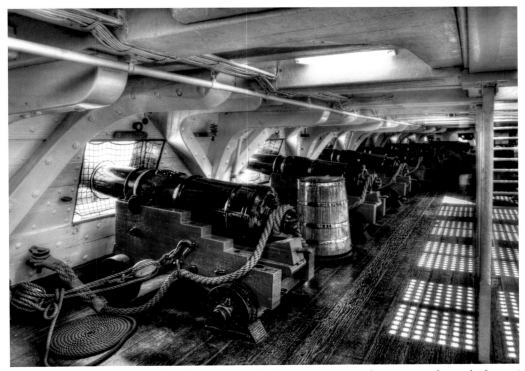

*Gundeck of Constitution with 24 pounders seemingly ready for action.*

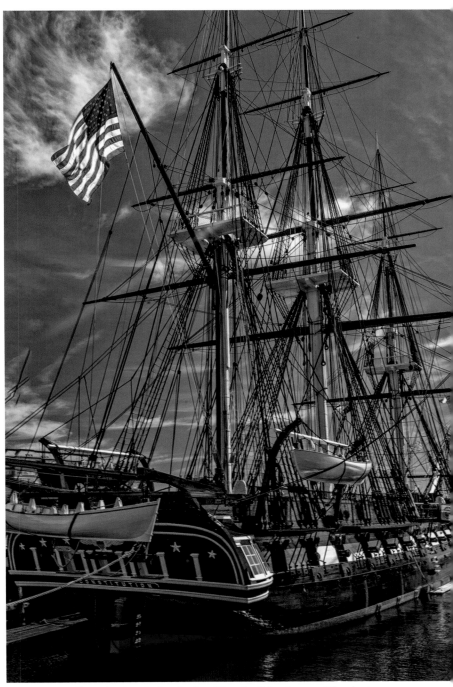

Constitution *is berthed at Pier 1 of the former Charlestown Navy Yard, at one end of Boston's Freedom Trail.*

51

By the time the war ended in 1815, Boston merchants had found new outlets for their capital. American commerce had all but stopped during the embargo of 1808, during the tense years before the war, and during the war itself. Merchants saw a need to diversify their holdings and did so by investing in manufacturing. A group of Boston merchants, the Boston Associates, began planning the first large-scale manufacturing plants in the nation.

At Waltham, the Boston Associates built a factory to make cloth, using the water of the Charles River to power the looms. The Waltham experiment was notable for bringing under one roof all aspects of wool manufacture—combing and carding to make the fibers straight, spinning the yarn, and the final weaving of cloth. This became a model for future American manufactures. Previously, individual farmers would shear sheep, and their wives would spin the yarn and weave the cloth. All of this happened in farmhouses throughout New England. Now the production would take place in factories, like the ones built at Waltham. In the 1820s, the Boston Associates bought land on the Merrimack River in Chelmsford, where they founded the town of Lowell, named for Boston's Lowell family. Connected by canal and later by railroad to Boston, Lowell produced cotton textiles. Both the raw cotton, brought from the southern states, and the finished cloth flowed through the port of Boston.

*(inset bottom left) Old mill buildings re-purposed for 21st Century business tenants. on the Merrimack River in Lawrence.*

*View of portion of Lawrence Heritate State Park and the Merrimack River from the old clock tower atop the New Balance factory, Lawrence.*

*Charles River Museum of Industry & Innovation, Waltham*

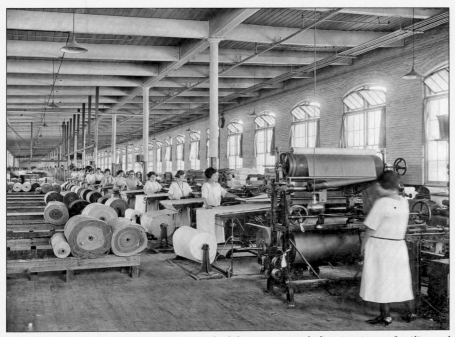

*Lowell's water-powered textile mills catapulted the nation—including immigrant families and early female factory workers—into an uncertain era of the Industrial Revolution. (Cloth inspection at Lawrence textile mill, Lawrence History Center, 1986.098.055)*

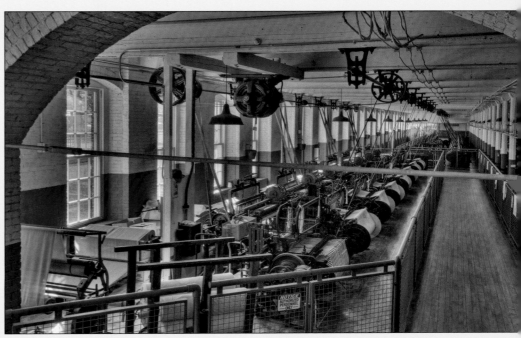

*One entire floor of the Boott Cotton Mills Museum in Lowell shows visitors exactly how a working mill actually looks. The floor is called the "Weave Room," and it is filled with industrial grade looms, running at top speed, allowing visitors to feel the buzz of a working mill.*

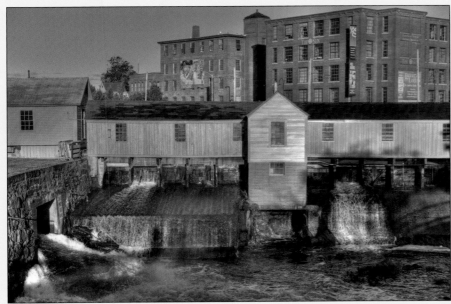

*The Swamp Locks gatehouse is part of the 5.6 miles of canals at Lowell National Historical Park. The canals channeled the Merrimack River's 32 foot drop to Lowell's mills providing power for the mill machinery. The American Textile History Museum is in the background.*

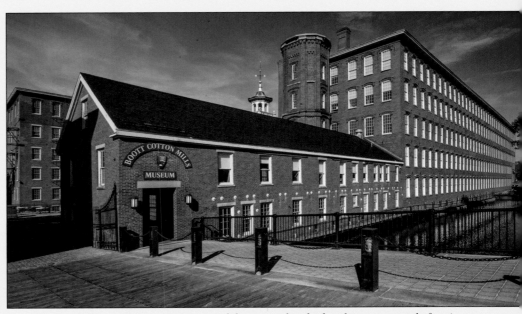

*Boott Cotton Mills was open and operational for over a hundred and twenty years before it finally closed in 1955. It has since been restored and reopened by the US Parks Department's Lowell National Historical Park as a museum.*

# The Civil War

WHEN THE CIVIL WAR BEGAN IN APRIL 1861, BOSTON WAS transformed. "That's the death blow of slavery!" Samuel Gridley Howe announced when he heard South Carolina militia had attacked Fort Sumter in Charleston. Bostonians who had opposed abolition immediately took up arms when their country's flag was attacked. President Lincoln called for volunteers to put down the rebellion, and within three days, Massachusetts sent three regiments to Washington. On April 19, the anniversary of the battles of Lexington and Concord, the Massachusetts troops had to fight their way through Baltimore, where pro-Confederate mobs controlled the city. The troops made it to Washington, the first to come to the capital's defense, but not without casualties.

Governor John Andrew, a Republican abolitionist who had hired lawyers to defend John Brown, had the bodies of the Massachusetts soldiers brought home to a funeral in King's Chapel. The war would not result in a quick triumph for the north, rather, it would call on sacrifices from all.

None could have predicted, when the war began, how thoroughly it would transform Boston and the nation. Among the first to volunteer were Boston's Irish, whose relations with the antislavery vanguard had been bleak. Now that the American flag had been fired upon, though, Irish and Irish-American citizens flocked to enlist in the cause of the United States. Thomas Cass had commanded the Columbian Guards who escorted Anthony Burns back to slavery in 1854. Now he led the thousand men of the 9th Regiment of Massachusetts Volunteers, who marched up Long Wharf on June 25, 1861, to receive their colors from Governor Andres: "as Citizens of Massachusetts, be assured that her honor will never be disgraced by the countrymen of Emmet and O'Connell." The 9th fought at Bull Run, Antietam, Gettysburg, and the Wilderness. A month after the regiment left Boston, it encamped outside Washington, on the slopes of Robert E. Lee's estate. Over breakfast the men talked with Lee's slaves. Company sergeant and historian Daniel Macnamara wrote that "in some unaccountable way" the Irish 9th was "connected with their future destiny, and would in time lead them out of the house of bondage."

Leading the enslaved out of the house of bondage, though, was not yet Union policy. The regiment commanded by Colonel Fletcher Webster—Daniel Webster's son—had trained on George Island to a new song proclaiming that though "John Brown's body lies a'mouldering in the grave/His truth goes marching on!" The men sang this song as they marched up State Street to receive their colors from Governor Andrew, conscious that they were retracing in reverse the route taken by Anthony Burns seven years earlier. The song quickly spread through other units until word

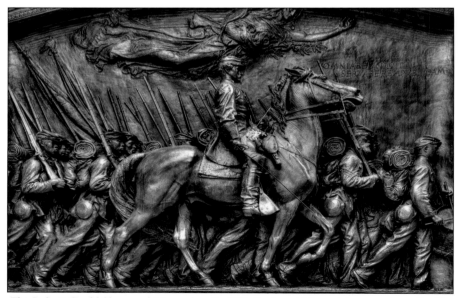

*The statues of bold lions on either sides of the grand marble staircase of the Boston Public Library serve as a memorial to the 2nd and 20th Massachusetts Regiments of the Civil War.*

*The Robert Gould Shaw and Massachusetts 54th Regiment Memorial, across from the New State House on the Boston Common. Someone landed a boquet of flowers on Shaw's saddle.*

came down from the U.S. Army command that the men were not to sing "John Brown's Body." The war was not to end slavery, it was to save the Union.

Whatever the official policy of the Union, the war was about slavery. In 1862, President Lincoln issued the Emancipation Proclamation and began allowing black men to enlist in the Union army. A recruiting station opened in the African Meeting House, and quickly free black men from Boston and from throughout the North formed the Massachusetts 54th Regiment. Two of the abolitionist Frederick Douglass's sons served in the regiment, which was led by white abolitionist Robert Gould Shaw and other white officers. The men trained in Readville (now Hyde Park) before receiving their colors from Governor Andrew at the State House and marching down Long Wharf to steam to the war. The men of the 54th, like the men of the Massachusetts 2nd, 9th and the 28th, proved themselves in battle. Leading an assault on Fort Wagner on a sandy island off the South Carolina coast, they march through a fiery artillery barrage to reach the gun emplacements of Fort Wagner. They broke through the Confederate defenses, getting to the tops of the barricades before the Confederates cut them down. Shaw died, and half of his men were either killed or wounded. Sergeant William Carney, the highest-ranking black non-commissioned officer (no blacks were commissioned), saw the flag bearer shot, but Carney snatched the banner before the colors fell. Folding the flag into his shirt, Carney crawled from the front lines to safety. "The old flag never touched the ground, " he said later. The 54th fought on, and Carney became the first African-American to receive the Congressional Medal of Honor.

Men and women from Massachusetts made the war to save the Union into the war to end slavery. Samuel Gridley Howe traveled to Washington in the fall of 1861 to inspect sanitary conditions in the army camps. During the long train ride to Washington, Howe's wife, Julia Ward Howe, was struck by the sheer numbers of men in uniform encamped along the rail line, their numbers swelling as the Howes neared the capital. Inspired by what she had seen, Julia Howe woke up in the middle of the night. In her mind the strains of "John Brown's Body," the visions of the thousands of men in uniform marching to Washington, the flag-draped caskets in King's Chapel, and the struggle over slavery in Boston and now in Virginia kept her awake. She found a few sheets of her husband's stationery in the darkness of the hotel room, and certain that the nation was being transformed but not sure exactly how, she wrote:

*Mine eyes have seen the glory of*
*the coming of the Lord.*
*He is trampling out the vintage where*
*the grapes of wrath are stored.*
*He has loosed the fateful lightning*
*of his terrible swift sword.*
*His truth is marching on!*
*Glory! Glory! Hallelujah!*
*Glory! Glory! Hallelujah!*
*Glory! Glory! Hallelujah!*
*His truth is marching on!*

When she returned home to South Boston, Mrs. Howe sent a copy to James T. Fields, editor of the *Atlantic Monthly*. Fields paid her five dollars and printed the song on the first page of his February 1862 issue under the title "Battle Hymn of the Republic."

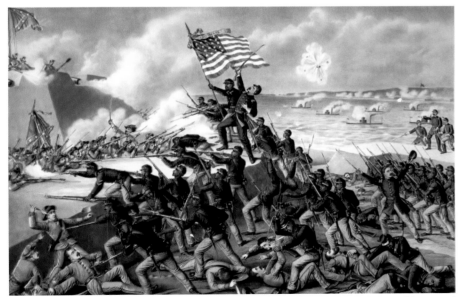

*The 54th Regiment storming Fort Wagner (Kurz & Allison-Art Publishers, Library of Congress)*

The Civil War transformed the nation and, with it, Boston. African-American residents and Irish immigrants were now part of the city's fabric. Boston's population had quadrupled since the 1820s and needed more space.

One of the boldest plans to expand the city grew out of one of the great failures of private enterprise, an attempt in the 1820s to use the Back Bay's surging tides to power mills along its shores. The Roxbury and Boston Mill Company built a Great Dam 50 feet wide from the edge of Boston Common across the Back Bay to Brookline. A Short Dam intersected the Great Dam at Gravelly Point, Roxbury. This created two basins. After the high tide filled the western basin, the water was forced into the larger receiving basin. This surge turned the wheels of eighty mills, grinding flour, sawing wood, spinning cotton or wool, rolling iron, and making anchors, cannon, farm tools, and grindstones. "How shall the citizens of Boston fill their empty stores?" a promotional brochure asked. "Erect these mills, and lower the price of bread."

At first, the possibilities seemed endless and so lucrative that one eager speculator tried to climb through the company's window to invest. The Back Bay's power did turn a few mills, but the Merrimack River, which other Boston investors had harnessed to turn the mills at Lowell and Lawrence, had more power. The Back Bay's industrial era was over. Railroad lines built across the receiving basin's marshy flats kept the area from flushing at high tide, and flushing is what was needed. Sewer lines emptied from Beacon and Arlington Streets, next to what had become a dumping ground. Instead of a new industrial center, the Back Bay was a wasteland and public health menace. With conflicting lines of jurisdiction was difficult to find a solution.

In 1856, the Commonwealth decided to fill its parts of the Back Bay, lay out new streets across the new land, and sell the building lots. The Great Dam from the Common to Brookline became Beacon Street, and the Short Dam is now Hemenway Street. Trains brought gravel and stone from Needham, excavated by the new steam shovel invented by South Boston's John Souther, filling in the shoreline as far as Clarendon Street by the time of the Civil War and reaching Gloucester Street by 1871. By 1882 the entire Back Bay had been filled from the Public Garden to Kenmore Square. Wealthy Bostonians moved from Beacon Hill and the newly created South End to form a new social and cultural center. The land sales brought so much revenue that the Commonwealth could support new cultural institutions in the Back Bay, such as the Museum of Comparative Zoology (now the Museum of Science), and to endow other cultural institutions throughout the State.

At the center of this new showplace was Art Square, where the new Museum of Fine Arts opened on July 4, 1876. The museum, which moved to Huntington Avenue in 1909, has become one of the world's premiere cultural institutions. In 1883, Art Square was renamed Copley Square, for the famous eighteenth-century portraitist. In 1895 the Boston Public Library (founded in 1849) moved there, to a building designed by Charles McKim and built of granite and Italian marble. Boston Public Library created the nation's first branch library system, opening its first branch in East Boston in 1869.

The creation of an art museum and a public library as the centers of the new Back Bay was a sign of Bostonians' community vision. In 1881, Major Henry Lee Higginson, successful businessman and Civil War veteran, called on Bostonians to create a symphony orchestra to provide "the best music at low prices, such as may be found in all the large European cities." No American city had such an orchestra, though Boston had been a musical center since earlier in the century. In 1833, the Boston Academy of Music had begun giving free music lessons to children and adults, and four years later it created a music program for Boston's public schools. The academy had shifted its focus to performing music in the 1840s, though it did not have a permanent professional ensemble. The New England Conservatory, founded in 1867, continues to bring young musicians to the city. Under Higginson's leadership, the Boston Symphony Orchestra became a model for other American orchestras, performing classical music for a broad audience (tickets sold out quickly) and offering lighter classical music at "Pops" concerts. In 1909, the Boston Symphony moved to its present home, at the intersection of Massachusetts and Huntington Avenues.

Boston's political and finanacial worlds remained divided by ethnicity and social class. But in other areas, Bostonians in the 1920s and 1930s began to come together. In 1929, Arthur Fiedler, the son of a Boston Symphony violinist, conducted the first Boston Pops concert outdoors on the Charles River Esplanade. Fiedler introduced these outdoor concerts, notably on July 4, and for the next 50 years as conductor of the "Pops," Fiedler brought music out of the concert hall to wherever people gathered to listen. America's Bicentennial celebration in 1976 attracted a huge crowd, which the Guinness Book of World Records cites as the largest ever assembled for a classical concert. Arthur Fiedler so loved this night that he conducted the Fourth of July concert for the 50th time in 1978. Fiedler died the following year.

*In 1941, the construction of the new music shell took place with a $300,000 trust, donated by benefactor Maria Hatch, to build a memorial for her late brother, Edward.*

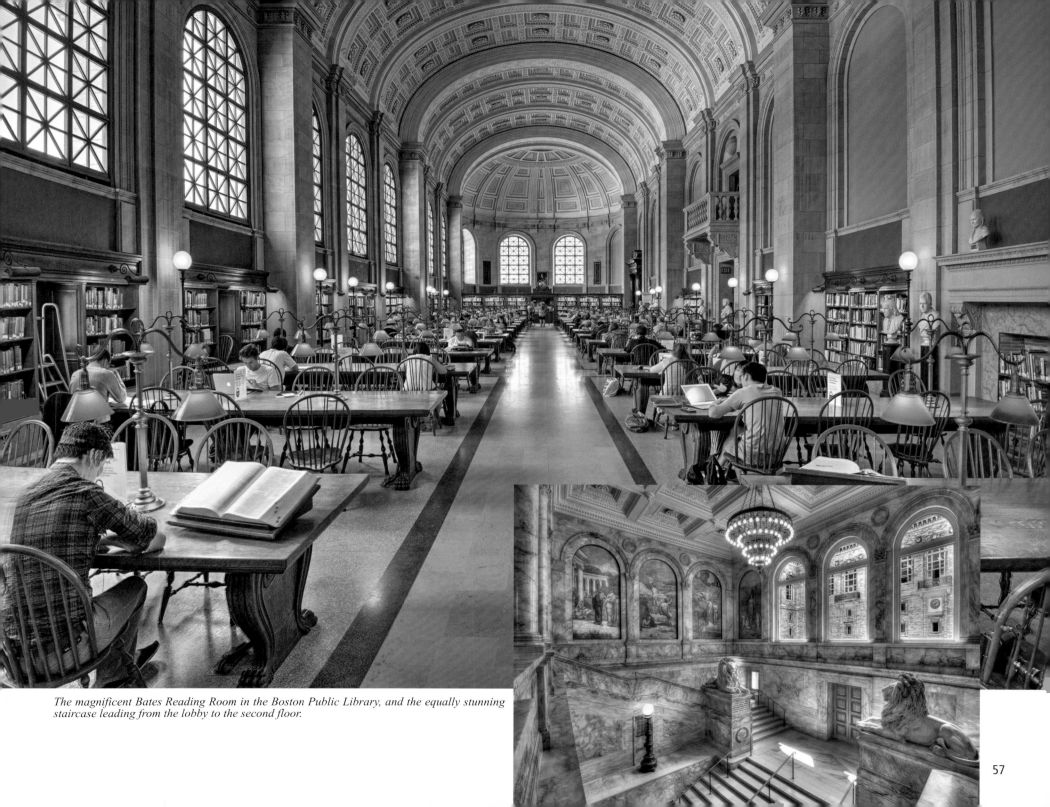

*The magnificent Bates Reading Room in the Boston Public Library, and the equally stunning staircase leading from the lobby to the second floor.*

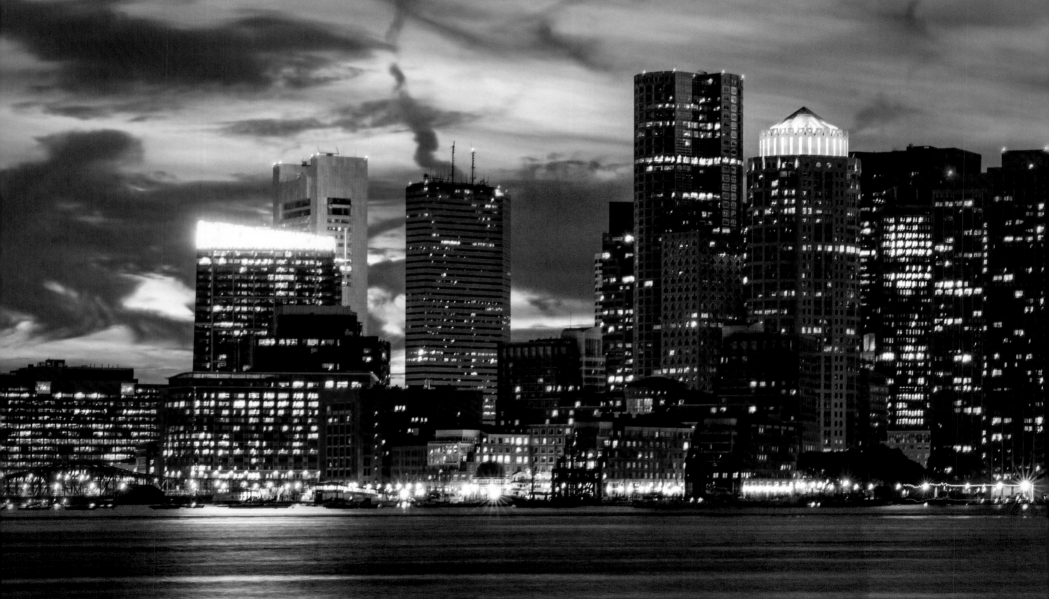

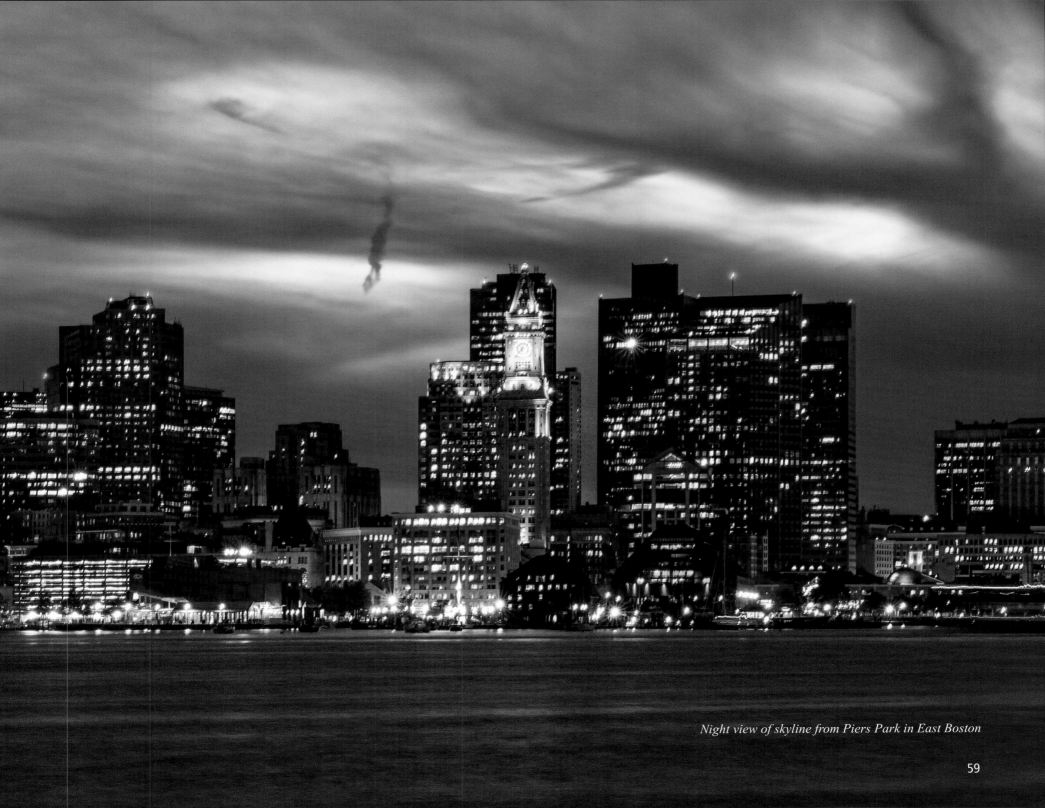

*Night view of skyline from Piers Park in East Boston*

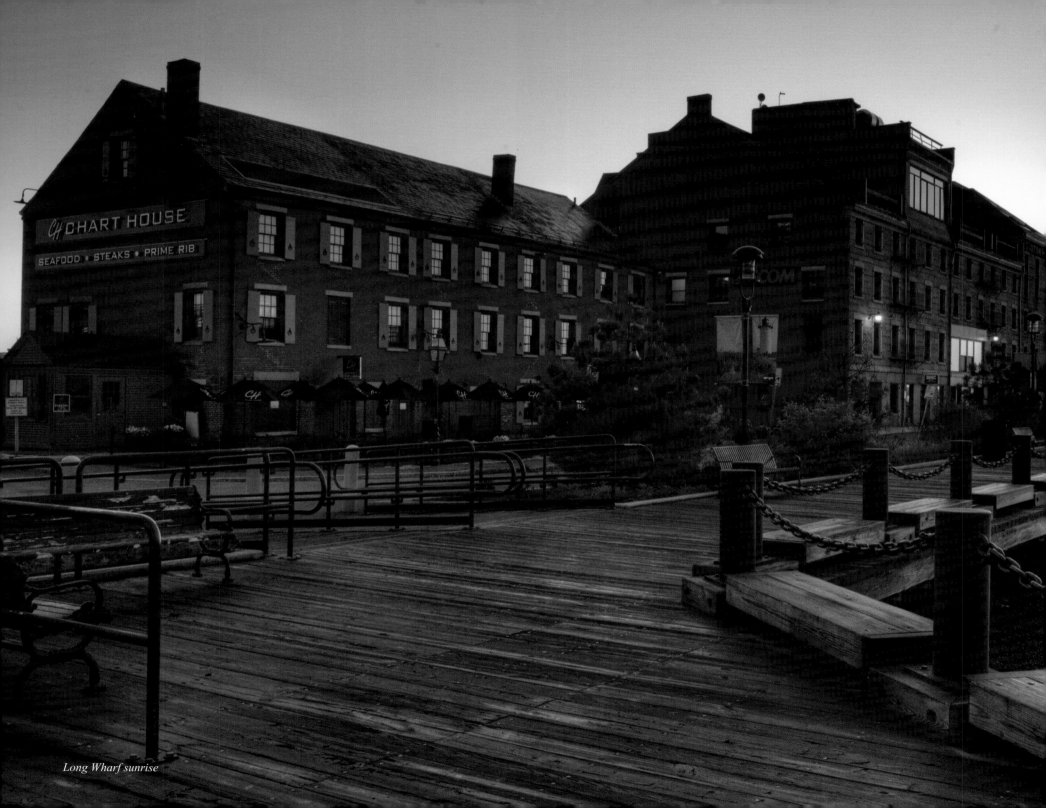

*Long Wharf sunrise*

## Robert J. Allison
### from *A Short History of Boston*

FROM THE END OF LONG WHARF, WE CAN SEE HOW THE CITY CONTINUES TO BE TRANSFORMED. THE PLANES LANDING ACROSS the harbor continue to bring new Bostonians, still coming from Ireland and England and Italy, but now also from Central America, Africa, and Asia to transform and enrich the city.

Just east and south of the airport on Deer Island stand the egg-shaped sewage digesters. When the Massachusett people lived here, Deer Island was named for the deer that swam to this outermost island of the inner harbor chain. In 1676 Deer Island was the final Massachusetts home for hundreds of Indians, taken prisoner during King Philip's War and sold as slaves in the West Indies. Almost two centuries later, in the 1850s, Suffolk County's prison and a quarantine hospital were built on the island. Many immigrants took sick on the rough Atlantic passage and died in the Deer Island hospital, their lives in the New World cut short. They lie buried on Deer Island. The digesters now dominate the skyline; they also make Boston Harbor one of the cleanest urban harbors in the world.

Between Deer Island and Long Island, what was King's Roads, the water entrance to the town in colonial Boston, is now President Roads; it is still the main shipping channel into the city. Long Island, at more than 200 acres the harbor's largest, has housed hotels, a chronic disease hospital (more than 2000 victims of disease lie in unmarked graves), a homeless shelter, a Civil War training ground, and Cold War missile silos. Beyond Long Island is Georges Island, with its Civil War-era fort where Union soldiers trained and Confederate prisoners were held. Georges Island is now the centerpiece of the Boston Harbor Islands National Recreation Area.

Dominating the harbor skyline is Spectacle Island, resurrected, like the harbor itself, from a century of being a garbage dump. The huge mounds of trash have been capped with excavations from the Big Dig, but not before archaeologists uncovered evidence of the island's past use as a Native American fishing ground. Today, the grassy slopes of Spectacle Island, laid out with walking trails, allow visitors to look out seaward and back toward the city in the kind of landscaped urban oasis Frederick Law Olmsted created a century ago. From Long Wharf, regular boat service to these islands allows the urban population to continue to enjoy the natural surroundings of the harbor.

As a boy growing up in the Old Harbor housing project and as a young lifeguard along the sandy strand of Carson beach in South Boston. Moakley remembered when the harbor was fit for swimming and when it was best found by following your nose. As a state senator in the 1960s, Moakley blocked plans to develop the harbor islands, instead having them made into a State Park. After the 1988 election, when George H. W. Bush defeated Massachusetts Governor Michael Dukakis by pointing to Boston Harbor's filth, Moakley and U.S. Senator Edward M. Kennedy worked to secure federal money to clean the harbor. With a clean harbor, Moakley next moved to have the State Park became a Federal Park, one of the few natural urban areas in the country.

From Long Wharf is seen the gleaming glass of the John Joseph Moakley Federal Courthouse on Fan Pier. The area stretching south of the Moakley Courthouse is being transformed into Boston's newest development, rising, much as the Back Bay did, on the edges of what had been an urban industrial wasteland. Moakley remembered dodging the freight trains on Fan Pier as a boy, trying to catch watermelons that fell from the cars. When the courthouse was named in his honor just a few months before his death, he thought of the "beautiful circle" his life had made, from a gritty urban youth to a respected and beloved statesman. The courthouse is one monument, and the harbor and its islands stand as another, fitting memorial to Joe Moakley and to all who have enjoyed them—Native American and immigrant—and all who will continue to.

From Long Wharf we can see far into the past, into the age of glaciers and geologic transformation, to the Massachusett people who fished in their Quonehassit, to Maverick and Blackstone and Winthrop, to the days of codfish and the rum trade, the Revolution and immigration, the China trade and clipper ships, industrial development and environmental destruction. Long Wharf remains a vantage point from which to watch the continuing transformation of Boston.

# The Fourth of July

Traditionally, the grand finale of the Independence Day concert is a stirring rendition of Tchaichovsky's 1812 Overture by the Pops. A huge fireworks display lights up the entire Back Bay district, with hand-powered church bells ringing from ancient edifices in the nearby neighborhoods.

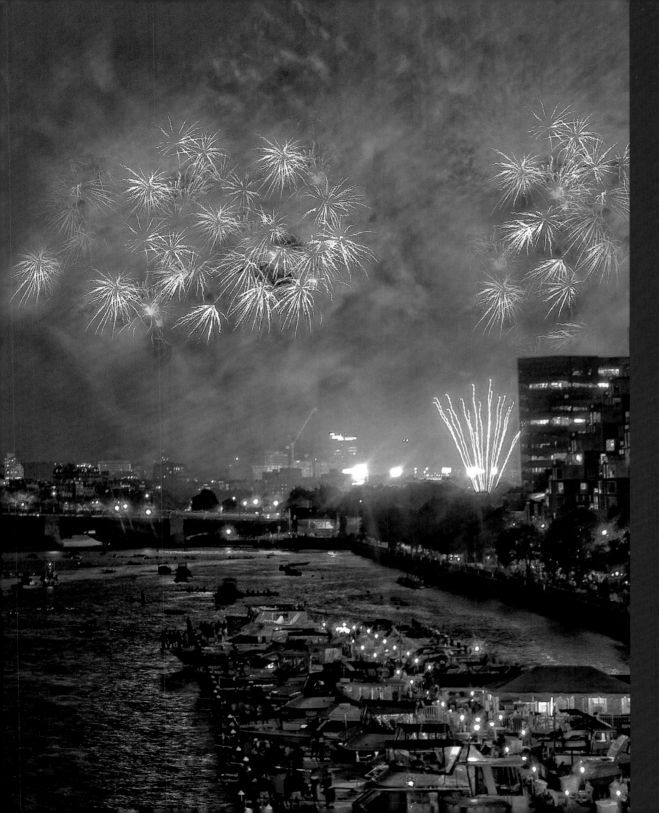

EACH YEAR HUNDREDS OF THOUSANDS OF PEOPLE attend the July 4th celebration at Boston's Charles River Esplanade. There is a free concert featuring the Boston Pops Orchestra, along with an ensemble cast of major artists. The Esplanade becomes saturated with a mass of people, and the Charles River Basin is filled with countless pleasure boats. The Pops concert is crowned with a huge fireworks display over the river in a grand finale

The new riverway was originally called the Beacon Street Esplanade. The park quickly became a popular refuge for city residents. In 1940, the Hatch Memorial Shell was completed, and has been a popular venue for public concerts ever since.

The Boston Pops Orchestra was established in 1885, presenting light classical music works from waltzes to populist marches. In 1929, Arthur Fiedler, a 35-year old Boston-born violinist, was named conductor of the orchestra. Fiedler had initiated the free open-air concerts at the Hatch Shell, which brought classical musical to the masses; a true public service. He retired in 1980, after more than 50 years in this position. The Fiedler Footbridge commemorates Arthur Fiedler's life, as well as the beautiful sphinx-like Fiedler Statue (below) located on the island opposite the shell.

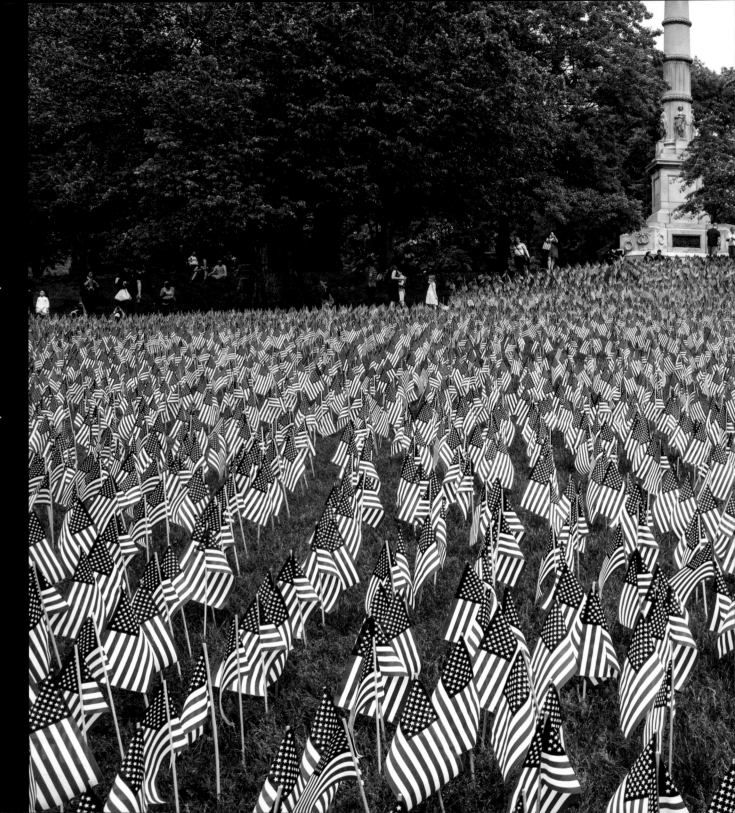

*"Everything we hold precious
in this country has been made possible
by those who gave their all."*
President Barack Obama
Arlington National Cemetery
Memorial Day, May 25, 2014

This remarkable garden of 37,000 American flags was planted at the foot of the Soldiers and Sailors Monument for the 2014 Memorial Day weekend. Each flag represents a brave Massachusetts service member who lost his or her life defending our country since the Revolutionary War.

This roster was begun on the morning of April 19, 1775 on the Lexington Common, where eight colonists were the first to fall in what would become the Revolutionary War. The first eight flags in this garden honor them, and all who would follow. They were:

John Brown
Samuel Hadley
Caleb Harrington
Jonathon Harrington
Robert Munroe
Isaac Muzzey
Jonas Parker
Asahel Porter

www.massmilitaryheroes.org

A young visitor to the Common on Memorial Day is most suitably attired in a patriotic dress to honor the 37,000 Commonwealth men and women who perished in all of the nation's conflicts since that April morning in 1775. In a few years Helena Eva Busch, who celebrated her first birthday a month earlier, will gradually come to understand the scope of the losses so poignantly reflected by the flags displayed on the lawn here. Her father, David Busch, served a tour in Iraq as a combat medic in the Army (sgt.) and continues his service as a Boston fire fighter.

The Harbor

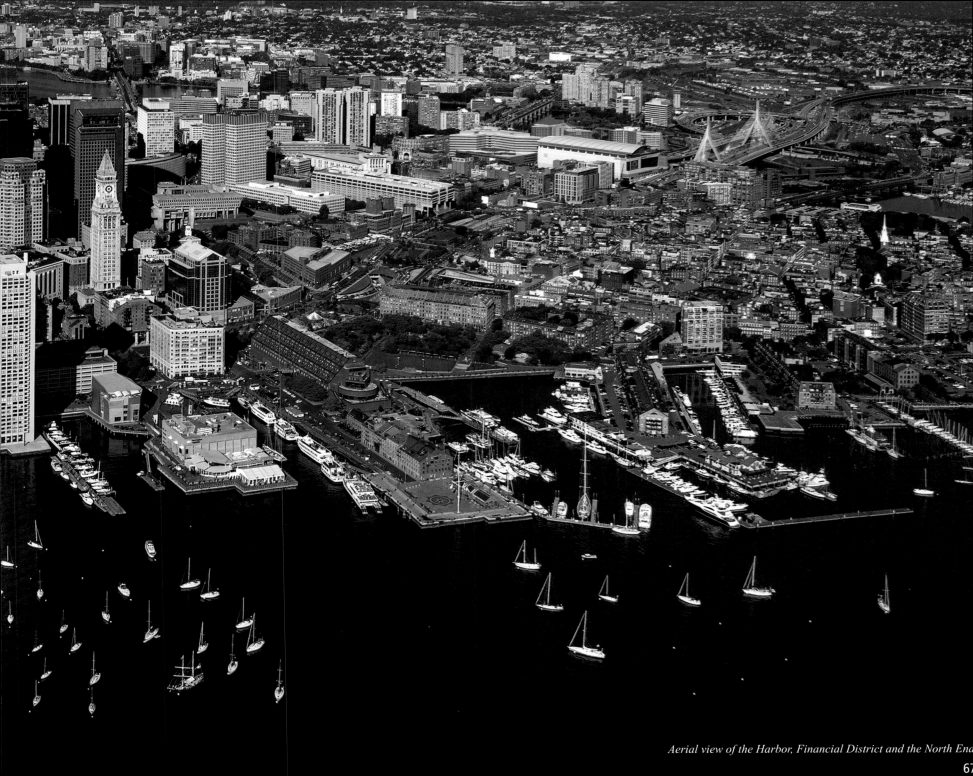

*Aerial view of the Harbor, Financial District and the North End*

Boston ~ July 4th 1870

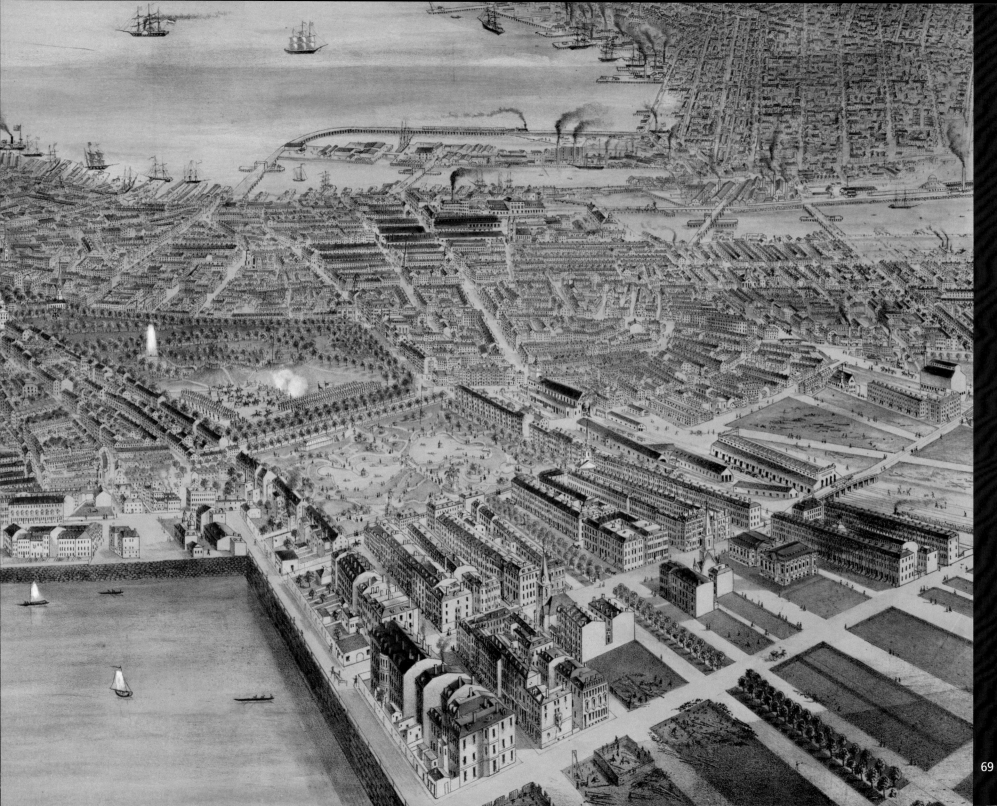

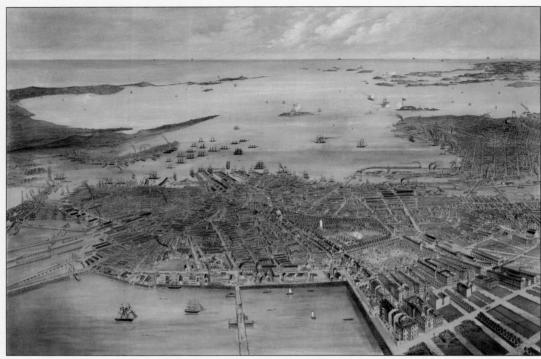

*Here we see the full extent of the large detail view on the previous page.*

This view of Victorian Boston portrays a prosperous city during its Independence Day celebration. The artist created this view, which he dated July 4, 1870, looking at the city from the west. Just right of center in the foreground is Boston Common, where a military re-enactment is taking place. Boston Harbor and Bay occupy the upper half of the composition, but clearly visible are Forts Winthrop and Independence on Governor and Castle Islands, with cannons firing and American flags flying proudly over the forts.

The artist shows a city undergoing rapid change. Industries are beginning to crowd portions of the waterfront. The harbor is full of the clipper ships that brought fame to Boston in the 1850s. However steamships, only two of which are visible, subsequently decimated New England's shipbuilding industry, which was built on wooden ships. The shipping trade that fueled Bostons prosperity for two centuries was also declining due to the arrival of the railroads in the 1830s.

On the left and right sides of the drawing, rail lines terminate at North End and Back Bay stations. By placing these railroad facilities in the foreground, the artist suggests that this city was now firmly in the grasp of a new mode of transportation.

*This erial view over MIT in Cambridge encompasses the Charles River Basin, Back Bay, the Common, Beacon Hill, downtown Boston, and the Harbor Islands in the distance.*

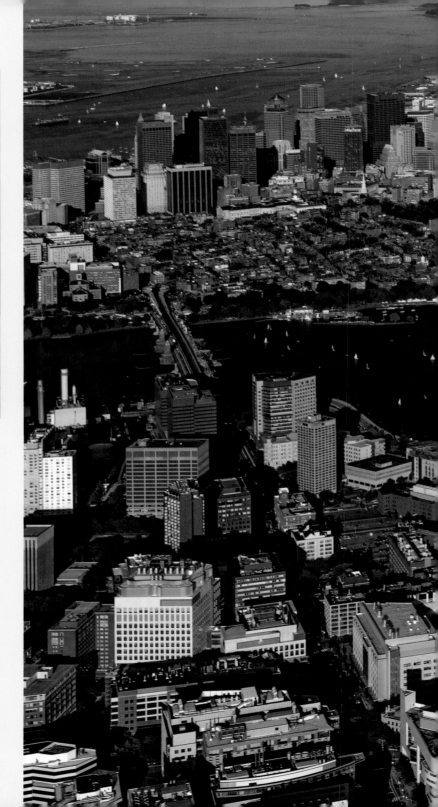

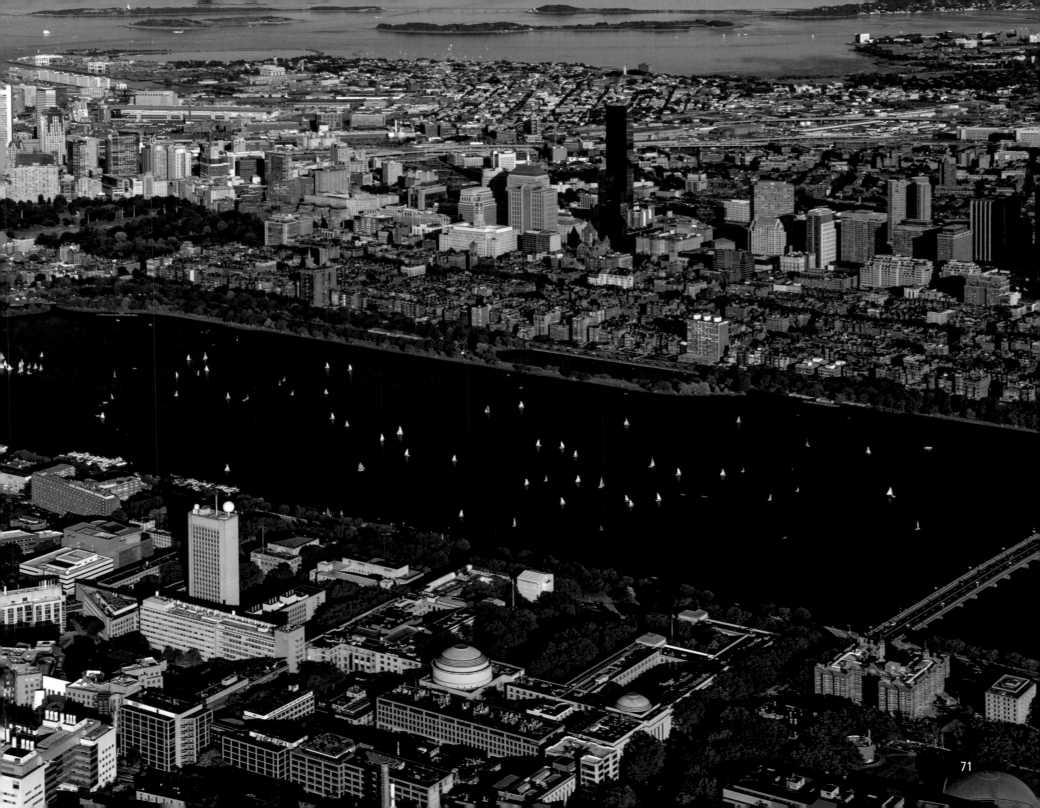

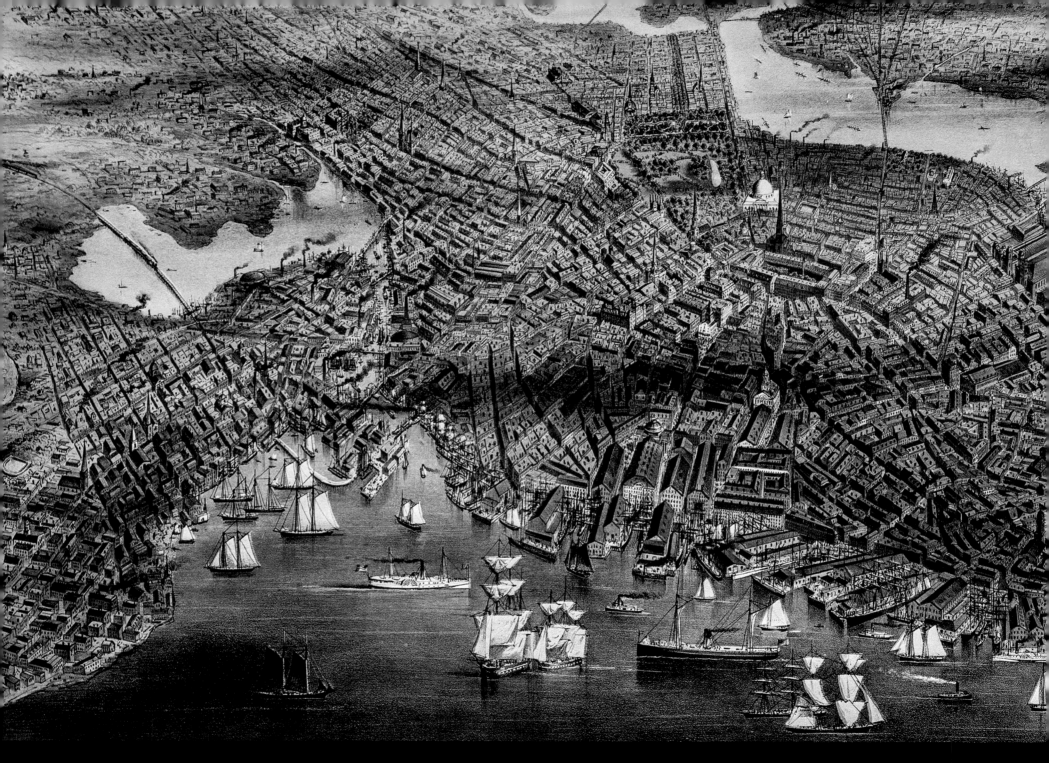

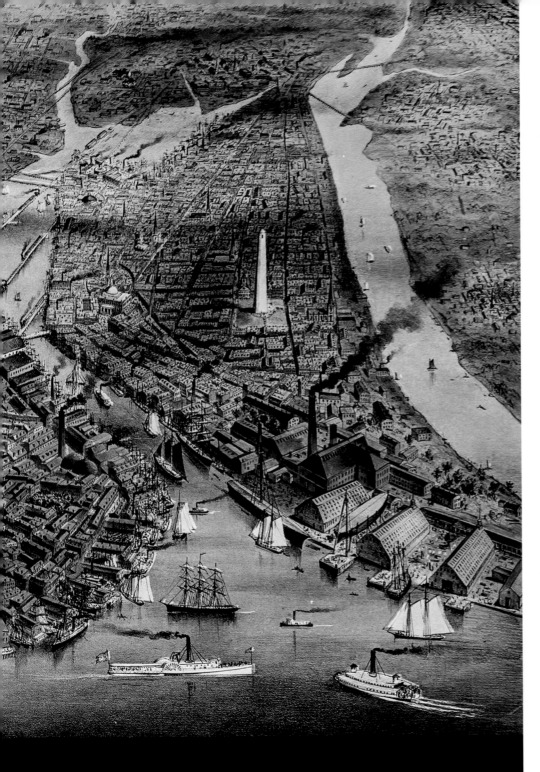

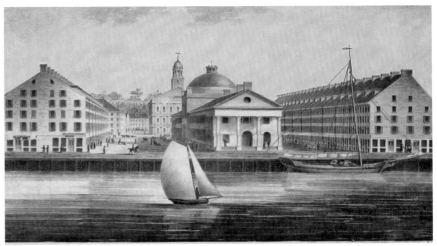

*Quincy Market on the waterfront of 1827. (J. Andrews, Boston Public Library, 000544)*

*Bird's eye view of Boston in 1873. Here we have a marvelous look of the thriving harbor from the Dorchester Heights monument (left) to the Bunker Hill Monument and the East Boston waterfront (right). While there are still plenty of vessels under sail, the advent of steam power is clearly at hand. We can also see that the waters of the harbor extend north to the very front of Quincy Market (above). The main market building was built immediately east of and "behind" Faneuil Hall, which at the time sat next to the waterfront, at the town dock. In an early example of Boston's tendency for territorial growth via landfill, part of the harbor was filled in with dirt to provide a plot of land for the market. (Lithograph by Currier and Ives, Library of Congress)*

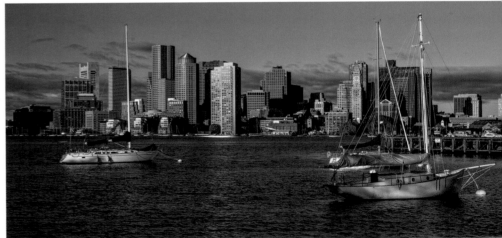

*Boston skyline photographed from Piers Park in East Boston. This vantage point is from the area of wharves visisble in the bottom, right corner of the bird's eye view at left.*

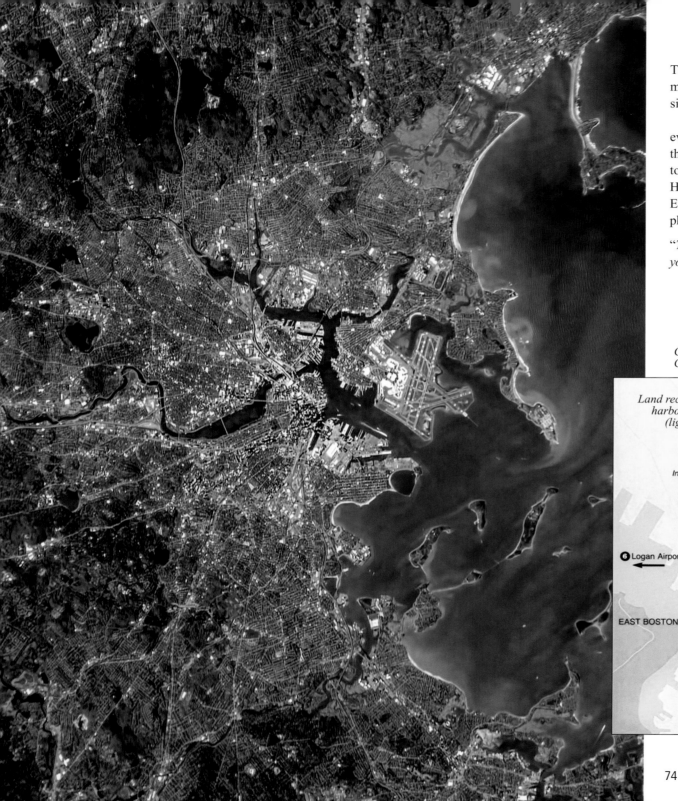

These maps, diagrams and photograph visually reflect just how much of the harbor has been reclaimed from the ocean floor since 1775.

Also interesting to see is how imaging technology has evolved from the painstakingly detailed, pen and ink map of the wharves and downtown area of the city, produced in 1814, to what it looked like through the lens of astronaut Chris Hadfield's Nikon from his viewpoint 220 miles above the New England coast in May of 2013. His 'tweet' accompanying this photograph read:

*"Tonight's Finale: Boston, you're a beautiful harbor city. Hope your Bruins play a memorable playoff game tonight vs the Leafs."*

*Chris Hadfield photo, Copyright NASA and the Government of Canada (May 12 2013, iss035-E-34339)*

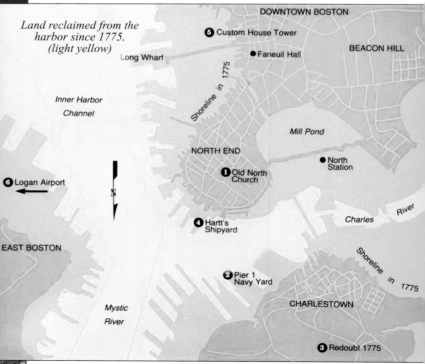

Land reclaimed from the harbor since 1775. (light yellow)

DOWNTOWN BOSTON

❺ Custom House Tower

● Faneuil Hall

BEACON HILL

Long Wharf

Shoreline in 1775

Inner Harbor Channel

Mill Pond

NORTH END

● North Station

❶ Old North Church

❻ Logan Airport

Charles River

❹ Hartt's Shipyard

Shoreline in 1775

EAST BOSTON

❷ Pier 1 Navy Yard

CHARLESTOWN

Mystic River

❸ Redoubt 1775

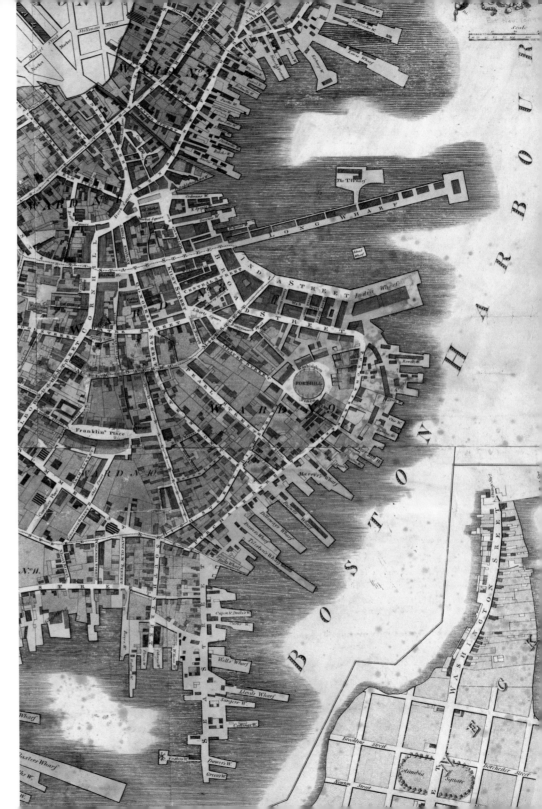

Detailed views of the wharves of downtown Boston today, and in 1814.
Google Maps (above) and John Groves Hales, Boston Public Library (06_01_005501)

# *History of the Landfills*

**Jeffery Howe**, Boston College

A VISITOR FROM OUR 21ST CENTURY WOULD SCARCELY RECOGNIZE THE Boston area of 1630. The landscape has been transformed tremendously in the last 384 years. The land area of Boston has more than tripled since 1630. It may not always be apparent to the driver navigating the narrow streets of Boston, but the creation of this city is one of the great engineering feats of American History.

The three original hills of Boston, Pemberton, Beacon, and Mt. Vernon, no longer dominate the landscape as they once did. Not only are they obscured by tall buildings, but the hills which made up the Trimountain have been cut down by 60 feet or more. In the early 19th Century, the crests of these hills were carted away, and dumped in the coves to provide more area for building.

Old maps depicting Boston reveal an irregular, spidery peninsula, almost an island, really. The North End was distinct from the main body of the Shawmut peninsula, as it was first known. High tides often nearly isolated the North End from the rest of Boston.

As late as 1775, little had changed in Boston. The most noteworthy early alterations to the landscape were the construction of the Long Wharf to the east, nearly one half mile in length, and the construction of a dam across the arms of the North Cove, creating a mill pond that harnessed tidal power to drive grist mills and sawmills.

By 1820, landfill projects had begun, although the northern mill pond was not yet filled in. The largest change to the landscape shown in this map is the new dam across the Back Bay, meant to create a second tidal power source.

As recently as 1830, Boston was still very much a marine city, with Quincy Market and the Custom House immediately adjacent to the harbor. The modern day visitor to Quincy Market is probably not aware that they are standing on the ancient shoreline of Boston Harbor.

A diagram of the sequence of landfill projects illustrates the pattern in which the city grew. The West Cove and the Mill Pond were the first to be filled in during the early 19th Century, followed by the South Cove, East Cove, and South Boston, which began to be filled in 1836. The South Bay was filled following 1850.

The Back Bay was filled in between 1857 and 1894, with Charlestown and the Fenway area beginning to be filled shortly after. The last quarter of the century saw new projects begun in East Boston, Marine Park and Columbus Park to the south. The area that became Logan airport began to be filled in 1922. Each project added to Boston, but the filling of the Back Bay was the largest single project.

The initial alteration to the Back Bay was the creation in 1814 of a long dam, known as the Mill Dam, which extended from Brookline to the edge of Boston Common. Intended to harness the power of the tides, the project was a failure as a source of power. By the mid 1830s, the area behind the dam was further subdivided by newly constructed railroad beds that criss-crossed the bay.

The Mill Dam was a popular promenade, and ultimately became the foundation of Beacon Street. The blocking of the bay by these constructions created vast reservoirs of stagnant water, made less appealing by the addition of raw sewage. The environmental impact of these projects was not well understood. The condition of the bay was a serious problem, and added incentive to the move to fill in this area.

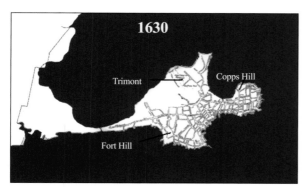

*Boston Proper – 487 acres*

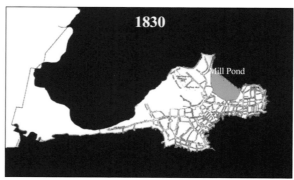

*Mill Pond – adds 50 acres*

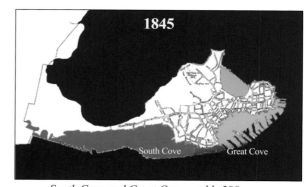

*South Cove and Great Cove – adds 298 acres*

The hunger for new land was more intense than ever at mid-century.

Photographs from the late 1850s (overleaf), taken from the State House on Beacon Hill, show that the landfill had made very little progress as yet. The Bay is still mostly water, and the train crossing areas are still visible at the upper left.

Boston at mid-century was a thriving metropolis, beginning to burst the narrow confines of its original terrain. Boston Common, which had been a fixture since the 17th Century, was well established, but the public garden was hardly begun at this time. Beacon Street was just being developed, and a railroad station occupied a prominent position at the south edge of the Common. The modern city of Boston emerged from the waters, an Atlantis in reverse.

New technologies were required for the filling of the Back Bay. It was a larger area to be filled—more than 700 acres—and the easy sources of fill were already cut down. The invention of the railroad and steam shovel (by Massachusetts native William Otis in 1839) made it possible to bring in gravel from as far away as Needham to the west. It was a tremendous undertaking, and carefully organized. At the peak of activity, 3,500 carloads per day were dumped in the Back Bay.

The Back Bay became a center for cultural institutions as well as fashionable residences. Copley Square was developed in the 1870s, first with Trinity Church, followed by the New Old South Church, the Museum of Fine Arts, and the Boston Public Library in 1888. Adjacent to Trinity Church and the Public Library was the original building for the Museum of Fine Arts, erected in 1877. Constructed in a vibrant Victorian Gothic style, the building lasted only a little over 30 years before it was replaced. The site is now occupied by the Fairmont Copley Plaza Boston.

The original profile of Boston remains beneath the surface of the modern city. When one realizes the dimensions of the changes made to this site, one is filled with a new appreciation for the achievement of earlier centuries. The landfill projects in Boston filled in the bays and smoothed out the irregularities of the Shawmut peninsula. The historical sequence of landfill projects in Boston also helps explain some of the peculiarities of the modern urban landscape. Boston streets, laid out in the 17th and 18th Century, followed a coastline which has moved and avoided hills which are no longer there. One can safely dismiss the myth that the tangled patterns of Boston streets were established by colonial cowpaths.

An extraordinary amount of effort was expended to transform the landscape of Boston. Powerful forces contributed to make all of this activity happen. The great increase of population in 19th-Century-Boston made the creation of new land imperative. The accompanying increase in land values made these ventures profitable, and the development of new technologies in the 19th Century made it possible to alter the landscape on such a scale.

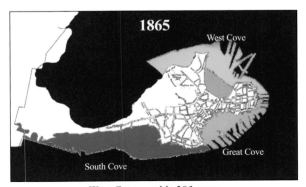

*West Cove – adds 203 acres*

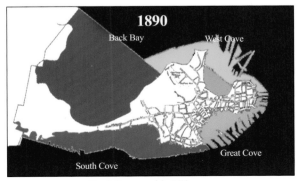

*Back Bay – adds 570 acres*

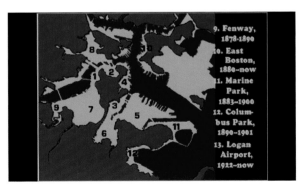

*To view an animation of the evolution of Boston's landfills go to: magiclightphoto.ca, click on Boston cover and scroll to bottom*

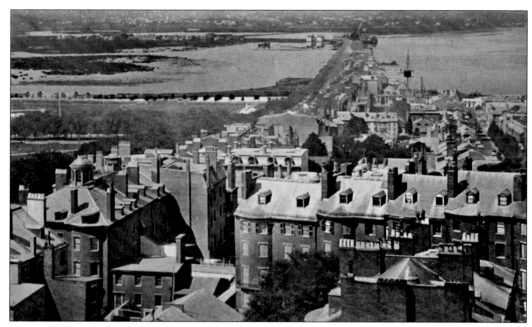

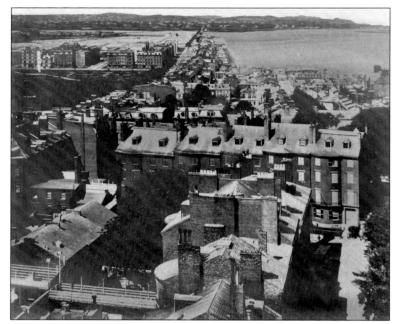

*Back Bay from the dome of the State House, c1858. The truly amazing thing revealed by these three, Back Bay images is that they span a period of only about 50 years. Bostonian Society (000106 and right 002390)*

*Back Bay from the dome of the State House, 1863. New land is being created here and grand appartment buildings appear on Arlington Street (top left).*

*That oft-used expression; 'A picture is worth a thousand words', seems right for this exquisite panorama of the Charles River Basin taken from the dome of the State House in 1906. Hard to believe that the entire area of the old Mill Pond is now home to the residential and business buildings from Beacon Street to Copley Square and beyond. These images also reflect the improvement in the quality of photography in its first 50 years.*

*The road running off to the horizon under this caption is Beacon Street, site of the original causeway visible in the photos above. And the inexorable march of 'fill and build' found architectural expression in the beautifully developed Back Bay, much of which survives well into our 21st Century.*

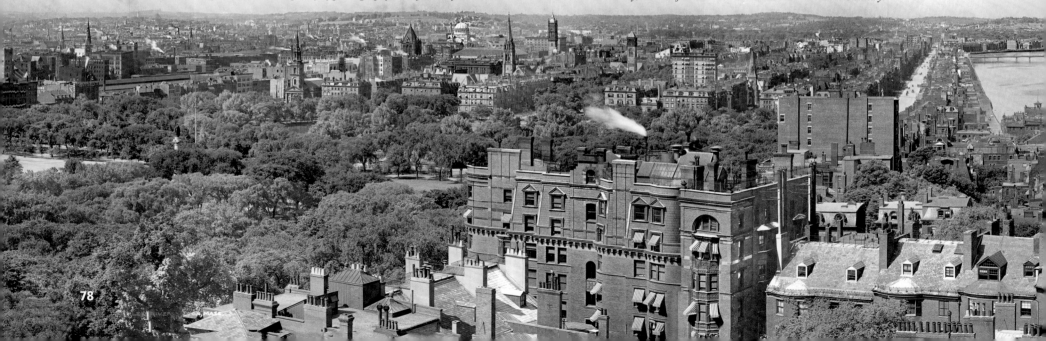

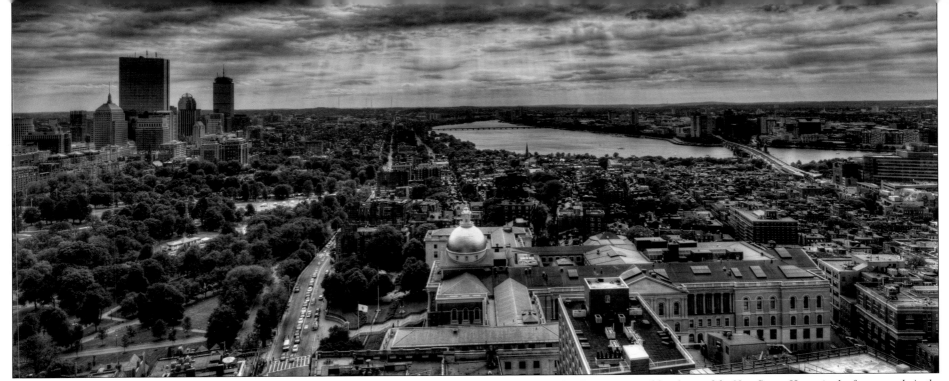

*View of the Charles River Basin and Back Bay from the 24th floor of One Beacon Street today. Interesting to note the shimmering, golden dome of the New States House in the foreground. As the highest vantage point from which to photograph downtown Boston in the early days, it provided my fellow photographers with their platform to shoot their Boston in 1858, 1863 and 1907.*

*Look closely a the Longfellow Bridge below and you will see it in the final stages of construction in 1907. A $255 million project which started construction in Summer 2013 will replace structural elements of the bridge, and restore its historic character. This massive restoration is expected to be completed in 2016. Library of Congress (photomerge (4a09992_4a409993_4a09994)*

*According to Philip Greenspun's weblog; The "total paid for the new bridge" was about $2.5 million. In today's dollars that's approximately $65 million. Interesting to note that the row of six-storey town houses present in the c1858 view (top left) have survived to today, as has the six-storey apartment building to their left, in this 1906 image below.*

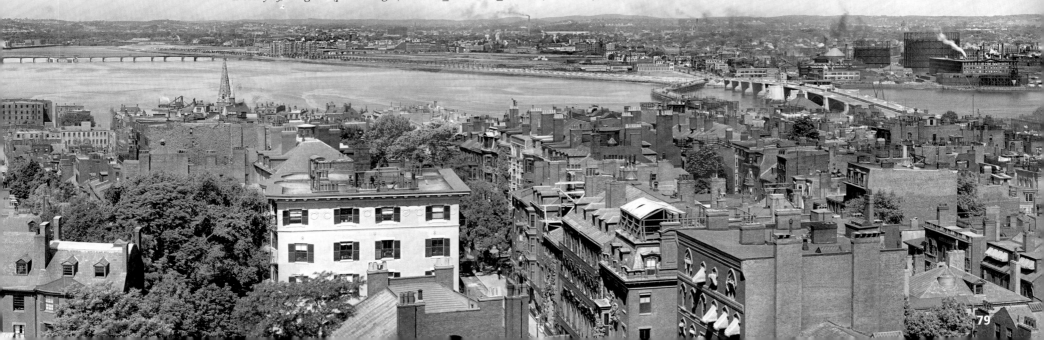

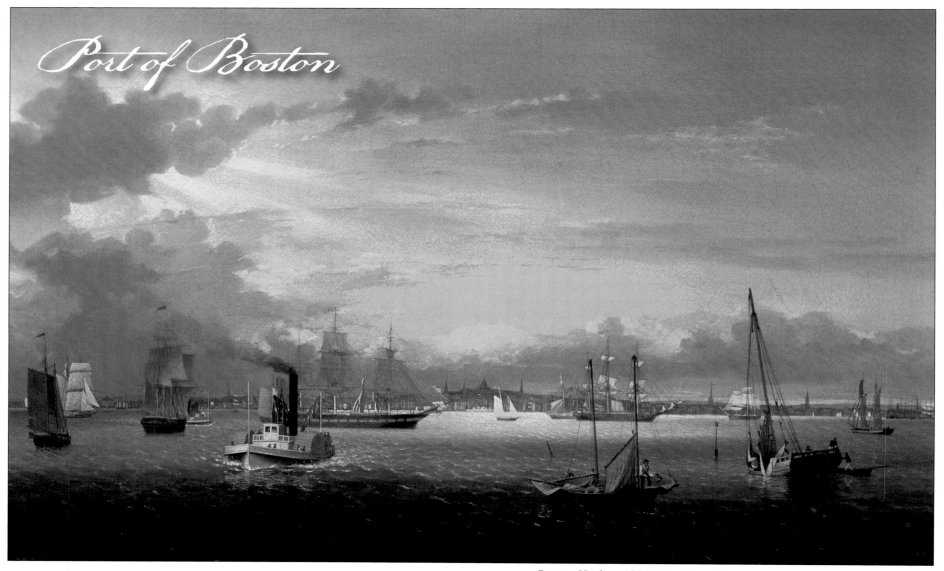

*Boston Harbor, 1854. Fitz Henry Lane*
*White House Art Collection*

*It is interesting to note that the artist placed one little, side-wheel steamer in the foreground, surrounded by sail-powered vessels. Look at the way he further emphasized the coming age of steam that would end the era of the Boston clipper ships by highlighting the tiny vessel with a shaft of sunlight.*

THE PORT OF BOSTON WAS HISTORICALLY IMPORTANT for the growth of the city, and was originally located in what is now the downtown area. The Land reclamation and conversion to other uses means that the downtown area no longer handles commercial ship traffic, although there is still considerable ferry and leisure use of the downtown waterfront. Today the principal cargo-handling facilities are located in the Boston neighborhoods of Charlestown, East Boston, South Boston, and in the neighboring city of Everett. The Port of Boston has also been an entry point for many immigrants.

Before the colonization of the Americas, the area served as a trading post for Native Americans in the region. After the establishment of the Boston settlement by John Winthrop in 1630 and the creation of a local shipbuilding industry, the port served the rapidly expanding American colonies. During that time, trade involved finished goods from England in exchange for lumber, fully constructed vessels, rum, and salted fish

With the rapid growth of the Mid-Atlantic colonies in the 1750s, the ports of New York and Philadelphia began to surpass Boston for inter-colony trade. In response, Bostonian merchants established trade with foreign nations besides Great Britain. This trade led to a huge increase in the wealth of Boston merchants. However, the British government's imposition of regulations restricting trade to Great Britain, combined with newly enacted taxes on the colonists, caused Bostonian merchants to join the more radical elements in American society. After the Boston Tea Party, the British Parliament passed the *Boston Port Act* which shut down the port until the East India Company was compensated for the damaged tea. These actions led to the American Revolutionary War.

Though economically devastated by the Revolutionary War, the Port of Boston was again prospering with trade with various foreign ports such as Shanghai. The port's fortunes were further augmented with a navy base at Charlestown. By the mid-19th Century, the shipbuilding industry reached its peak as displayed by the clipper ships developed by Donald McKay. The port also saw many land reclamation projects and the construction of new piers.

With the beginning of the Industrial Revolution in the United States, activity in the port turned towards trade between the states. Starting in the mid-19th Century, the Port of Boston was eclipsed yet again by other eastern seaboard ports such New York City as local merchant companies were bought out by New York businessmen. In 1956, control of the port was handed to the Massachusetts Port Authority (Massport), which began the process of modernizing the port. During the 1980s and 1990s, a project dedicated to the cleanup of Boston Harbor was overseen by the Massachusetts Water Resource Authority (MWRA).

In 1966, Sea-Land introduced containerized shipping and later established one of the first container ports on Castle Island, where Conley Terminal now stands. To meet the growing demand for container shipping, Massport constructed a common-use container port on what is now Moran Terminal. However, the port faced a setback with the closure of the Charlestown Navy Yard in 1974.

In the mid-1990s, the port went through another round of modernization. Container shipping operations were consolidated at Conley Terminal while Moran Terminal was dedicated to automobile shipping. A project to dredge the harbor commenced in 1997.

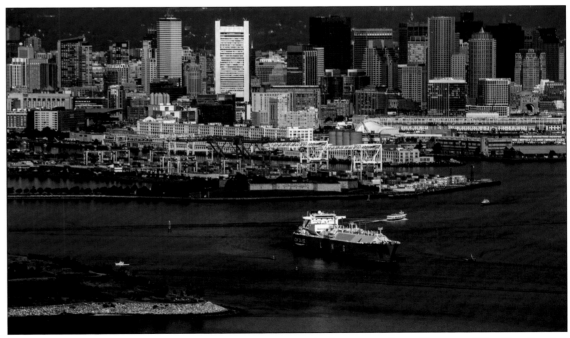

*A GDF Suez S.A., liquefied natural gas (LNG) tanker entering the deep-water channel known as "President Roads", which will lead it safely to the open Atlantic. The ship is passing between the tip of Thompson Island (bottom) and Castle Island, the Conley Container Terminal and downtown Boston in the background.*

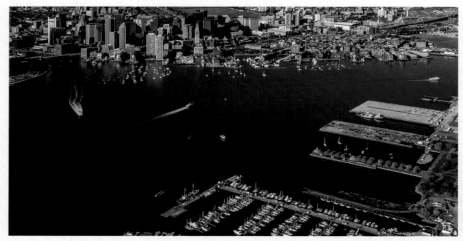

Aerial view of the Harbor over the wharves of East Boston, The beautifully restored Piers Park is an oasis amidst the ruins of several old wharves in this area near Logan Airport. The skyline photograph on page 32 was taken from the end of this pier.

View of Boston Harbor from the derelict wharves of East Boston today.

View of Boston Harbor (below) over the wharves of East Boston, 1906. Interestingly, this photographer combined two photographs to create this photomerge but, it appears that he failed to notice that the steamer in the first shot (right) steamed straight into his second photo (left) (Library of Congress photomerg, 4a09981 and 4a09982)

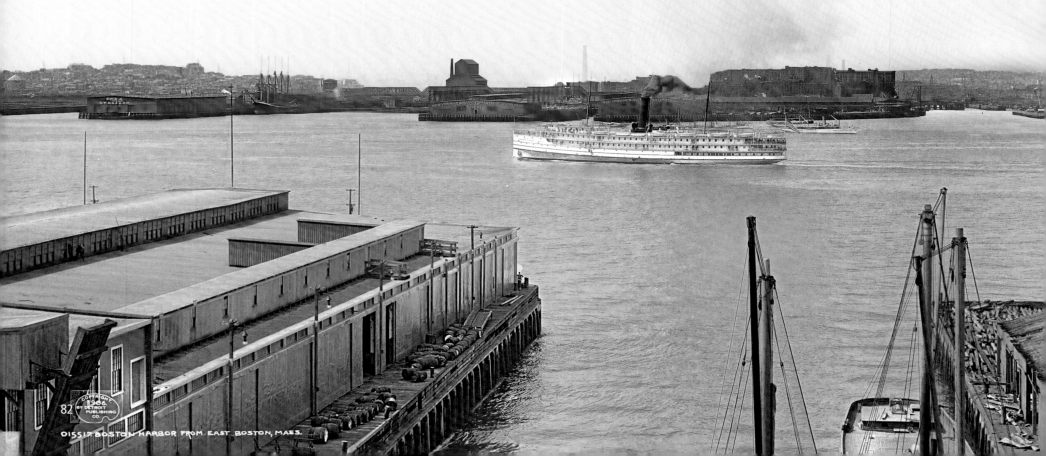

COPYRIGHT 1906 BY DETROIT PUBLISHING CO.

015517 BOSTON HARBOR FROM EAST BOSTON, MASS.

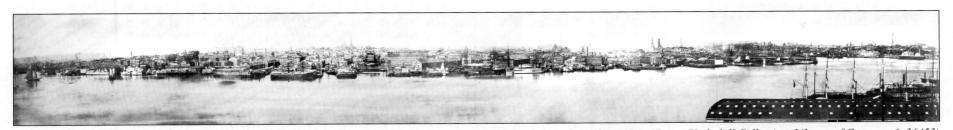

*(Above) Panoramic view of Boston Harbor from The Charles River to the entrance of Fort Point Channel in 1876.   (Irving Underhill Collection, Library of Congress 6a36453)*

Construction of Long Wharf began around 1710. As originally built, the wharf extended from the shoreline adjacent to Faneuil Hall and was one-third of a mile long, thrusting considerably farther than other wharves into deep water and thus allowing larger ships to tie up and unload directly to new warehouses and stores. Lined with warehouses, it served as the focus of Boston's great harbor. Over time the water areas surrounding the landward end of the wharf were reclaimed, including the areas now occupied by Quincy Market and the Customs House. The Wharf was the center of the shipping industry in one of the most vibrant harbors in early America. From here, clippers set sail for Europe, the East Indies, and the Orient.

*In its heyday, Long Wharf was 1,586 feet in length and 54 feet wide, providing docking facilities for up to 50 vessels. J. Carwitham, Yale Center for British Art, Paul Mellon Collection (3644504)*

*Gardner building (1760) and the stone Custom House Block (1848) on Long Wharf. The wharf buildings have been converted to residential, commercial and office spaces.*

In the 1950s, the construction of the John F. Kennedy Expressway served to separate Long Wharf from the central business district, but Boston's famous Big Dig project put the expressway below ground some 40 years later, restoring access to Long Wharf, now a thriving cultural and recreational area.

Today, clipper ships have been replaced by ferries and sightseeing boats. Ferry services heading to Provincetown, Logan Airport and the Harbor Islands National Recreation Area depart from the pier. Several small sightseeing cruises also commence at Long Wharf, educating passengers on the history of the harbor and the city.

*Harbor-touring, schooner (right) approaching the* USS Constitution *docked at the Charlestown Navy Yard. This photograph was taken from the 26th-floor observation deck on the magnificent Custom Tower (below), now the Marriott Custom House.*

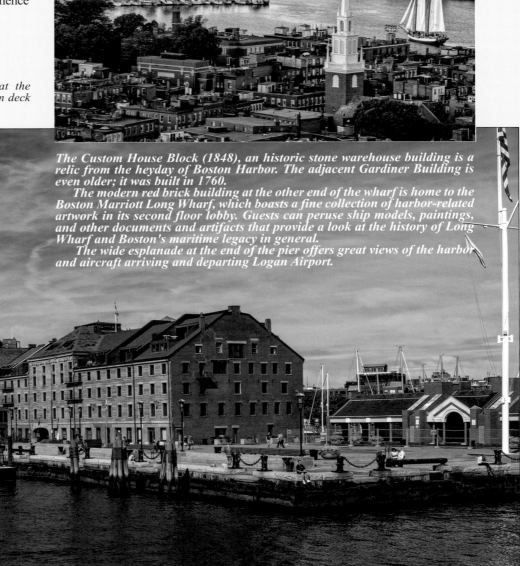

*The Custom House Block (1848), an historic stone warehouse building is a relic from the heyday of Boston Harbor. The adjacent Gardiner Building is even older; it was built in 1760.*

*The modern red brick building at the other end of the wharf is home to the Boston Marriott Long Wharf, which boasts a fine collection of harbor-related artwork in its second floor lobby. Guests can peruse ship models, paintings, and other documents and artifacts that provide a look at the history of Long Wharf and Boston's maritime legacy in general.*

*The wide esplanade at the end of the pier offers great views of the harbor and aircraft arriving and departing Logan Airport.*

# Seafood

FOR OVER 100 YEARS, NEW ENGLAND FISHERMEN HAVE BEEN LANDING their catches at the Boston Fish Pier. While the fishing gear has evolved over the decades, the basics have not changed. Fishermen still go to sea and face all the same chalenges and hardships the Atlantic Ocean can dish out.

BOSTON
FISH
PIER
914-2014
100
YEARS

*Historic, Boston Fish Pier, next to the World Trade Center in South Boston's Seaport District*

**Crew of trawler Lydia and Maya** *unloading their catch of sole and red fish at the Atlantic Coast Seafood area of the Boston Fish Pier. It is entirely possible that some of this sole will end up plated (far right) at a local restaurant in a few hours.*

*Trucks waiting to load catch for delivery throughout New England.*

ATLANTIC COAST SEAFOOD, A FAMILY OWNED AND OPERATED FRESH FISH wholesale distributor, is a thriving facility off-loading the Boston fishing fleet, made up of over 20 ground fish vessels. They have established a way to ice, power, unload, repair and fuel these vessels to ensure the Boston Fish Pier is a full-service port, like its counterparts in Gloucester and New Bedford. The company unloads multiple boats on any given day, seven days a week, 12 months a year. Once a vessel has been unloaded, its catch is separated, weighed, packaged and shipped out to various establishments across the northeast, all in the same day. One of the company's long-standing customers is a familiar name across New England whenever seafood restaurants enter the conversation.

Legal Sea Foods was born in 1950 when George Berkowitz opened a fish market in the Inman Square neighborhood of Cambridge. He opened it adjacent to his father Harry's grocery store, Legal Cash Market, where customers were given "Legal Stamps" (forerunners of S&H green stamps) with their purchases. It's here that the "Legal" name became synonymous with quality and freshness. In 1968, the Berkowitz family opened its first seafood restaurant, right next to the fish market. The fish was simply prepared, either broiled or fried, and served on paper plates at communal picnic tables. Despite the low-key trappings, the food was second to none and word quickly spread. This early success led to further expansion and now, six decades later, with over 35 restaurants along the Eastern Seaboard, the family philosophy endures: Legal Sea Foods is a fish company in the restaurant business.

Publisher's Note: These two companies did not pay to appear in this book. Tory Bramante, third generation owner of Atlantic Coast Seafood, was very helpful in allowing me to photograph his operations. Like many Americans, his grandfather, a fisherman in Sicily, immigrated to Boston in the early 1900s. He taught his son to fish and that son passed along his knowledge to his son Tory, who took the business to heart, opening his company on the Fish Pier in 1986. And my 'Crab Cake Combo' convinced me that Legal Sea Foods' recent recognition by *USA Today*, as Best Seafood Restaurant in America, was well deserved.

*Sauteed Day Boat Sole on the table of a Legal Sea Foods restaurant in the greater Boston area. Legal Sea Foods photo*

87

When the Boston Fish Pier opened in 1914, *The Fishing Gazette* described it as "the largest, most complete and sanitary building in the world devoted exclusively to the handing of fish—a monument to the industry for all time". Built to accommodate Massachusetts' flourishing fishing trade of the early 1900s, the 1,200-foor long, 300-foot wide pier and its buildings provide a large, efficient facility for fishermen, fish processors and fish distributors. The facility included its own power plant as well as the world's largest ice manufacturing plant. In 1963, the Boston Fish Pier reached its peak, landing a total of 339 million pounds of fish.

Over the next four decades, territorial disputes with Canada, competition from subsidized foreign fishing fleets, and over-fishing dramatically reduced the quantity of fish being caught by the New England fleet, sending the industry into a downward spiral. The decline of the industry dramatically reduced the number of businesses on the Boston Fish Pier and the number of vessels landing there.

By 1972, little had changed since the pier's original construction and years of neglect had taken their toll on the facility. The giant buildings were dilapidated and many areas were boarded up and vacant. Fishing boats were landing at alternative ports because of the poor condition of the piers' docking facilities. Threatened with condemnation, the facility was being considered for non-water dependent commercial development.

In April of 1972, The Massachusetts Port Authority (Massport) took control of the Pier. A feasibility study determined what needed to be done to restore the facility for the fishing industry. The report also identified space on the Pier no longer needed for fishing-related uses. The surplus space was slated to go through rehabilitation for offices. The Massport plan called for market-rate office rents to subsidize industry users in order to prevent the struggling fishing industry from being pushed off the waterfront. From 1975 through 1983, a total of $25 million, 68% funded by Massport and the remainder funded by the federal government, was invested in the Pier to transform it into what is now a unique and successful mixed-use waterfront development project. The Fish Pier is located in South Boston, just a short distance from Boston's financial district and directly across the harbor from Logan International Airport. Today, 120,000 square feet of renovated space on the first two floors of the pier's two three-story processing buildings is leased to fish processors and distributors. Separate first floor elevator lobbies lead office tenants to third-floor office space.

Although new uses have been introduced to the Pier, fishing and fish processing remain its primary function. In 1989, 16 million pounds of fish were landed on the Pier and, supplemented by trucked-in product; 32 million pounds was processed there.

The Fish Exchange building is now known as the Exchange Conference Center. The historic home of Boston Fish Auction now serves as the centerpiece to corporate and private functions, with a breathtaking view of Boston's Harbor.

exchangeconferencecenter.com

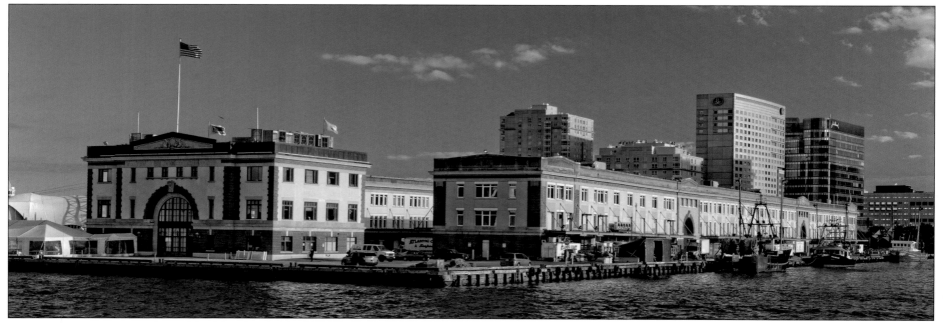

*Three buildings of the Boston Fish Pier with the ever-growing Seaport District in the background.*

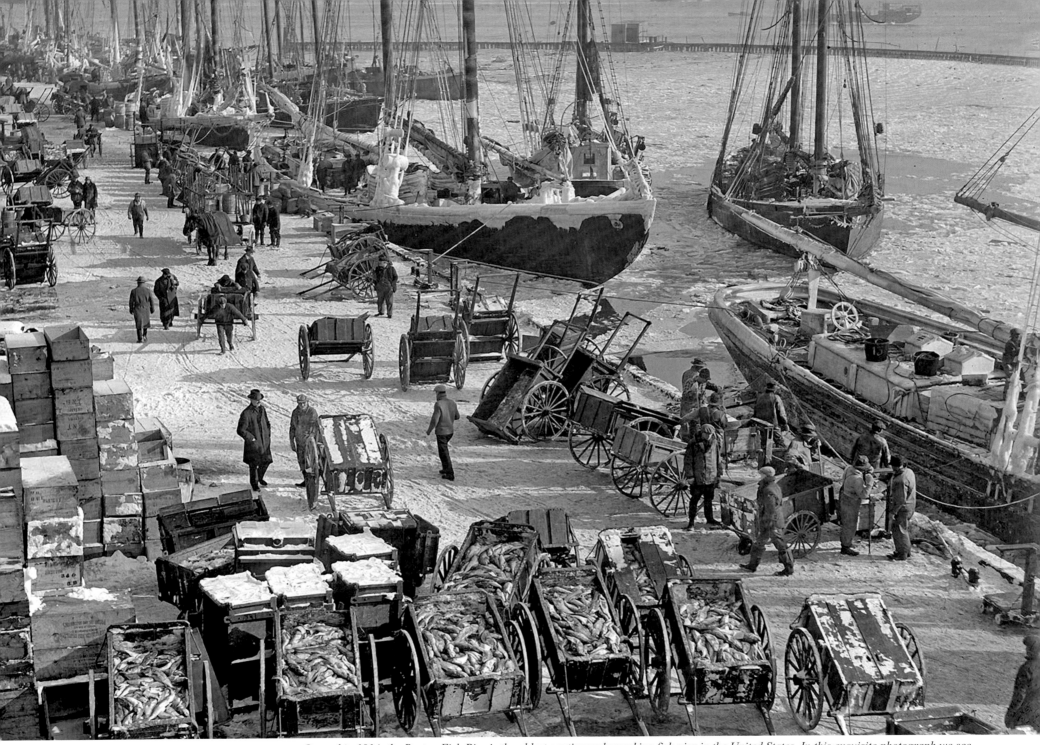

*Opened in 1914, the Boston Fish Pier is the oldest continuously working fish pier in the United States. In this exquisite photograph we see classic fishing schooners unloading their catches of cod on a busy day in February, 1930. (Leslie Jones, Boston Public Library 007035)*

Custom House

BOSTON'S HISTORIC CUSTOM HOUSE WAS ORIGINALLY BUILT AS A GREEK temple in 1847. It became the city's first skyscraper when a tower was built on top of the neoclassical temple in 1915.

In 1913, to the surprise of many Bostonians, a tower was added on top of the Greek temple. The tower, designed by Peabody and Stearns, reached a height of 496 ft (151m) when it was completed in 1915. A city building height limit, at the time set at 125ft (38m) was ignored, since the Custom House was federally owned. It was by far the tallest tower in the city and it would continue to keep that title until 1964, when the Prudential Tower was built in Boston's Back Bay district. While not everyone in Boston was enthusiastic about their first skyscraper, the Custom House Tower soon became an iconic landmark.

In 1986, the custom department moved to a more modern building and the Custom House stood empty until it was converted into today's Marriott's Custom House in 1999. Inside the rotunda is a small maritime museum. Check with the hotel for access to the 26th-floor observatory, which offers beautiful, 360-degree views of the city and harbor. Today's building is more than 500 feet (150 meters) removed from the water's edge, but when it was originally built between, 1837 and 1847, it was right on the waterfront, at an ideal location between the docks and the financial and administrative heart of the city centered around State Street. The granite building was designed by the American architect Ammi Burnham Young, who created a classical Greek temple with massive Doric columns and a pediment on all four sides. A skylight in the dome brought natural light into the central rotunda. Perched on the corners of the cornice are four sculpted eagles. Above is a four-sided clock, with a diameter of 22 ft (6.7 m), beautifully illuminated at night. The tower culminates in a pyramidal top. And even though it is now dwarfed by some of the skyscrapers in the financial center nearby, the tower still features prominently on the city's skyline.

*(Library of Congress, 4a24864)*

*Views of the Custom Tower and Grain and Flour Exchange Building (1893) today and c1915.*

90

*(Library of Congress, 4a11353)*

*Here, between 1900 and 1906, stands the original Greek Temple, completed in 1847, provided the unique base upon which the tower was added in 1915.*

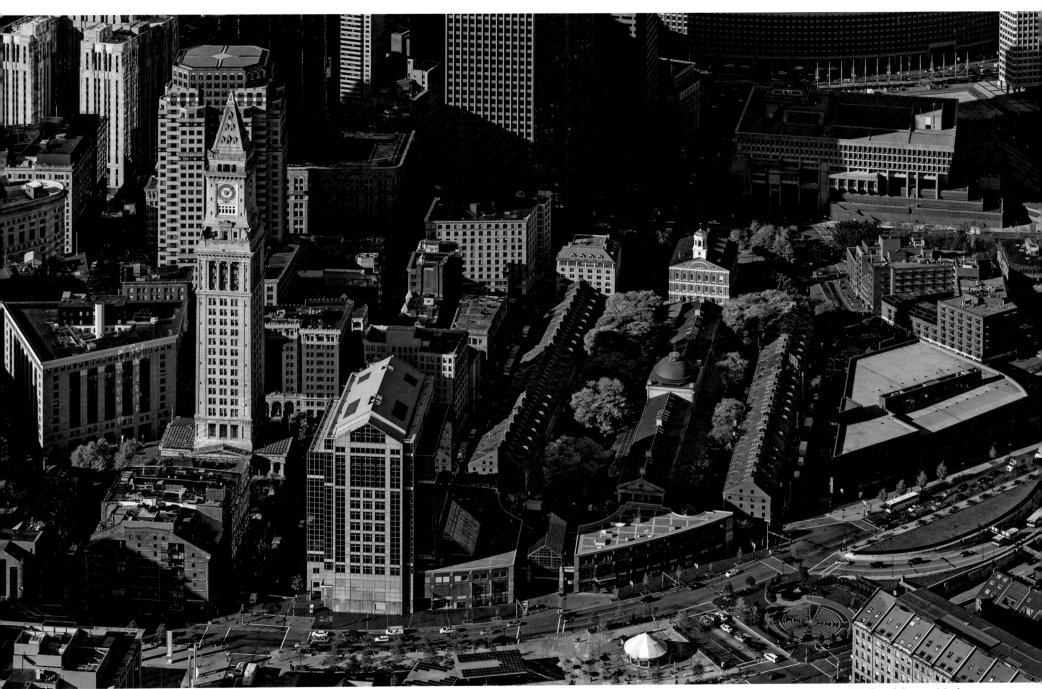

*Aerial view of Marriott's Custom House in its historic setting beside iconic Faneuil Hall and Quincy Market.*

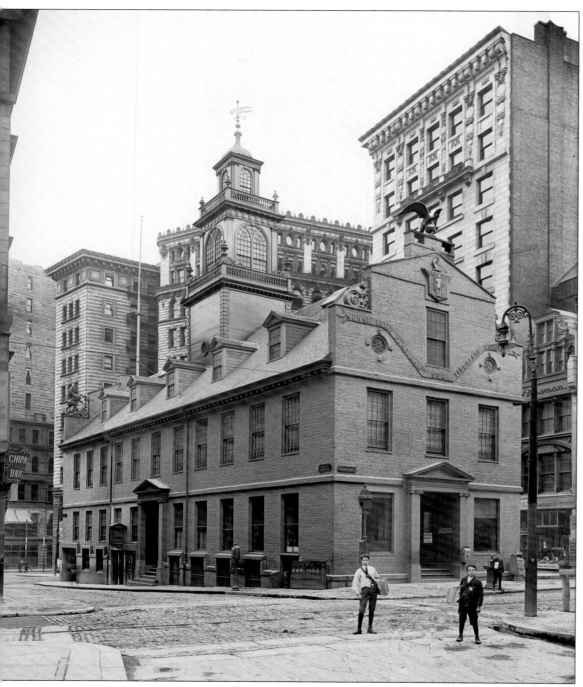

*West end of the Old State House at the corner of State and Washington Streets c1906.*
*(Library of Congress, 4a13548)*

As the city was building anew, it also tried to hold onto the past. In 1791, a group of Bostonians formed the Massachusetts Historical Society, the first organization in the United States dedicated to preserving history. The Massachusetts Historical Society is still one of the nation's premier repositories of historical records and artifacts. Included in its collections is a jar of tea preserved from the Boston Tea party. In 1806, a group of Boston intellectuals, led by minister William Emerson formed the Anthology Club, which was devoted to literature, history and the arts. The Anthology Club also began collecting books and paintings, outgrowing various meeting places before building the Boston Athenaeum in 1849 on Beacon Hill. These cultural institutions suggest that the tumultuous port city of the 1760s had become a more refined place in the 19th Century.    **Robert Allison**, *A Short History of Boston*

Established in 1881, the nonprofit Bostonian Society is the primary steward and caretaker of the Old State House and its collection of Revolutionary American artifacts and records. The Society is credited with twice rescuing the Old State House from destruction, first organizing opposition to its demolition as a 'traffic impediment,' and later to the rejection of an offer by Chicago's citizens to move the building to Lake Michigan. Since then it has preserved and maintained this national historic treasure and interpreted for the public the important stories contained herein. In addition to operating a museum of Revolutionary Boston history, the Bostonian Society maintains a research library and a collection of over 7,500 books, 350 maps, and over 30,000 photographs. The Bostonian Society also holds an extensive collection of paintings, statuary, clothing, weaponry, medals, and ephemera. The Bostonian Society is dedicated to studying, and preserving Boston's uniquely important history, embodied in materials, records, and structures such as the Old State House, and in sharing with the public an understanding of the important revolutionary ideas born here.    **Bostonian Society,** bostonhistory.org

*Not only has the Old State House survived challenges to her existence in the 20th Century, but several of her distinguished neighbors have also celebrated their 100th birthdays. The Ames Building (left foreground of color image opposite) was completed in 1893 and has been converted into the today's Ames Boston Hotel. Just to the right of the Custom Tower is the 12-story Boston Stock Exchange, built in 1896, it is now joined to the 40-story, Exchange Place at 60 State Street.*

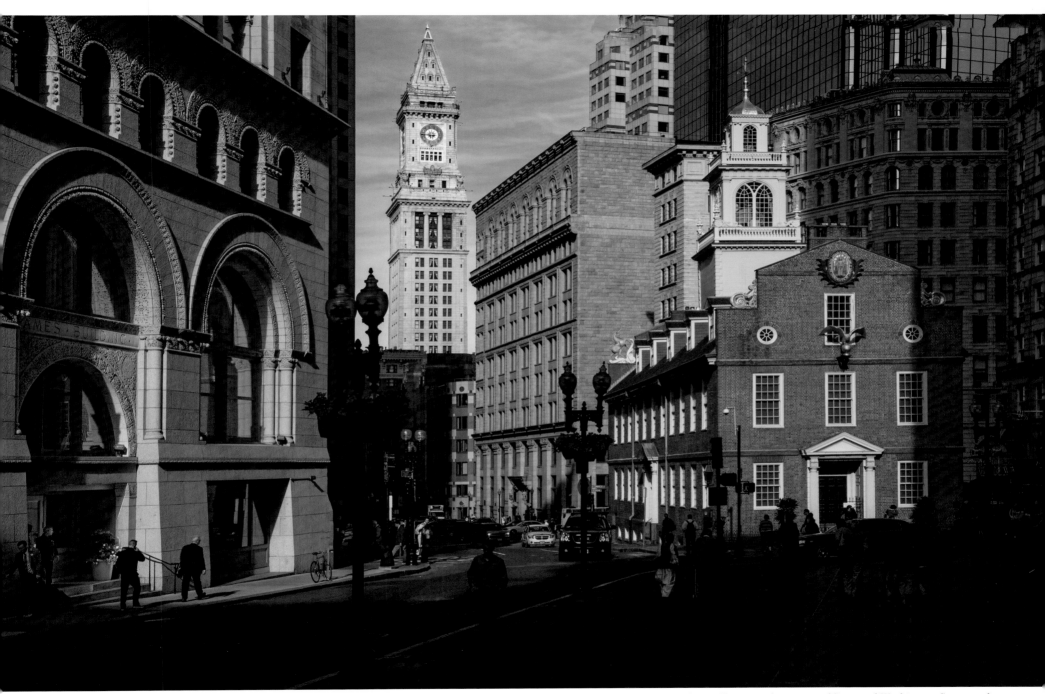

*Thanks to the efforts of the Bostonian Society, the Old State House continues to occupy its place of honor at the corner of State and Washington Streets today.*

The Old State House, the oldest surviving public building in Boston, was built in 1713 to house the government offices of the Massachusetts Bay Colony. It was a natural meeting place for the exchange of economic and local news. A Merchant's Exchange occupied the first floor and the basement was rented by John Hancock and others for warehouse space. As the center of political life and thought in the colonies, the Old State House has been called one of the most important public buildings in Colonial America. The central area of the second floor was the meeting place of the Massachusetts Assembly, one of the most independent of the colonial legislatures. The Council Chamber of the Royal Governor (above) was located upstairs at the east end of the building, looking toward Long Wharf and the harbor. This room was the setting for many stirring speeches and debates by dedicated patriots against the British crown. Official proclamations were read from the Old State House balcony, on the east side of the building, looking down State (formerly King) Street. On July 18, 1776, the Declaration of Independence was first proclaimed from here to the jubilant citizens of Boston. From 1830 to 1841, the building was used as Boston's City Hall.

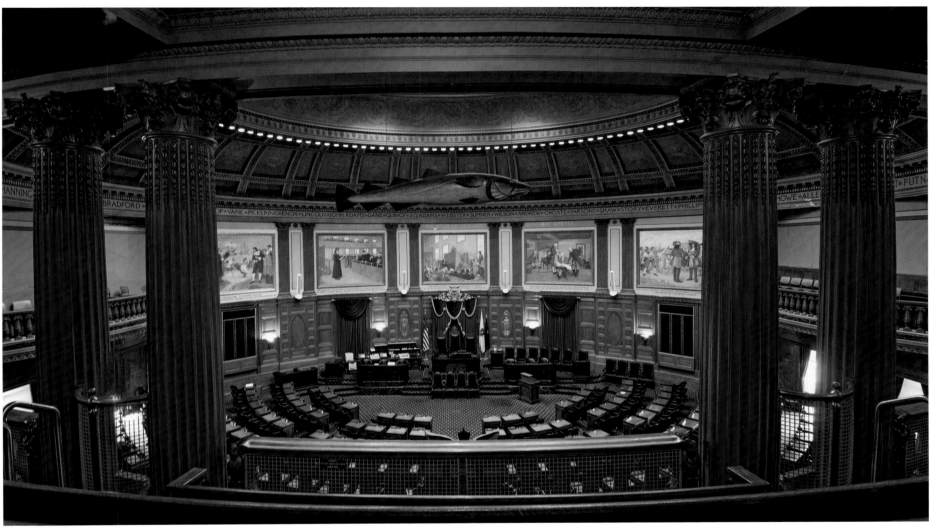

It is in this room in the New State House that the larger of the two legislative bodies conducts its business. The Speaker of the House is elected by the representatives and presides from the elevated chair behind the podium. Representatives can vote electronically by pushing a green "Yea" or a red "Nay" button on their desks. The results of the vote appear next to each representative's name on the boards in the front of the room.

The room is paneled in Honduras mahogany. Behind the Speaker's podium are the Albert Herter murals, "Milestones on the Road to Freedom." The names on the ceiling cornice commemorate men who made important contributions to the Commonwealth and the nation prior to 1895.

Above are the galleries for the public, guests of the Speaker, and the press. Hanging over the public gallery is the famous Sacred Cod, symbolizing the importance of the fishing industry in the early Massachusetts economy. It was given to the House in 1784 by a Boston merchant, Jonathan Rowe. Rowe felt that by hanging the cod in plain view of the legislators they would always be reminded of the importance of the fishing industry to the city and the state as they went about their business.

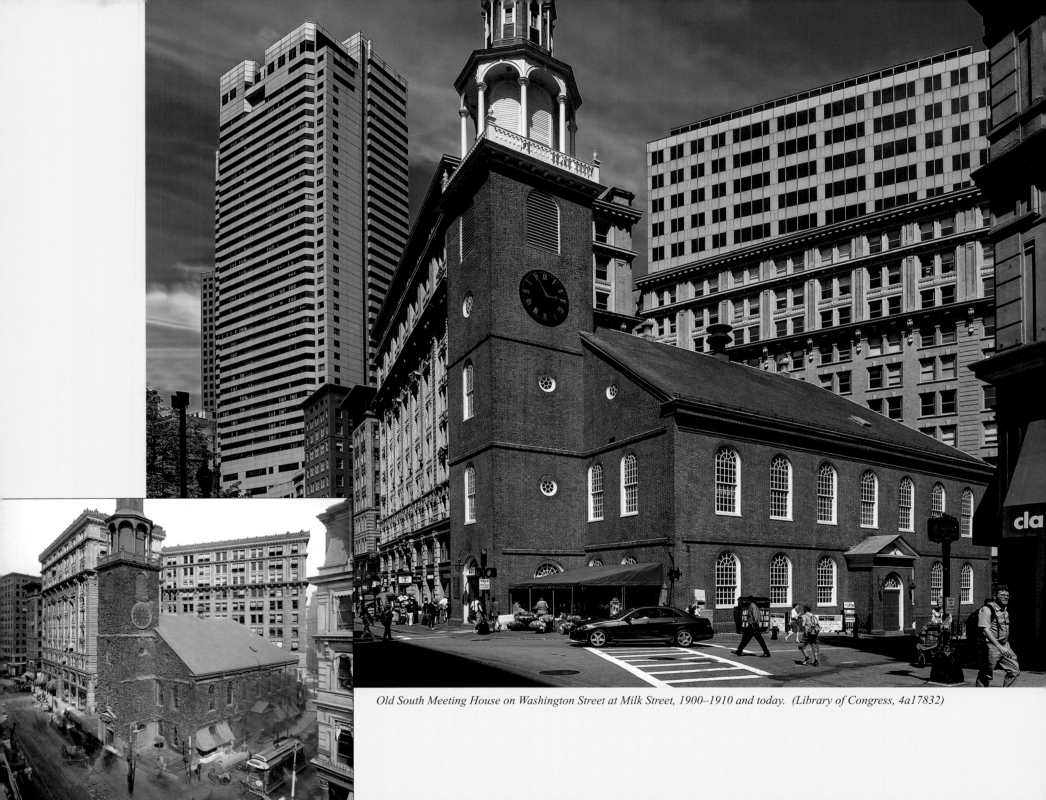

*Old South Meeting House on Washington Street at Milk Street, 1900–1910 and today.  (Library of Congress, 4a17832)*

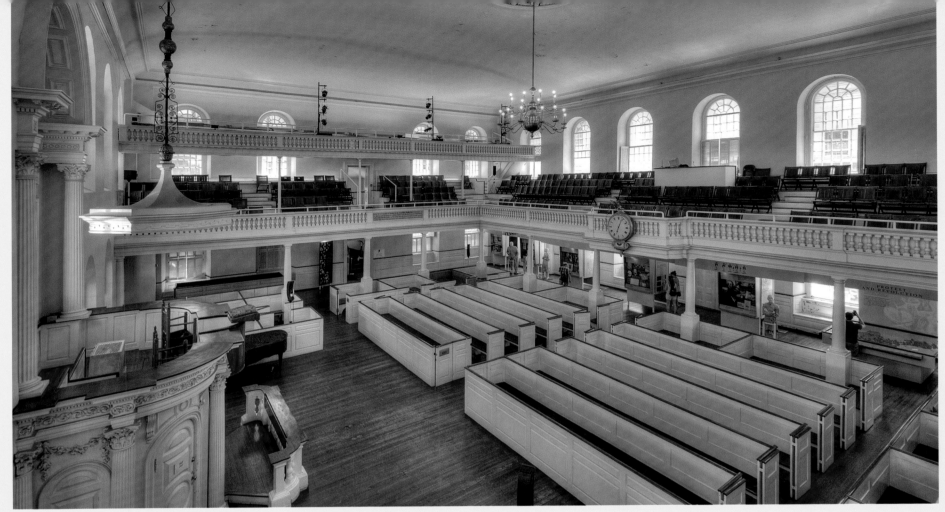

Built in 1729 as a Puritan meeting house, Old South has been an important gathering place for nearly three centuries. The Old South congregation built their first wooden meeting house in 1669, but overcrowding became a problem and the congregation tore it down to build a new, more spacious brick meeting house in 1729. Members of Old South's congregation included African-American poet Phillis Wheatley, patriot leader Samuel Adams, William Dawes, who rode with Paul Revere to Lexington, and Benjamin Franklin.

Standing in the center of town, the Old South Meeting House was colonial Boston's largest building and was used for many public gatherings as well as for worship. In Boston, meetings too large for Boston's town hall, Faneuil Hall, were held at the Old South Meeting House because of its great size and central location. Old South Meeting House has an enormous 1768 tower clock created by Gawen Brown that is still working today. The Old South Meeting House clock is the nation's oldest American-made tower clock still operating in its original location.

One of the nation's most important colonial sites, Old South Meeting House still stands in the heart of bustling downtown Boston today, open to the public daily as a historic site and museum. Old South Meeting House was a favorite stage in Boston's drama of revolution, the place where colonists gathered time after time to challenge British rule in the years leading to the American Revolution. It is the place where unprecedented numbers of people from all walks of life engaged in debate and dialogue that would change the fate of a nation. These gatherings were larger and more inclusive meetings than were ever held in the colony before, earning the building a reputation as the hotbed of rebellion.

From outraged protests over the Boston Massacre, to the night Samuel Adams gave the secret signal that began the Boston Tea Party... From the heroic effort to save a grand historic landmark from demolition, to a free speech policy enacted amidst the height of censorship ... Old South Meeting House is the place where, meeting by meeting, vote by vote, a revolution began.

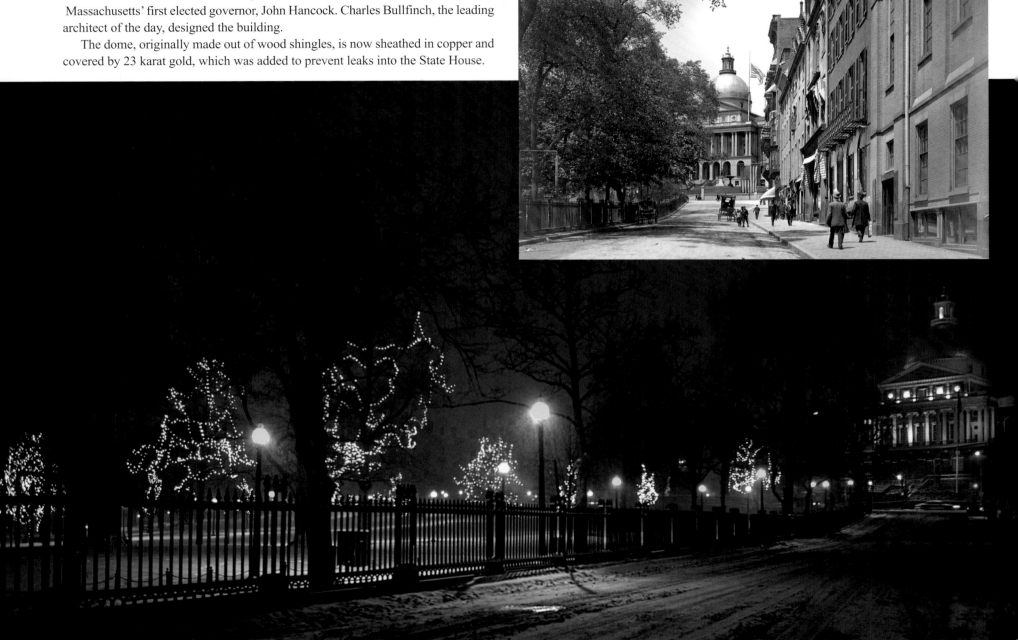

Built in 1798, the "new" State House is located across from Boston Common on the top of Beacon Hill. The land was owned by Massachusetts' first elected governor, John Hancock. Charles Bullfinch, the leading architect of the day, designed the building.

The dome, originally made out of wood shingles, is now sheathed in copper and covered by 23 karat gold, which was added to prevent leaks into the State House.

*Views up Park Street to the "new" State House today and c1900.  Library of Congress (4a13531u)*

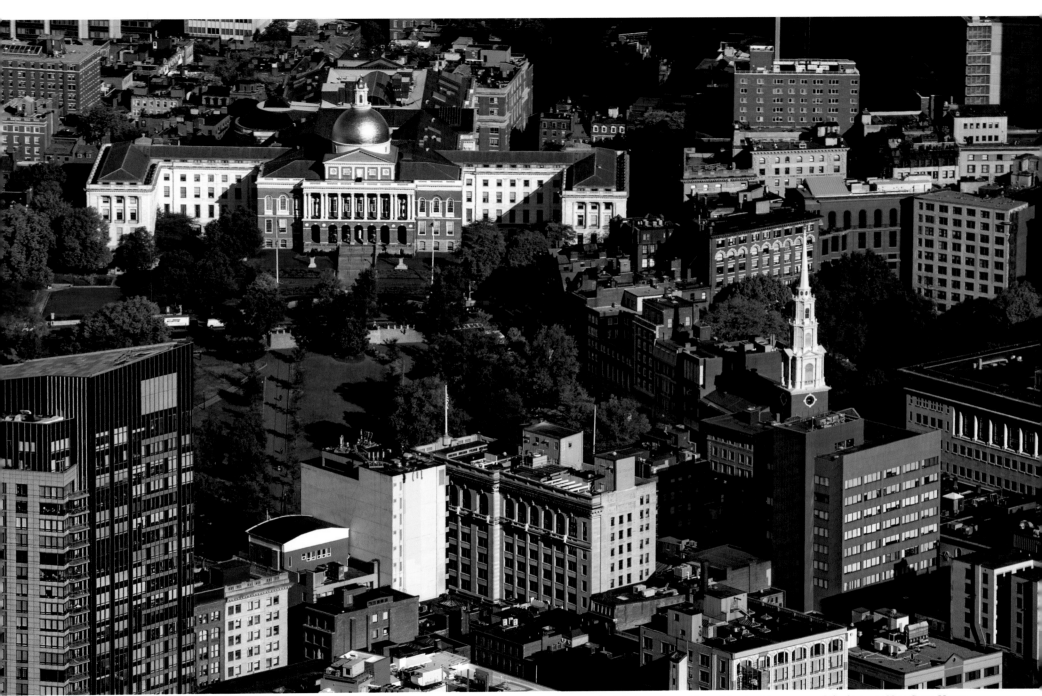

*Aerial view of a portion of Boston Common and the historic New State House.*

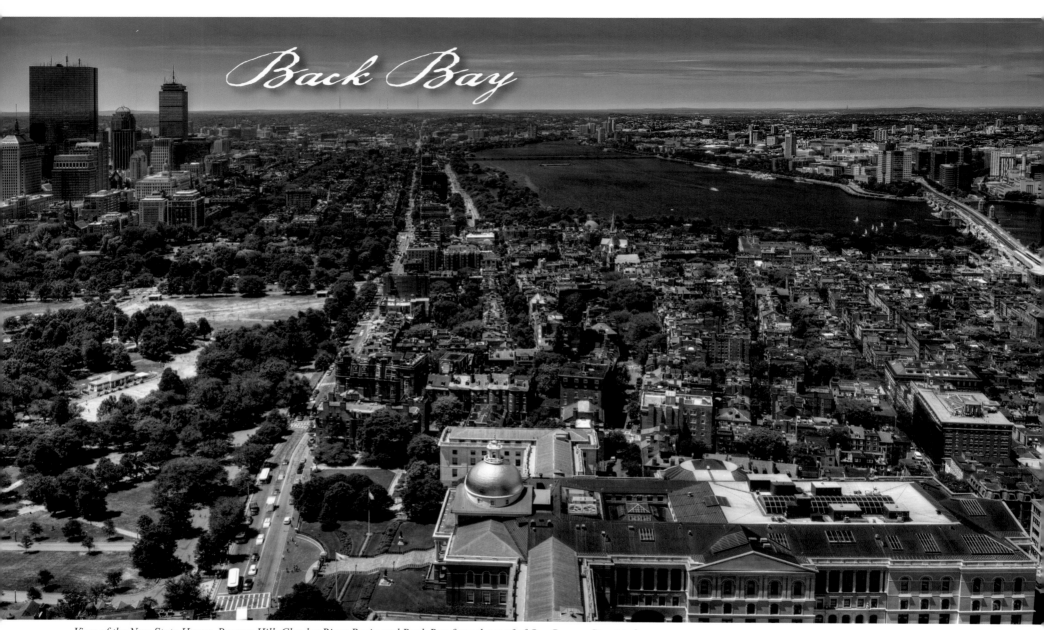

*View of the New State House, Beacon Hill, Charles River Basin and Back Bay from the roof of One Beacon Street today.*

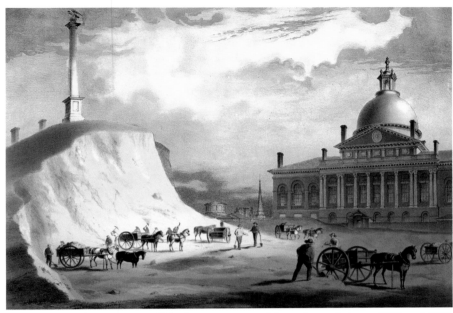

*Beacon Hill under excavation. Fifty feet were removed from the top between 1807 and 1832, and the Sentinel Monument was moved to its present location beside the New State House.*
*(Boston Public Library 002260)*

THE NEWLY WEALTHY BOSTON MERCHANTS WANTED TO ESCAPE THE CLOSE confines of the North and South Ends, where they were surrounded by longshoremen and dockworkers, boarding houses and taverns. A group of investors, the Mount Vernon Proprietors, planned to develop Beacon Hill as a district of mansions. Its southern slope, facing the Common, would be the town's most prestigious area. The development faced two major obstacles. First, much of it was owned privately, and second, it was too steep to develop.

The Proprietors first set out to buy the land. One of the owners, portrait artist John Singleton Copley, had remained loyal to the British crown and now arrived in London. The Proprietors approached him there. They did not tell him that they had plans to develop Beacon Hill or that they were already building a new State House not far from his pastureland. He sold them the land thinking it worthless pastureland, not knowing their grand plan to turn it into Boston's premier real-estate development.

Having bought the land, the Proprietors next made it suitable for building. Workmen carried the dirt in handcarts down the slope to the Mill Pond, filling in that basin. Architect Charles Bulfinch, designer of the new State House on Beacon Hill as well as many of the mansions of the Proprietors, laid out streets on the new land of the Mill Pond in a triangular pattern, creating an industrial barrier, the Bulfinch Triangle (bounded by Merrimac, Causeway, Canal and Market streets), between the new Beacon Hill neighborhood and the old North End.

This stately column stands in the place of the city's earliest alarm system. Shortly after arriving in Boston, the colonists erected a beacon on top of the area's highest hill—then called Sentry, or Sentinel, Hill—in order to announce any impending danger, such as fire or an attack on the settlement. According to historical records, the beacon was never used, but it eventually became a landmark. Heavy winds knocked down the original beacon in 1789, and architect Charles Bulfinch designed a new structure, consisting of a Doric brick column placed on a stone pedestal and topped with a gilded eagle. The monument you see today is a reproduction of Bulfinch's column, which had to be removed when the top of the hill was leveled in 1811.

*Three ladies impeccably turned out in their Victorian finery, enjoy a stroll along the recently constructed Boston Embankment on the Charles in 1912. Boston Public Library (06_01_005501)*

THE ESPLANADE WAS DEDICATED AS THE BOSTON Embankment in 1910. The Embankment was created as part of the construction of the 1910 Charles River Dam (today the site of the Museum of Science). The parkland was criticized for its lack of shade trees, refreshment stands, recreation facilities, transportation utility, and visitors. It extended to Charlesgate (upstream of the Harvard Bridge), connecting with Olmsted's Emerald Necklace (see page 109). To address criticism, trees, a refreshment pavilion, and concerts were brought to the park.

A major expansion of the Esplanade took place from 1928 to 1936, widening and lengthening the park land. These improvements were aided by a one-million-dollar donation from Helen Osborne Storrow, in memory of her husband James. The Storrow Memorial Embankment, designed by Arthur Shurcliff added the first lagoon, boat landings, plazas, playgrounds, and the Music Oval, where a temporary bandshell was placed. The summer of 1929 was the first year Arthur Fiedler and the Boston Pops performed on the Esplanade.

In 1941, the construction of the Hatch Memorial Shell gave the Pops, and a wide range of other artists and performers, a first-class stage for popular summer events. In the first decades of the 21st Century, half a million people attend the Boston Pops concert and fireworks display held there every Independence Day. The Hatch Shell also hosts free public concerts, movies, and special events—walkathons, races, and festivals such as Earth Day—that draw hundreds of thousands of additional spectators each year.

The next major change to the Esplanade began in 1949, with the construction of Storrow Drive. To make up for park land lost to the new road, additional islands including multiple paths were built along the Esplanade. In the 1960s, the Esplanade was linked to Herter Park in Brighton, and other upstream parks, with the construction of the Dr. Paul Dudley White Bike Path. This 18-mile (29 km) loop travels along the entire basin on both the North and South sides of the river, making it especially suitable for biking, inline skating, and running.

*Back Bay and the west end in 1928 and (right) today. This pairing shows the expansion and beautification of the Esplanade that so many Bostonians and visitors now enjoy.*

*(Boston Public Library 08_02_000642)*

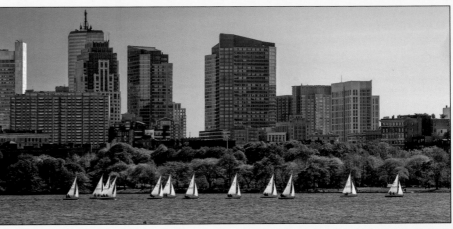

*Originally known as the Community boat Club, this is the oldest public sailing program in the country. It was founded in 1937 by Joseph Lee, Jr. as a summer program for the children of the West End neighborhood; the boats sailed from a pier near Massachusetts General Hospital.*

*The children also helped to build the boats in the winter; the structured activities filled an important need for many young urban residents. Community boating expanded to offer programs to metropolitan Boston residents of all ages and became the largest program of its kind in the country.*

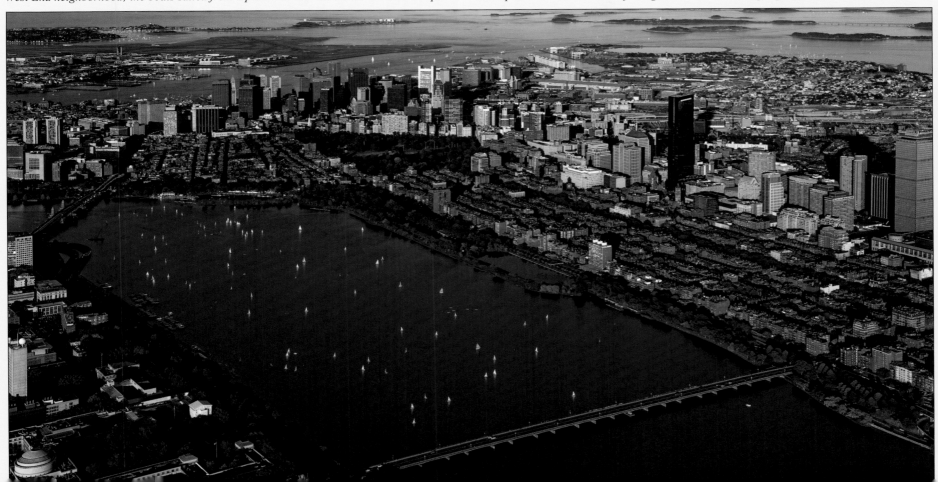

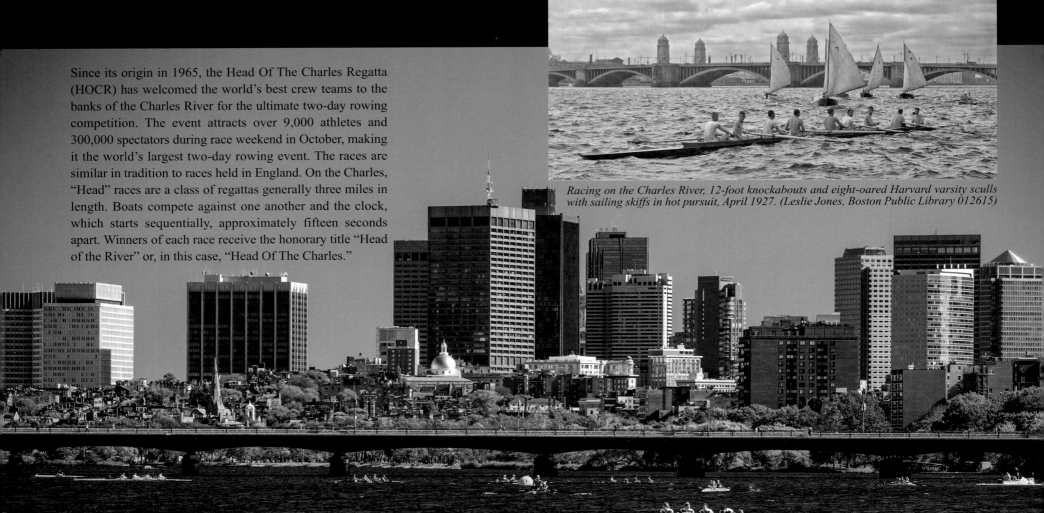

Since its origin in 1965, the Head Of The Charles Regatta (HOCR) has welcomed the world's best crew teams to the banks of the Charles River for the ultimate two-day rowing competition. The event attracts over 9,000 athletes and 300,000 spectators during race weekend in October, making it the world's largest two-day rowing event. The races are similar in tradition to races held in England. On the Charles, "Head" races are a class of regattas generally three miles in length. Boats compete against one another and the clock, which starts sequentially, approximately fifteen seconds apart. Winners of each race receive the honorary title "Head of the River" or, in this case, "Head Of The Charles."

*Racing on the Charles River, 12-foot knockabouts and eight-oared Harvard varsity sculls with sailing skiffs in hot pursuit, April 1927. (Leslie Jones, Boston Public Library 012615)*

*Rowers preparing for their HHOCR races in front of the Boston University's DeWolfe Boathouse (below) and near the Harvard Bridge (above) in 2013.*

*Esplanade and Hatch Shell from Cambridge showing oarsmen on the Charles, c1942. (Leslie Jones, Boston Public Library 035637)*

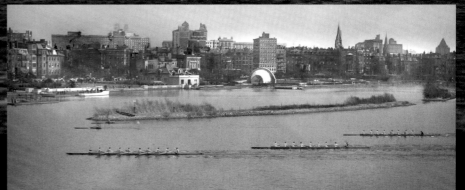

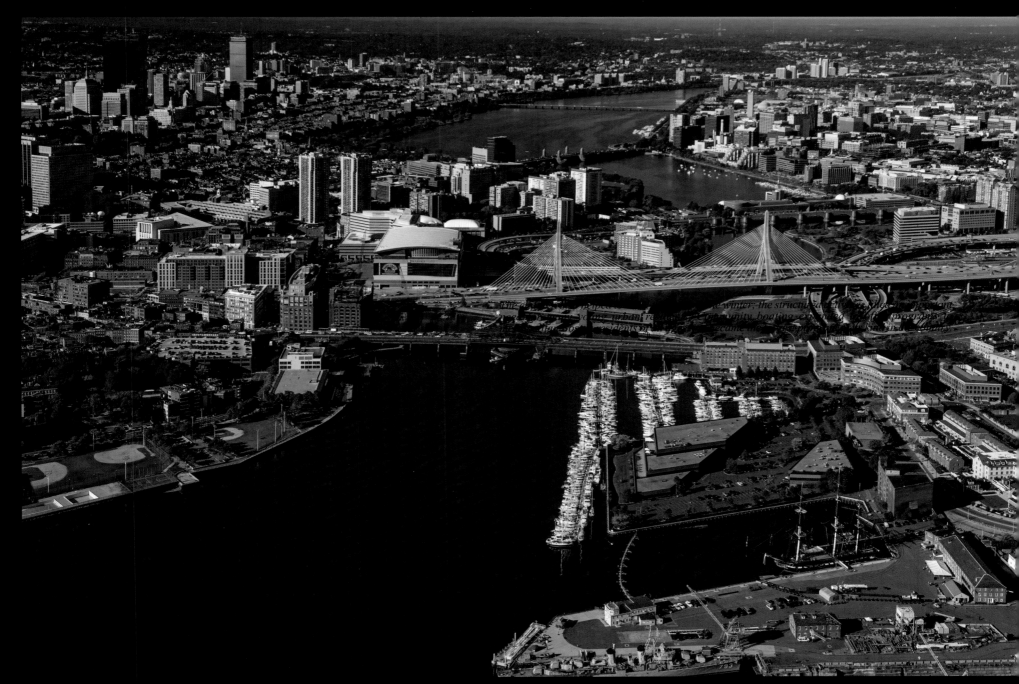

*Aerial view of the Charles River on a perfect September morning. The Charlestown Navy yard is visible at bottom right with the USS* Constitution *alongside her dock awaiting the appreciative throngs of visitors.*

Commonwealth Avenue Mall is a *grande allée* of shade trees forming the central axis of the Back Bay, connecting the Public Garden to the Back Bay Fens. Designed by Arthur Gilman, who was inspired by the new Parisian boulevards, the Mall was set out from 1858 to the 1870s under the Back Bay Development Plan. From its inception, the Mall has been a vital amenity for both residents and visitors.

*The Hotel Vendome fire was the worst firefighting tragedy in Boston history. Nine firefighters died when part of the building collapsed unexpectedly on June 17, 1972. Today a memorial, comprised of a narrow low wall constructed of black granite and draped with a bronze fire fighter's helmet and coat, commemorates the losses. The hotel survives today as a condo complex (center of photo at right). Commonwealth Mall from Exeter to Clarendon, 1890. Bostonian Society (000479)*

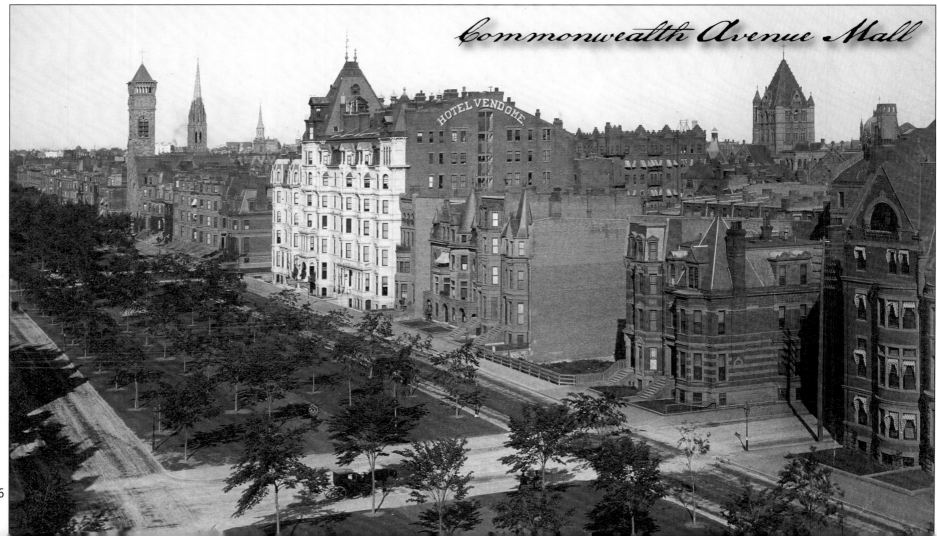

Commonwealth Avenue Mall

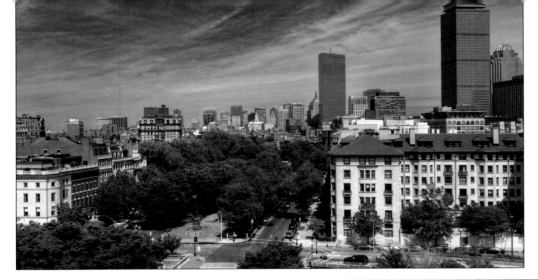

Originally planted with American and European elm trees, the Mall today is a mixture large, hardy shade trees. Even though the sculptures were not part of Gilman's plan for the long, uninterrupted allée of trees, they have become a focal point for people's enjoyment. Today, the trees, sculptures, benches, and walkway are important elements of this historic park that have endured through the decades, but there have been been a few changes to the Back Bay skyline since the turn of the 20th Century.

*Commonwealth Avenue at Charlesgate, c1930 and today. Another of Boston's grand old hotels, the Somerset hosted many famous celebrities including Judy Garland, Ted Williams and in 1966, the Beatles. Like many of these grande dames, the hotel was converted to luxury condominiums in 1984 (inset left).*
*(Bostonian Society (000477)*

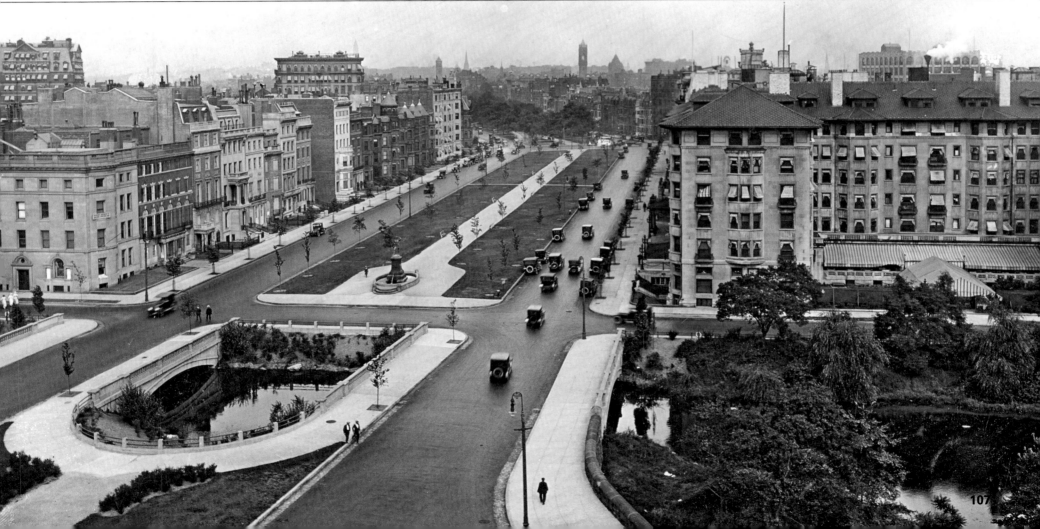

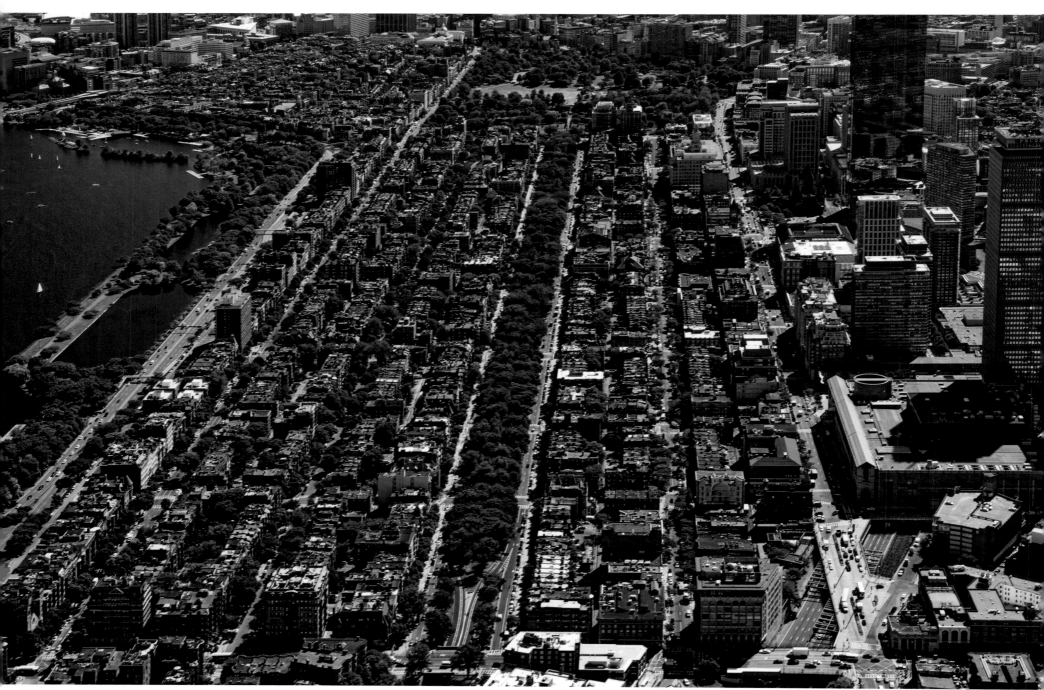

*Aerial view of Commonwealth Avenue looking east from Massachusetts Avenue today.*

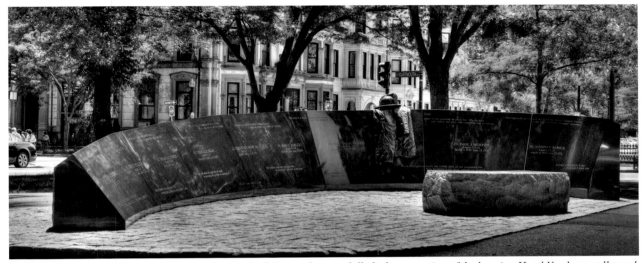

*This granite and bronze memorial honors the nine firefighters who were killed when a section of the burning Hotel Vendome collapsed. in 1972. Its unadorned, modern design focuses our attention on the absence of the deceased men, symbolized by a helmet and a jacket draped over the curved wall (inset right). Built in 1871, the hotel survives today as condominiums and is visible behind the monument.*

*Statue of Samuel Eliot Morison, Rear Admiral, United States Naval Reserve (1887–1976) who was an American historian noted for his works of maritime history that were both authoritative and highly readable. To view this statue in different light see page 212.*

To view this statue in different light see page 212.

## Emerald Necklace

*In addition to the intellectual refuges created in Boston in the late 19th Century, the city created an environmental refuge in this period. Frederick Law Olmsted, the country's foremost landscape architect and designer of New York City's Central Park, came to Boston in 1878 charged with creating an entire urban park system. Olmstead's Emerald Necklace runs from the common, the oldest urban park in the nation, through the Public Garden, along Commonwealth Avenue, through the Fenway to Jamaica Plain, and finally connects with Franklin Park in Roxbury. Olmsted designed his parks to be oases in crowded urban neighborhoods—from the Emerald Necklace, which he planned to connect by way of Columbia Road with South Boston's Marine Park, to East Boston's beautiful Wood Island Park across the harbor.*

Robert Allison

*The Mall's statues will take you on a stroll through the history of the United States. You will pass nine different monuments commemorating events and people that changed the history of both the city of Boston and the nation.*

*Commonwealth Avenue Mall became the spine of the elegant new Back Bay neighborhood and the crucial green link between the Public Garden and Frederick Law Olmsted's park system known as the Emerald Necklace*

**Commonwealth Avenue Mall is the grandest boulevard in North America.**

Winston Churchill

# A Boston Retrospective

**Lawrence S. DiCara**

I HAVE LIVED IN BOSTON ALL MY LIFE AND BEEN ACTIVE BOTH AS AN elected official and a private citizen for most of that time. Nothing was more extraordinary during that period than to observe the changes to the built environment which have resulted from leadership not only at City Hall, but also in the city's business community.

But for Mayor Collis and others in the political leadership in the 1960s who had the courage to tear down the flop houses, tattoo parlors and burlesque establishments in Scollay Square, we could not have built Government Center—a combined effort of the city, state and federal governments. Without regard to whether one appreciates the architecture of that era, a new city hall in Government Center meant that a newly elected Kevin White would frequently stare out his window at a decrepit and all but abandoned Quincy Market and an elevated central artery which separated the heart of the city from its harbor.

In the early 1970s, I led the floor fight that resulted in the authorization of public expenditures and the signing of a long-term lease, which brought about the redevelopment of Quincy Market by the Rouse Company. It was not an easy vote; small shopkeepers lost their livelihood. After we cut the ceremonial ribbon, 150 years to the day after the opening of the original Quincy Market in 1826, tourists from around the world came to Boston. At one point it was suggested that more people visited Quincy Market than Disney World.

But for the millions of tourists and others visiting Quincy Market each year who were confronted by a decaying, rusting, dripping, elevated highway, there may not have been the political will to tear down the central artery and replace it with a highway system which is both modern and efficient AND underground. I was part of the business community's effort (we were then known as the Artery Business Committee) that worked hard to make sure it happened. Having Ted Kennedy and Tip O'Neill as allies without any doubt helped the cause. It was as bold a move as had been the construction of the first subway—in Boston—in 1897. I can tell you from personal experiences that in both situations—Quincy Market and the Central Artery—there were naysayers, and there were losers as a result of these difficult political decisions. Mayor Kevin White and Governor Michael Dukakis deserve enormous credit for having the political courage to rehabilitate Quincy Market and to tear down the Central Artery.

Almost 50 years after the passage of the Government Center Urban Renewal Plan, we have now seen that, since the seaport is easily accessible, unlike when it required walking beneath an unwelcoming 1950s highway, it has become a vibrant part of the city. That Boston Harbor no longer smells, as a result of a massive cleanup, makes waterfront property even more attractive. Therefore, without any doubt, decisions made in the early 1960s have resulted in economic growth 50 years later.

There are many other similar tales. Congressman Joe Moakley brought the federal courthouse to the Seaport and the Silver Line rapid-transit which followed. Governor Sargent and Mayor White said "no" to the Southwest Expressway and installed and created a below-ground transit corridor for the Orange Line, the Massachusetts Bay Transit Authority (MBTA) Commuter Rail lines and for Amtrak, which reinvented Roxbury and Jamaica Plain in the following decades. Norman Leventhal and a cadre of business leaders brought about the demolition of an ancient parking garage and the creation of a glorious, privately managed park at Post Office Square above a subterranean, five-level parking facility.

The scenarios are different but the essential ingredient is enlightened political leadership. Boston's story is a great story and is one of the reasons why, unlike when I was in public life, Boston is no longer spoken of in the same sentence as Detroit and Cleveland and St. Louis—old cities that have never recovered from the economic changes that followed World War II.

Today we truly are a world-class city where all are welcome – the city many of us dreamed about a generation ago. Of all the nation's large cities, Boston has the highest percentage of its population between 18 and 30. We have seen our population increase almost yearly, reversing a decades-long trend. We are no longer the old grey dowager depicted by visitors. We are a center of innovation, as well as of finance, and home to some of the world's greatest educational institutions and hospitals.

*Whale watching boat* Asteria, *of the New England Aquaium, passes between Castle Island Park in South Boston and the Deer Island WastewaterTreatment Plant near Logan Airport.*

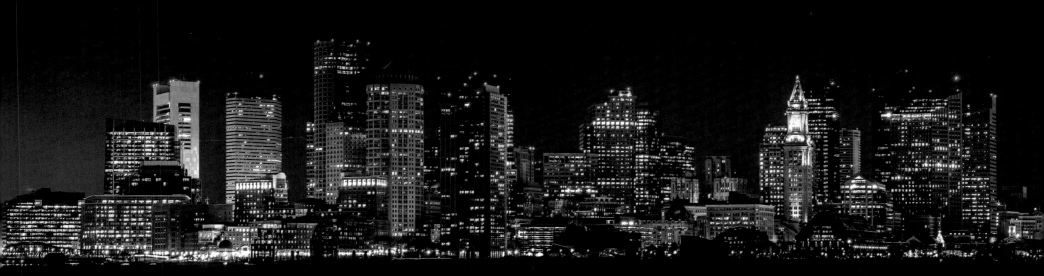

*"I have kept a hand in the extraordinary renaissance of Boston as a lawyer specializing in real estate. In the 30 years that have passed since my last run for public office, the trends that began to emerge in the 1970s continued and grew and became more pronounced. Today Boston is a very different city from the one in which I was born in 1949. The demographic diversity of its citizens from a racial, generational, income and ethnic standpoint could not have been imagined just after the Second World War. The economic development, growth of new business and industry, and sheer wealth now evidenced by elegant pricey restaurants with martini bars and million-dollar condos would not have been guessed at by John B. Hynes when he ran against James Michael Curley in 1949 and began to bring the city into the modern era."*

Lawrence DiCara
*Turmoil and Transition in Boston*
Boston, Hamilton Books, 2013

# Building a New Boston
## Lawrence S. DiCara
From *Turmoil and Transition in Boston*

THE MODERN ERA IN BOSTON EFFECTIVELY BEGAN IN 1949, WHEN CITY Clerk John Hynes defeated James Michael Curley to become Mayor of Boston and with the passage of the American Housing Act of 1949. These two events set the stage for the next decades.

John B. Hynes, the city's low-key and hard-working City Clerk, was acting Mayor in 1947, while Mayor James Michael Curley served a five month sentence at the federal prison in Danbury on a conviction of mail fraud for war profiteering. Instead of thanking Hynes for his loyal service, Mayor Curley insulted Hynes on the very day he returned triumphant to Boston. The mild mannered clerk became so angry that he challenged Curley and beat the 74-year-old political legend in the election of 1949. Even then, Curley was an icon, but by the late 1940s he was becoming a caricature of himself and increasingly seen by Bostonians as a political dinosaur. His defeat signaled that Bostonians were looking for a bit of competence and a mayor with some administrative ability after the war. During his campaign, Hynes promised new housing to replace the ragged tenements and a new parking garage to be located underneath Boston Common. That election launched the modern era in Boston politics.

The city was in terrible fiscal and physical shape after the War. To be honest, it had been in terrible shape since the Great Depression of the 1930s. The old industries were long gone. The seaport was a shadow of its former self. The traditional immigrant ghettos with substandard housing were collapsing from exhaustion and neglect and crowding the downtown commercial core. The tempo of Navy Yard work in Charlestown slowed as demand ebbed with the end of World War II. There had been no major commercial development in decades. The city's tallest building was the Custom House Tower. Its lower floors were authorized during the administration of President Martin Van Buren in 1837. Before the waterfront was filled in, shipswould pull up at the end of the city docks, almost touching the Custom House. In 1947 the old John Hancock Tower, a foot shorter than the Custom House Tower, was built. Those two towers were literally the only discernible landmarks on the city skyline. Downtown Boston, with its narrow curving streets that traced the long ago trail of cow paths, was also being overwhelmed by the automobiles of the commuters coming into the city each day to work. America's love affair with the automobile surged in the 1950s and there was simply no place to park all those cars.

Another major event occurred in 1949 that had lasting impact on the physical face of Boston. That was passage of the *American Housing Act of 1949*, a sweeping landmark bill that was part of Harry Truman's Fair Deal. The legislation expanded construction of public housing as well as the federal role in mortgage insurance. It provided for billions of dollars in federal funds for slum clearance and the construction of 800,000 public housing units, and authorized FHA mortgage insurance. The housing crisis was severe, particularly with veterans returning home after the War. Millions were living in sub-standard housing. The cold-water flats where my father grew up were still there and still completely inadequate. Public housing was considered a big step up from buildings that lacked central heat or hot water. The Congressman from South Boston, John W. McCormack was already U.S. House Majority Leader by 1949. He made sure that new federal housing projects were located in his neighborhood of South Boston, where they provided safe, clean and affordable housing for returning veterans and their growing families. Those projects remain in operation in Southie to this day.

*Originally built as housing for veterans returning from the Second World War, these homes on Newcroft Circle in Matapan have been modified over the years to suit current owners.*

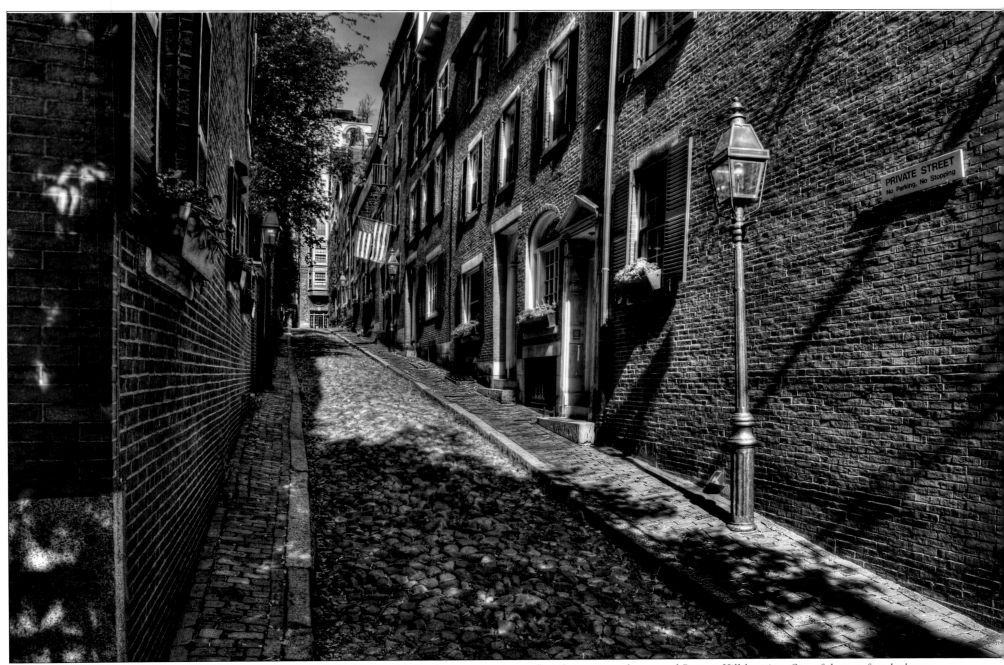

*Tiny Acorn Street, in Beacon Hill, is probably the most-photographed in Boston. It is lined on both sides with beautifully renovated, three- and four-storey townhouses built in 1825. Home* *prices reflect their unique charms and Beacon Hill location. One of them, a four-bedroom, four-bath of 2902 square feet (on a lot of 871 square feet) sold in 2013 for $2,950,000.*

Knocking down dilapidated slum tenements was universally cheered. No one wanted to keep those old firetraps, so entire blocks and streets were eradicated to make way for new housing. The prevailing philosophy of urban renewal was knock down and build up; get rid of the old to make way for the new. It is a pattern seen in nature, where forest fires obliterate acres of old trees only to make way for new growth. It is also part of what Teddy White, a Dorchester native, called the ballet of urban life. Change is constant in urban America, although there are times when it is barely discernible.

This potent combination of slum clearance money and highway construction money after World War II transformed Boston. The Central Artery, named after Mayor John "Honey Fitz" Fitzgerald, the grandfather of President Kennedy, divided city neighborhoods and separated the waterfront from the rest of the city. It was an elevated highway that the passage of time only made more ominous, dangerous and ugly. Homeless people, drunks and criminals haunted its shadow. No law abiding person would venture underneath the elevated at night for fear of becoming a victim of crime.

In 1948, Department of Public Works Commissioner William F. Callahan, later head of the Massachusetts Turnpike Authority [whose son's name is on one of the two old airport tunnels that link downtown Boston to Logan International Airport in East Boston] proposed a 25-year Master Plan for highway construction for the Boston area. The proposal called for a Southwest Corridor Expressway to run along the old railroad right of way from Rte 128 and the Dedham line straight through Roxbury and Jamaica Plain, ending in the South End. The goal was laudatory. Commuters could zip without pause from Dedham and Norwood and other points south right into town for work every day. The six lane expressway would run for 10.3 miles. Of course, the new highway would slice neighborhoods in two and displace thousands of residents. Hyde Park residents were so upset there was talk of seceding from Boston. To make way for the highway, blocks of factories and old residential housing in Roxbury and Jamaica Plain were knocked down.

But this time, the town rebelled. Bostonians had been informed by the experience with the Southeast Expressway and other controversial urban renewal projects. The times had also changed and ordinary people were becoming empowered. In the 1960s, massive public demonstration became a state of art that defined the decade with enormous marches opposing the war in Vietnam and in favor of Civil Rights. This filtered down to the local level of residents opposed to highway construction and airport expansion in Boston.

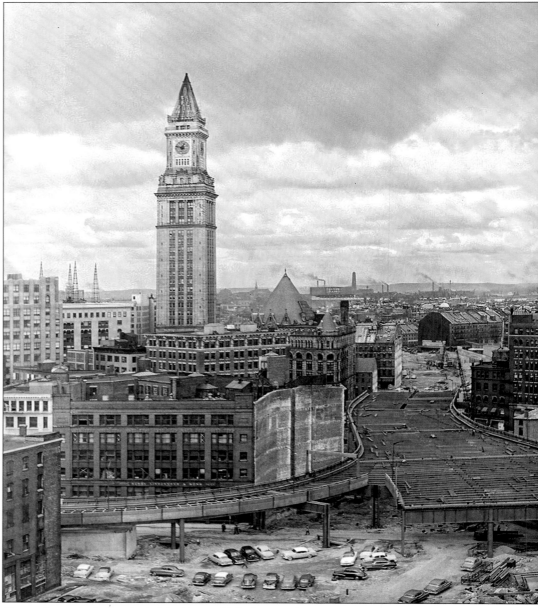

*View to the north along today's John Fitzgerald Surface Road as it is being covered by the new Central Artery in November of 1954. Ironically, this elevated highway occupied the same space as the old elevated streetcar network, torn down in the 1940s. And finally in the 21st Century, the elevated Central Artery is gone, replaced by the beautiful park space of the Rose Fitzgerald Kennedy Greenway (right). (Leslie Jones Photo, Boston Public Library 034787)*

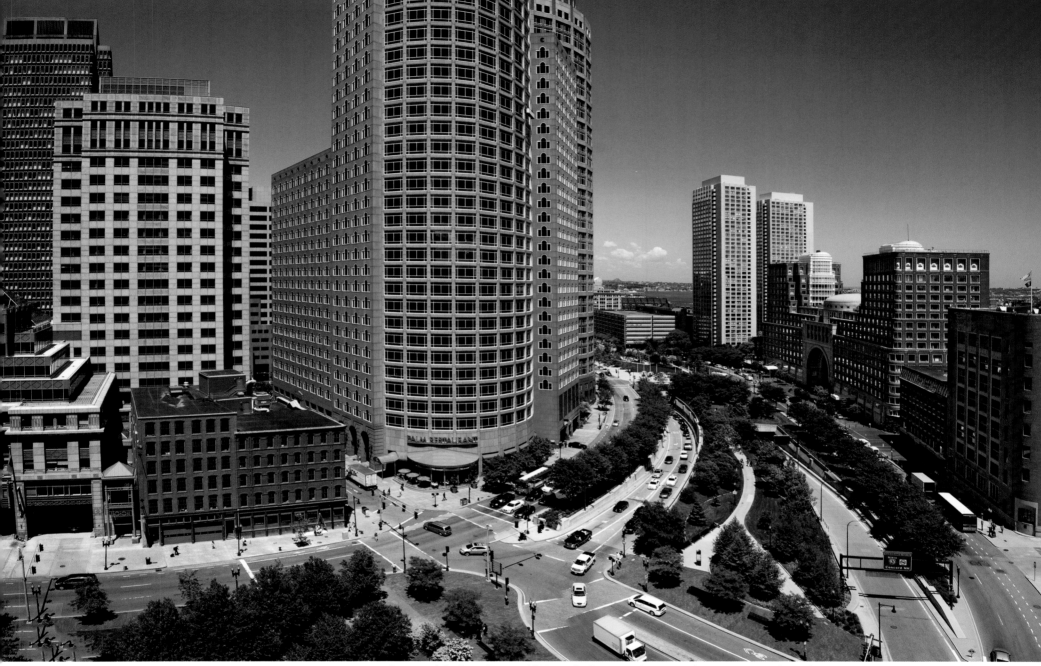

*Section of the Rose Fitzgerald Kennedy Greenway between Atlantic Avenue and Purchase Street (at Oliver). Landmark buildings in the photograph include International Place (center) .and Rowes Wharf and the twin Harbor Towers to the right of Atlantic Avenue. A northbound entrance to the underground portion of I-93 can be seen at bottom right.*

The very good thing about a democracy is that those in charge need to listen to their constituents—or lose power. Governor Frank Sargent, an affable Yankee Republican at a time when Republicans championed the environment, listened. In February of 1970, Governor Sargent ordered a moratorium on the Southwest Expressway. He insisted the project be rethought and redesigned and include mass transit. By 1973, Interstate 95 had been rerouted along Rte. 128, the highway built in a loop around Boston. Resources were re-deployed to build tunnels in place of the existing Elevated Subwayline that created an eyesore down Washington Street. The subway tracks, commuter rail lines and the new Amtrak rail line either went underground or were designed at grade to become a seamless part of the neighborhood, rather than walls breaking up communities. Nine new Orange Line stations eventually opened, including several in Jamaica Plain, sparking a resurgence of that neighborhood, and a 52-acre linear park topped the whole thing with a ribbon of green through the neighborhoods. Governor Sargent's successor, Mike Dukakis, was even more passionate about mass transit. During his time in office, Dukakis rode the Green Line subway to the State House nearly every day from his home in Brookline. Years later after leaving public office, he served on the Amtrak Board of Directors. None of this would have happened had it not been for the united front presented by Sargent, Dukakis and Mayor White. Leadership in this instance was crucial.

The Southwest Corridor experience is vital to understanding what came later, because nothing takes place in a vacuum. In government and politics, as in life, one event or incident triggers another and that triggers another. The chain reaction from either overt action, or sometimes from stubborn inaction, plays out for decades. In this case, the defeat of the Southwest Expressway led the way to the revitalization of entire neighborhoods and the creation of the Boston celebrated and admired today.

Major construction projects take years to complete, because the prep work involved in taking property, clearing away old buildings and repairing the infrastructure can be as time-consuming as the actual new road construction. By the late 1960s, the negative fallout from three major projects had transformed the politics of development. Those projects were: the Southeast Expressway; the elimination of the old West End to make way for Charles River Park; and destruction of seedy Scollay Square to make way for the new Government Center which included state, federal and city public buildings including the new City Hall, a still controversial structure in the brutalist style.

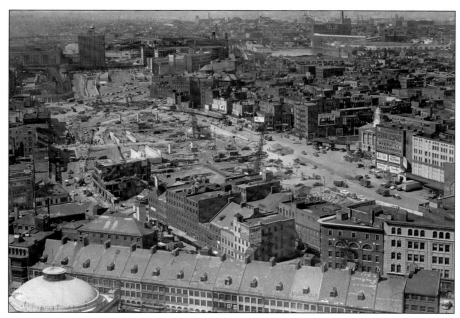

*By 1952 the demolition has already cleared many of the buildings in the center of the photo at left and signs of new highway construction is already in evidence.*
*(Leslie Jones Photo, Boston Public Library 034863)*

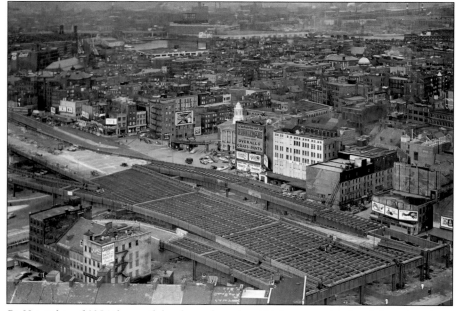

*By November of 1954 the swath has been cleared and highway construction is booming along. In all three photos, portions of Quincy Market and North Market are a good reference to the area of transition that this trio of images reflects. (Leslie Jones Photo, Boston Public Library 034863)*

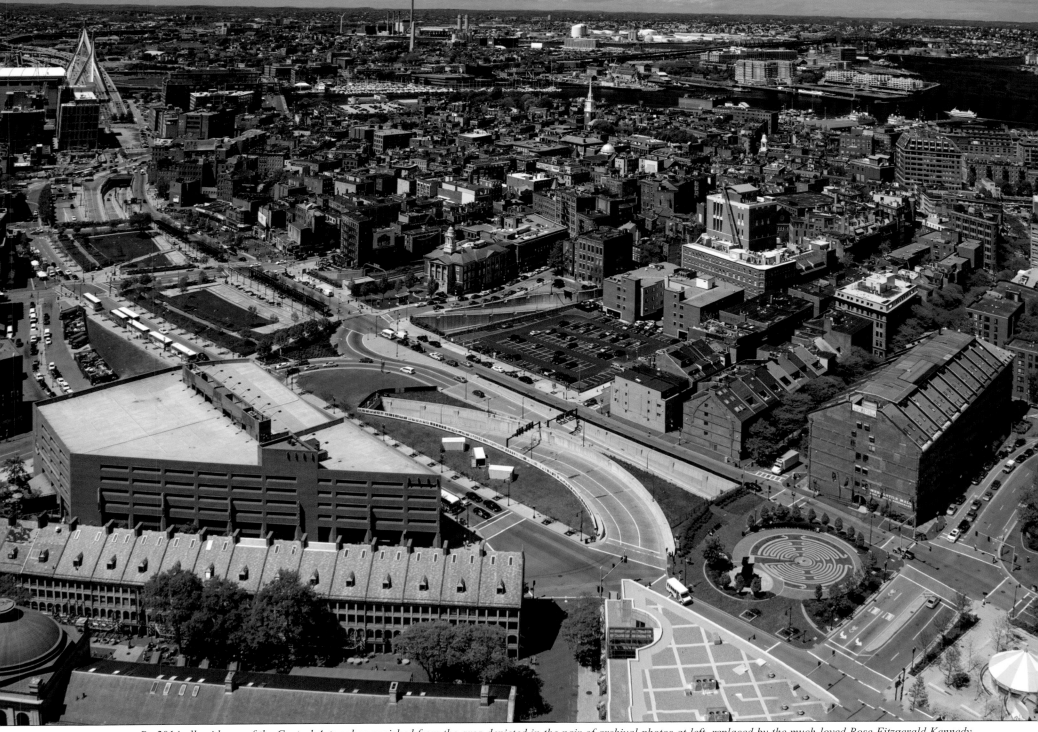

*By 2014 all evidence of the Central Artery has vanished from the area depicted in the pair of archival photos at left, replaced by the much-loved Rose Fitzgerald Kennedy Greenway that artfully covers a myriad of highway and subway traffic bustling along beneath the surface. And the North End is once again open and inviting to people in downtown Boston. This photograph was taken from the observation deck above the clock of the Marriott's Custom House hotel off State Street at McKinley Square.*

The Bicentennial in 1975-1976 set a deadline for completion of the Quincy Market redevelopment, but it was only one of the elements putting pressure on the city to transform the waterfront area. My friend Bill McCue considered renting a one-bedroom apartment at the then brand new Harbor Towers highrise apartments on the waterfront, for what I recall was $135 a month in 1971. (By 1985 rents had jumped past $400 and today they have moved above $2000.) He invited me to take a look at it with him. Harbor Towers (far right in photo opposite), two 40-floor residential towers, built in the same unforgiving brutalist style as the New City Hall, were intended by the Boston Redevelopment Authority (BRA) to be affordable housing and bring some nightlife to the waterfront area. At the time, the project seemed foolhardy. Crossing under the Expressway to get there from City Hall was a dicey trip and the highrise towers seemed completely out of place for Boston. Today the address is highly desirable because of the remarkable water views.

The change in the value of Harbor Towers came about because of the depression of the Central Artery, that gave energy to a tremendous renewal of the old waterfront area now features expensive lofts, condominiums, hotels, a convention center and other amenities that make it a vital part of the city. Once Quincy Market opened to great praise and popularity in 1976, the city became aware that tourists never ventured further because the forbidding overhead highway effectively acted as a barrier to the waterfront.

During Dukakis' administration, the brilliant Transportation Secretary Fred Salvucci, a Brighton native who had earlier worked for Kevin White as manager of the East Boston City Hall, aggressively championed the Central Artery project. Eventually, Speaker Tip O'Neill managed to get the massive federal funds needed to take down that ugly elevated highway and put it underground. When it was first proposed, Barney Frank, ever the quipster, joked that it would be cheaper to raise the city than depress the artery. He was not wrong, but the project has completely transformed the waterfront area. Tourists now can walk easily from downtown to the waterfront and development on the waterfront has made Boston a highly attractive location for national conventions. Motorists can now zip through Boston from points South to points North without any trouble. It is yet another public project that changed the city in a profound way.

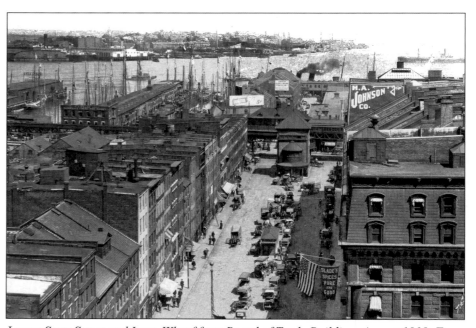

*Lower State Street and Long Wharf from Board of Trade Building, August 1908. Ferry has just arrived and people can be seen waiting to transport passengers. Elevated streetcar lines can also be seen running over Atlantic Avenue. They would be torn down in the early 40s and replaced by the controversial John F. Fitzgerald Expressway, known locally as the Central Artery which was, in turn replaced by the Big Dig (Central Artery/Tunnel) project, completed in 2007.*

*View to the west up State Street from the John F Fitzgerald Surface Road to the Old State House on Congress Street.*

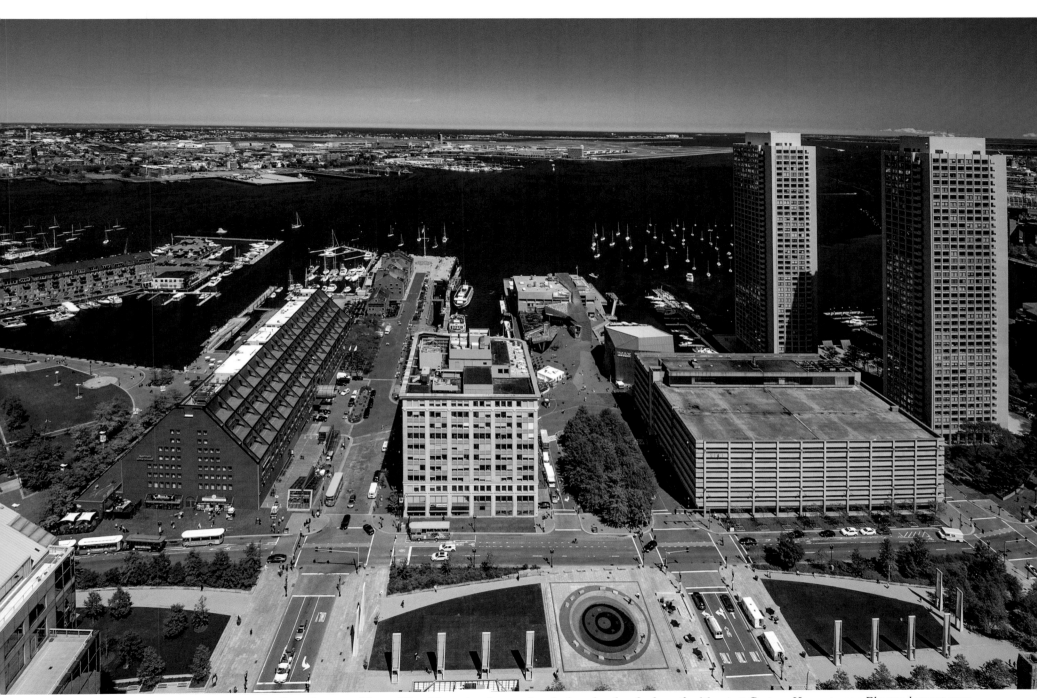

*Lower State Street and Long Wharf from the observation deck under the clock on the Marriott Custom House tower. Elevated street cars and Central Artery are a distant memory as the Greenway now hides Interstate 93 which runs beneath its surface.*

119

The word "organic," like the word "holistic," is frequently used, and often misused, these days. I especially object to any references to the changing demographics or economics of a city as being "organic." After more than 40 years of being in the room, I am convinced that major changes in Boston, or in most any other city, result from the actions of elected officials and the government over which they preside. These changes are rarely the direct result of grassroots and well-meaning bottom-up participatory efforts. Some of the major projects in Boston, Quincy Market, Copley Place, Charlestown Navy Yard, Central Artery/Tunnel, the Norman Leventhal Park at Post Office Square, the South West Corridor, the Silver Line, would not have taken place but for activist government and elected officials who acted with vision—and often not in agreement with the desires of the majority. Statues are not constructed to honor those who waited for the crowd to gather and then ran to the front of the parade.

Few things give me more pleasure than to walk through Norman Leventhal Park in Post Office Square. Norman's nephew, David, was my Harvard classmate, and I became friendly with Norman and his late brother Robert during my first campaign. We have been friends and allies ever since. Norman brought me in as a member of the legal team that helped to bring about the development of the park. It required enormous political courage by the Flynn Administration to break the lease with Frank Sawyer, who operated a very old and ugly parking garage on that site. The city is a far better place because of Norman's vision and the good work of John Connolly, Bart Mitchell, Steve Coyle and their colleagues in the Flynn Administration, who helped create this beautiful park. I am delighted when I spot Norman strolling through his park when he is in town.

Shakespeare wrote that past is prologue, and the knowledge I gained as a city councilor informed my legal career. I have had a seat at the negotiating table for a great many economic development projects in Boston. When I stroll through downtown with one of my daughters, I can point to nearly any building or complex and tell her a personal story of how the building came to be bought, sold, renovated, built or repurposed. It is a very good feeling ... and not just because it makes the three DiCara girls proud of their Dad. Those deals created jobs and homes for all kinds of people, transformed decrepit shells into viable businesses, and generated millions of dollars in tax revenues. More important, those deals brought Boston back as one of the pre-eminent cities in the United States and one of a handful of truly international cities in this country. When fiscal conservatives rail against government spending, I point to these multiple examples of prudent government investment which have brought an incalculable improvement in the economy and quality of life to the city.

*Bill Horsman Photo*

*Post Office Square with its controversial parking garage in the early 1980s (top) and the beautiful Norman Leventhal Park that accupies this space today.*

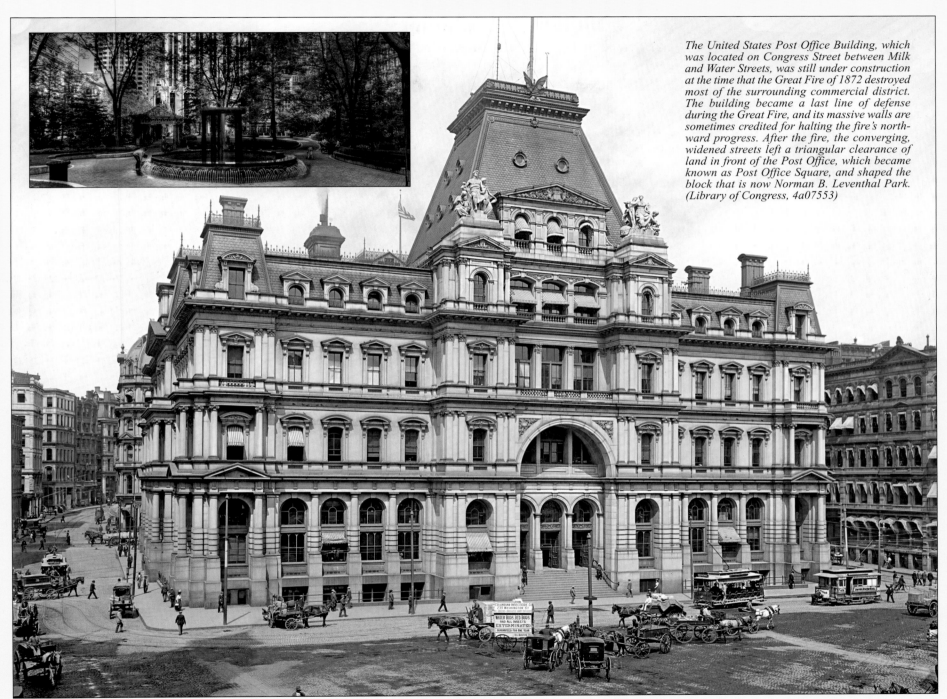

The United States Post Office Building, which was located on Congress Street between Milk and Water Streets, was still under construction at the time that the Great Fire of 1872 destroyed most of the surrounding commercial district. The building became a last line of defense during the Great Fire, and its massive walls are sometimes credited for halting the fire's northward progress. After the fire, the converging, widened streets left a triangular clearance of land in front of the Post Office, which became known as Post Office Square, and shaped the block that is now Norman B. Leventhal Park. (Library of Congress, 4a07553)

The ground cover, shrubs and trees define and reinforce sidewalks, fountains, art, and a restaurant featuring a gamut of building materials—rick, stone, wood, metal and glass (colour inset above).

Alvaro Lima, the talented director of research for the BRA, compiled some data for me at the request of my old friend Peter Meade, the BRA director, which explains Boston's economic development. In the 1980s, more than 13 million square feet of office space were added in Boston, along with more than 5,000 hotel rooms and 40,000 new jobs. The growth continued for the next 20 years. By 2010, Boston had almost doubled the office space available in 1960, added more than 62,000 housing units and more than 100,000 jobs. Most extraordinary of all, Boston's population began to grow again. While there are fewer residents in 2010, a total of 617,594 according to the federal census, than the 697,197 recorded in 1960, the sharp decline of the 1950s, 1960s and 1970s switched to growth in the 1980s. The city kept on growing even though Boston housing and the cost of living became far more expensive. Lifestyles changed radically as everyone who lived through those years knows well. The notion of someone like me, a lawyer who was gainfully employed, living in his parent's attic in the same house as his grandmother with three generations under one roof is no longer even close to the norm. More college-educated people live alone than ever before. Couples have far fewer children. Indeed, there are one-third fewer school age children in Boston now than when busing began. I have friends who live alone in luxurious multi-million dollar homes in a neighborhood that was once a slum teeming with extended families of immigrants living in two-room hovels and sharing a single bathroom with other families. It is truly remarkable that this sort of change could happen in one place in a matter of a century.

The large tenements in the downtown wards, so common before and during World War II, were replaced as a result of the urban renewal plan, which wiped out the West End, and by construction of the Central Artery, which chopped the North End and Chinatown into pieces.

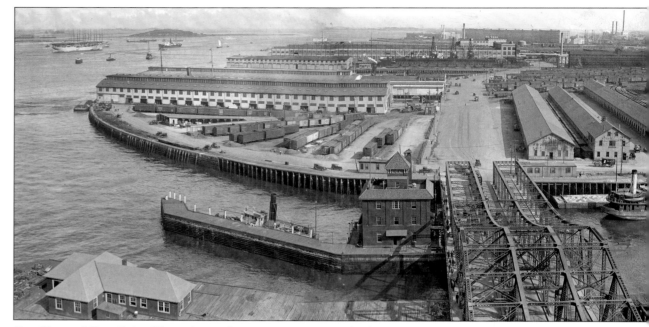

*Fan Pier and Fort Point Channel area from appraisers stores building, c1926. This building today is home to the U.S. Coast Guard First District. (Leslie Jones Photomerge, 016805 and 016807, Boston Public Library) Over the course of the 19th Century, South Boston gradually grew northward over the mud flats separating it from downtown. In the 1860s, a plan for Harbor improvements evolved. It included a proposal to build a seawall at the boundary of today's Fan Pier. The pier's distinctive curve made it an ideal location for a rail yard, hence the name 'Fan Pier'. Radiating out like blades on a fan, several railroad lines ended at the edge of the pier, allowing an efficient transfer point for shipping cargo.*

By 1960, the downtown population was far lower than it had been just decades earlier. In recent years, large residential buildings have been built downtown that house hundreds of condo owners and apartment dwellers under one roof.

One of Boston's greatest strengths is brain power. This has been true since the first Bostonians settled here. Generations of bright young people have come to Boston and Cambridge to earn a higher education at the region's superb colleges and universities. Many of them stay to work, create new businesses, and raise their own families. Boston attracts many because it became a center for high technology, cutting edge health care, financial services and education at the very time those industries became the new engines for prosperity and success in the 21st Century. As the capital city of Massachusetts and the largest city in New England, with a seaport, an international

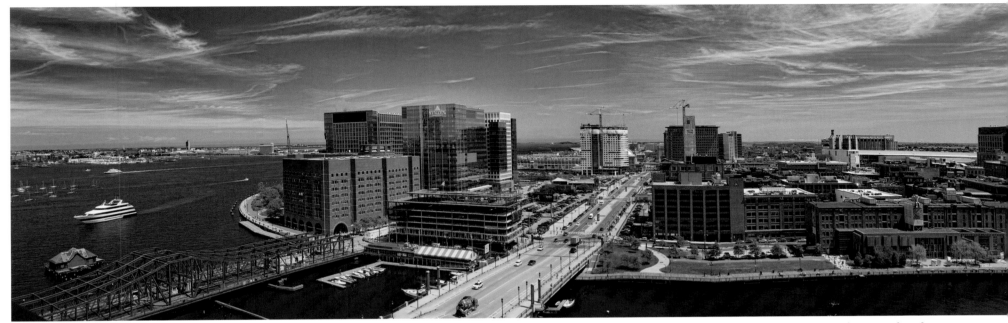

*Boston's Historic Fan Pier Neighborhood including the Seaport District, South Boston Waterfront, John Joseph Moakley Courthouse,World Trade Center, Boston Liberty Wharf, Children's Museum, Institute of Contemporary Art and Boston's Innovation District. Today's South Boston Waterfront district was once entirely underwater, therefore this stretch of Boston is completely man-made, and this area boasts the largest acreage of filled-in land in the city (with the exception of Logan Airport).*

airport and some of the best hospitals and universities in the world, Boston was primed to roar back. Mike Dukakis won the Democratic nomination for President in 1988 in part because of the power and appeal of the "Massachusetts Miracle."

Political leadership also made a difference in the federal resources that came to Boston. The Big Dig that depressed the central artery and built the Ted Williams third harbor tunnel to the airport are the most vivid examples of the difference smart public investment can make in a city. The powerful and long-serving Massachusetts Congressional Delegation always put the interests of Massachusetts and Boston first. Ted Kennedy may be known for his passion for national health insurance and other big issues, but he worked just as hard getting federal money for the city, state, hospitals, schools and community projects. I often wonder if the bright young people who ride the MBTA Silver Line to work in the Seaport each morning would even recognize Joe Moakley if he were sitting next to them

on the car. Joe was singularly responsible for the construction of the Silver Line. He understood that accessible public transportation had to be provided if the seaport were to be developed. The same happened when the South West Corridor money was used to rebuild the Orange Line. That led directly to the gentrification and prosperity of Jamaica Plain. The seaport is what it is today because modestly compensated administrative assistants can use their "Charlie" cards on public transit to get to and from their jobs in the fancy offices overlooking the harbor.

Political leadership in the 1970s and decisions to invest public money and clout behind certain economic development projects laid the foundation for today's prosperity. Had Kevin White not sold all those downtown parking garages and pushed for the revitalization of the Faneuil Hall Marketplace and the Charlestown Navy Yard and development of all the "Places" that dot downtown—Lafayette Place, Copley Place, International Place—Boston would not look or feel the way it does today.

When white flight accelerated after Judge Garrity's busing order in the 1970s, the vacuum created by the loss of large white families was filled by new Bostonians who were better educated, often single and childless, sometimes gay, and invariably richer. Those folks have changed the city. While the overall city population is lower in 2010 than it was 50 years earlier, the population of certain areas, particularly downtown Boston and the South End has skyrocketed. These new residents raised the average income of the city substantially and transformed the Waterfront and other dreary tenement districts into luxurious and high-end communities. If you ride the Green Line at 10 p.m., it feels like 10 a.m. with an amazing number of young, multi-ethnic riders. Indeed, riding the MBTA or walking down Boston streets often has the flavor of a mini-New York City on a more comfortable and manageable scale. It is an exciting change.

It is important to acknowledge that there are many elements and people who made up the "old" Boston who are still living in the neighborhoods. And this is a good thing. The stalwarts who stayed in place are, however, literally dying off. Every month Dolan's and Gormley's bury a few more members of the Greatest Generation. The elderly widows still living in West Roxbury and South Boston and Roslindale are living in houses that are now worth appreciably more than they were in the 1970s, when depressed housing values limited the options for the families who did move out of the city and pointed them to places like Brockton and Randolph, where houses were cheap and public services minimal.

Sadly, many of the "old" Bostonians live at an economic disadvantage in a society where brains count for far more than the brawn of the past. In Jamaica Plain, where we are raising our family, you can see that the delta between the haves and have-nots has increased quite dramatically in recent years. But it has changed over time. When I was driven to Boston Latin School as a boy, the journey went from Dorchester through what was then a Jewish ghetto in Mattapan, past cemeteries and open space, and then, after crossing that enormous bridge over Forest Hills onto the Arborway and the Jamaicaway. I thought those houses on the Jamaicaway in Jamaica Plain,

including the famous mansion with the shamrock shutters installed by James Michael Curley, belonged to the richest people in the world. Indeed, Jamaica Plain had once been the home of the gentry. After a period of decline, JP is now a neighborhood of affluence again. The differences between new and old are stark: we own; they rent. and then, after crossing that enormous bridge over Forest Hills onto the Arborway and the Jamaicaway. I thought those houses on the Jamaicaway in Jamaica Plain, including the famous mansion with the shamrock shutters installed by James Michael Curley, belonged to the richest people in the world. Indeed, Jamaica Plain had once been the home of the gentry. After a period of decline, JP is now a neighborhood of affluence again. The differences between new and old are stark: we own; they rent. We go to college; they do not. We go out to eat at restaurants all the time; they do not. They have lots of kids; we do not. Twenty years ago, there were four Catholic churches in Jamaica Plain; now there are two. There were four Catholic schools; now there are none. There is a perception gap between the haves and have-nots living in the same community that is almost comical. I call it "the aluminum siding conundrum." There are people, like my own parents, who worked hard to save enough money to put aluminum siding on their homes. Then there are people, like me and Teresa, who worked hard to save money to take the siding off our house on Burroughs Street and restore it to its original Victorian splendor.

Boston also increasingly became, once again, a favored spot for immigrants. The city has always been a welcoming place for newcomers. The BRA estimated that more than 151,000 foreign-born residents were living in Boston in 2008 and half of them emigrated during the previous decade. The diversity is extraordinary. Foreign-born residents add up to one fourth of the city population and come from 100 different countries. A total of 29 per cent came from the Caribbean; 24 per cent from Asia; 17 per cent from Europe; 10 per cent from Central America; 9 per cent from South America, and 9 per cent from Africa.

The newcomers behave just like the Irish and Italian and Jewish immigrants of the 19th Century; they congregate near their countrymen, work hard, and strive to create opportunity for their own children. East Boston, which was Italian-American when I ran for the City Council in 1971, is now predominantly Latino; Roslindale, which was always Irish and then Greek, now has Latinos and Haitians. Allston-Brighton is Chinese, Russian and Brazilian, and Dorchester is loaded with Haitians and Vietnamese. Dorchester Avenue has turned into one big pho shop! In Hyde Park, the predominant ethnicity of foreign born residents is Latino and Haitian.

In the public schools, almost half of the students either spoke a language other than English or another language in addition to English. When the local newspapers print photographs of the valedictorians from Boston public schools, a number of the best and brightest were born in a foreign country. I am happy to report that the attitude towards bilingual education has changed since my childhood, so these children are not forced to abandon their first language, as I was.

*Boston Latin High School, Class of 1893 (A. H. Folsom, Boston Public Llibrary 005161)*

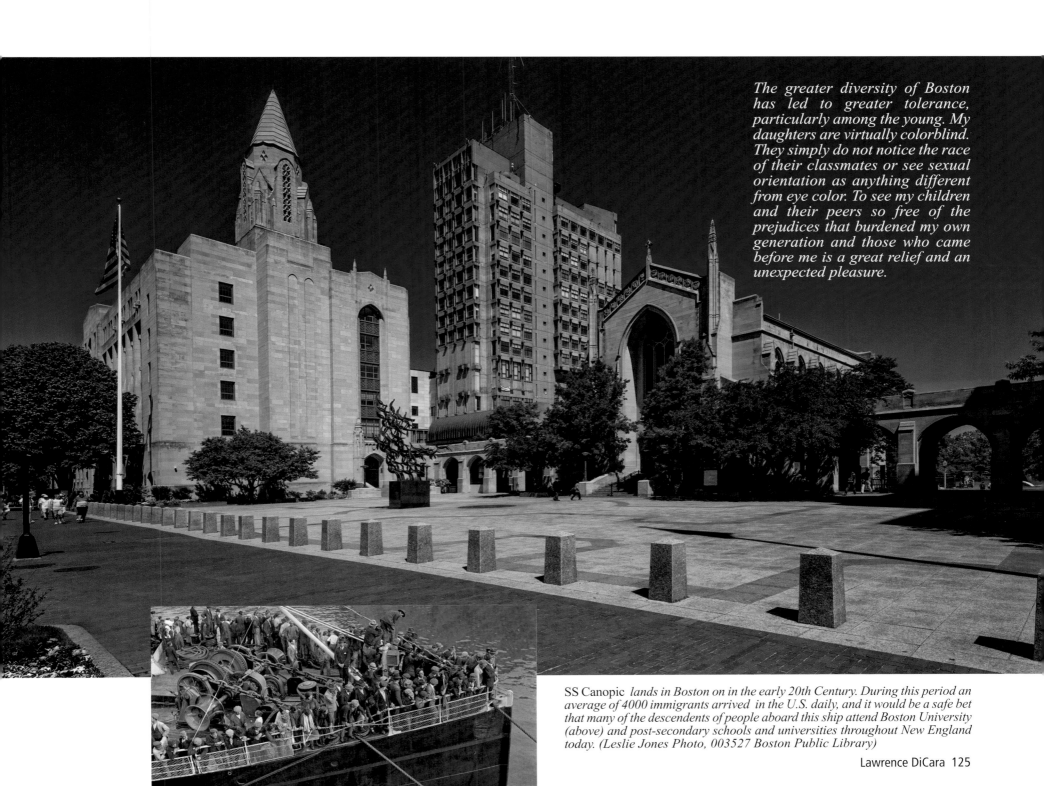

*The greater diversity of Boston has led to greater tolerance, particularly among the young. My daughters are virtually colorblind. They simply do not notice the race of their classmates or see sexual orientation as anything different from eye color. To see my children and their peers so free of the prejudices that burdened my own generation and those who came before me is a great relief and an unexpected pleasure.*

*SS Canopic lands in Boston on in the early 20th Century. During this period an average of 4000 immigrants arrived in the U.S. daily, and it would be a safe bet that many of the descendents of people aboard this ship attend Boston University (above) and post-secondary schools and universities throughout New England today. (Leslie Jones Photo, 003527 Boston Public Library)*

Lawrence DiCara 125

I AM COMPLETING THIS MEMOIR: 30 YEARS SINCE I RAN FOR MAYOR AND 35 years since I served as President of the Boston City Council. Today Boston is a dramatically different city, and America is a dramatically different country. I keep a well-thumbed version of Edwin O'Connor's classic novel, *The Last Hurrah* (1956), on a shelf at home in Jamaica Plain. In that book, Mayor Skeffington, a fictional character widely believed to be modelled on former Boston Mayor James Curley, speaks of the possible changes in his city: "For some time, something new has been on the horizon: namely, the Italians. But when they take over, that will be an entirely different story, and I, for one, won't be around to see it. I don't imagine," he said thoughtfully, "that it'll be too much fun anyway." Well, Boston had an Italian Mayor for 20 years, and the City did just fine. Believe it or not, when I ran in 1983, intelligent people still questioned whether a candidate of Italian descent could ever be elected Mayor of Boston.

In the same era, America has elected a black President, one raised, in part, outside the boundaries of the United States. His father was a student from Kenya. Our Governor is also a man of color, raised on the south side of Chicago in the most difficult of circumstances. The Republican candidate for President this past November, an old friend from Massachusetts, was a Mormon. The very fact that the 2012 election saw a black man and a Mormon contest for the Presidency is an extraordinary commentary about the United States, and one which none of us likely could have predicted 30 years ago. In 2013, Boston would elect a new Mayor. I predicted that almost anyone, of almost any background, could be a viable candidate and that there was no certainty as to what the next Mayor would look like, or where his grandparents may have lived. Boston elected Marty Walsh, a state legislator from Dorchester, who was also an active union member and whose parents had emigrated from Ireland. Throughout the campaign, Marty was very open about the challenges he had faced growing up and received extraordinary support from the recovery community.

It is always dangerous to predict the future but the demographic trends in the city have exposed a political conundrum that will unquestionably affect the future of the city. While Boston is now "majority minority" in terms of population, the power in elections still lies with white voters. That is because many of the newcomers to Boston are immigrants who are not citizens and cannot vote. The path to citizenship still is sadly too long and winding for those who come from foreign lands in search of a better life. And, as I noted in my book, the white residents of Boston today are more likely to be affluent, single, liberal, and perhaps gay, with no children or few children. Children under the age of 18 make up just 17 per cent of the city population, half the percentage of 1970. The average household size has decreased by nearly 25 per cent in the last 50 years. The high cost of housing is discouraging to families with children who find more economical homes in the suburbs. A generation ago, an O'Hara from St. Gregory's Parish marrying a Sullivan from St. Brendan's was considered a ``mixed'' marriage. Today, a young educated white resident could live in a precinct where whites, blacks, Hispanics and Asians make up equal portions of the overall population and may be married to someone of the same gender.

However, these newcomers feel disconnected from municipal government. They vote for Governor, Senator and President, but rarely for Mayor. This is why precincts with elderly housing developments have a disproportionate impact on city elections. Those seniors rarely miss voting in any election. The residents young enough to be their grandchildren who grew up someplace else do not engage. Less than half of those who voted in the 2012 presidential election are likely to vote in the next mayoral election. I do not have a crystal ball but, it is clear that the successful mayoral candidate of the future may be the one who can excite educated Bostonians in their 20s and 30s, the voters who turned out in huge numbers for Senate candidate Elizabeth Warren and Presidential candidate Barack Obama.

Another important question, as we look towards the future of the City, is will the history of the City be repeated? Will the imperial mayoralty of Kevin White, which brought about so much of the Boston we know today, return? Will we revert to the populist impulse, which helped to elect Ray Flynn as the anti-White 30 years ago? Or will we opt for another "urban mechanic", such as Tom Menino who served an unprecedented five terms and remained popular with voters even as he decided to retire from public life. Public opinion polls in 2013 suggested voters still liked him but were ready for a change at the top. It's anyone's guess how that dynamic will play out. Many years ago, Walter Lippmann wrote, "The law of politics is the law of the pendulum." What he did not write, and what none of us can ever know, is how far the pendulum will swing in one direction and how quickly it might swing back.

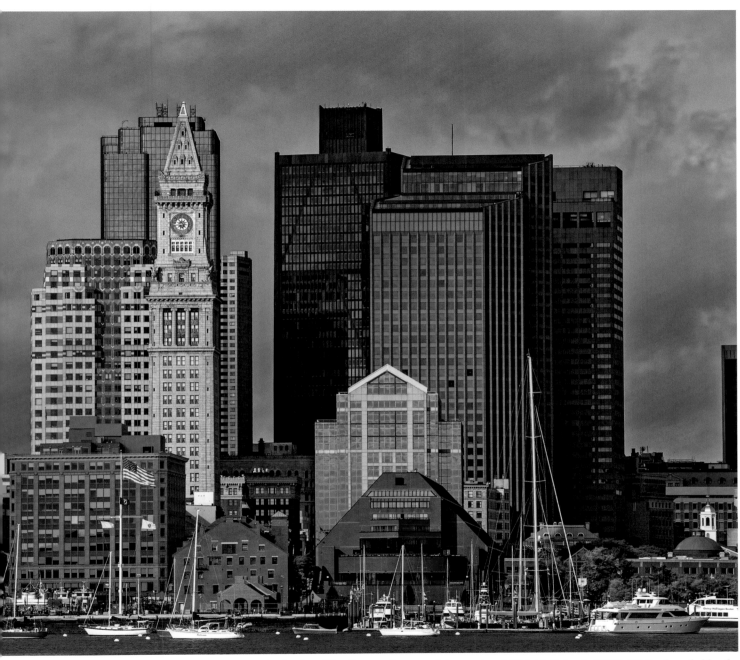

TURMOIL
AND TRANSITION
IN BOSTON

A POLITICAL MEMOIR FROM THE BUSING ERA

LAWRENCE S. DiCARA
WITH CHRIS BLACK

This section by Larry DiCara is excerpted from his book, *Turmoil and Transition in Boston, A Political Memoir from the Busing Era* (Hamilton Books, 2013). In this beautifully written account, Larry DiCara and his co-author Chris Black sweep us away on a journey through a generation of Boston's history providing us an intimate portrait of a city in transition from its Brahmin-Irish-Italian past in the 1950s to what is today a wonderfully diverse, booming metropolis. From page one to the last sentence, you will be mesmerized by DiCara's personal story of this tumultuous period in the life of one of America's great cities.

*View of the Long Wharf area from out in the harbor. The Custom Tower celebrates her 100th birthday in 2015. While dwarfed by the glass towers that surround her, she still outshines them all with her classic architectural elegance and charm.*

# Immigration

**Robert J. Allison**
From *A Short History of Boston*

WITH NO POSSIBILITY OF ENTERING BOSTON'S FINANCIAL WORLD AND NO protection against unemployment or on-the-job injury, many immigrants turned to politics. Joining the political process increased the possibility of a job with the city or a connection to social services, and thus offered the best avenue for improvement.

From his base at the Hendricks Club in the West End, near today's TD Garden (formerly Fleet Center and Boston Garden), Martin Lomasney became one of the most powerful men in Boston. Lomasney hated to be called a political boss; he was pleased when a journalist nicknamed him "the Mahatma" instead. A quiet man most comfortable working behind the scenes, for most of his political life he was more powerful than any mayor, serving on Boston's Board of Aldermen and Common Council and in the State Legislature, State Senate, and 1920 State Constitutional Convention. He promoted the building of North Station and Boston garden and lowered the price of natural gas for city residents. When a disgruntled city contracter tried to assassinate Lomasney in City Hall, the Mahatma quipped, "The people didn't think an awful lot of aldermen, but they didn't think we ought to be shot without a fair trial."

In East Boston, thousands of immigrants had debarked from the Cunard Steamship Line and climbed the golden stairs from the dock onto Webster Street. As in the West End, politics and hard work became the way to a new life. Two Irish immigrants, Patrick and Brigid Kennedy, met at sea and married shortly after arriving. Both died shortly after reaching their promised land, but not before they had a son, Patrick Joseph Kennedy, who grew up to own a tavern in East Boston. From this base Patrick became a political leader. Kennedy's son, Joseph P. Kennedy, graduated from Boston Latin and Harvard College, and in 1914 married the daughter of another neighborhood political boss, former Boston mayor John Fitzgerald, known as "Honey Fitz." Fitzgerald's parents, like Kennedy's, came from Ireland during the migration of the 1840s. Like Kennedy in East Boston, Fitzgerald began his political career in the North End by opening a tavern. He was elected to Congress in 1894, the year after his daughter Rose was baptized in St. Stephen's Church. Political power was passing from the hands of the Brahmins to the hands of immigrants.

Would the new Bostonians preserve the legacy of the Yankees? The answer came in 1895 when Congressman Fitzgerald, who as a boy had once sold newspapers on the corner of Beacon and Park Streets, became interested in having the USS *Constitution* return to Boston for the centennial of her launch. Using his political power to get money from Congress to restore *Constitution*, he also enlisted the support of Charles Francis Adams, president of the Massachusetts Historical Society. These two men—the grandson of John Quincy Adams and the grandfather of John Fitzgerald Kennedy—worked together to bring the ship back to Boston.

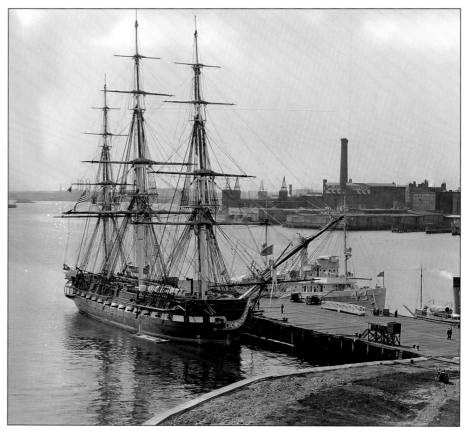

USS Constitution *on display at the Charlestown Navy yard, 1932 (Leslie Jones photo, Boston Public Library 007982)*

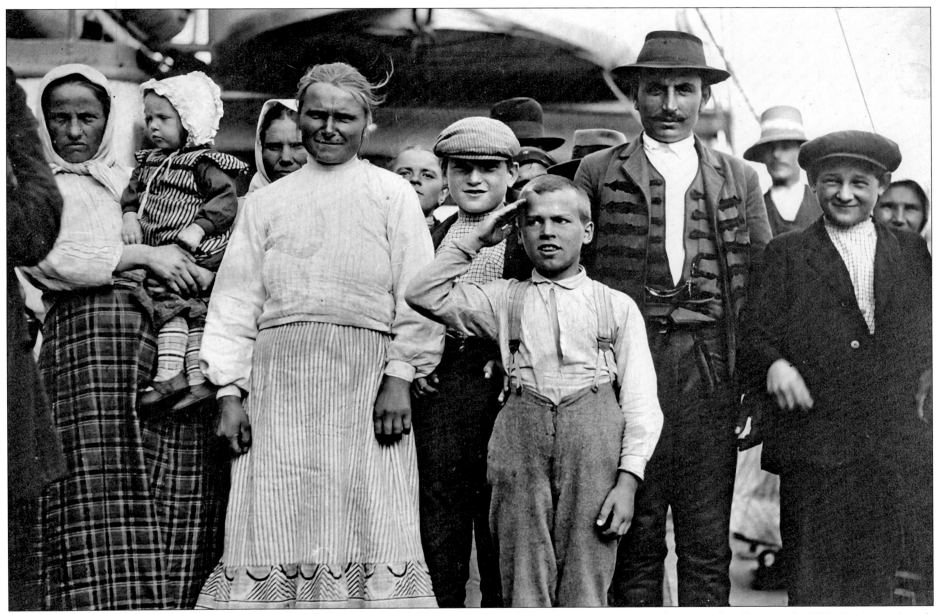

*An immigrant boy salutes his new country on a ship approaching Boston in the 1890s. Immigrants brought much with them but also embraced what they found in the New World. (Boston Public Library 076673)*

*It was decided that the controversial but celebrated mayor needed two statues, so both Curleys now hold court across from Faneuil Hall. One is the bold "Young Jim" striding forward to take on the Brahmin elite; the other, an older man, sits on a park bench reflecting on his life and legacy. The elder Curley's position on one end of his bench naturally invites people to sit down for a visit. Here we see Boston Police Officer Garvin McHale enjoying the illustrious man's company.*

James Michael Curley stormed the Boston political world. Born in the Irish slums of Roxbury, Curley formed a political organization that took on all—the Brahmin bankers of State Street and the other urban ward bosses like Lomasney, whom he dismissed as "chowderheads." For half a century Curley dominated Boston politics, elected to the Board of Aldermen in 1903 when he was in jail and winning his last term as mayor in 1945 when he was under federal indictment. But Curley was not a petty criminal. For many Bostonians, this self-described "mayor of the poor," who has gone to jail for helping a friend, was a hero. They chose him four times to be mayor, twice sent him to Congress, and once elected him Governor of Massachusetts.

As mayor, Curley centralized patronage in his office, making the ward bosses less important. Curley's administrations delivered services to the neighborhoods, building parks, bath houses, and schools; improving roads; and building a tunnel under Boston Harbor. But Curley joyfully alienated business leaders, and his administrations could not solve the problems of the Depression or of Boston's long economic decline.

*Curley reportedly explained that his shamrocks announced to one and all that the Irish were coming to Jamaica Plain.*

Defeated for reelection by city clerk John B. Hynes in 1949, Curley retired to his mansion overlooking Jamaica Pond. He tweaked his Yankee neighbors by having shamrocks cut into the shutters, while they asked how he could afford such a mansion on the mayor's salary. Curley ran three more times, unsuccessfully, for mayor. More than two decades after his death, the city finally decided to honor its most famous mayor with a statue. But Curley's legacy was complicated—was he the bold Robin Hood challenging the status quo or the corrupt demagogue who bankrupted the city?—that he needed two statues. Both Curleys now hold court across from Faneuil Hall. One is the bold "Young Jim" striding forward to take on the Brahmin elite; the other, an older man, sits on a park bench reflecting on his life and legacy. Novelist Edwin O'Connor immortalized Curley and his political world in the novel *The Last Hurrah,* which so touched the retired mayor that Curley wrote his own memoir, which he called *I'd Do It Again.*

*Certainly one of Boston's most colorfull mayors, James Michael Curley had this 21-room, neo-Georgian mansion built for himself in upscale Jamaica Plain during his first term in 1915.*

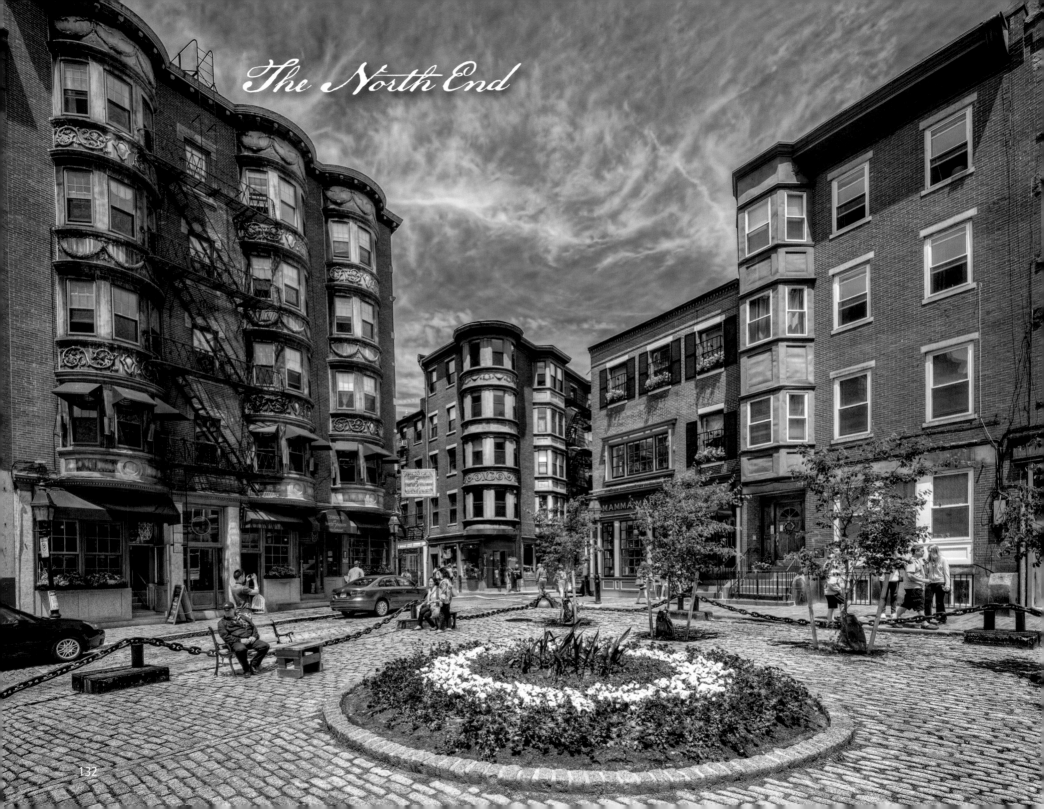

The North End

THE ITALIAN MASSES THAT FLOWED INTO THE NORTH END ON THE heels of the departing Irish, and at the apex of the Jewish settlement, found a neighborhood in dire physical condition; a run down, overcrowded slum of deteriorating tenement buildings. The Genoese were followed by the Campanians, who were followed by the Sicilians, the Avellinese, the Neopolitans, and the Abruzzesians. Each group settled in their own area within the North End, creating their own enclave within the greater North End neighborhood. By 1900, the Italian population in the North End was 14,000. Over the next 20 years it would more than double to 37,000 and at its peak, in 1930, 44,000 Italians were packed into an area less than one square mile in size." The neighborhood had become 99.9% Italian and was said to be more densely populated than Calcutta.

The first arrivals, the Genoese, made their living as fruit and vegetable vendors and as pedlars selling wine, cheese, and olive oil from North End storefronts and from stalls along the open-air Haymarket in Dock Square. Access to these North End markets and shops was greatly facilitated by the construction of North Station (in 1893) and by the Metropolitan and West End Street Railway companies. In the meantime, the Sicilian immigrants, who had colonized the length of North Street along the harbor by 1925, found employment in the booming commercial fishing fleets. Others were able to find work in the construction trades—as masons, metalworkers, carpenters, and general laborers—with Italian contractors. But to no small degree, it was the neighborhood itself that offered many job opportunities—providing for the feeding, clothing, servicing and ministering to the masses of fellow immigrants and *paesani* who filled the neighborhood to overflowing.

*(left) Achingly beautiful North Square is the perfect setting to enjoy a cup of fresh roasted coffee with a canolli from a North End bakery.*

*Haymarket, Boston's centuries-old open air market, offers fresh produce in the historic heart of the city, just steps away from Faneuil Hall Marketplace. Perhaps two thirds of the Haymarket vendors are from Boston's Italian North End. Relative newcomers from Asia, North Africa, and the Caribbean run others, expanding the rich variety of produce that you'll find here. Note that it is only open on Fridays and Saturdays throughout the year.*

*With over fifty years of baking expertise on Hanover Street, Mike's specializes in using only the top notch, freshest ingredients for their Italian-American pastries.*

*Family-owned and operated since 1932, Bova's on Salem Street has made all their homemade products fresh daily with only the healthiest ingredients.*

133

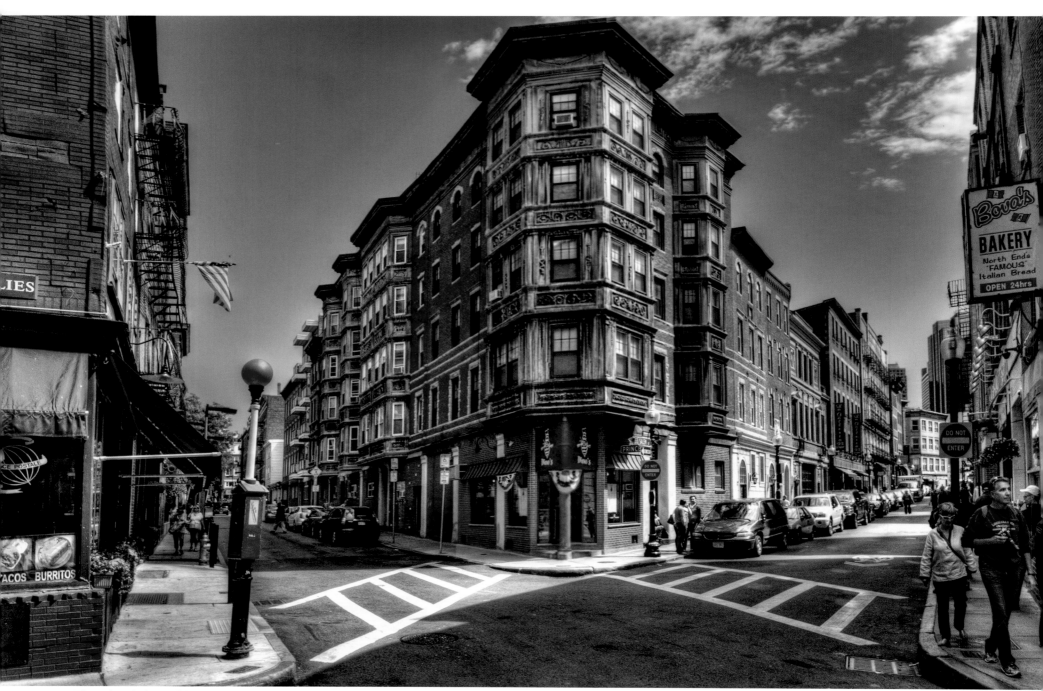

*The achingly beautiful corner of Prince and Salem streets can rise to the level of a religious experience when a cannoli from Bova's Bakery is brought into the North End magic.*

*Al Dente Restaurant on Salem Street is a favourite with locals and you will need a reservation any night.*

*Couple selling vegetables at the corner of Prince and Salen streets, 1935. Note that the large photograph at left was taken from this corner. (Leslie Jones Photo, Boston Public Library 003527)*

*Since 1926, Regina's delicious brick oven pizza has been inspired by the love of good food and the special pride of three generations of the Polcari Family.*

*Father waiting for his son and daughter to organize their funds to complete the purchase of store-made* Lemon Slush, *a Polcari's special that has been sold from its 100-year-old barrel since day one.*

## TIMES HAVE CHANGED IN BOSTON'S NORTH END

Today the neighborhood retains much of its "Old World" feel. Tourism provides an economic underpinning. However, many neighborhood grocery stores, fruit vendors, butcher shops, bakeries, shoe stores, clothiers and cobblers have simply disappeared to be replaced by restaurants. With a population barely one quarter of its 44,000 peak in 1930, fewer services are required to sustain the community. Ten of its 12 schools have been subdivided and converted to condominium apartments. Churches and parishe halls have been auctioned off to the highest bidder.

Yet today, Italian-Americans still comprise about 30% of the resident population. Italian remains the *lingua franca* throughout the North End. It is one of the most vibrant and thriving neighborhoods of its kind. Old customs and traditions die hard (if ever at all). For despite the fact that 50 individual religious societies once existed in the North End—only 12 remain today—these societies with their religious Feasts and Processions, remain an integral part of North End neighborhood life and culture, drawing large summertime crowds. After years of construction and the building of tunnels and removal of the elevated Expressway, with new open park spaces, the North End has finally, physically rejoined downtown Boston—for the first time in over two centuries.

*Guild Nichols,* northendboston.com

ANTHONY POLCARI STARTED POLCARI'S COFFEE IN 1932. The coffee shop had been a dream of his since he came over from Italy at the age of 20. Working as a pocket-maker at a local tailor's shop, Mr. Polcari saved up to open his own coffee store on Salem Street in 1932. Polcari's Coffee was a family-owned business. Mr. Polcari's wife Rose and children, Ralph, Anthony and Marie all worked in the store, helping their father achieve his dream. Ralph soon took over the store from his father. Ralph did not have a son or daughter to work in the business with him. For a guy who didn't have any children, Ralph created a family. Polcari's Coffee was his family and livelihood.

Polcari's Coffee still stands on the corner of Salem and Parmenter streets. The grocery store has retained its old-world flavor, which keeps it on North End tourist routes and stops. It provides fresh, rare spices to the chefs of the North End, as well as deli meats, candy, pasta, nuts, tea and of course, coffee. With a plethora of rare coffees including Blue Mountain and Hawaiian Kona, old favorites are still the most popular. They include Mr. Polcari's house blend (a mixture of dark and light roast) and the Italian roast (an espresso).

The current owner considers himself "a museum-keeper, committed to running this business with Mr. Polcari, Ralph and the rest of their family, in mind." He goes on to explain; "I feel so blessed to have known Ralph and carry on this business in his name. I'm also proud of Boston's North End and of my Italian heritage".

*Bobby Eustace*, Owner, Polcari's Coffee
polcariscoffee.com

*Nicki Labonte has the weekend duty at the well worn counter in Polcari's Coffee.*

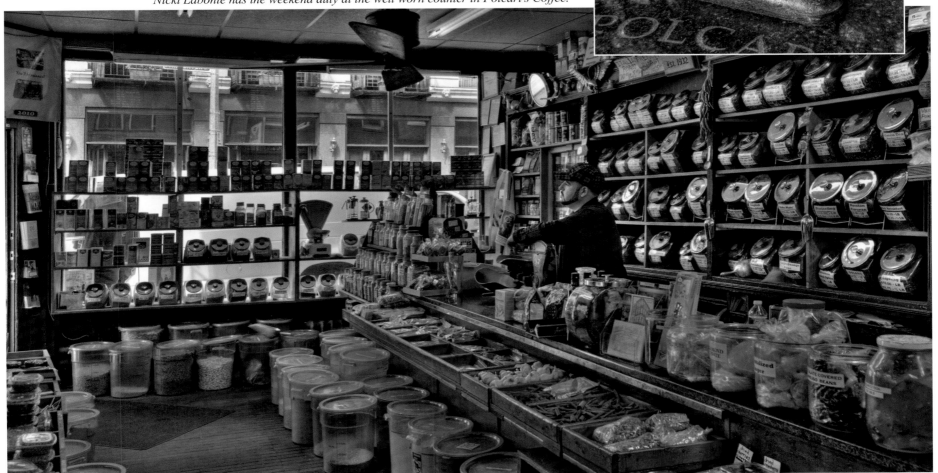

*That scale on the counter in front of Nicki was made in Dayton, Ohio in 1906 and was on this spot on opening day in 1932. It is estimated to have weighed over 2 million pounds and continues in front-line service to this day.*

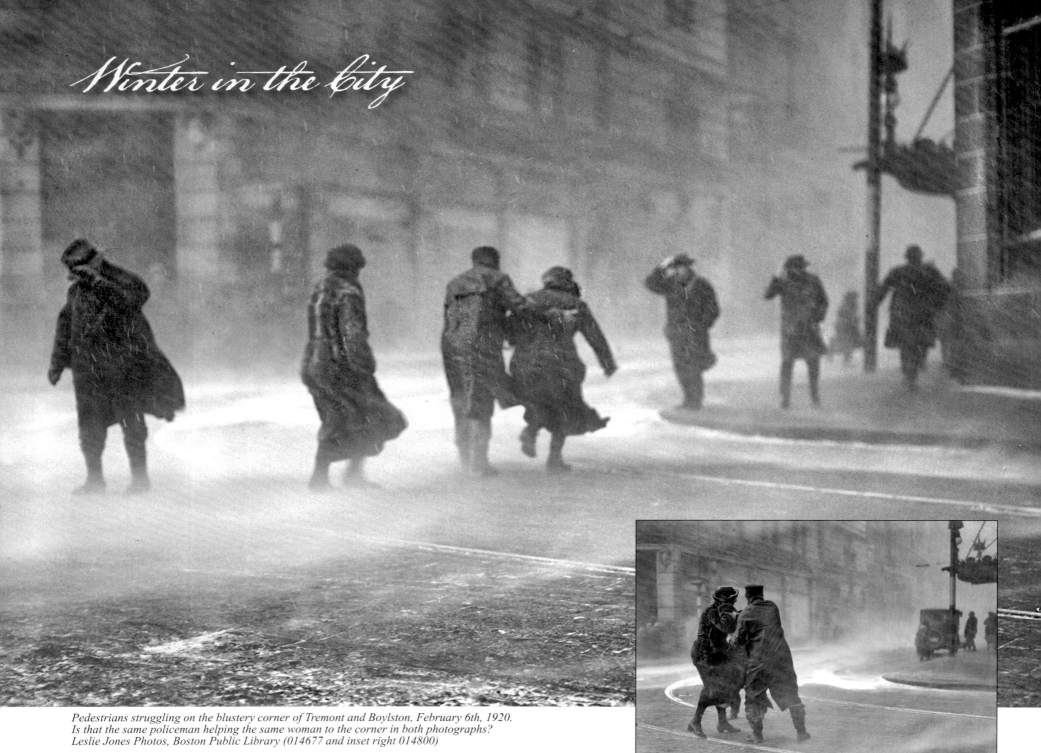

# Winter in the City

*Pedestrians struggling on the blustery corner of Tremont and Boylston, February 6th, 1920.*
*Is that the same policeman helping the same woman to the corner in both photographs?*
*Leslie Jones Photos, Boston Public Library (014677 and inset right 014800)*

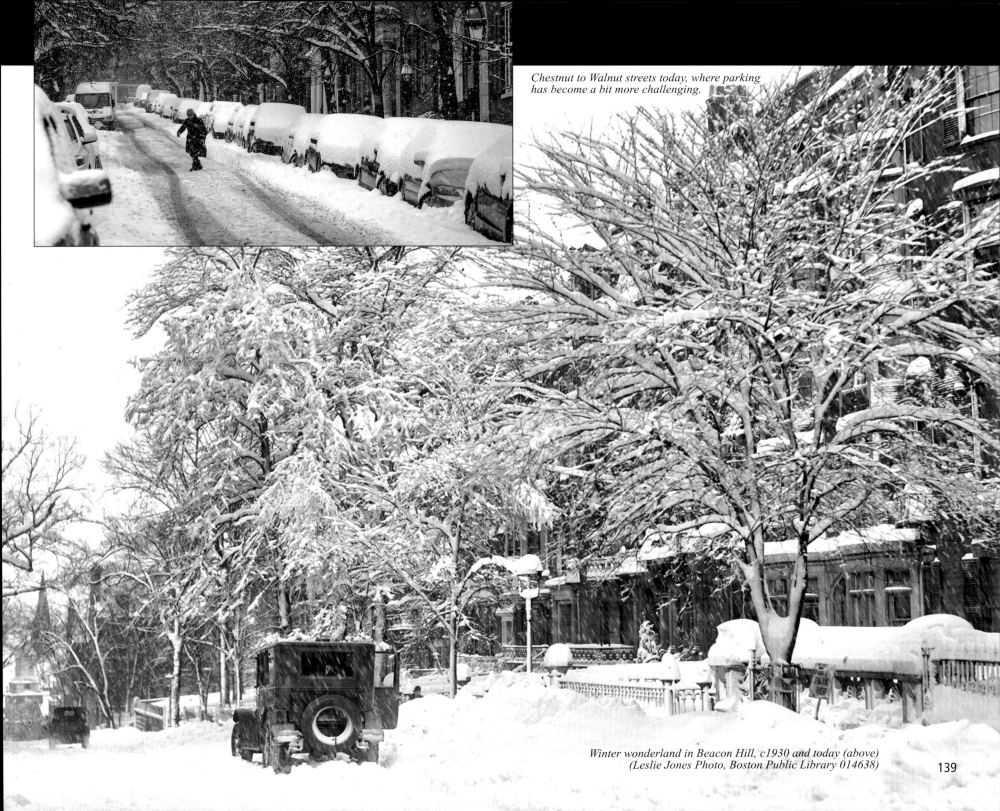

*Chestnut to Walnut streets today, where parking
has become a bit more challenging.*

*Winter wonderland in Beacon Hill, c1930 and today (above)
(Leslie Jones Photo, Boston Public Library 014638)*

139

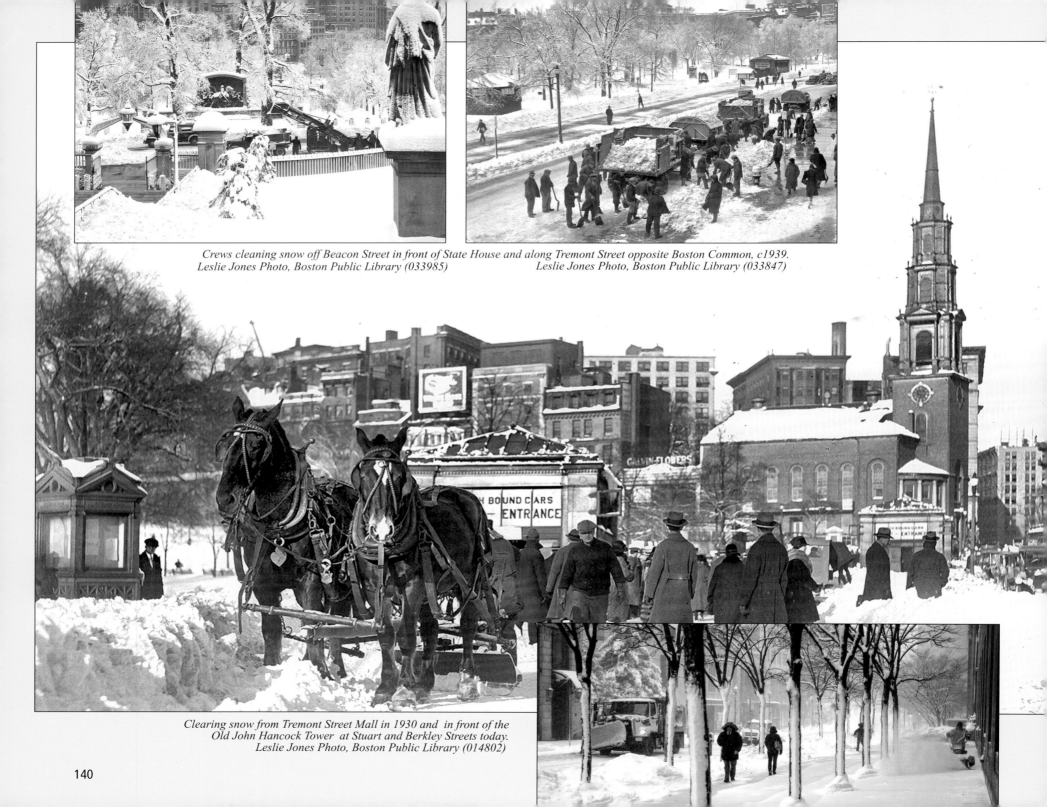

*Crews cleaning snow off Beacon Street in front of State House and along Tremont Street opposite Boston Common, c1939.*
*Leslie Jones Photo, Boston Public Library (033985)*
*Leslie Jones Photo, Boston Public Library (033847)*

*Clearing snow from Tremont Street Mall in 1930 and in front of the*
*Old John Hancock Tower at Stuart and Berkley Streets today.*
*Leslie Jones Photo, Boston Public Library (014802)*

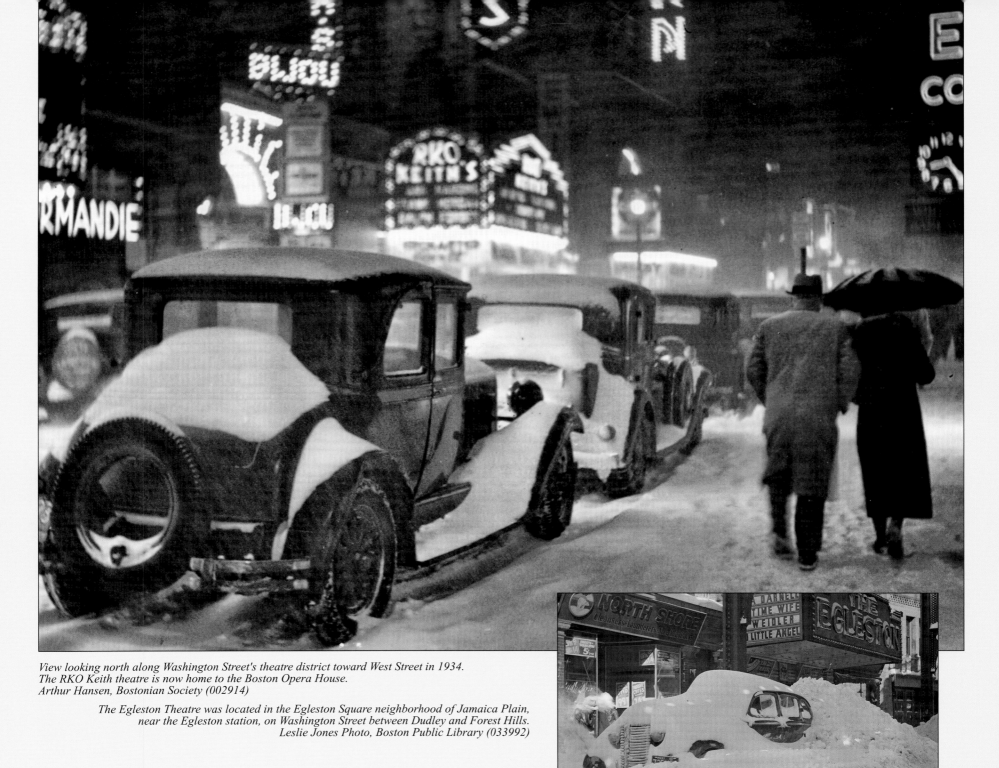

*View looking north along Washington Street's theatre district toward West Street in 1934.*
*The RKO Keith theatre is now home to the Boston Opera House.*
*Arthur Hansen, Bostonian Society (002914)*

*The Egleston Theatre was located in the Egleston Square neighborhood of Jamaica Plain,*
*near the Egleston station, on Washington Street between Dudley and Forest Hills.*
*Leslie Jones Photo, Boston Public Library (033992)*

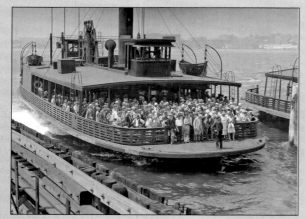

*Crowded ferry* Ashburnham *arrives at Revere Beach, 1927.*
*(Leslie Jones, Boston Public Library 008225)*

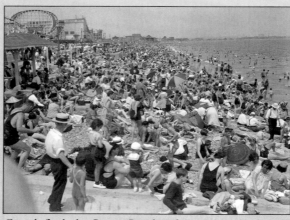

*Crowds flocked to Revere Beach and Amusement Park, 1937.*
*(Leslie Jones, Boston Public Library 024197)*

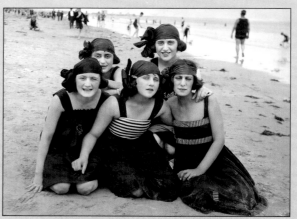

*Ladies enjoying thier day at Revere Beach, c1920*
*(Leslie Jones, Boston Public Library 024648)*

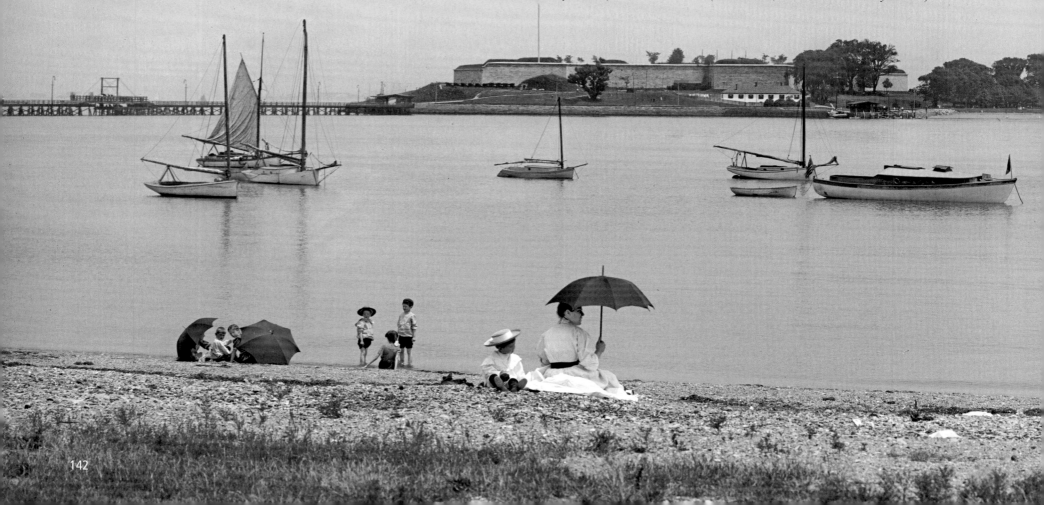

Crowds starting to fill up Nantasket Beach, August 1920.
(Leon Abdalian, Boston Public Library 000556)

Family enjoying City Point Beach in South Boston, 1906.
Fort Independence is visible on Castle Island, when it was
still an island. (Library of Congress 4a13564)

Couple enjoying the perfect spot to walk their dog
with their morning coffee, on beautiful Nantasket Beach.

THE TURN OF THE CENTURY SAW THE GROWTH OF THE THEATRE DISTRICT that had been concentrated in the area of lower Washington and Tremont streets beginning around 1836. Movie palaces, ornate purveyors of motion pictures, came onto the scene in the 1920s. By 1935, downtown Boston had 40 theaters. Six of them shared the lower Washington Street block that now features the Boston Opera House, Modern Theatre, and Paramount Center. These three restored theater gems offer almost-nightly live performances, films, and dance. But Boston's vibrant theater scene includes more than a dozen major performance venues in the Downtown Theatre District, plus even more in other neighborhoods and nearby Cambridge.

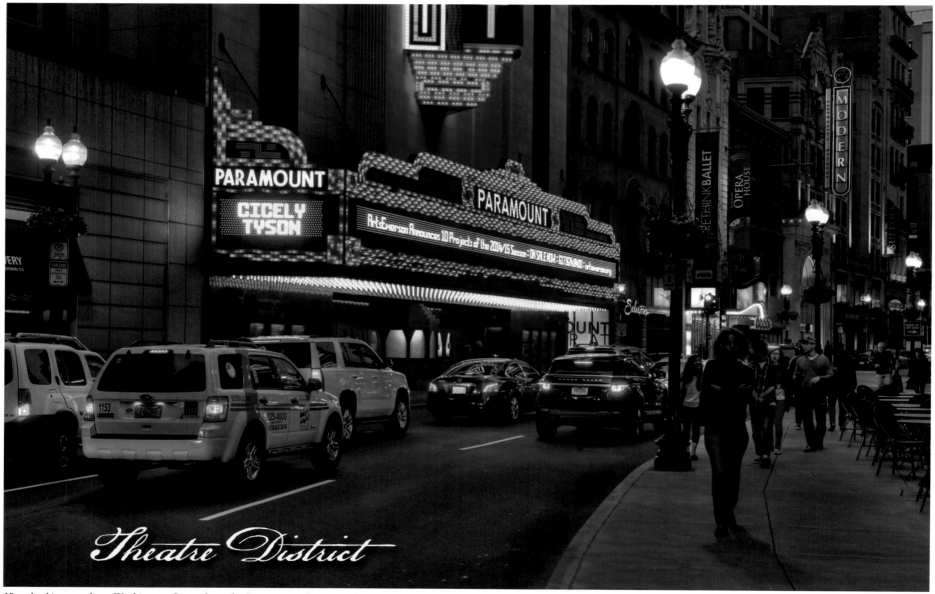

*View looking north on Washington Street from the Paramount Center to the Boston Opera House and the Modern Theatre..*

144

Suffolk's commitment to the Modern Theatre and the restoration project is inspired, in part, by the Modern's history of innovation. In 1876, four years after the Great Boston Fire destroyed the nearby business district, Architect Levi Newcomb designed the original building on the Modern Theatre site in the French Renaissance style to house Dobson Brothers, the largest carpet manufacturers in America.

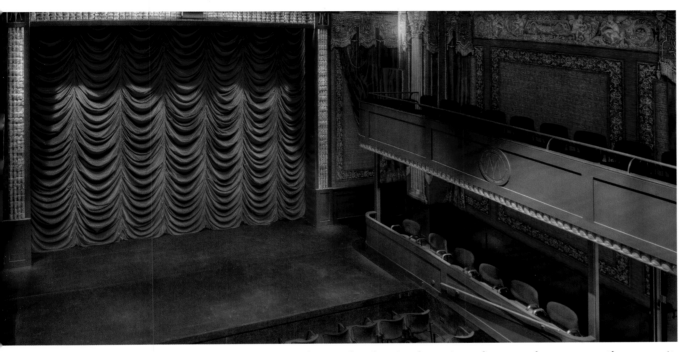

*Boston Opera House photo*

*Suffolk University's Modern Theatre programming advances the educational experience for our students; engages the community through cultural, social, and civic programming; promotes excellence and innovation in the arts; and entertains all who pass through our open doors. Our programming is intimate in scale, thoughtful in content, and contemporary in approach.*

In 1913, when motion pictures began moving from makeshift nickelodeons to theaters, the first three floors of the Dobson Building were converted into the Modern Theatre, the first Boston theater designed specifically to show films using this new technology. Admission was 15 cents, and musical accompaniment was provided on an Estey Organ designed specifically for use in the theater.

In 1928 the Modern Theatre, equipped with the latest technology, premiered *The Jazz Singer* as the first "talkie" in Boston. It later introduced the double feature in an effort to compete with newer theaters showing movies and vaudeville together.

The Modern Theatre was included on the National Register of Historic Places in 1979 as part of the Washington Street Theatre District. In 1995 it was designated a Boston Landmark.

Other venues from Broadway to Avant-Garde include; Charles Street Playhouse (74 Warrenton Street), Colonial Theatre (106 Boylston Street), Cutler Majestic Theatre at Emerson College (219 Tremont Street), Orpheum Theatre (140 Clarendon Street), Shubert Theatre – now part of Citi Performing Arts Center (265 Tremont Street), Wang Center for Performing Arts – Citi Performing Arts Center (270 Tremont), and the Wilbur Theatre (246 Tremont Street).

The Boston Opera House is one of the finest examples of the vaudeville circuit palace at the pinnacle of its development. Designed in a combination of French and Italian styles by Thomas White Lamb, one of the foremost theatre architects of his day, it was erected under the close personal supervision of Edward Franklin Albee to memorialize his late partner, Benjamin Franklin Keith. Because it was constructed as a tribute to vaudeville's greatest impresario, it was built with a degree of luxury in its appointments that is almost unrivalled.

Today, The Boston Opera House hosts the region's most active program of top touring Broadway shows, Boston Ballet performances and other high-quality cultural presentations and concerts in New England's most magnificent theater. bostonoperahouse.com

Financial District

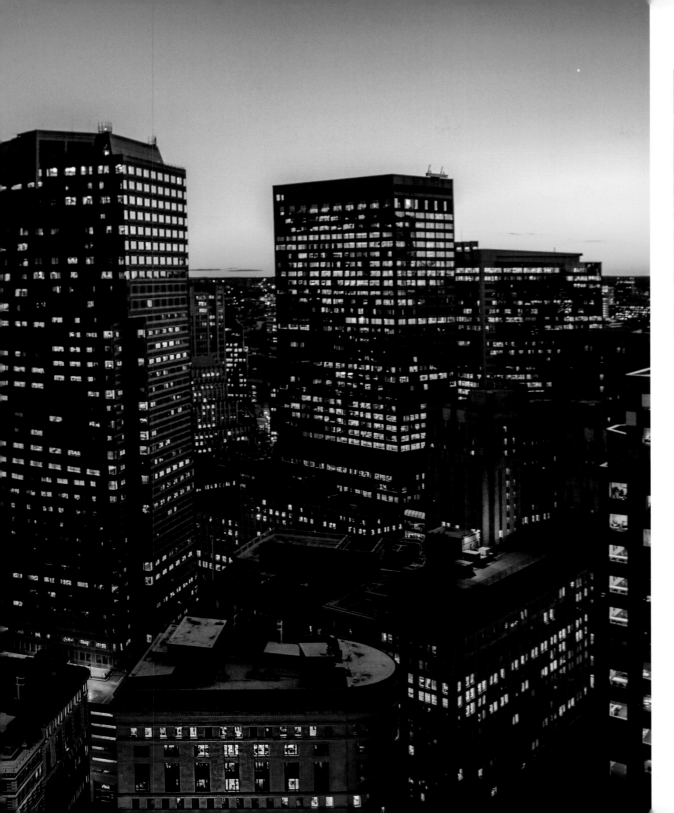

*In this 1932 aerial view, the Federal Building on Post Office Square dominates, while today it is surrounded by gleaming office towers. The Custom Tower is prominent in the background and provided the vantage point from which the colour photo at left was captured.* (Boston Public Library 014638)

LIKE MANY AREAS WITHIN BOSTON, THE Financial District has no official definition. It is roughly bounded by Atlantic Avenue, State Street, and Devonshire Street. Dewey Square, One Financial Center, and the plaza and towers housing the Federal Reserve Bank of Boston are located near South Station, adjacent to and just south of the area defined above. Also part of the Financial District are 33 Arch Street, One Federal Street, the First National Bank Building building, and 101 Federal Street. The area contains many of Boston's highrise buildings in a fairly densely packed area, significantly more than the Back Bay which contains Boston's two tallest highrises, the Prudential Center and the John Hancock Tower.

*View of the heart of Boston's Financial District from the 26th-floor observation deck of the Marriott's Custom House tower on State Street at India.*

147

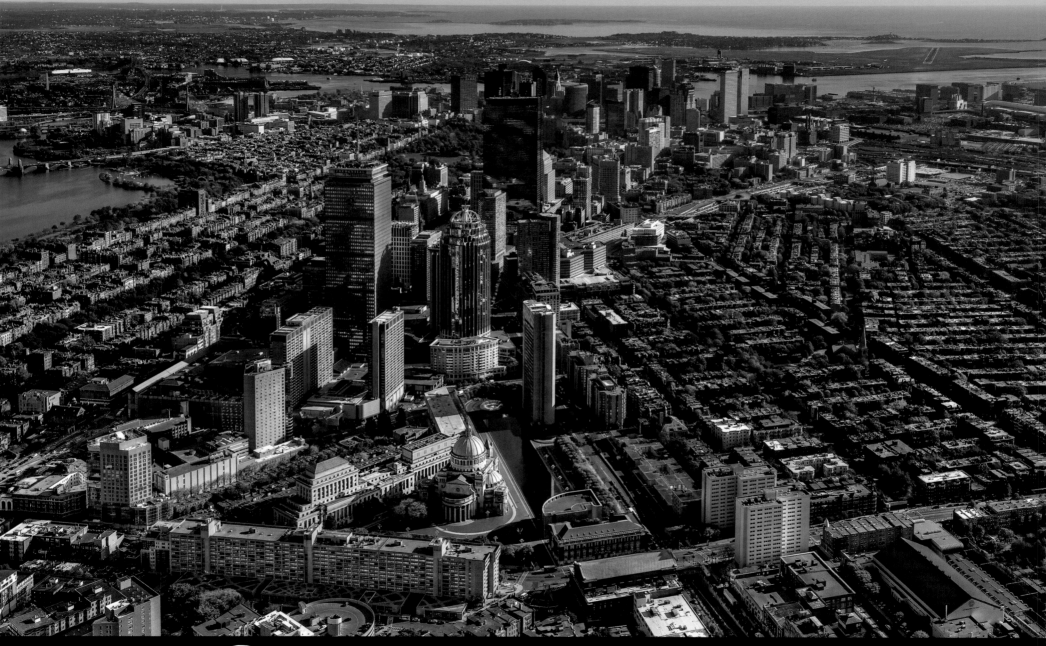

*Downtown*

Boston's colonial leaders once called downtown Boston home, and the district's residents traded on the wharves and in shops leading from the waterfront. The seat of government was the Old State House at the head of State Street.

Much of downtown's street pattern dates from the 17th Century. Contrary to legend, cows did not lay out Boston streets, although many of the streets between Washington and Tremont were once cow paths leading to the Common. Today's Washington Street was the main road in colonial Boston and was lined with buildings at an early date.

By the mid-19th Century, the semi-rural area around Washington Street was adapted to commercial uses. The Great Fire of November 1872 destroyed more than 500 buildings in a 65-acre area. Property owners reconstructed the district within several years, often rebuilding in Victorian-era styles. Because the fire stopped at Washington Street, a number of so-called "pre-fire" buildings survive in the blocks between Washington and Tremont streets, such as the Old South Meeting House.

By the late 19th Century, early skyscrapers began to make their appearance as retail establishments evolved into major department stores and financial institutions moved beyond their traditional homes in the Post Office Square area.

*Courtesy of the Boston Preservation Alliance and*
*the Downtown Boston Business Improvement District (BID)*

Boston's "High Spine" is an architectural planning design that arose in 1961, designed by the Committee of Civic Design, part of the Boston Society of Architects. The basic idea of the High Spine is to create a string of skyscrapers that runs from the Financial District to the South End, on a path that would not disrupt pre-existing, historical communities and give the city a distinctive skyline that would act as a visual reference for one's location within the city. This "Spine" is dramatically visible in the aerial at left.

*View of the Prudential Building and 111 Huntington from the reflecting pool at the Christian Science Center, visible in the foreground of the aerial photograph at left.*

149

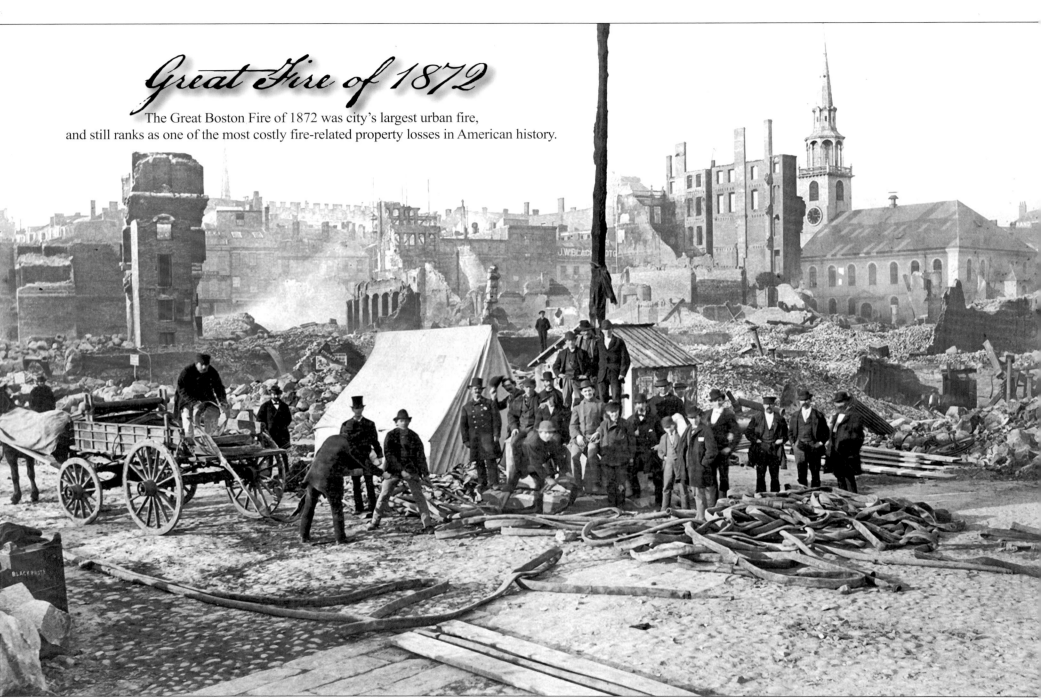

# Great Fire of 1872

The Great Boston Fire of 1872 was city's largest urban fire,
and still ranks as one of the most costly fire-related property losses in American history.

*A few firefighters, police officers, and probably city officials, pose for this photograph on what remains of Franklin Street near corner of Arch. (Boston Public Library (003862)*
*The Old South Meeting House at the corner of Washington and Milk streets, where firefighters stopped the blaze, can be seen at top right.*

*Three weeks after Boston's great fire of 1872, Harpers Weekly published this view illustrating the extent of the burned district. This area today is home to Boston's financial district. Go back to the photo taken from the observation deck of Marriott's Custom House tower (preceeding page) and imagine what this scene would have looked like on November 10th, 1872. The red dot at the north end of the fire scene here reflects the approximate location of the three photos on these pages.*

THE FIRE STARTED IN A BUILDING AT 83-85 SUMMER STREET in the downtown area. The first alarm was received at 7:24 p.m. from Box 52 located at Summer and Lincoln Streets. The fire had nearly total possession of the building of origin upon the arrival of the first fire engine, Engine Co. 7 from their quarters at 7 East Street, near South Station. Hose Company 2, from Hudson Street, is credited with getting the first water on the fire. Nearly all the cities and towns surrounding Boston sent help. Some cities sent steam engines by railroad, with many coming great distances. The fire was finally stopped at the corner of Washington and Milk Streets (photo at left) through the efforts of the firefighters to save the Old South Meeting House, on the opposite corner of Milk Street.

In those two days, the conflagration destroyed 776 buildings across 65 acres of land, with the assessed value of the properties at nearly $13.5[1] million and personal property loss of of $60 million dollars. The downtown area of Boston had undergone a rapid development in the years after the Civil War, but improvements, especially water mains, had not been upgraded during these years.

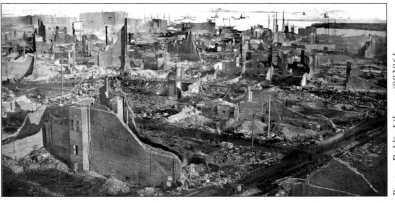

*View to the southeast from the smoulderig ruins of Trinity Church on Summer Street, towards the harbor at the mouth of Fort Point Channel. Like the other photos on this spread, the three viewpoints are all in the vicinity of the red dot on the bird's eye view at left.*

The fire spread rapidly, creating its own energy or firestorm from the tremendous heat generated. Although many or most buildings were made of brick or stone, the window frames and other fixtures were made of wood, thus allowing the fire to communicate to nearby structures. During the course of the fire, which burned uncontrolled for more than 12 hours, buildings were blown up using black gun powder in a controversial effort to create a fire break.

Despite the enormity of the fire, only two Boston fireman were killed, with the total deaths numbering between 13 and 30, depending on the source.

[1]with inflation; $1.00 in 1872 would be worth $128.00 today.

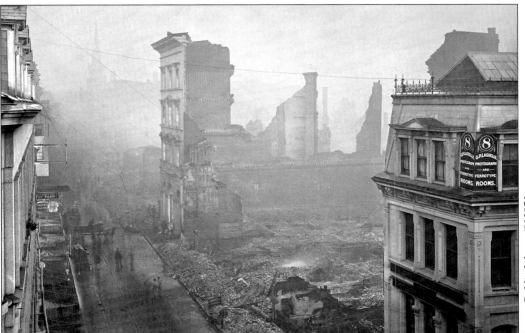

*View to the north along Washington Street from Winter Street.. The spire of the Old South Meeting House is just visible throug the smoke two blocks away and, miraculously, Mr. Lasselle's fourth-floor photography studio, and the building it occupies, seems to have dodged the fire bullet.*

As one of the nation's oldest big cities, Boston has been the birthplace of many progressive historic, social and political movements. Many of the country's great institutions can be traced to traditions established by colonists who built a community on a hill overlooking a deep-water harbor. One of those traditions concerned public safety: it was a Boston citizen's duty to look out for his fellow citizens; helping those in need would benefit everyone. Thus, it is no coincidence that the Boston Fire Department enjoys a reputation of being the oldest and one of the finest fire departments in the country.

From its organization in 1678, the Boston Fire Department, through ingenuity and necessity, grew into a powerful firefighting force noted for its dedication, innovationand bravery. In the early nineteenth century, bucket brigades and hand-drawnCivil War, horse-drawn apparatus and steam fire engines came into use. By the 1920s, "tubs" gave way to more efficient hand-drawn suction engines. Just before the horses were replaced by motor fire apparatus, which became a diesel-powered fleet late in the twentieth century.

While the city of Boston has undergone many changes through urban renewal and expansion, much of "Old Boston" remains. Though they are now wider, many of the original streets and alleys are still in place. Most of the sites of fires and disasters are readily accessible and identifiable. You can stand near the location of landmark events such as the Great Boston Fire of 1872 (previous page) or the infamous Cocoanut Grove Fire or at the Vendome Firefighters Memorial and imagine the trauma, tragedy and triumphs that once occurred before you.

Boston Fire Historical Society, *Boston's Fire Trail*, The History Press (2007)

The Boston Police grew alongside the Fire Department. A Court of Guard known as the first Boston Watch was created in 1631. At 6 PM on May 26, 1854 the Boston Watch and Police ceased to exist and the Boston Police Department came into being.

*The Massachusetts Fallen Firefighters Memorial was dedicated September 11, 2007. Located at our State Capitol, the Memorial stands tall as a tribute to the spirit, courage and dedication of past, present and future firefighters.*

*Division One Headquarters, Boston Fire Department*

THE BOSTON FIRE MUSEUM, owned and operated by the Boston Sparks Association, has occupied the old firehouse at 344 Congress St, Southh Boston, since 1983. The goal of the Museum is to preserve and display fire fighting memorabilia from the Greater Boston area, educate and inform the general public on fire safety, restore and maintain the "Landmark" building we occupy, and to support the fire service in general.

The Museum Committee, which oversees the operation of the Museum, is an all-volunteer group of people dedicated to informing friends and visitors about the history of fire fighting. Since the Boston Fire Department is one of the oldest in the nation, there is a rich tradition to salute.

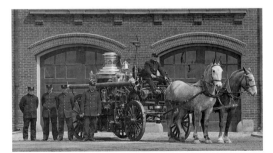

*Horse-drawn steam engine, Winthrop, c1915. (Leslie Jones, Boston Public Library 003889)*

153

## Sports

**Robert J. Allison**
From *A Short History of Boston*

I N SPORTS, AS IN MUSIC, BOSTONIANS BEGAN TO TRANSCEND THE BOUNDARIES of race, class, and ethnicity through such amateur sporting events as the Boston Marathon. By the 1930s, the marathon, begun by New York runners in 1897, the year after South Boston's James Brendan Connolly won the first gold medal in the modern Olympics, had a new champion in Boston's Johnny Kelley. In the first decades of the century, Bostonians built new sporting palaces, notably Harvard Stadium in Brighton (the country's first steel-reinforced concrete building) in 1902 and what is now the oldest ice hockey rink in the world, the Boston Arena (now the Matthews Arena at Northeastern University), in 1909. The Boston Bruins (one of the National Hockey League's original teams) played at the Boston Arena from their birth in 1924 until 1928, when they moved into their new home at the Boston Garden—and promptly won the Stanley Cup.

Professional baseball came to Boston in 1876 with the creation of the Braves, who had the best record in baseball five times in the 1890s. When the rival American League was born in 1901. Boston had a new team, the Red Sox, who won the first World Series over the Pittsburgh Pirates in 1903. The Red Sox opened their new home at Fenway Park in 1912. The Red Sox went on to win eight world championships with a pitching staff that included Cy Young and left-hander Babe Ruth, who played the outfield on days he did not pitch. Ruth set a baseball record with 29 home runs in 1919, a record one Boston sportswriter predicted would never be broken. But that winter Ruth was sold to the struggling New York Yankees, and though his wife continued to live on their Sudbury farm, Ruth became a New York slugger.

Boston had the first organized football club in the United States: the Oneida Club, whose school-boy members played on Boston Common during the Civil War. College football was one of the dominant American sports in the late 19th-century, and Harvard Stadium (opened in 1903) was home to a Rose Bowl championship team in 1920. Professional football emerged in the 1920s, and the Boston Bulldogs, in the upstart, short-lived American Football League in 1926, played at both Fenway Park and Braves Field before folding. Braves Field was home to a National Football League club, the Boston Braves, in the early 1930s; these Braves changed their name to the Boston Redskins in homage to their coach, William Henry "Lone Star" Dietz, who claimed Native American heritage, and to end confusion with the baseball team. After losing the football championship to the New York Giants in 1936, the Boston Redskins decamped to Washington, D.C., and Boston would not have another professional football team until the Boston Patriots took the field at Harvard Stadium in August 1960.

Boston's baseball teams also struggled. The Red Sox owners chose not to rebuild Fenway Park's left-field grandstand when it burned in 1926. The Red Sox reached a nadir in 1932, losing 111 games and drawing only 180,000 fans during the season. Tom Yawkey of South Carolina bought the struggling team in 1933. When a fire nearly destroyed Fenway Park in January 1934, Yawkey had it rebuilt in time to open the season, and then began the longer process of rebuilding the team. Braves owner Emil Fuchs brought Babe Ruth back to Boston in the twilight of the slugger's career, though Ruth retired in 1935 when he learned Fuchs did not plan to make him the team's manager. The all-star game hosted by the Boston Braves in 1936 has the distinction of having the lowest attendance ever, with 15,000 empty seats at Braves Field (now Nickerson Field at Boston University).When Ted Williams joined the Red Sox in 1939, the city gained a true champion, even though a championship still proved elusive. The following year, attendance at Fenway Park broke the

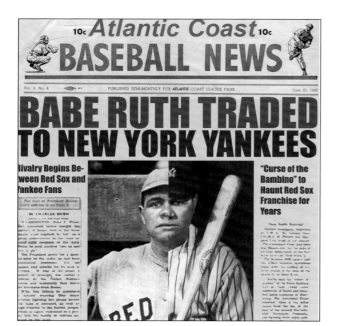

*The Curse of the Bambino was a superstition evolving from the failure of the Boston Red Sox baseball team to win the World Series in the 86-year period from 1918 to 2004. While some fans took the curse seriously, most used the expression in a tongue-in-cheek manner.*

*This misfortune began after the Red Sox sold star player Babe Ruth, sometimes called The Bambino, to the New York Yankees in the off-season of 1919–1920. Before that point, the Red Sox had been one of the most successful professional baseball franchises, winning the first World Series and amassing five World Series titles from that first one in 1903 through to 1918.*

*It should be noted that the team has won three World Series titles since 2004 so we may assume the curse has been lifted*

record set in 1909. Today the Red Sox are consistently one of the top MLB teams in average road attendance, while the small capacity of Fenway Park prevents them from leading in overall attendance. From May 15, 2003 to April 10, 2013, the Red Sox sold out every home game—a total of 820 games (794 regular season) for a major professional sports record.

Boston has teams in the major American sports—baseball, hockey, basketball, and football—and in the first decades of the 21st Century each of Boston's teams won championships. Along with the professional franchises, Boston hosts other unique sporting events--the Head of the Charles Regatta, one of the premier rowing events, every September; the Beanpot, a hockey tournament among Boston's colleges, in February; and the Boston Marathon, a 26.2 mile race that draws thousands of runners from around the world.

Was it one Boston, knit together out of many diverse elements, as John Winthrop had hoped? Fitzgerald's work to save *Constitution*, Bernstein and Fiedler bringing people together with music, Bostonians joining together to cheer their teams suggest the possibility. Or was it many Bostons, a network of separate communities each preserving its own past: Yankee versus immigrant, black versus white, Christian versus Jew? Bostonians who lived during the late 19th and early 20th Centuries did make remarkable efforts to bring all together into one community.

*Boston's four major sports teams include (top to bottom) the Patriots, Celtics, Bruins and the Red Sox, seen here in the first moments of their victory in the 2013 World Series.*

155

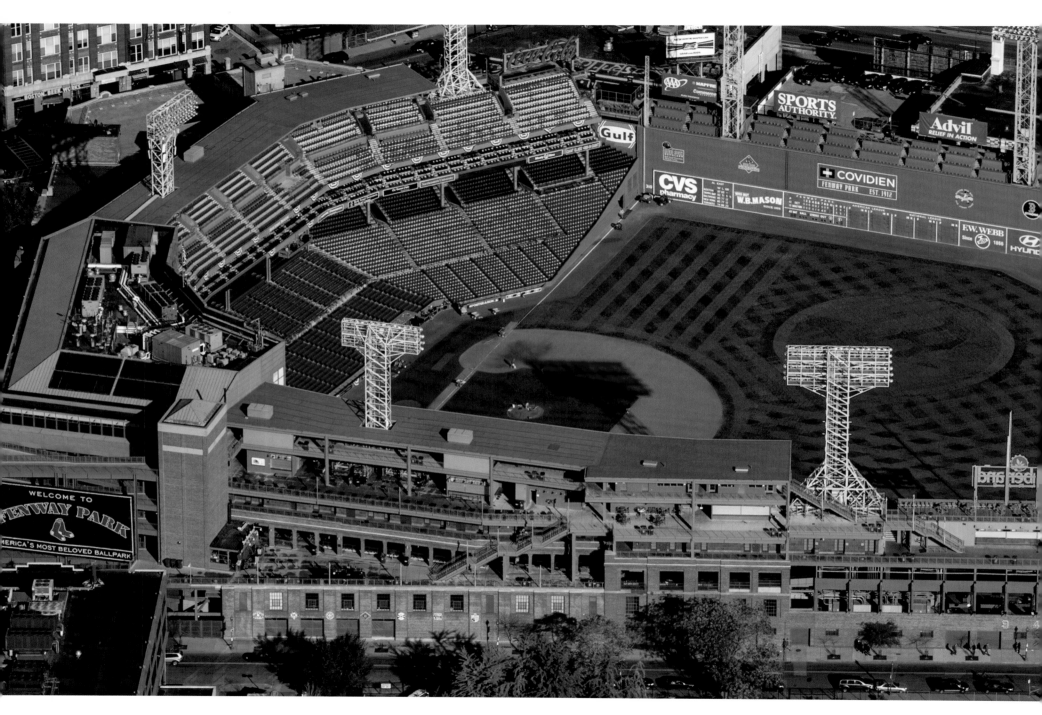

*Fenway Park, home to the Boston Red Sox since 1912*

# Fenway

**F**ENWAY PARK'S INAUGURAL YEAR WAS EXCEPTIONAL ON MANY LEVELS. After extensive construction in the early months of 1912, Fenway Park hosted its first game on April 9, an exhibition between the Red Sox and Harvard College.

"The essence of Fenway is its intimacy, a coziness that encourages, even demands, intensity. Fans become family; nicknames flourish.

From the first decade's Grey Eagle, Smoky Joe and the Babe to mid-century's Little Professor, the Moose from Moosup and the Splendid Splinter himself, choral chants have echoed off its walls: Rooster, Boomer, Steamer and Spaceman; Oil Can and Eck, Looie and Dewey, Pudge and Yaz; Petey, Big Papi and Yoook.

Bill Veeck, the visionary owner of the Cleveland Indians and St. Louis Browns, explained Fenway Park's uniqueness this way: "Other places have spectators; Fenway has 35,000 participants."

In the past century, teams have tried other ideas, from domes to donuts. Indoor baseball in the uncozy domes of the 1960s, '70s and '80s soon crumbled into obsolescence in Houston, Seattle and Minneapolis. A concrete donut, the "all-purpose stadium," stood at many an offramp until sponsors discovered that fans preferred ballparks, not stadiums.

Nathan Cobb of The Boston Globe coined the term "Red Sox Nation" in 1986, but Mayor John F. Fitzgerald had such a vision when he greeted the team at Faneuil Hall after the Red Sox won the 1912 World Series. "Your fame is not Boston's alone," he said on October 17. "In every part of the United States you are heroes and this same tumultuous greeting would be extended to you from Maine to California."

Today the Red Sox are consistently one of the top MLB teams in average road attendance, while the small capacity of Fenway Park prevents them from leading in overall attendance. From May 15, 2003 to April 10, 2013, the Red Sox sold out every home game—a total of 820 games (794 regular season) for a major professional sports record.

# On Marathon Anniversary
## Much to Embrace

I T WAS A DAY MARKED BY SOMBER REFLECTION AND PAINFUL REMEMBRANCE, one year after a pair of homemade bombs inflicted unspeakable suffering at the Boston Marathon. But when Patrick Downes took the stage Tuesday at an anniversary tribute, he described a year filled with love and gratitude.

*More than a hundred people affected by the Boston Marathon bombing, including survivors, first responders, law enforcement personnel, local business affiliates, local professional athletes, and government officials, returned to the finish line on Boylston Street for a group portrait on Sunday, April 6, 2014. (DINA RUDICK photo, The Boston Globe, Getty Images)*

Downes, 30, lost a leg after the bombings, as did his wife, Jessica Kensky. The two had been married for less than a year. Speaking to a raptly attentive room of 2,500 fellow survivors, first responders, and family members at the Hynes Convention Center, Downes described with quiet feeling the sacrifices of family and the bonds forged between strangers, the "individual snapshots of grace" he called "the most humbling experience of our lives." "History will tell of the devastation visited on our families," Downes continued. "I hope it will also tell of the compassion and unity that followed."

The gentleness of his message resonated in a 90-minute program largely focused on finding the good in the aftermath of April 15, 2013. The tribute honored those most affected by last year's violence, including Krystle Campbell, Martin Richard and Lingzi Lu, the three people killed by the bombing and the police officer Sean Collier, killed in the manhunt that followed.

In his remarks, Downes called the victims "our guardian angels." "Let them hear us roar," he urged the crowd, looking ahead to next week's Boston Marathon and the thousands who will line the course. Downes also expressed gratitude for the community of survivors who have drawn strength and understanding from one another. "We should never have met this way," he said, "but we're so grateful for each other."

In impassioned remarks calling the anniversary "an important day for America" and equating Boston's response with the best instincts of all Americans, Vice President Joseph Biden lauded the city for its example. "You're living proof that America can never, never, never be defeated," Biden said. "Terrorists try to instill fear . . . and it infuriates them that we refuse to bend, to change, to yield to fear. "That's what makes us so proud of this city—that you have never yielded."

There were plainspoken reminders of the pain that remains, some of the most poignant from Thomas M. Menino, longtime mayor of Boston. The crowd stood to applaud as he made his way slowly to the podium and spoke in a voice sometimes hoarse with emotion. "This day will always be hard," Menino said. "It will never be easy to be close to that place where our lives broke apart." But, he said, "You are strong at this broken place. Compassion took hold of this city," and it was "a mighty force." Mayor Martin J. Walsh, elected last fall, called for hope in the names of those who died. "We can believe, as Martin did, as Krystle, Sean, and Lingzi did, that anything is possible," Walsh said. "Because, after all, this is Boston, a city of hope."

Another survivor, Adrianne Haslet-Davis, called for April 15 to become "a day of action" when the warmth and kindness shown to victims of the bombing will be extended to others in need of aid. "There are people in your community who need your support, your patience and time, when dealing with situations like ours," said Haslet-Davis, a dancer who also lost a leg last April. She has begun to dance again using a prosthesis.

Haslet-Davis beamed as she walked swiftly back across the tribute stage, her gait smooth and fluid, without the slightest hitch.

**Jenna Russell**, *Boston Globe*, April 16th, 2014

*"Even the darkest night will end and the sun will rise."*
Victor Hugo, *Les Miserables*

*Adrianne Haslet-Davis, with her twin brothers Timothy and David Haslet, who ran for her right up to the last mile where she joined them for an emotional crossing of the finish line. That radiant smile says so much!*
*KEN M. MCGAGH Photo*
*Metro West Daily News, Framingham*

*Group of the '5700' enjoy the sights of Boston the day before the race. Here they pose for a keepsake photo in the Public Garden with a portion of the bronze statue of Mrs Mallard of "Make Way For Ducklings" fame, adorned with her Easter bonnet and Marathon name tag.*

On May 16th, 2013 the BAA (Boston Athletic Association) announced that the approximately 5700 runners who were unable to complete the 117th Boston Marathon would in fact be invited back for the 2014 race. There were many reasons why this was made possible, but in the end it was best summed up by race director Dave McGillivray's ringing comment that anyone who runs Boston deserves to experience "the euphoria of running down Boylston Street to the finish line". Boston spectators are known for their impassioned support and unbridled enthusiasm, and they gave these returning athletes some of the loudest cheers during the 2014 race.

This group of passive, but very vocal non-finishers came to be known as "The 5700 Boston Strong". Through a petitiion organized by Ryan Polly of Williston, Vermont, they became just enough of a voice that they helped shape their long road back to the start line in Hopkinton on the morning of April 21st, 2014. Most finished their year-long race, crossing that shining yellow line on Boylston Street where they sharred their magic moments with family and friends (right).

*"People didn't run to beat their best time," she said. "They ran to enjoy the course and enjoy the spectators. It was a different attitude and a different race." Kelli Wheeler, 5700 member and 2014 finisher*

*Group of friends from the '5700' posing on the finish line they day before the Marathon.*

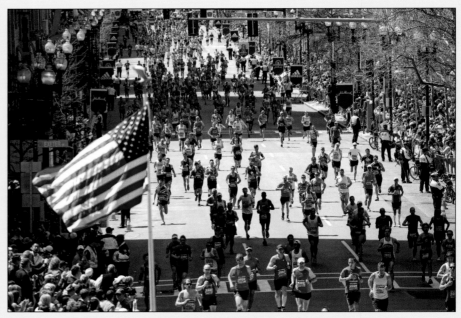

*Runners on the final stretch, just yards away from the finish line on BoylstonStreet. According to the BAA; 31,931 runners – 98.4% of the starters – crossed the finish line. (NICOLAS CZARNECKI photo, Metro Boston),*

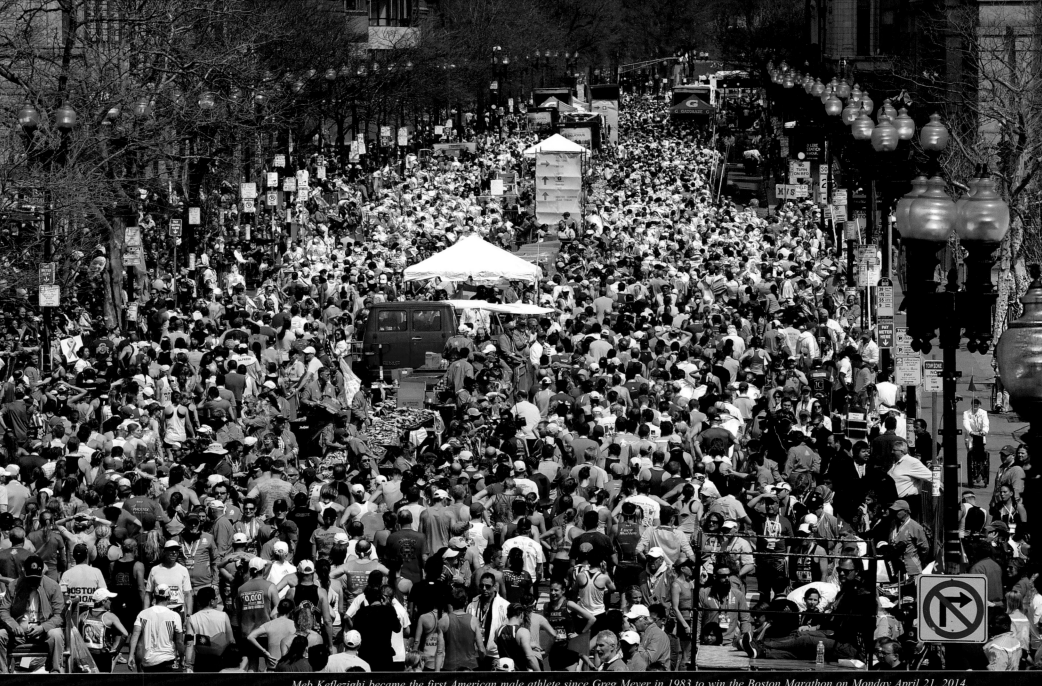

*Meb Keflezighi became the first American male athlete since Greg Meyer in 1983 to win the Boston Marathon on Monday April 21, 2014, while Kenya's Rita Jeptoo won her second women's title title in a row and third overall. Runners share their joy and tears with family and friends after crossing the finish line on sunny Boylston Street, the place where thousands of 'happy endings' were finally realized.*
*(TIMOTHY A. CLARY photo, AFP, Getty Images)*

161

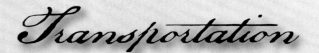
# Transportation

WATER IS THE CORNERSTONE OF CIVILIZATION. IT IS A DAILY necessity for sustaining life in all living things on the planet, and has played a key role in the transportation of goods and people since the dawn of civilization. As the 20th Century emerged, the age of steam had arrived and sailing ships were in transition, becoming a thing of recreation as their role in commerce began its speedy decline. In this area of Boston Harbor the movement of people by ferry and coastal

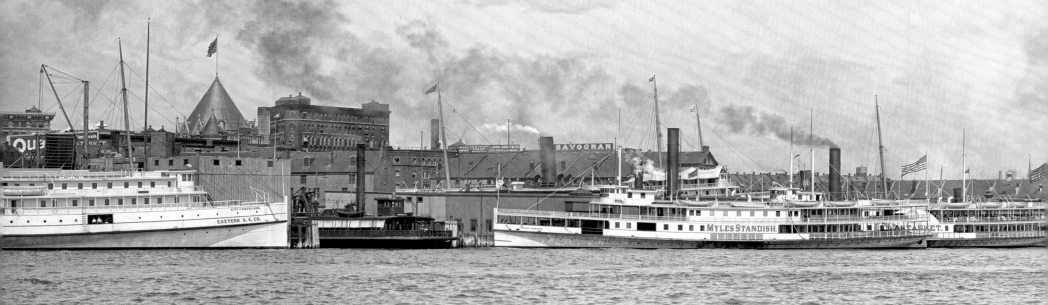

*Boston Public Library 000653*

*Passenger steamer docked at Rowes Wharf, 1928,*

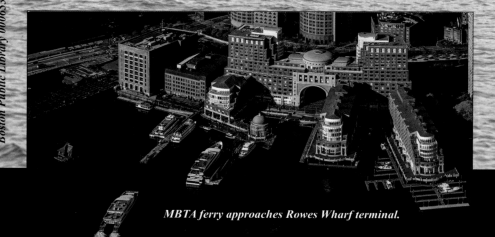

*MBTA ferry approaches Rowes Wharf terminal.*

steamers is in full swing. But the dominance of steamships would be short lived, soon to be pushed aside by railways and the steam locomotive. With the advent of the internal combustion engine the final nail was driven into the coffin of steam-powered transport. By the middle of the 20th Century roads and the automobile again changed the way people and goods moved inland from the coast. By the end of the century, air and the interstate highway system dominated, and passenger rail travel declined precipitously.

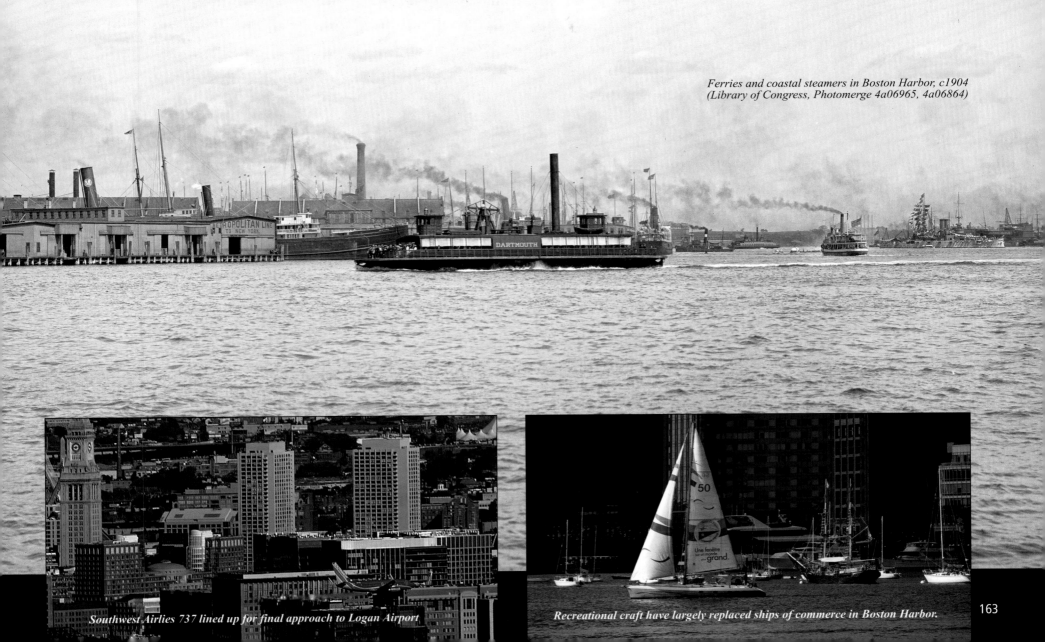

*Ferries and coastal steamers in Boston Harbor, c1904 (Library of Congress, Photomerge 4a06965, 4a06864)*

*Southwest Airlies 737 lined up for final approach to Logan Airport*

*Recreational craft have largely replaced ships of commerce in Boston Harbor.*

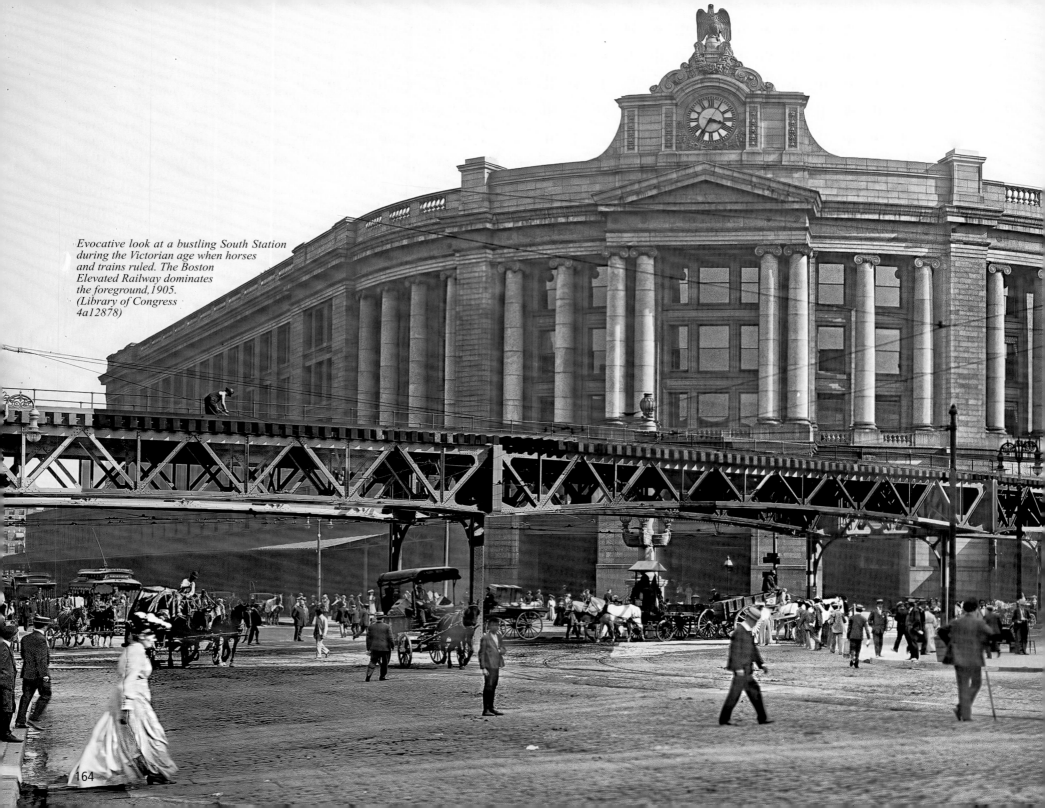

*Evocative look at a bustling South Station during the Victorian age when horses and trains ruled. The Boston Elevated Railway dominates the foreground, 1905. (Library of Congress 4a12878)*

164

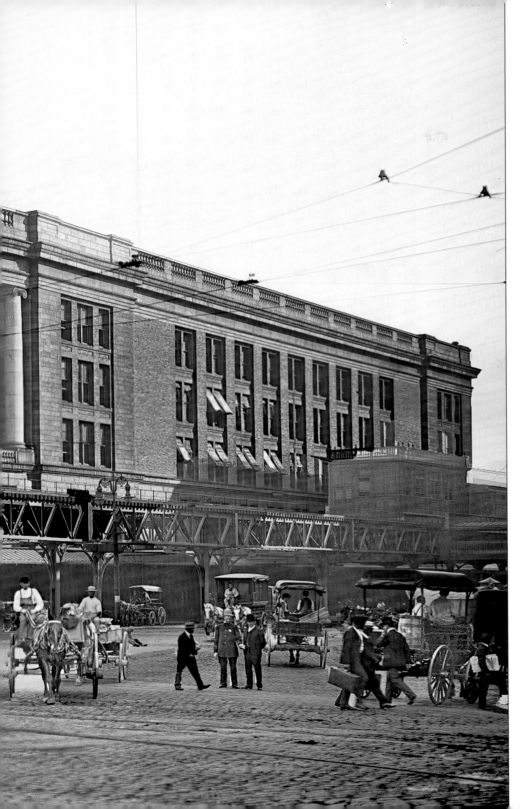

IT WAS DECEMBER 30, 1898 AND BOSTON'S NEW SOUTH UNION STATION was big news in the city and far beyond. In the presence of 5,000 invited officials and guests, Boston Mayor Josiah Quincy, was joined by New Haven Railroad head Charles P. Clark, to introduce his city and the world to the largest railway station ever built .The following day, New Year's Eve 1898, amid a typical Boston snowstorm, an estimated 10,000 attended a public sneak preview and further dedicatory events.

While it was already the largest, South Station quickly became the busiest train station in the world, handling about 38 million passengers in 1913, ranking higher than its second nearest competitor, Boston's North Station, which handled 29 million and New York's Grand Central Station, which handled 22 million that same year.

Following the heights of the early 1900s came a long period of further consolidations and decline in train travel. During World War I, a government takeover of rail helped stem the industry's financial problems.

Despite financial difficulties, passenger numbers still held strong. Then, in 1929, the Great Depression added to the station's decline in fortunes. During World War II, trains were filled with soldiers traveling for military purposes. In 1945, swollen by GIs returning from war, South Station again made history when over 135,000 visitors poured into its halls each day.

*Over a century later the venerable old South Station survives as a hub for subway (MBTA) and commuter rail traffic (MBTA and Amtrak).*

*Interior view of South Station, c1970 (Spencer Grant, Boston Public Library 000703)*

Soon after the war, the rail industry resumed its decline, with the former rail kings faltering financially and the New Haven Railroad declaring bankruptcy. Automobile travel continued to climb in popularity with increased car sales and new highway systems. Boston was no exception, with the old elevated Central Artery rolling out in the 1950s, giving new, easier access to the city by automobile.

Today, the station has become a true intermodal center, with an adjacent bus station and direct connection to the MBTA's Red Line. The MBTA's Silver Line now provides a direct connection to the Black Falcon Cruise Terminal in South Boston, as well as Logan Airport in East Boston.

*Jet taking off from Logan Airport's Runway 9 with the towers of Boston's Financial District in the background.*

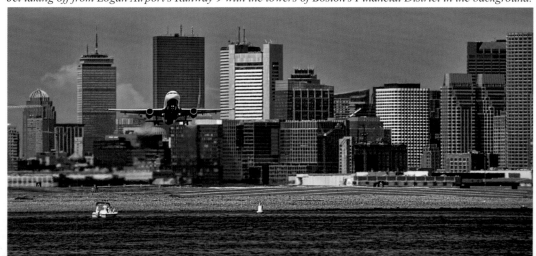

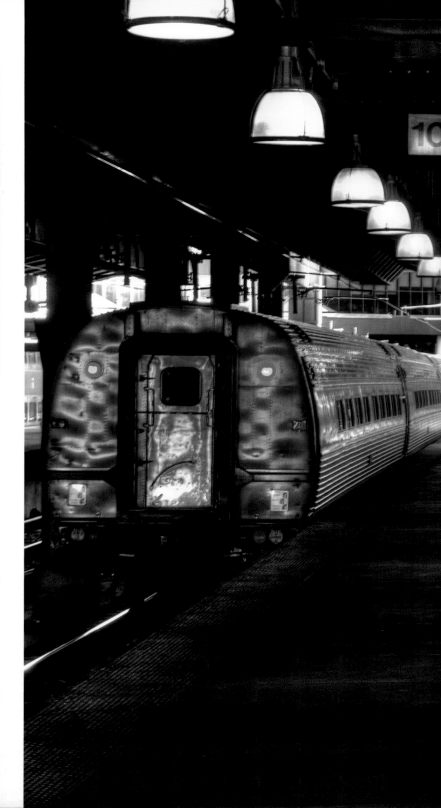

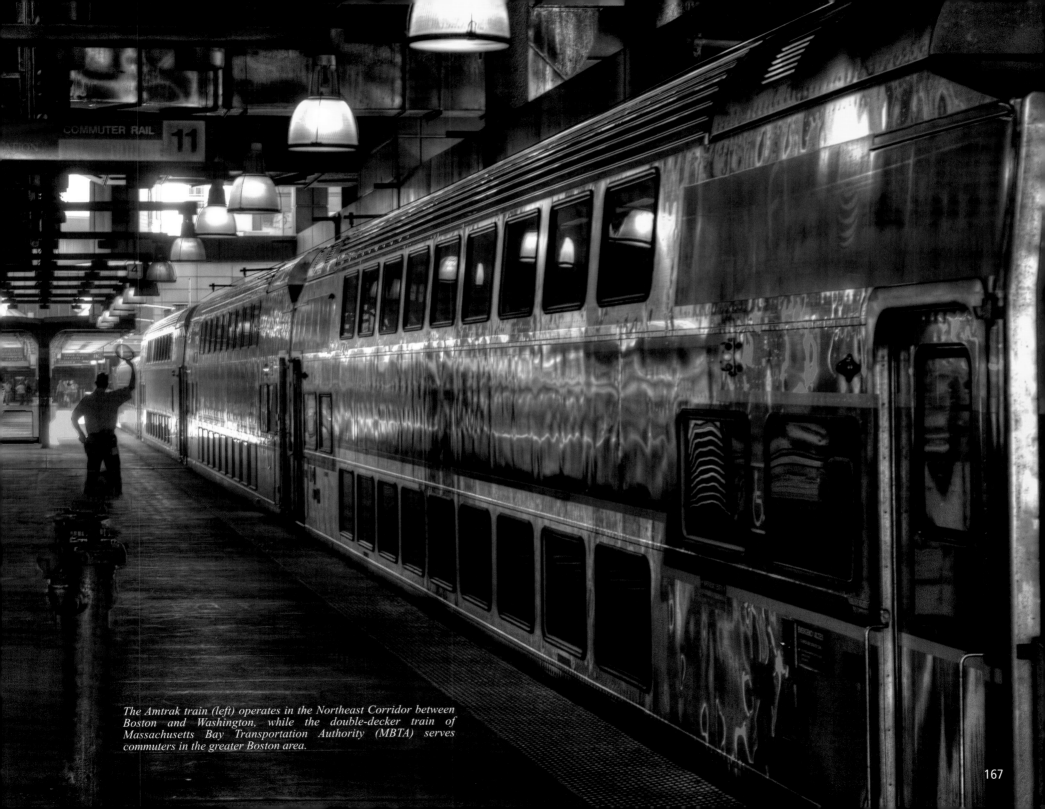

The Amtrak train (left) operates in the Northeast Corridor between Boston and Washington, while the double-decker train of Massachusetts Bay Transportation Authority (MBTA) serves commuters in the greater Boston area.

COMMUTER RAIL 11

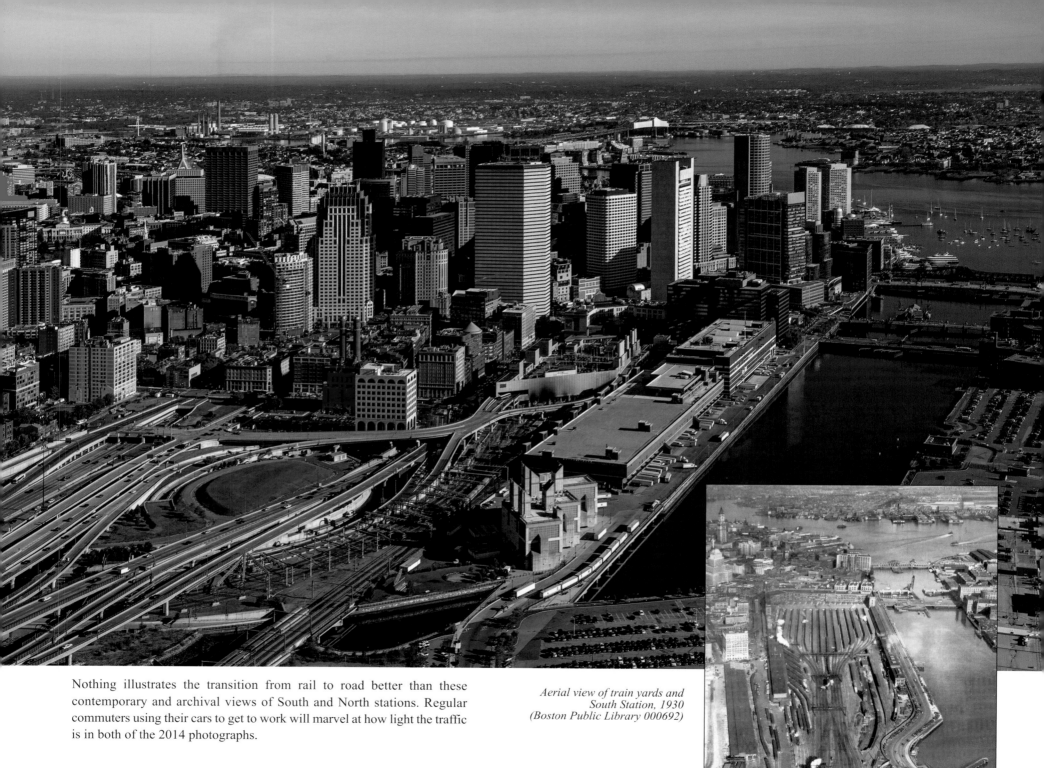

Nothing illustrates the transition from rail to road better than these contemporary and archival views of South and North stations. Regular commuters using their cars to get to work will marvel at how light the traffic is in both of the 2014 photographs.

*Aerial view of train yards and
South Station, 1930
(Boston Public Library 000692)*

168

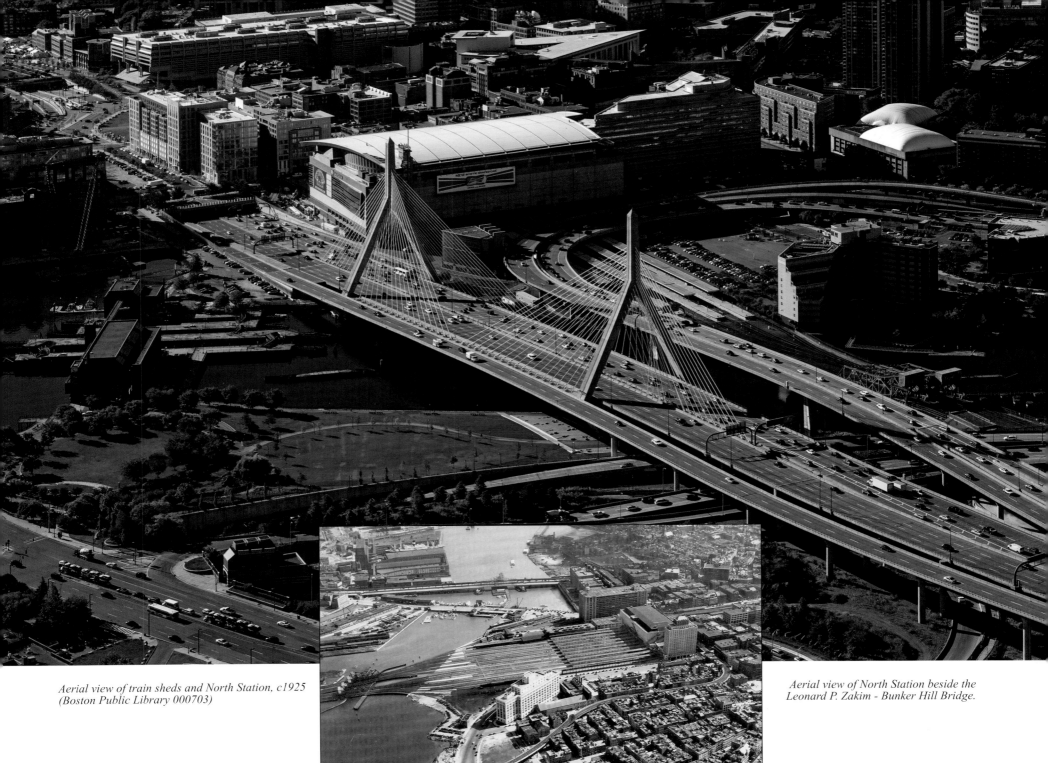

*Aerial view of train sheds and North Station, c1925 (Boston Public Library 000703)*

*Aerial view of North Station beside the Leonard P. Zakim - Bunker Hill Bridge.*

169

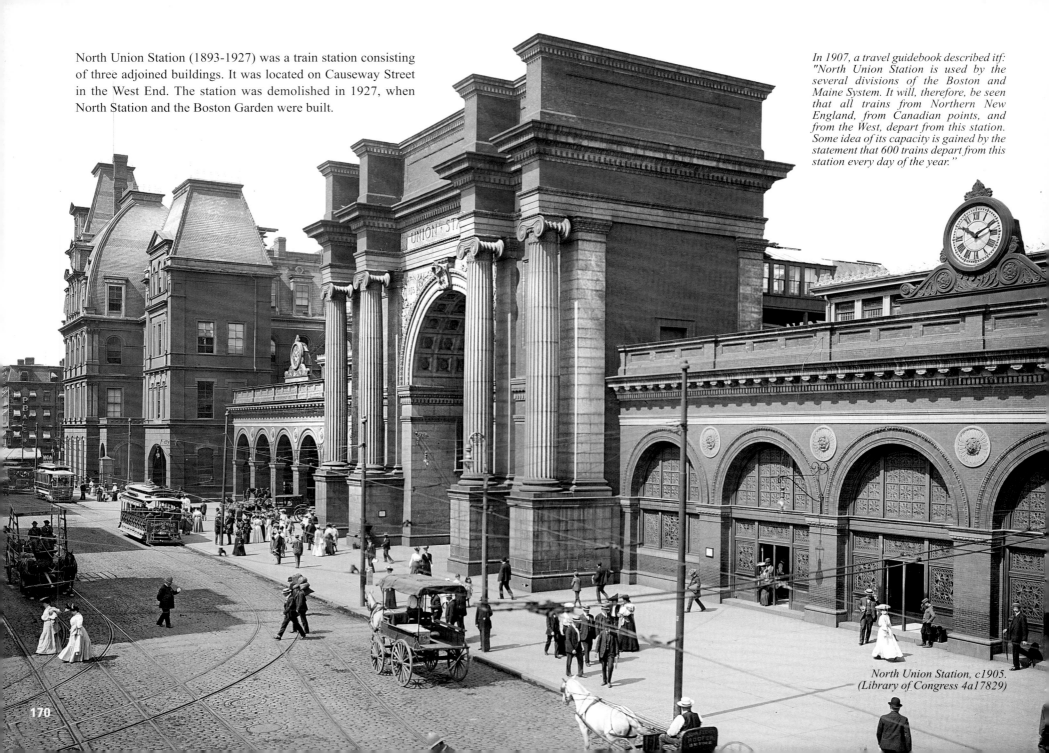

North Union Station (1893-1927) was a train station consisting of three adjoined buildings. It was located on Causeway Street in the West End. The station was demolished in 1927, when North Station and the Boston Garden were built.

*In 1907, a travel guidebook described itf: "North Union Station is used by the several divisions of the Boston and Maine System. It will, therefore, be seen that all trains from Northern New England, from Canadian points, and from the West, depart from this station. Some idea of its capacity is gained by the statement that 600 trains depart from this station every day of the year."*

*North Union Station, c1905.*
*(Library of Congress 4a17829)*

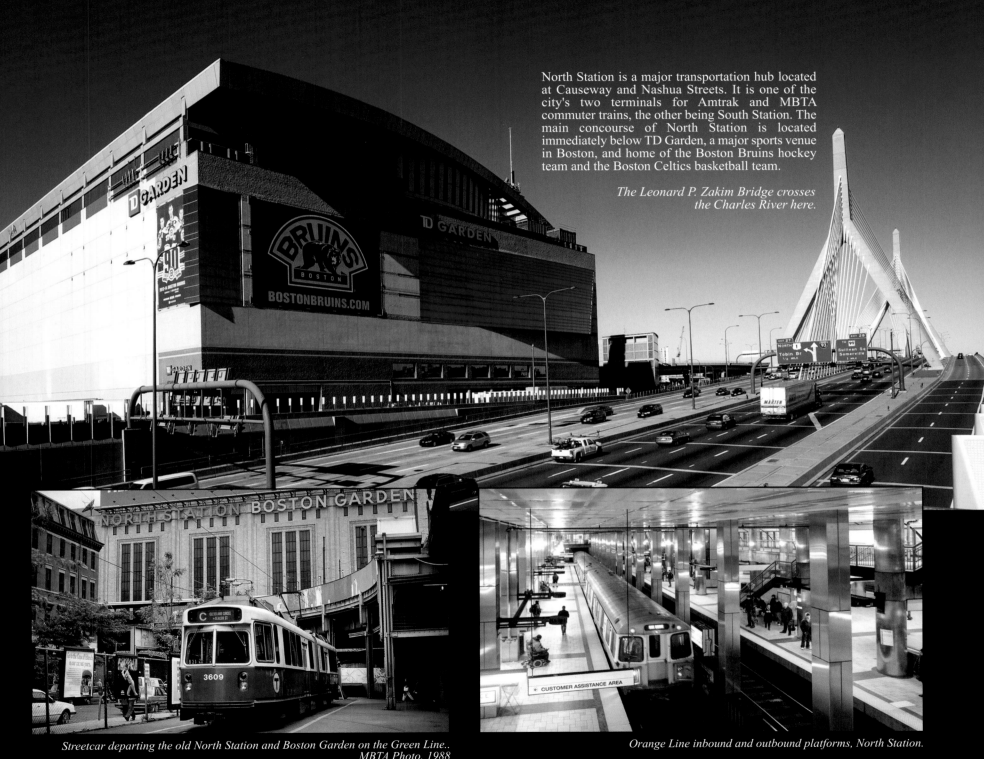

North Station is a major transportation hub located at Causeway and Nashua Streets. It is one of the city's two terminals for Amtrak and MBTA commuter trains, the other being South Station. The main concourse of North Station is located immediately below TD Garden, a major sports venue in Boston, and home of the Boston Bruins hockey team and the Boston Celtics basketball team.

*The Leonard P. Zakim Bridge crosses the Charles River here.*

*Streetcar departing the old North Station and Boston Garden on the Green Line..*
*MBTA Photo, 1988*

*Orange Line inbound and outbound platforms, North Station.*

# The Big Dig

THE CENTRAL ARTERY/TUNNEL PROJECT (CA/T), KNOWN unofficially as the Big Dig, was a megaproject in Boston that rerouted the Central Artery (Interstate 93)—the chief highway through the heart of the city—into a 3.5-mile (5.6 km) tunnel. The project also included the construction of the Ted Williams Tunnel (extending Interstate 90 to Logan International Airport), the Leonard P. Zakim Bunker Hill Memorial Bridge over the Charles River, and the Rose Kennedy Greenway in the space vacated by the previous I-93 elevated roadway. The construction work was done between 1991 and 2006, and concluded on December 31, 2007.

The Big Dig was the most expensive highway project in the U.S. and was plagued by escalating costs, scheduling overruns, leaks, design flaws, charges of poor execution and use of substandard materials, criminal arrests, and one death. The Boston Globe estimated that the project will ultimately cost $22 billion, including interest, and that it will not be paid off until 2038.

This project was developed in response to traffic congestion on Boston's historically tangled streets, which were laid out long before the advent of the automobile. As early as 1930, the city's Planning Board recommended a raised express highway running north-south through the downtown district, in order to draw traffic off the city streets.

Dedicated in 2004, The Rose Fitzgerald Kennedy Greenway is a ribbon of contemporary urban parks created in the space where an elevated highway once stood. As a result of Boston's Big Dig, that highway now runs beneath these parks. The Greenway is reconnecting Boston—providing a reminder of how important public parks are to the vitality, health and life of a city.

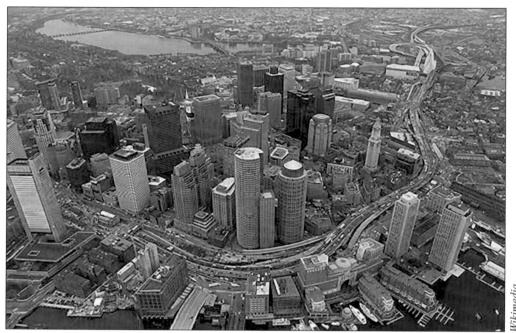

Wikimedia

*Nothing illustrates how effectively the elevated Central Artery cut off the harbor and the North End from Downtown Boston and the dramatic improvements that resulted when I-93 was put underground.*

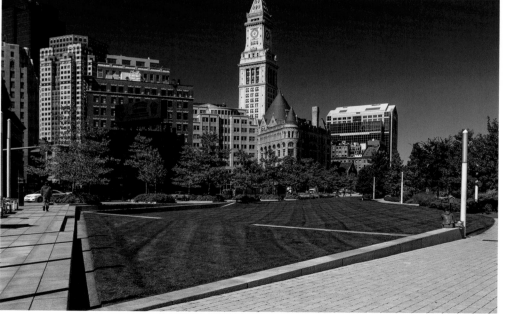

*Portion of Rose Fitgerald Kennedy Greenway in front of Rowes Wharf.*

*The Ted Willliams Tunnel takes the Massachusetts Turnpike under Boston Harbor.*

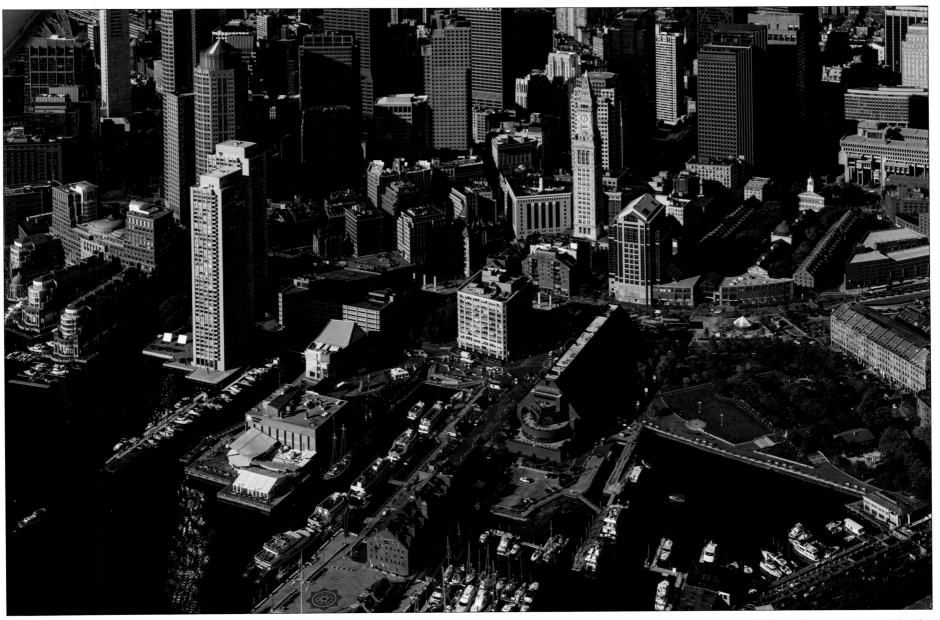

*This aerial view shows the Rose Fitzgerald Kennedy Greenway as it traces its path through the downtown corridor that used to host the much reviled, elevated Central Artery, visible in the black and white photograph at top left. Here we see the beating heart of the harborfront between Rowes Wharf and Columbus Park, with a portion of Long Wharf and the New England Aquarium in the center of the photograph..*

# *The Bigger Dig*

**Doug Most,**
From *The Race Underground, Boston, New York,*
*And the Incredible Rivalry that Built America's First Subway.*

THE WORKERS WORE BAGGY PANTS, SUSPENDERS, LONG-SLEEVED SHIRTS with the sleeves rolled up their forearms, and hats to protect their hair and eyes from flying dirt and rocks. They started at the corner of Boylston and Tremont and made their way toward Charles Street. The carts with their big wooden wheels were slowly pulled out of the hole by horses and replaced by empty carts, which were quickly filled and pulled away just the same. It was tedious, but in the course of a nine- or 10-hour day, with more than three dozen men applying their muscle nonstop

except for a 30-minute lunch break, progress was fast. The trench was dug in sections, 10 feet long by 12 feet wide and 6 feet deep. Wooden braces were fixed against the dirt walls to prevent a cave-in and placed across the top of the trench to provide the foundation for bricks to be laid. As the trench got deeper, steel support beams were laid along the sides of the walls and along the top, perpendicular to the tracks. The deeper the workers went, the greater the risk. They were digging around water pipes, gas pipes, and sewer lines, and a leak from any of them could prove disastrous.

*Subway excavation underway for the Park Street section, 1895.( Bostonian Society 001323)*

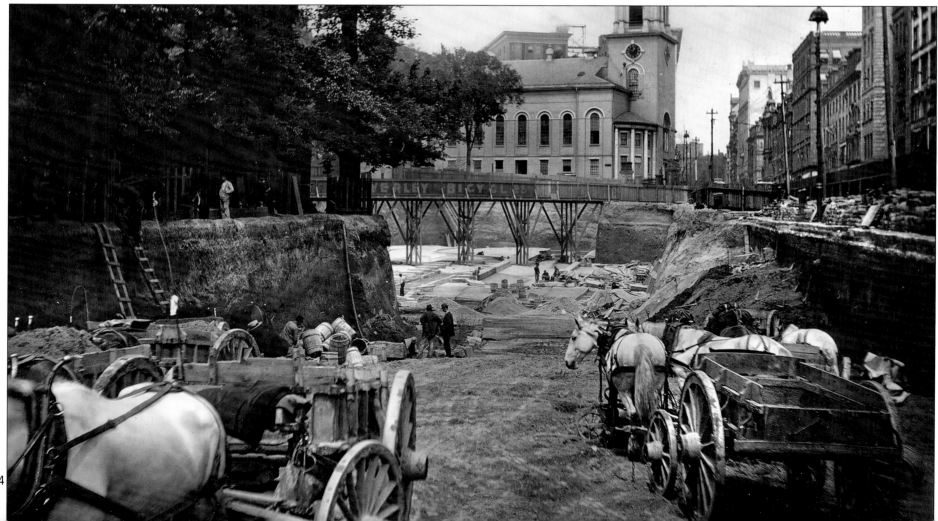

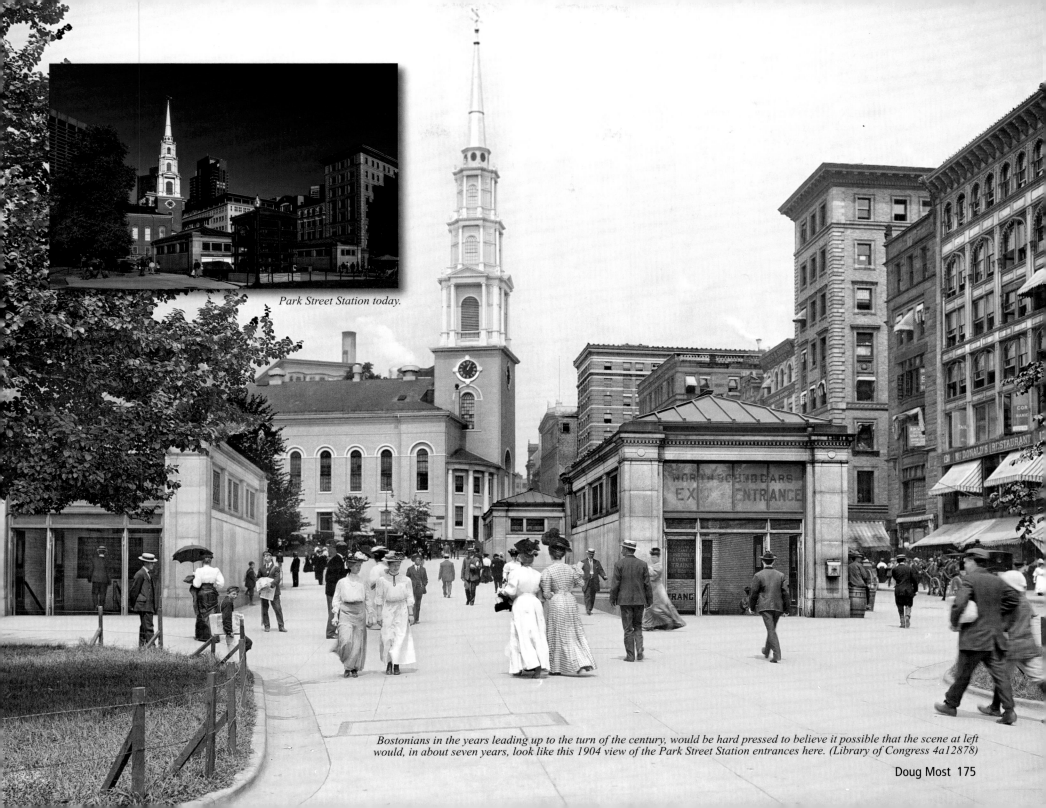

*Park Street Station today.*

*Bostonians in the years leading up to the turn of the century, would be hard pressed to believe it possible that the scene at left would, in about seven years, look like this 1904 view of the Park Street Station entrances here. (Library of Congress 4a12878)*

# The Race Underground

**Doug Most**

Birthplace of America's first subway

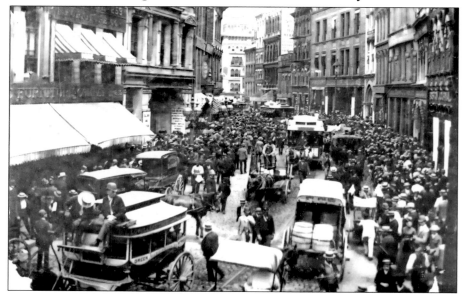

*Elevated view to the north of "Newspaper Row" on Washington Street, between Water and State streets, after the Sullivan vs. Kilrain fight, July 1889. (Bostonian Society 000104)*

*View to the south of adjacent block of Washington Street between Water and Milk streets today with newly restored Old South Meeting House visible in the distance.*

THERE WAS NOT MUCH TO LIKE IN BOSTON DURING THE DAYS WHEN HORSES ruled the streets in the late 19th Century. The city smelled. The rides were bumpy. All the clopping of hooves made such a racket it was impossible to carry on a conversation on the sidewalk. And crossing the street could be an exercise in futility at rush hour, as there was so little space between the back of one streetcar and the front of the next one.

On the other hand, the horses moved at such a slow pace that at least it was easy to anticipate their movements, and any sure-footed pedestrian could cross a street fairly easily in front of them with little worry of being struck. If a horse got too close, a quick swipe of a cane, a swing of a shopping bag, or a wave of an umbrella usually was enough to shoo the animal into slowing down or veering to the side. The horse became more efficient when streetcars were put on rails instead of cobblestone streets, making it easier for horses to do their wor,k but it was the introduction of the electric streetcar that spelled the beginning of the end for horse–pulled cars.

It was wet and warm on July 24, 1894, in Boston. A steady rain fell from morning to night, and the temperature hovered in the 70s. Maybe that's why not even thirty thousand people turned out for one of the city's most historic votes. Or maybe they were tired of all the talking.

The final vote, counted by hand, was reported differently in nearly every newspaper in town, perhaps because the clerk who had been in charge of the "No" column miscounted the tally at first by more than one thousand votes. But in the end, the result was the same. The referendum was passed. *The Globe* reported the final result as 15,458 in favor, and 14,209 opposed, meaning that, by a slim margin of 1,249 votes, the citizens of Boston said they were done with horses, done with electric streetcars cluttering their streets. They were ready for a subway. It was hardly overwhelming support.

Sam Little, who had replaced Henry Whitney as president of the West End Street Railway Company, said on the evening after the historic vote had been announced that he was surprised at the total number of people who voted and at the closeness of the vote. "I really thought a large number of people demanded an elevated road, from all the talk to that effect in the newspapers and one way and another, but the result doesn't seem to indicate it."

That was one way to look at the results. But another was that fears about the subway, despite assurances from respected doctors from Massachusetts General Hospital that the subway's air would be just as clean as the air above it, still had not been put to rest in the minds of many. "I don't believe in a tunnel or a subway," a local undertaker said after voting no. "I expect to be a long time underground after I am dead, but while I live I want to travel on earth, not under it."

As seven o'clock in the evening passed, the chamber room at City Hall was so packed that there was no room to move. Aldermen, department chiefs, city and state politicians, and citizens fascinated with the project all gathered to mingle and discuss the results. Surrounded by well-wishers, Mayor Nathan Matthews answered questions from reporters. For Boston's mayor, the vote was the victory he had pledged to achieve in his first inauguration speech in 1891. It had taken more than three years and created sharp divisions in the city, but the mayor was convinced that there was no other option. "The election shows that however the citizens may differ upon the merits of elevated railroads, subway routes, et cetera, a majority of them voting at a special election are in favor of a system of subways to be constructed and leased on public account," Matthews said.

"The verdict should be accepted as final and as a reasonably satisfactory conclusion to the rapid transit agitation."

"What is to be done next?" a reporter shouted at him.

"I should assume that the main plans can be prepared," the mayor answered, "and the work of construction begun and possibly well advanced before the close of the year."

*Ironworkers pause for a photograph near the site of the future Boylston Street Station, October 28, 1895. (State Transportation Library of Massachusetts)*

It was a few minutes after 6 a.m. on the morning of September 1, 1897. Boston's first subway car, an electric car, was on its way to making history, as the first subway car in America. After one final inspection to make sure the car was ready, the doors to the garage opened and the passengers let out a hearty cheer as the electric motor sent the Allston trolley on its way. The nine rows of benches were not filled yet, but they would be soon enough. Outside, a small group of onlookers waved their handkerchiefs and shouted out words of encouragement at the popular motorman. "Get there, Jim, old man, and don't let any of 'em get ahead of you," one cry went out.

Reed smiled. But he turned serious as his car rounded a bend, and he braked to a stop to allow another dozen passengers on board.

"All aboard for the subway and Park Street," he shouted with confidence. A voice shouted back at him, "That's right, Jim, you did that without a stutter!"

*Green Line train about to leave Park Street Station (above) and entrance to Harvard Square (inset right). One has to wonder what these stations and trains will look like 100 years on.*

As the car got closer to Boylston, the crowds along the street grew in numbers, with men, women, and children waiting and waving their hands high. Flower bouquets that the motorman Jimmy Reed had been handed were visible up front, but they were being crushed more with each stop. As Reed steered his car down Boylston Street, both sides of the street were lined with a sea of people and the roar became louder. Up ahead, he could barely make out the entrance to the tunnel, a black hole surrounded by a sea of people dressed in black.

The car by now was brimming over its edges, with passengers standing on the footboard and dangling off the side and limbs visible out of the windows despite the pleas of Stearns to keep all parts inside.

At the final stop before the tunnel entrance on Boylston between Arlington Street and Charles Street, when it seemed there was not a single inch of room left inside, two more people reached up from the sidewalk and grabbed hold of an arm that was being held on to by another arm and they were pulled on board and swallowed up by the excitable mass.

"The spaces between the seats were filled with standees," The Boston Evening Record wrote of the car, "the platforms were packed like sardine boxes. Each running board was two deep with humanity, while both fenders were loaded down until there was not enough room for a fly to cling!" A car with seats for 45 passengers and standing room for a few dozen more had 140 passengers. With Reed at the controls, the Public Garden on his left, and the clock on the Arlington Street church pointing at six o'clock, car number 1752 crept to the summit of the subway tunnel's downward slope.

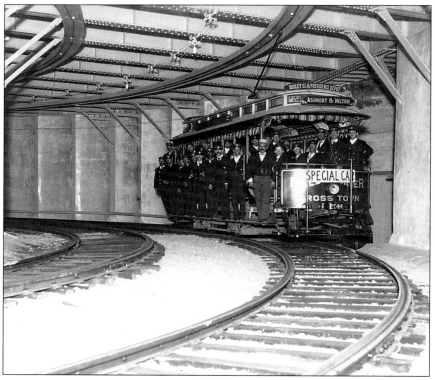

*Trial run from Park Street Station to Boylston, with subway staff, the day before the official opening in 1897. (Boston Public Library, 003008)*

*Located on the southeast corner of Boston Common, Boylston is one of the two oldest stations on the Green Line. After more than a Century of continuous operation (since 1897), the station's entrance retains an appearance more like its original look than any other station in the MBTA system. When it opened in 1897, it was the first underground rapid transit station in the US. I love the fact that this image is both a "then" and a "now" picture rolled into one frame.*

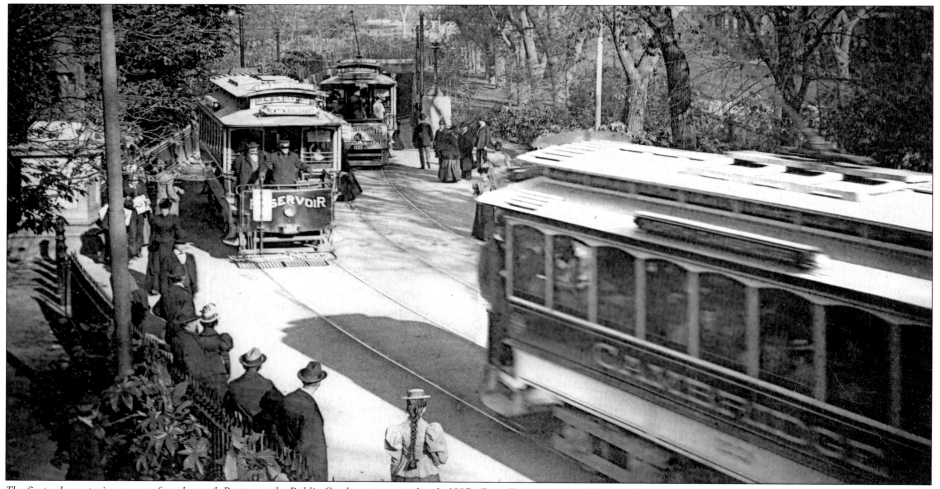

*The first subway trains emerge from beneath Boston at the Public Gardens on september 1, 1897. (State Transportation Library of Massachusetts)*

If there was a time to stop and acknowledge the moment, this was it. Perhaps a speech from Mayor Quincy was in order, or from the now ex-mayor Matthews, or Henry Whitney, or Governor Wolcott, anybody who had a hand in bringing America's first subway, an electric subway, to this day. Not only was it completed on time, in two and a half years, it came in at $4.2 million, under the $5 million projected cost. Along with ten people who had been killed in a gas explosion a few months earlier, four others had died in the building of the subway, and it was constructed without as much disruption to the streets as had been anticipated.

Municipal governments at the time were notorious for being small- minded, underachieving bureaucracies too easily intimidated by business interests and susceptible to corruption. Boston had defied all of those labels and even managed to preserve the one piece of land its people cherished the most, Boston Common. The uncovering of 910 bodies in the path of the subway route was an unfortunate finding, but the delicate handling of it had mitigated the public's worries. The subway was a success by every measure before it even opened. And as small flags waved amid the deafening cheers, the crowd almost seemed to be clamoring for someone to stop and recognize the achievement.

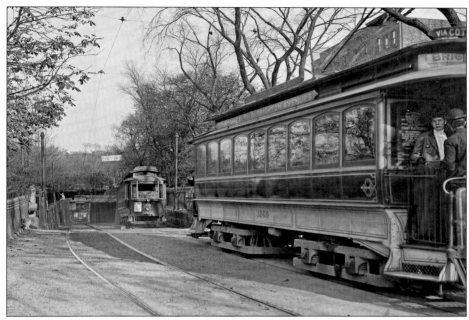

*Descent into subway, Public Garden, c1904. (Library of Congress, 4a17211)*

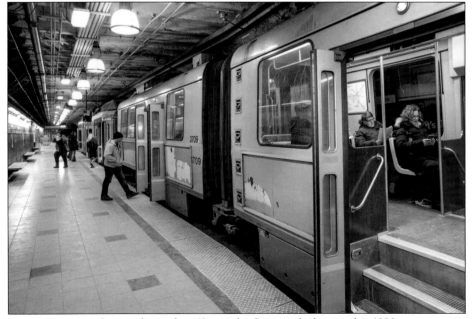

*Green Line train about to depart from Haymarket Station which opened in 1898.*

It had been ten years since two men, businessman Henry Whitney in Boston and Mayor Abram Hewitt in New York, first made serious overtures about tunneling beneath their cities. A decade later, one of those cities stood at the brink of history while the other had yet to put a shovel into the ground. For Boston, that was satisfaction enough.

By now Reed's car was so crowded it seemed in danger of tipping over, and it was difficult to imagine the electric motor having enough power to move it. Reed clanged his gong and switched on the electric current, and Allston car number 1752 eased forward, crested the hill, dipped down the incline, and disappeared beneath Boylston Street. The passengers in the front seats stood up on their tiptoes and leaned forward, peering ahead to see what sights awaited them.

And from the rear, a shout rang out. "Down in front!"

This essay by Doug Most is excerpted from his book, *"The Race Underground: Boston, New York, and the Incredible Rivalry That Built America's First Subway* (St. Martin's Press, 2014). *The New York Times* called it "a sweeping narrative of late 19th-Century intrigue and *The Week* named it one of "18 Books to Read in 2014." More information can be found at www.dougmost.com. Most is a deputy managing editor at *The Boston Globe.*

*The Race Underground: Boston, New York, and the Incredible Rivalry That Built America's First Subway* (St. Martin's Press, 2014)

*Today, architectural remnants incorporated into the new Dudley Street bus station evoke the grand era of the El when all of its elegance could be had for a nickel.*

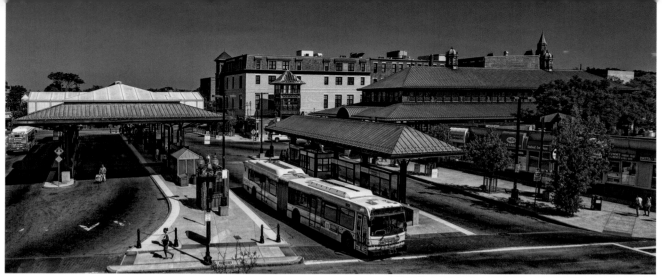

*Much of the roof structure in the 1904 image below was saved and incorporated into the Dudley Street Bus Station of today (above). (Below) Looking north at Dudley Street Station's northbound platforms in 1904, with the streetcar loops on each side. Dudley Station served Orange Line trains on the Washington Street Elevated in Roxbury from 1901 to its closing in 1987. (Library of Congress 4a30013)*

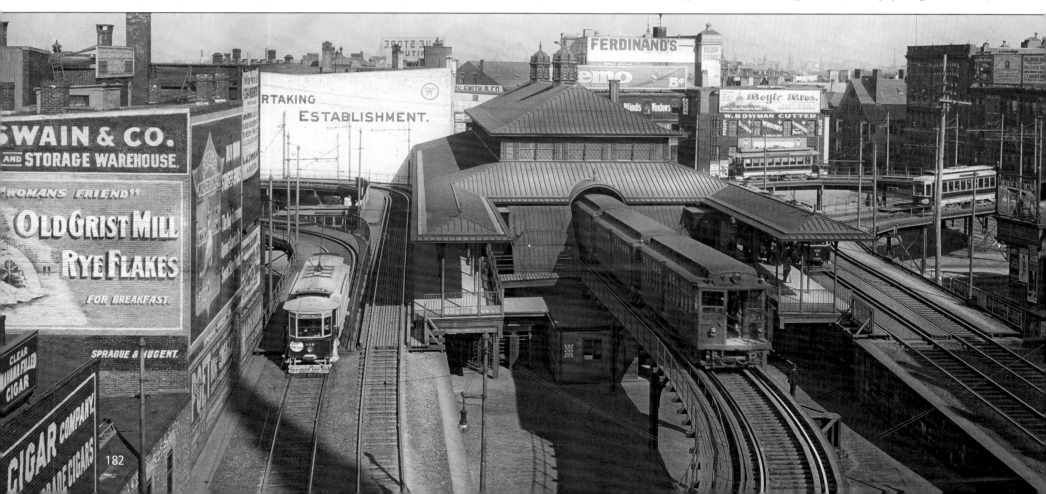

The Boston Elevated Railway broke ground in 1899 for a new transit service that opened in 1901, providing a seven-mile elevated railway that connected Dudley Street Station in Roxbury and Sullivan Square Station in Charlestown, two huge multilevel terminals. When the EL, as it was popularly known, opened for service, it offered an unencumbered route high above the surging traffic of Boston, until it went underground through the city.

The new trains of the EL were elegant coaches of African mahogany, bronze hardware, plush upholstered seats, plate glass windows, and exteriors of aurora red with silver gilt striping and slate gray roofs.

They stopped at ten equally distinguished train stations, designed by the noted architect Alexander Wadsworth Longfellow. All of this elegance, let alone convenience, could be had for the price of a five-cent ticket. The popularity of the EL was instantaneous. The railway continued to provide transportation service high above Boston's streets until 1987, when it was unfortunately ended after 86 years of elevated operation.

Today, the squealing wheels of the Elevated trains, the rocking coaches, the fascinating views, and the fanciful copper-roofed stations of the line are a missing part of the character of Boston, when one could ride high above the city for a nickel.

Frank Cheney and Anthony Mitchell Sammarco,
*When Boston Rode the EL*, Arcadia (2000) (Jacket description)

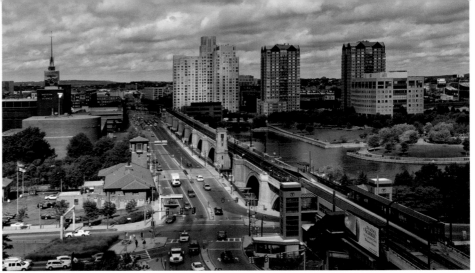

*While this beautiful bridge has survived into the 21st Century, the industrial buildings and railway yards of the early 20th Century have been replaced by North Point Park, a new office building and condos. The Science Park T Station has been artfully added to the south end of the bridge.*

*East Cambridge looking towards downtown Boston, 1910-1920. (Library of Congress, 4a24492)*

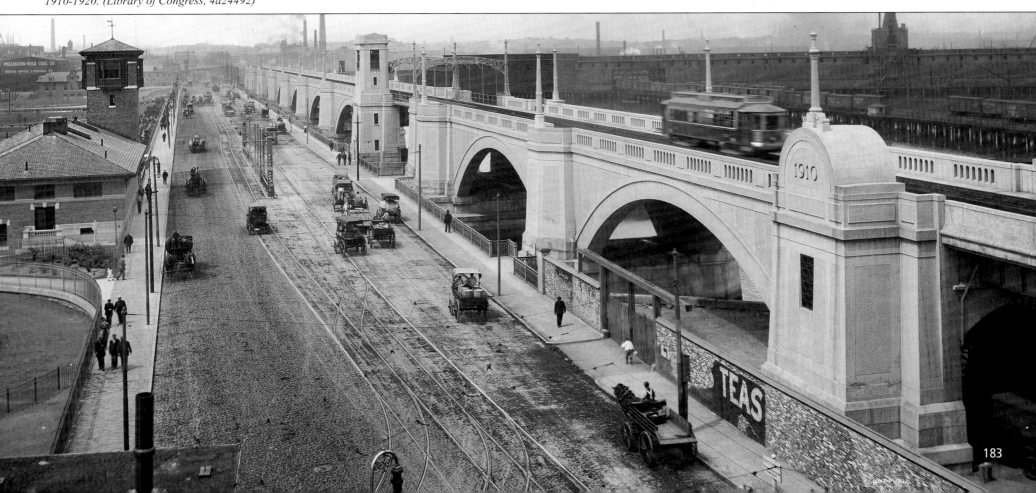

183

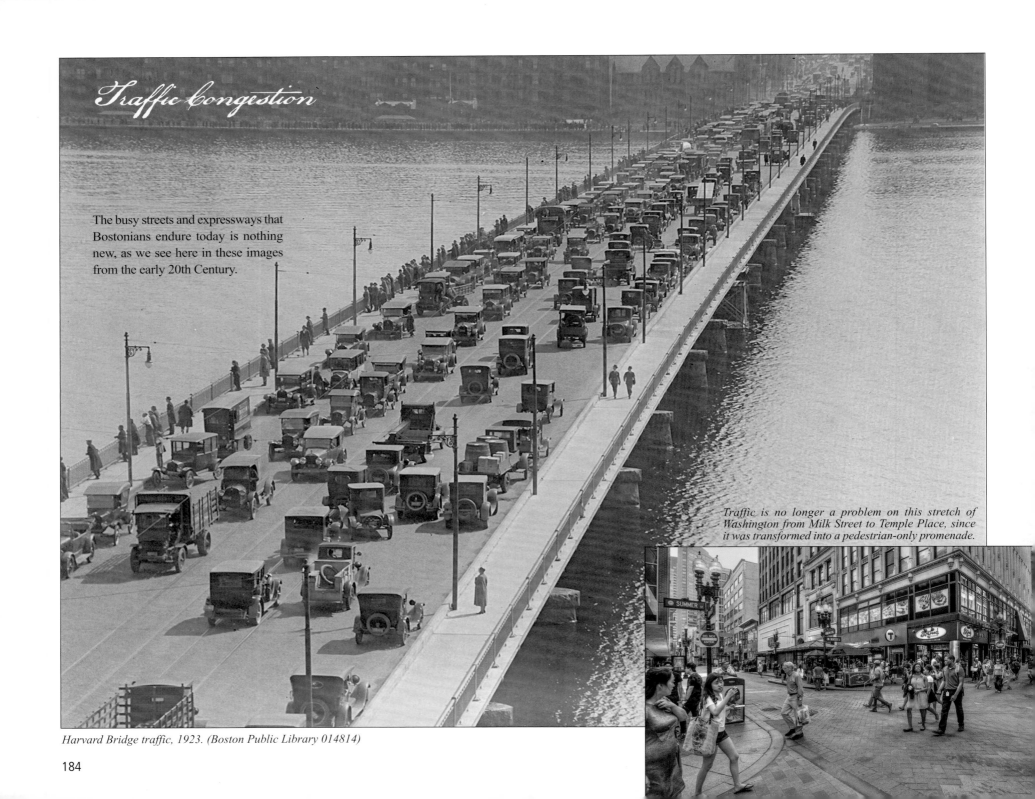

# Traffic Congestion

The busy streets and expressways that Bostonians endure today is nothing new, as we see here in these images from the early 20th Century.

*Traffic is no longer a problem on this stretch of Washington from Milk Street to Temple Place, since it was transformed into a pedestrian-only promenade.*

*Harvard Bridge traffic, 1923. (Boston Public Library 014814)*

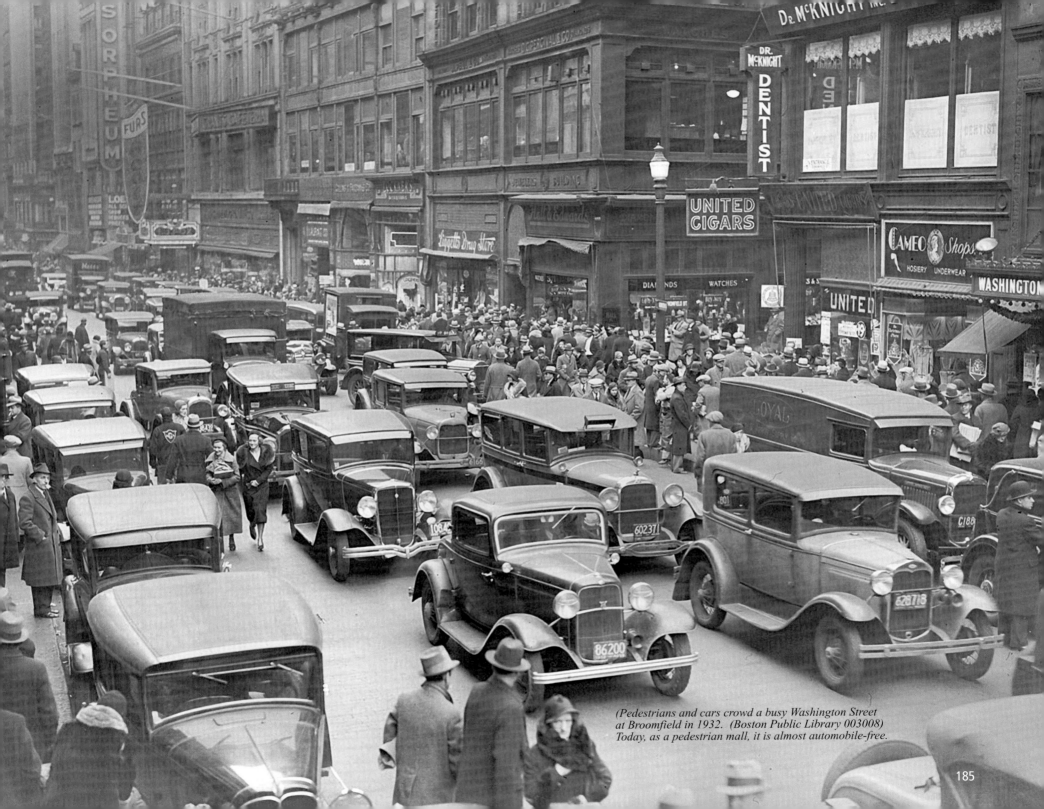

*(Pedestrians and cars crowd a busy Washington Street at Broomfield in 1932.  (Boston Public Library 003008) Today, as a pedestrian mall, it is almost automobile-free.*

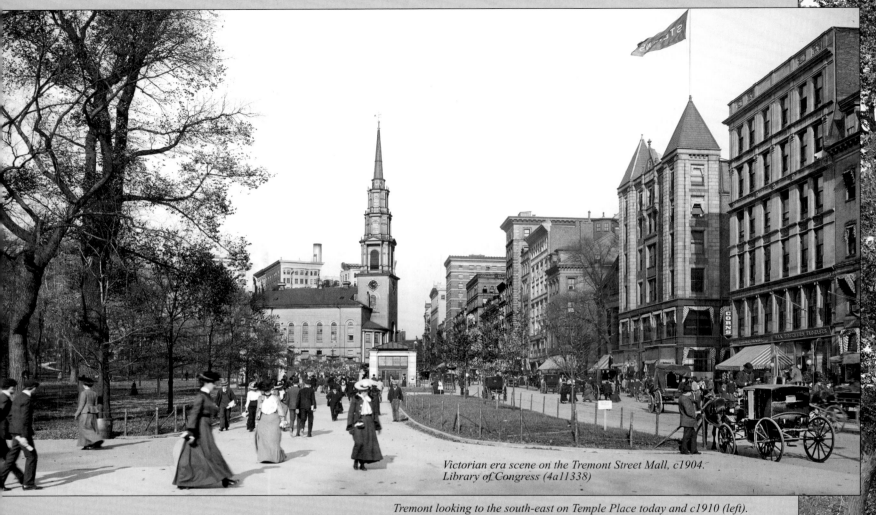

Victorian era scene on the Tremont Street Mall, c1904.
Library of Congress (4a11338)

Tremont looking to the south-east on Temple Place today and c1910 (left).

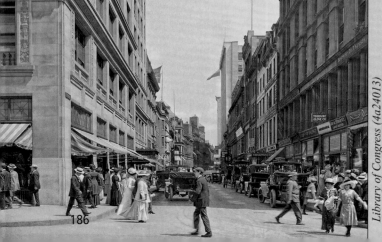

Library of Congress (4a24013)

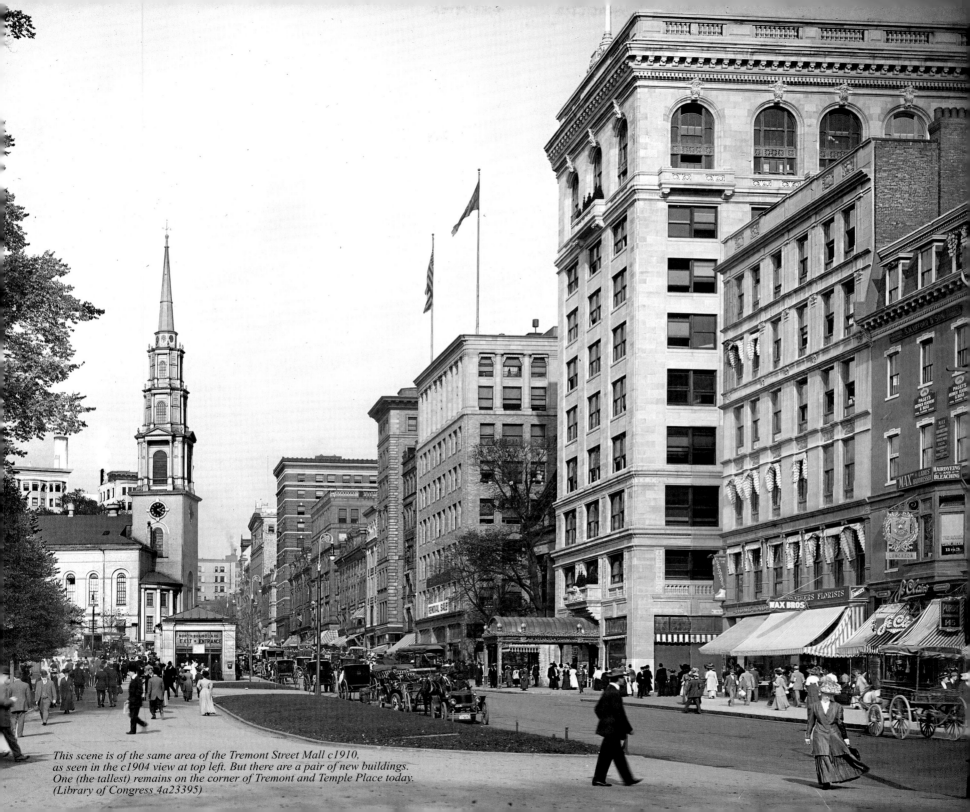

*This scene is of the same area of the Tremont Street Mall c1910,
as seen in the c1904 view at top left. But there are a pair of new buildings.
One (the tallest) remains on the corner of Tremont and Temple Place today.
(Library of Congress 4a23395)*

# Boston Common

THE NATION'S OLDEST PUBLIC PARK, THE FORTY-EIGHT ACRES OF THE Boston Common have belonged to the citizens of Boston since 1634. That's when each householder paid a minimum of six shillings toward its purchase from William Blackstone, the first European settler in Boston.

The original Common was gently rolling scrubland, sloping gradually from Beacon Hill to the tidal marshes of Back Bay. The original water line roughly followed today's Charles Street. It was only lightly wooded, with perhaps three trees of notable size, including the legendary "Great Elm." Of the four original hills and three ponds, only Flagstaff Hill and the Frog Pond are now discernible.

*Until the early19th Century, the Common, rough and rural, was well suited as a pasture, its primary purpose.*
*Beacon Street and the Common, 1808. John Ruebens Smith, Boston Public Library (003726)*

The 17th Century Common, rough and rural, was well suited as a pasture, its primary purpose. The village herd of 70 milk cows grazed peacefully, watched over by a town-appointed keeper. The Common was also a frequent site for hangings and other forms of execution of murderers, thieves, deserters, pirates, "witches," Indians, and religious dissenters, especially Quakers. The story of the 18th-Century Common is dominated by the events surrounding the Revolution.

British troops occupied the town, and by 1775 the Common was an entrenched camp with a garrison of 1,750 men. The British troops set off from the Common for encounters at Lexington and Concord and later at Bunker Hill. Following the British evacuation in March 1776, Bostonians reclaimed the Common. It was here that a huge bonfire blazed to celebrate the surrender at Yorktown in October 1781.

*Gentrification of the Common began slowly in the first decades of the 19th Century. The few cows remaing in thes view would be banished in 1830.*
*Boston Common, 1829. James Kidder, Boston Public Library (003955)*

189

As Boston grew and prospered in a new nation, its inhabitants saw in their historic Common a precious heritage. New residences, many of them by Charles Bulfinch, arose along the bordering streets, and the Common gradually became more park than pasture. By 1830, the city had banished the cows, filled several ponds, and added tree-lined malls and paths. In 1836 the entire space, a mile in perimeter, was enclosed with a handsome iron fence financed in part by public subscription.

In an age of optimism and public display, the 19th-Century Common played host to an extraordinary chronicle of events, both serious and fanciful, including balloon ascensions and early football. During the Civil War, the Common witnessed anti-slavery protests, recruitment rallies, a wild victory celebration, and then a mass demonstration of grief at the death of President Lincoln.

The 20th Century was a time of change for the Common. The malls accommodated the nation's first subway, in 1897. Two world wars brought victory gardens, war bond rallies, troop entertainment, and victory parades. The Common was the site of historic events like speeches by national figures such as Martin Luther King Jr., the protest rallies of the 1960s, and in 1979 the first papal mass in North America. By the 1970s the Common had suffered from many years of neglect, with half of its trees lost, the Frog Pond empty, fountains defunct, fencing removed, and a grave imbalance of use and care. In recent decades, public-private efforts have brought notable improvements including new fencing, a refurbished playground and bandstand, a rejuvenated Frog Pond with an artificial ice rink and restoration of the Brewer Fountain.

Today, the historic Boston Common attracts hundreds of thousands of people every year, both residents and visitors. It is a place of sports, informal and organized; exhibitions; musical events; a Shakespeare festival; rallies and protests; charity walks and art shows; and on New Year's Eve, Boston's famous First Night. Once a year, by long custom, the Ancient and Honorable Artillery Company, formed in 1638, marches again before the dignitaries of the day.

*Friends of the Public Garden*  friendsofthepublicgarden.org

*Group enjoying the delights of a stroll on the Long Walk, c1910. The Frog Pond is just visible through the trees on the right, Library of Congress (4a24015)*

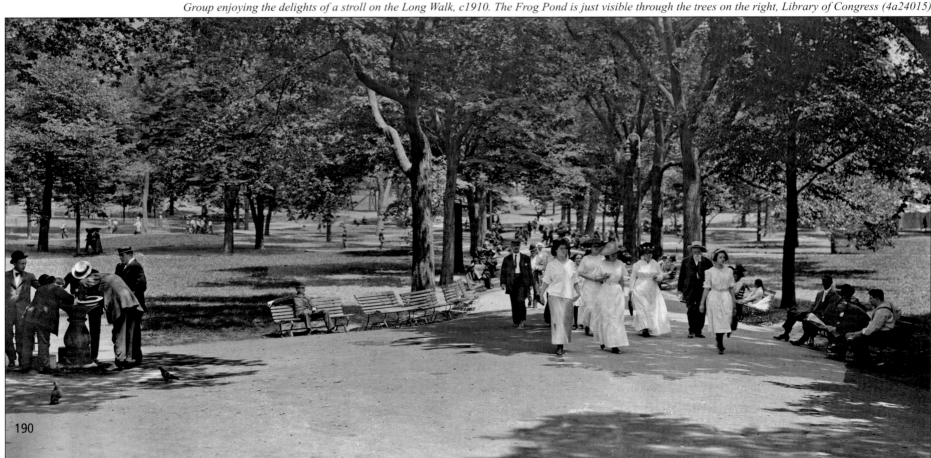

*A bronze statue of the ducklings by Nancy Schön is a popular attraction in Boston Public Garden.*

*Weeping willow beside the Lagoon in the Public Garden provides a bit of shade for quiet contemplation, a good read or family photos.*
*A century later the appeal of a stroll on the Long Walk has lost none of its appeal.*

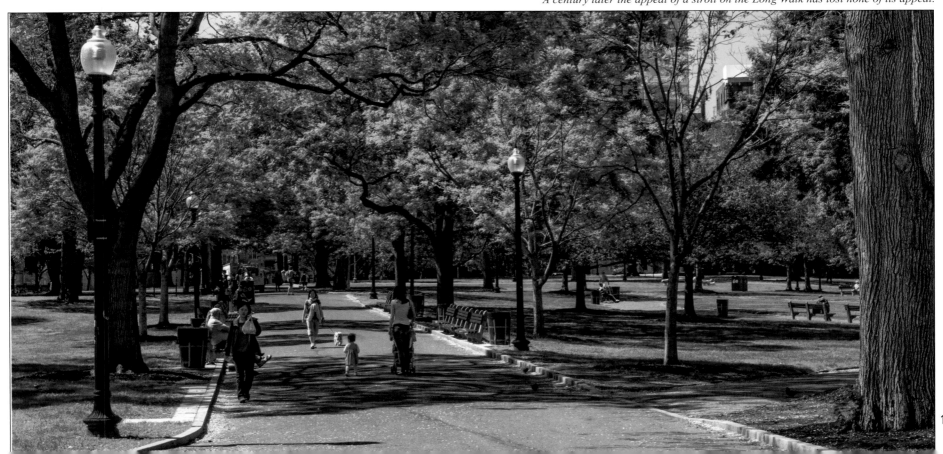

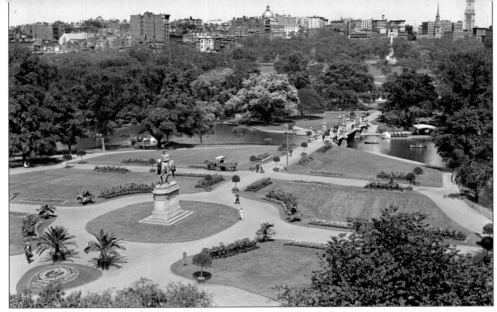

*View of the Public Garden from the the Ritz Carleton Hotel, then under construction in 1926, (Leslie Jones, Boston Public Library 003726)*

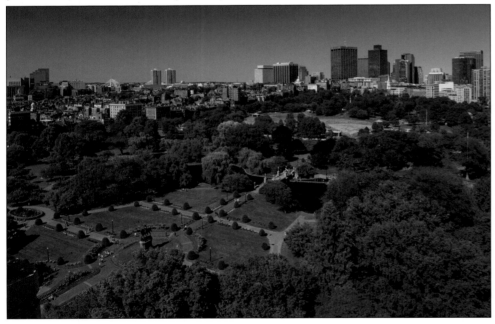

*Panoramic view of the Public Garden, the Common, Beacon Street and the downtown core, from the roof of the Taj Boston (formerly the Ritz Carleton). While almost 90 years separate these images the parks still maintain their original appearance, in stark contrast to the dramatic changes in their architectural surroundings. This aspect is really brought home in the large aerial view that further illustrates Boston's unique feature, The Back Bay and Beacon Hill also retain much of their 19th-Century character, while the downtown has been radically transformed since 1949, when the Custom House tower (just visible at top right in the black and white photo) dominated the skyline.*

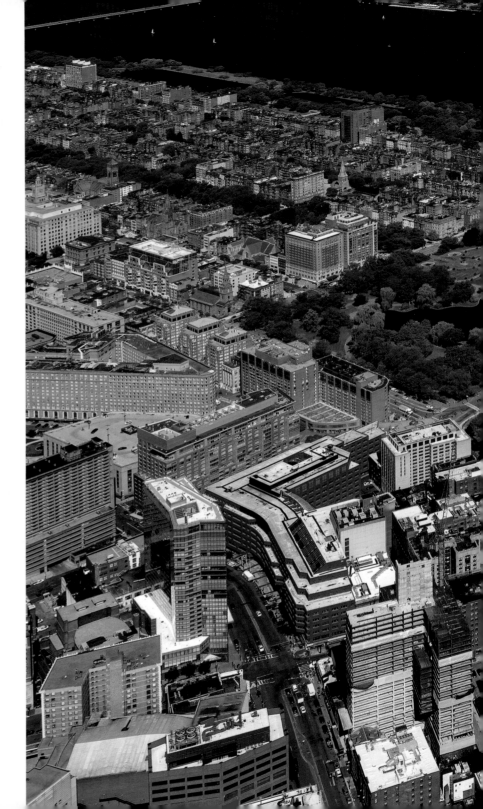

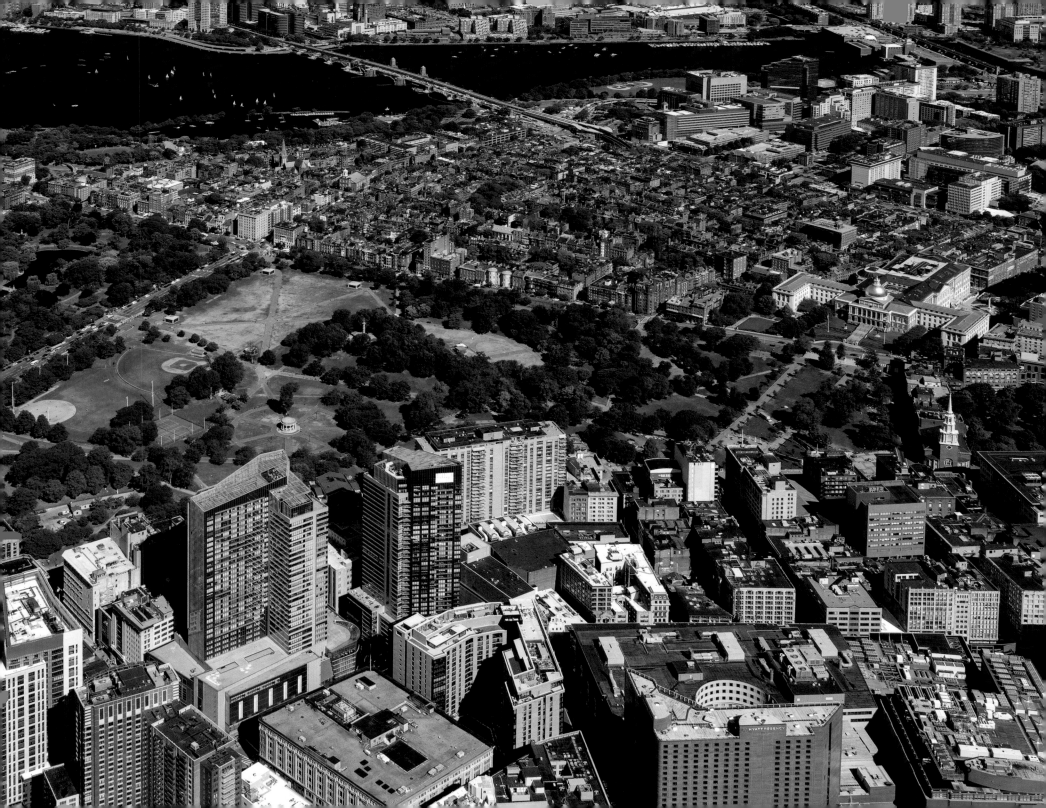

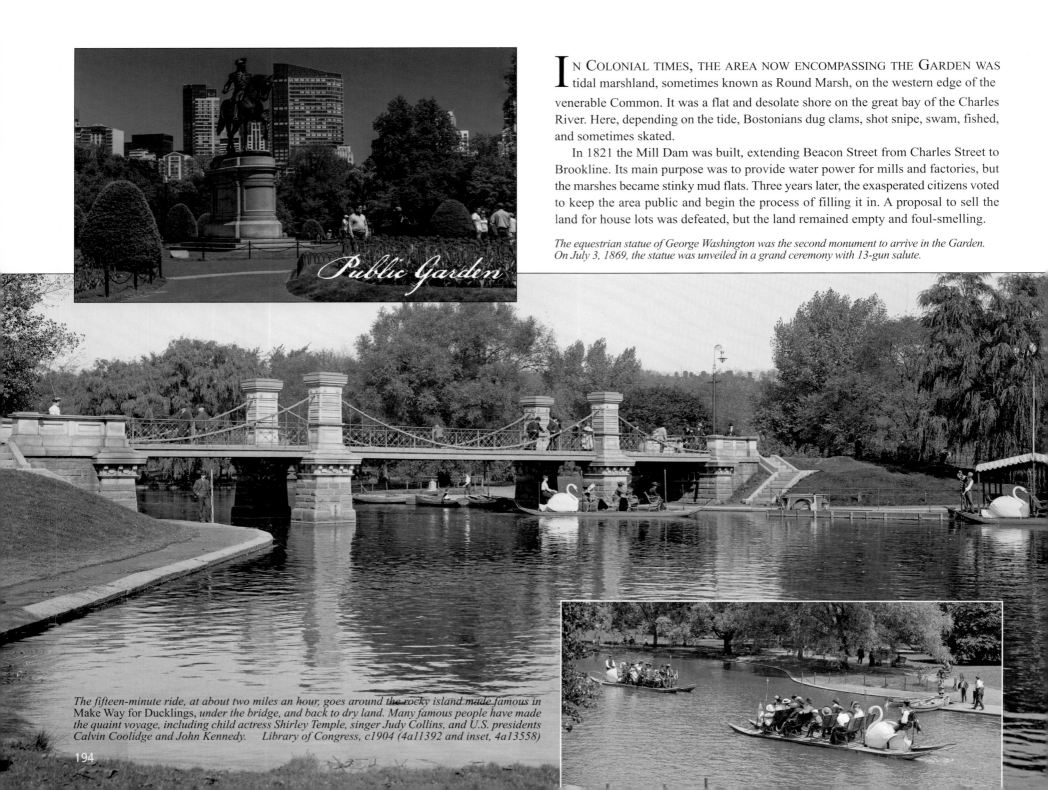

*Public Garden*

IN COLONIAL TIMES, THE AREA NOW ENCOMPASSING THE GARDEN WAS tidal marshland, sometimes known as Round Marsh, on the western edge of the venerable Common. It was a flat and desolate shore on the great bay of the Charles River. Here, depending on the tide, Bostonians dug clams, shot snipe, swam, fished, and sometimes skated.

In 1821 the Mill Dam was built, extending Beacon Street from Charles Street to Brookline. Its main purpose was to provide water power for mills and factories, but the marshes became stinky mud flats. Three years later, the exasperated citizens voted to keep the area public and begin the process of filling it in. A proposal to sell the land for house lots was defeated, but the land remained empty and foul-smelling.

*The equestrian statue of George Washington was the second monument to arrive in the Garden. On July 3, 1869, the statue was unveiled in a grand ceremony with 13-gun salute.*

*The fifteen-minute ride, at about two miles an hour, goes around the rocky island made famous in Make Way for Ducklings, under the bridge, and back to dry land. Many famous people have made the quaint voyage, including child actress Shirley Temple, singer Judy Collins, and U.S. presidents Calvin Coolidge and John Kennedy.     Library of Congress, c1904 (4a11392 and inset, 4a13558)*

Throughout the ensuing years, citizen groups successfully opposed city plans to sell the land. In the final settlement of state, city, and private claims in the Back Bay, it was agreed that the area between Charles and Arlington Streets would be devoted forever to public use. In the next decade the city filled the remaining area and laid out its 24 acres according to the landscape plan of architect George F. Meacham, winner of a public competition that paid $100. The plan contained many features notable in today's Garden, including the serpentine lagoon and winding paths. The 1860s brought further enhancements: four granite basins with fountains; the perimeter iron fence and gates; the bridge crossing the lagoon, the equestrian statue of George Washington and the Ether Monument, commemorating the use of ether in anesthesia.

By 1880 the Garden numbered among its choice collection of plants 1500 trees, and each spring bedding plants provided ribbons of color along the principal paths.

In 1877 the Swan Boats, designed by Robert Paget, first appeared on the lagoon. The boats were an immediate and enduring attraction. A lover of opera, Paget had been inspired by the finale of Richard Wagner's *Lohengrin*, when the hero crosses a river in a boat drawn by a swan. He designed a new boat, with a foot-propelled paddle mechanism enclosed by the figure of a giant swan. They remain the only boats of their kind in the world and today, the fourth generation of Pagets still operate the Swan Boats, continuing a cherished tradition..

www.friendsofthepublicgarden.org

*In these 21st Century view it is fun to see how little has changed in over 100 years of 'swan boating' on the Lagoon in the Public Garden.*

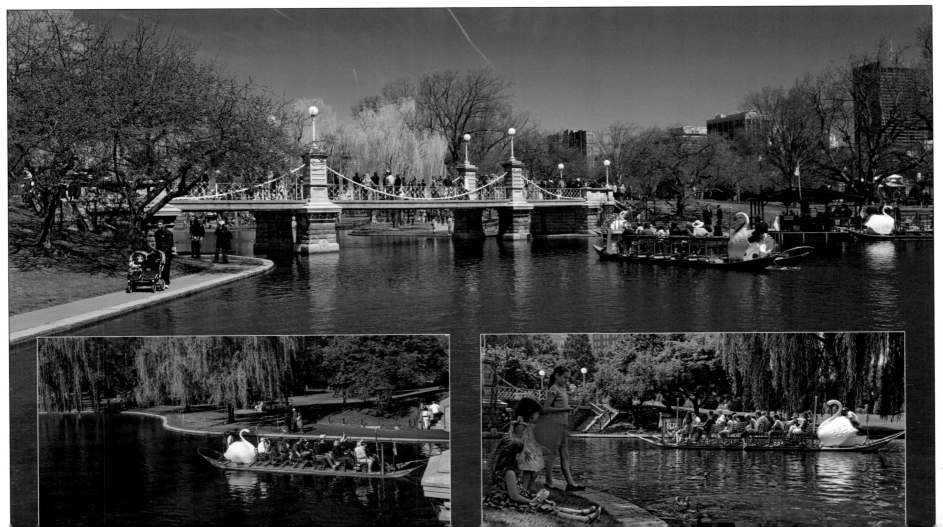

195

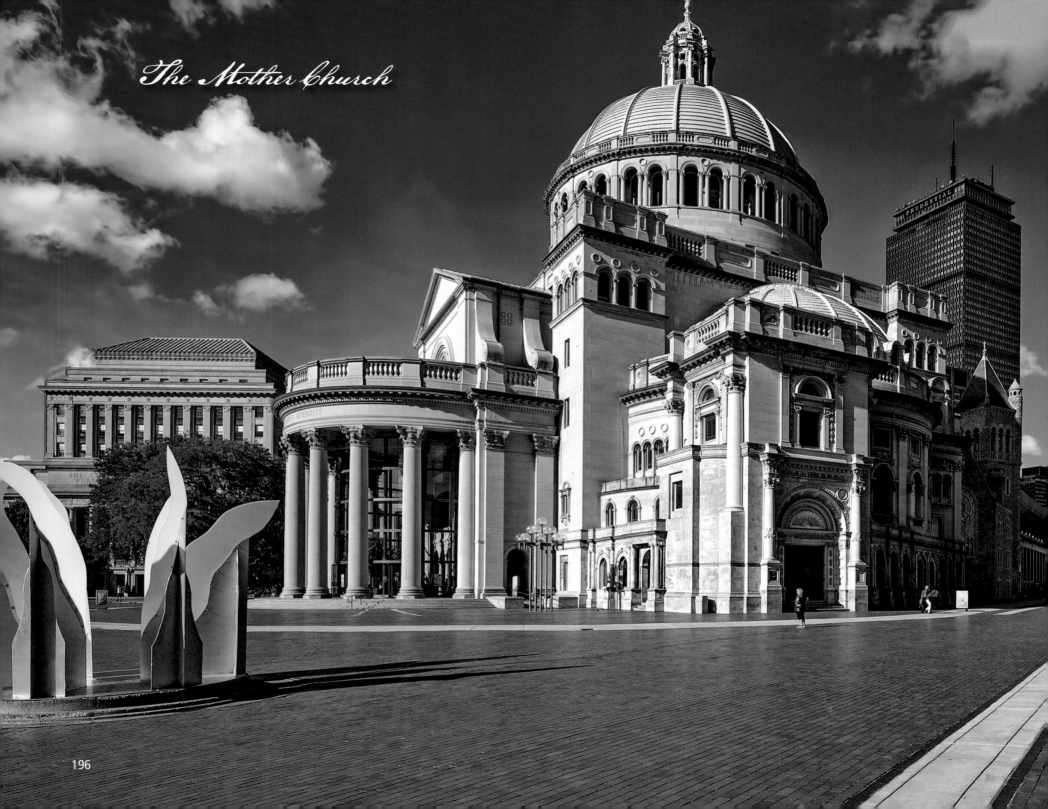

The Mother Church

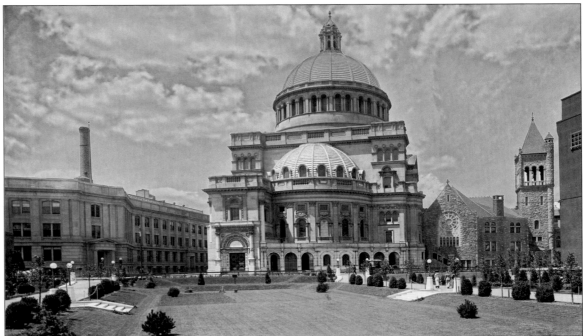

*Christian Science Church, 1910-1920. (Library of Congress (4a24018))*

The Original Mother Church is at the heart of the Christian Science Plaza and remains today much as it was when first built. The building was completed in 1894 in just 13 months' time. Designed by architect Franklin I. Welch of Malden, Massachusetts, the Church is reminiscent of the Romanesque architectural style. The exterior of the building is New Hampshire granite. The sanctuary seats about 900 people. Inside the sanctuary, frescoes stenciled by Italian artisans and finished off freehand decorate the upper part of the walls. Mosaic work around the lower part of the walls, the front platform, and the floor was done in the traditional style with each individual piece of stone set separately. The floor is white Italian marble. The pews, desk, and front of the organ are of red birch from eastern Canada.

The large, domed Mother Church Extension was designed by Charles Brigham and Charles Coveney of Boston, and Solon Beman of Chicago, and completed by 1906 in just 23 months. The outside of the building is Italian Renaissance to match the architecture in Boston at that time. The dome is in the Byzantine style. The inside of the dome is purely decorative, with electric lamps simulating natural light. The exterior of the dome rises to more than twice the height of the interior dome, or 224 feet. Because of the small plot of land, the Church edifice was built upward instead of outward, so the sanctuary, which seats over 3,000 people, is located on the second floor.

*The Mother Church is located on the picturesque Christian Science Plaza.*
*There are beautiful buildings and gardens, a fountain, and a reflecting pool.*

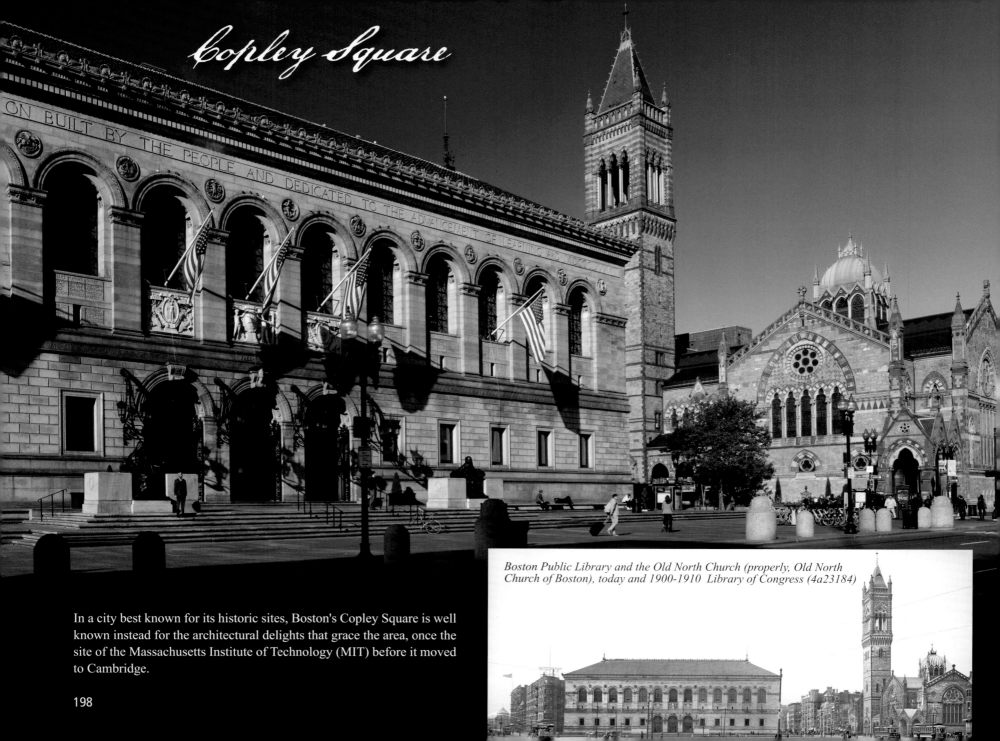

# Copley Square

ON BUILT BY THE PEOPLE AND DEDICATED TO THE ADVANCEMENT OF LEARNING A.D. MDCCCLXXXVIII

In a city best known for its historic sites, Boston's Copley Square is well known instead for the architectural delights that grace the area, once the site of the Massachusetts Institute of Technology (MIT) before it moved to Cambridge.

198

*Boston Public Library and the Old North Church (properly, Old North Church of Boston), today and 1900-1910  Library of Congress (4a23184)*

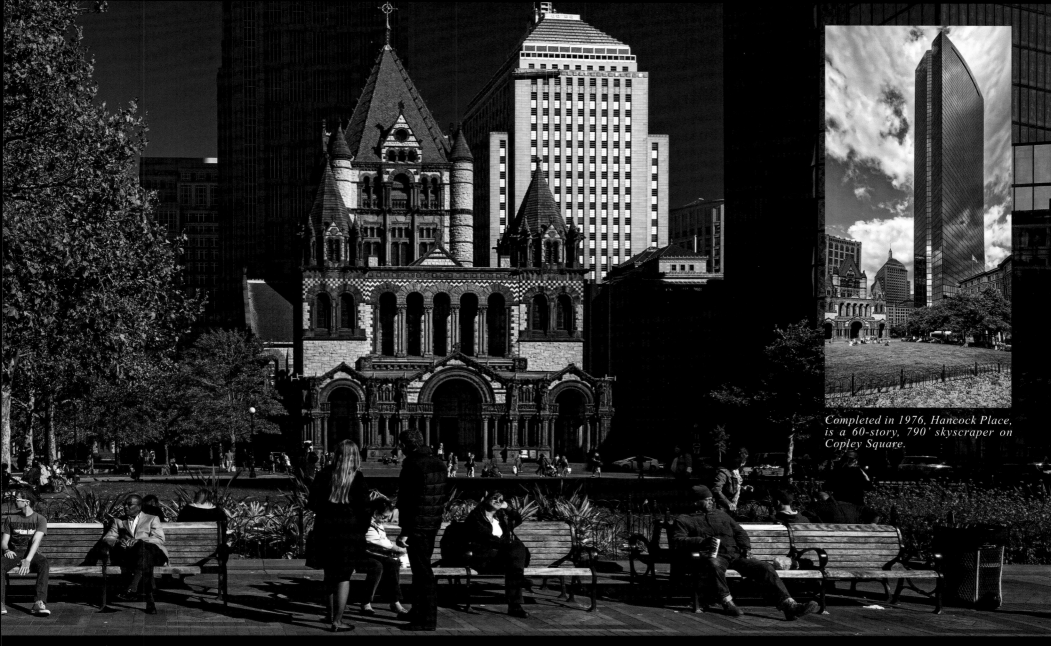

Completed in 1976, Hancock Place, is a 60-story, 790' skyscraper on Copley Square.

Anchoring the east side of Copley Square is Trinity Church, probably the most prominent landmark in a green space richly endowed on all sides with 19th Century, architectural gems. Also overlooking the square are the three John Hancock Insurance buildings (seen here in the background and at right).

"Trinity Church and the John Hancock building reflect a contrast of building techniques. The great mass of the solid stone of Trinity Church was of concern to the builders of the church, and H.H. Richardson ultimately reduced the height of the tower to reduce the weight. The John Hancock Building of 100 years later uses a light skeleton of metal which allows soaring height and an elegant curtain wall of glass." Jeffery Howe, Boston College

COPLEY SQUARE IS A SQUARE IN EVERY SENSE OF THE WORD. SINCE 1994, the streets have been configured in a square shape with equilateral sides. Located in the Back Bay area of Boston, you'll find both residents and visitors enjoying the greenery of the park as well as the magnificent buildings that surround the square.

By standing in the middle of Copley Square and turning from side to side, you have an eyeful of buildings in a variety of styles–from decidedly old to quite new.

Probably the most prominent landmark on the square is Trinity Church, designed by Henry Hobson Richardson and built between the years of 1872 and 1877. The style of the church has come to be known as "Richardson Romanesque" and has served well to establish the architect's fine reputation. Its clay roof, huge arches, and tall tower seem more reminiscent of Europe than 19th-Century America. It is continually lauded as one of the top ten buildings in America.

The wonderful Boston Public Librarysits on another corner of Copley Square. Opened in 1895, it was the first publicly supported municipal library in America. The architect was Charles F. McKim of the famed architectural firm of McKim, Mead, and White. It was the first library to include a children's room. The façade is meant to resemble an Italian palazzo in Rimini. This public facility houses the personal library of President John Adams.

Also overlooking the square are the three John Hancock Insurance buildings. The old John Hancock Building, now called the Berkeley Building, was for several decades the second tallest building in Boston, standing 26 stories in height. The John Hancock Tower, designed by Chinese architect I.M. Pei, is now the tallest building in New England, at 791 feet and 60 stories high. It is a modernist glass, monolithic skyscraper. Each bay of each floor is a single pane of glass. The highly reflective glass is tinted blue. There is a public observation deck at the top of the tower.

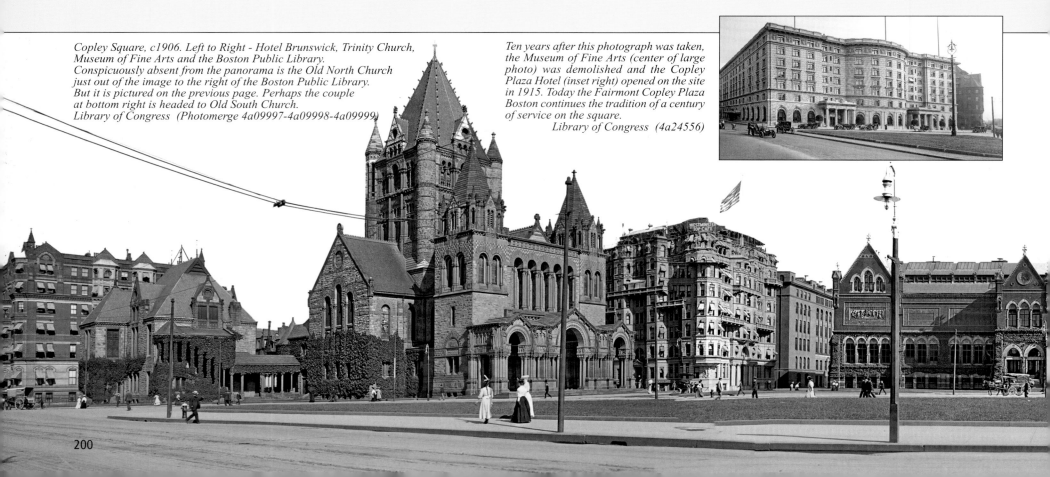

*Copley Square, c1906. Left to Right - Hotel Brunswick, Trinity Church, Museum of Fine Arts and the Boston Public Library.*
*Conspicuously absent from the panorama is the Old North Church just out of the image to the right of the Boston Public Library. But it is pictured on the previous page. Perhaps the couple at bottom right is headed to Old South Church.*
*Library of Congress (Photomerge 4a09997-4a09998-4a09999)*

*Ten years after this photograph was taken, the Museum of Fine Arts (center of large photo) was demolished and the Copley Plaza Hotel (inset right) opened on the site in 1915. Today the Fairmont Copley Plaza Boston continues the tradition of a century of service on the square.*
*Library of Congress (4a24556)*

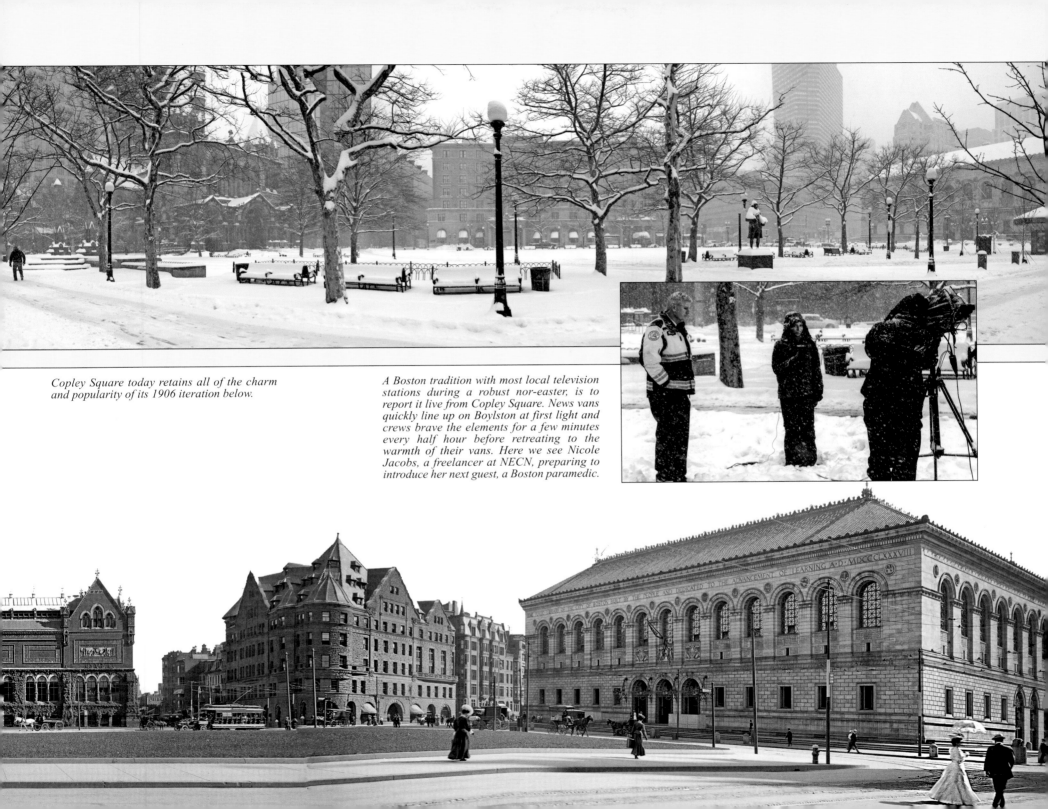

*Copley Square today retains all of the charm and popularity of its 1906 iteration below.*

*A Boston tradition with most local television stations during a robust nor-easter, is to report it live from Copley Square. News vans quickly line up on Boylston at first light and crews brave the elements for a few minutes every half hour before retreating to the warmth of their vans. Here we see Nicole Jacobs, a freelancer at NECN, preparing to introduce her next guest, a Boston paramedic.*

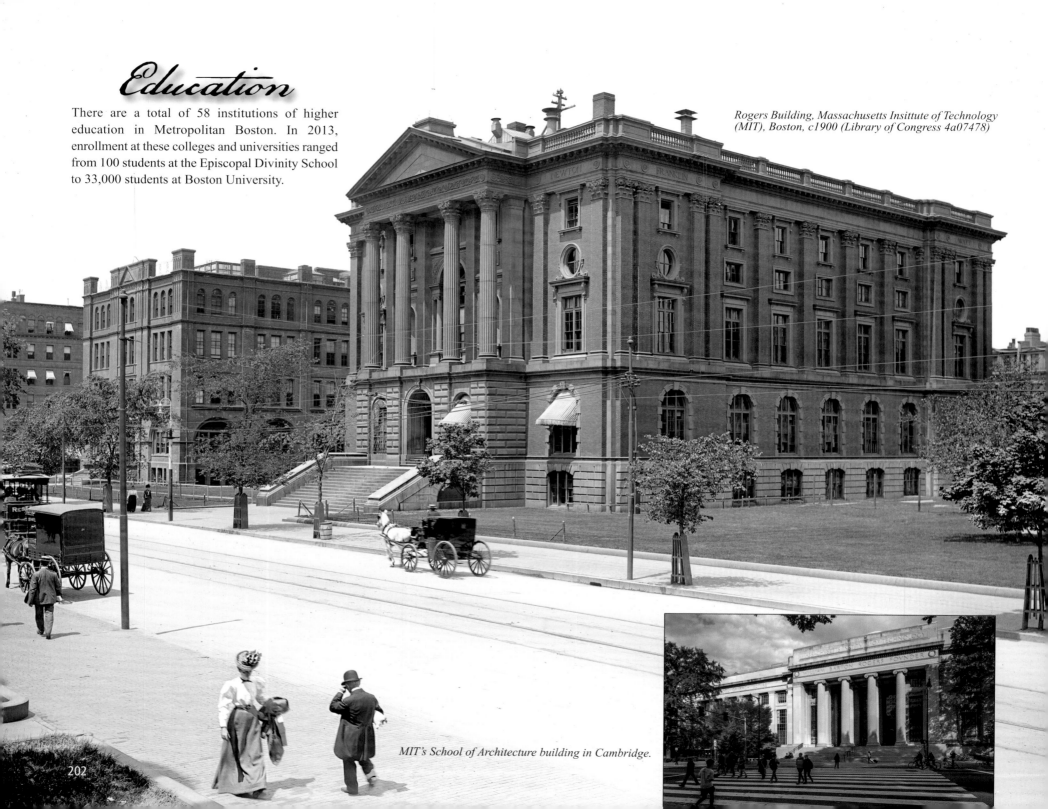

# Education

There are a total of 58 institutions of higher education in Metropolitan Boston. In 2013, enrollment at these colleges and universities ranged from 100 students at the Episcopal Divinity School to 33,000 students at Boston University.

*Rogers Building, Massachusetts Insittute of Technology (MIT), Boston, c1900 (Library of Congress 4a07478)*

*MIT's School of Architecture building in Cambridge.*

As early as 1859, the Massachusetts State Legislature was given a proposal for use of newly opened lands in Back Bay in Boston for a museum and Conservatory of Art and Science.

On April 10, 1861, the governor of the Commonwealth of Massachusetts signed a charter for the incorporation of the "Massachusetts Institute of Technology and Boston Society of Natural History" which had been submitted by William Barton Rogers, a natural scientist. Rogers sought to establish a new form of higher education to address the challenges posed by rapid advances in science and technology in the mid-19th Century, that he believed classic institutions were ill-prepared to deal with.

Imagine if Mr. Rogers could time-travel from his 19th Century to our 21st to see the dramatic results of his remarkable vision.

He would certainly be gratified to see that his institute has remained ever faithful to his wish to "address the challenges posed by rapid advances in science and technolory".

The Mission Statement on the MIT's web site begins; ..."to advance knowledge and educate students in science, technology, and other areas of scholarship that will best serve the nation and the world in the 21st Century. MIT is dedicated to providing its students with an education that combines rigorous academic study and the excitement of discovery with the support and intellectual stimulation of a diverse campus community. We seek to develop in each member of the MIT community the ability and passion to work wisely, creatively, and effectively for the betterment of humankind." These words would seem equally appropriate to all levels of educational institutions.

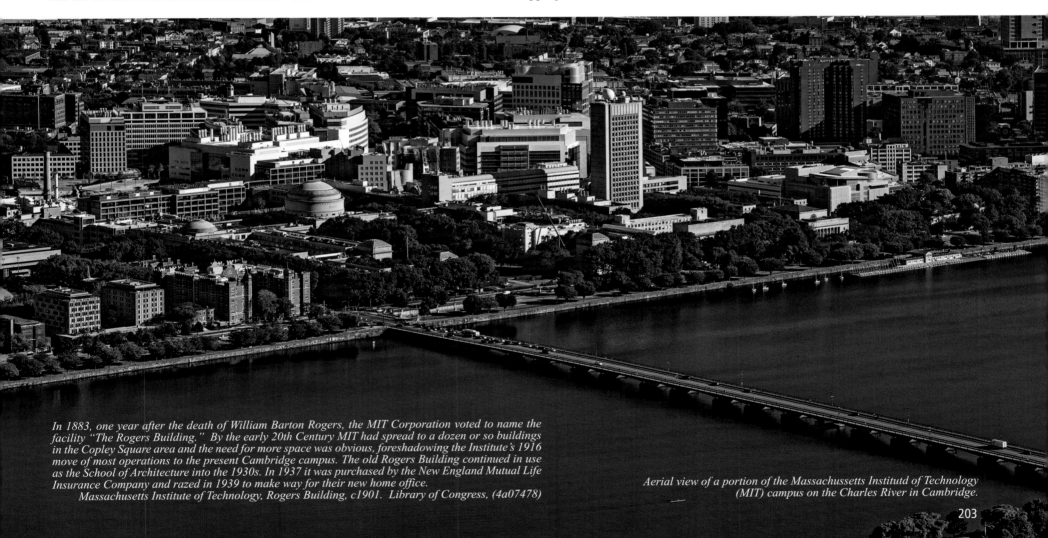

*In 1883, one year after the death of William Barton Rogers, the MIT Corporation voted to name the facility "The Rogers Building." By the early 20th Century MIT had spread to a dozen or so buildings in the Copley Square area and the need for more space was obvious, foreshadowing the Institute's 1916 move of most operations to the present Cambridge campus. The old Rogers Building continued in use as the School of Architecture into the 1930s. In 1937 it was purchased by the New England Mutual Life Insurance Company and razed in 1939 to make way for their new home office.*
*Massachusetts Institute of Technology, Rogers Building, c1901. Library of Congress, (4a07478)*

*Aerial view of a portion of the Massachussetts Institutd of Technology (MIT) campus on the Charles River in Cambridge.*

*Matthews Hall student residence with 60 rooms, completed in 1872, is thought to stand on the site of the original Indian College, built in 1654.*

Harvard is the oldest institution of higher education in the United States, established in 1636 by vote of the Great and General Court of the Massachusetts Bay Colony. It was named after the College's first benefactor, the young minister John Harvard of Charlestown, who upon his death in 1638 left his library and half his estate to the institution. A statue of John Harvard stands today in front of University Hall in Harvard Yard, and is perhaps the University's best-known landmark.

Harvard University has 12 degree-granting Schools in addition to the Radcliffe Institute for Advanced Study. The University has grown from nine students with a single master to an enrollment of more than 20,000 degree candidates including undergraduate, graduate, and professional students. There are more than 360,000 living alumni in the U.S. and over 190 other countries. It has many eminent alumni. Eight U.S. presidents and several foreign heads of state have been graduates. It is also the alma mater of 62 living billionaires and 335 Rhodes Scholars, the most in the country. To date, some 150 Nobel laureates have been affiliated as students, faculty, or staff.

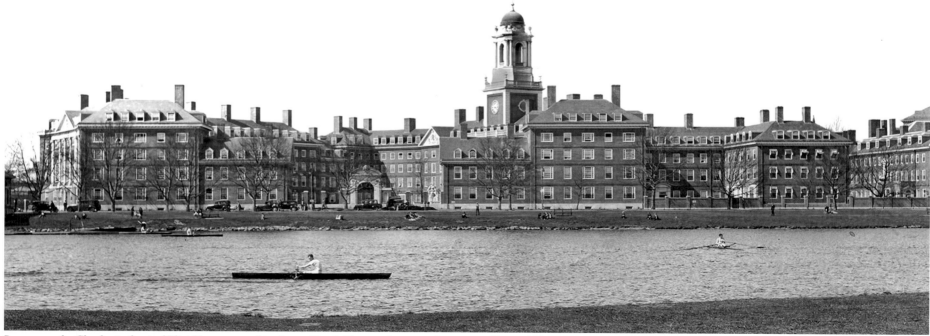

*Rowers on the Charles in front of Eliot House, one of twelve residential houses for upperclassmen at Harvard University, and one of the seven original houses at the College. Opened in 1931, the house was named after Charles William Eliot, who served as president of the university for forty years (1869–1909).*

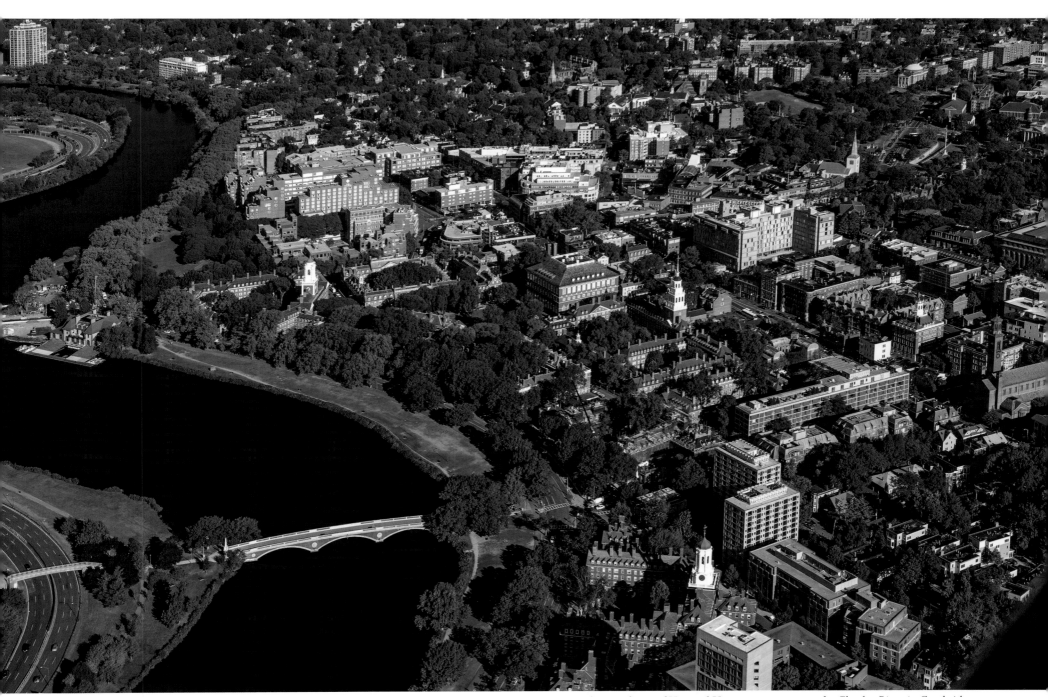

*Aerial view of part of Harvard University campus on the Charles River in Cambridge.*
*Eliot House, pictured at left, can be seen in the trees behind the red-roofed, Weld Boathouse.*

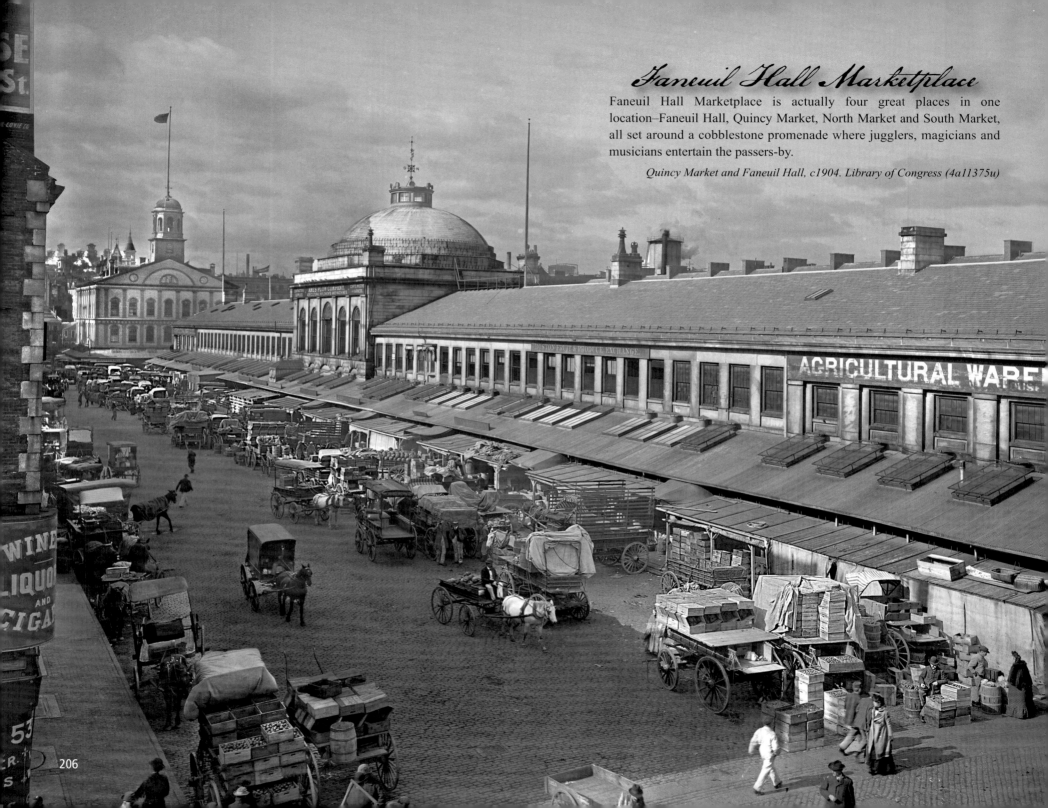

# Faneuil Hall Marketplace

Faneuil Hall Marketplace is actually four great places in one location–Faneuil Hall, Quincy Market, North Market and South Market, all set around a cobblestone promenade where jugglers, magicians and musicians entertain the passers-by.

*Quincy Market and Faneuil Hall, c1904. Library of Congress (4a11375u)*

IN 1742 PETER FANEUIL, BOSTON'S WEALTHIEST MERCHANT, BUILT FANEUIL Hall as a gift to the city. The edifice was home to merchants, fishermen, and meat and produce sellers, and provided a platform for the country's most famous orators.

It is where colonists first protested the *Sugar Act* in 1764 and established the doctrine of no taxation without representation. Firebrand Samuel Adams rallied the citizens of Boston to the cause of independence from Great Britain in the hallowed Hall, and George Washington toasted the nation there on its first birthday. Through the years, Faneuil Hall has played host to many impassioned speakers, from Oliver Wendell Holmes and Susan B. Anthony to Bill Clinton, Ted Kennedy and Barack Obama, always living up to its nickname, The Cradle of Liberty.

To better accommodate the merchants and shoppers, Faneuil Hall was expanded in 1826 to include Quincy Market, which was designed in the then popular Greek Revival style and later dubbed for Boston Mayor Josiah Quincy. The market remained a vital business hub throughout the 1800s; but by the mid-190s, the buildings had fallen into disrepair and many stood empty.

The once thriving marketplace was tagged for demolition until a committed group of Bostonians sought to preserve it in the early 1970s. Through the vision of Jim Rouse, architect Benjamin Thompson and Mayor Kevin White, the dilapidated buildings were revitalized, thoroughly changing the face of downtown Boston. This renovation was the first urban renewal project of its kind, one that spawned imitations in this country and abroad.

*Faneuil Hall Marketpace on a busy October afternoon. Hard to believe that Boston came close to losing these buildings in the urban renewal frenzy of the 1970s.*

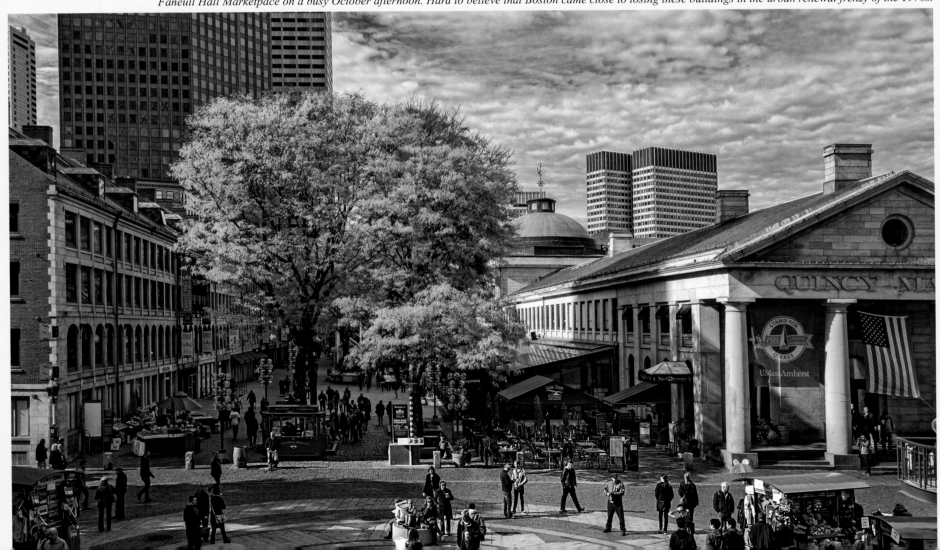

207

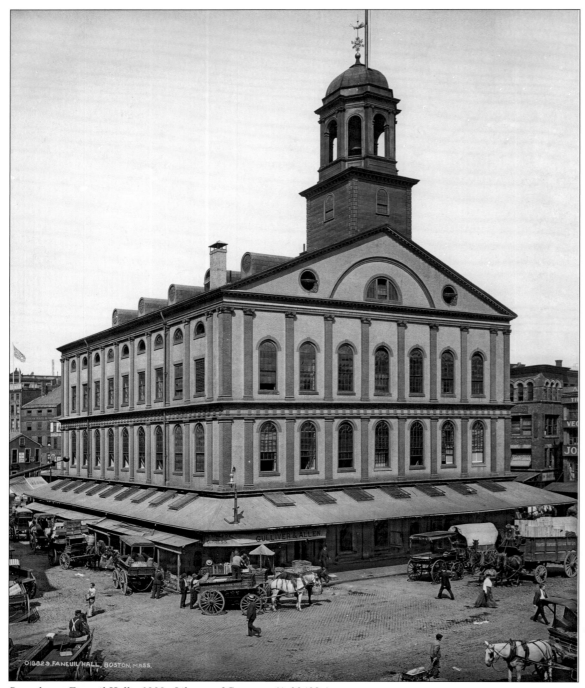

When Boston became a city the use of Faneuil Hall as a government meeting place came to an end, but it was still regularly used for non-governmental events. Today, the first floor contains a lively marketplace and the second floor is a meeting hall where many Boston City debates are held. The fourth floor is maintained by the Ancient and Honorable Artillery Company.

Today, what is known as Faneuil Hall Marketplace is still Boston's central meeting place, offering over 18 million visitors annually an unparalleled urban marketplace. The unique and burgeoning array of shops, restaurants and outdoor entertainments have made it a premiere destination.

*Busy day at Faneuil Hall, c1900. Library of Congress (4a30408u)*

208

*Views of Faneuil Hall from the air and from the 26th-floor observation deck of Marriott's Custom House tower, visible in the background at right.*

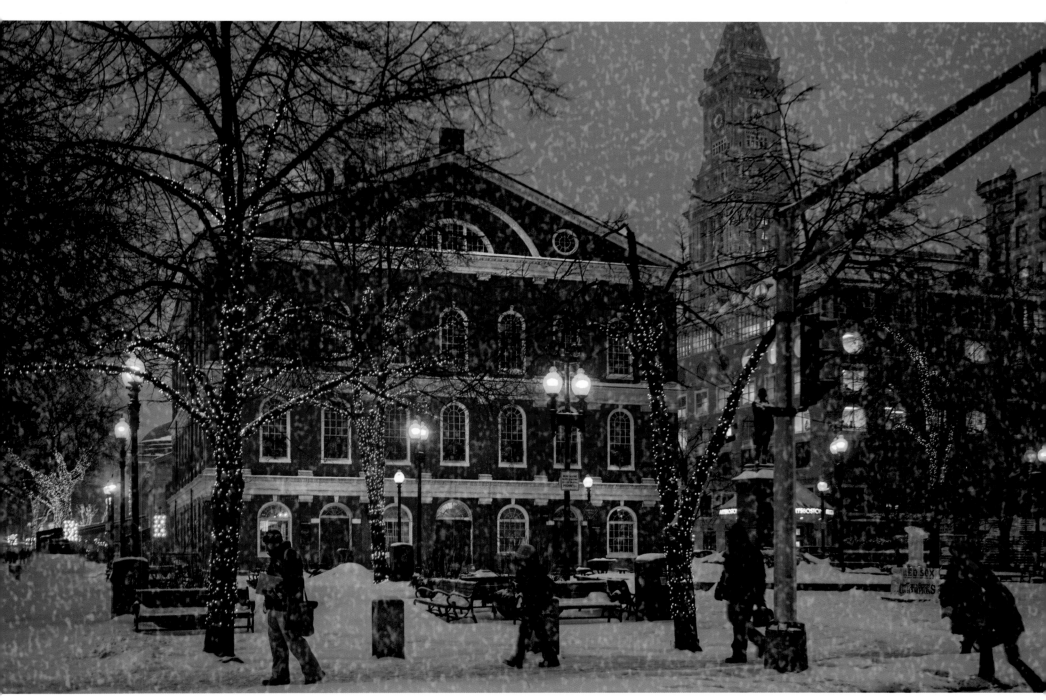

*Faneuil Hall showing off her annual Christmas lighting as viewed from Congress Street.*

209

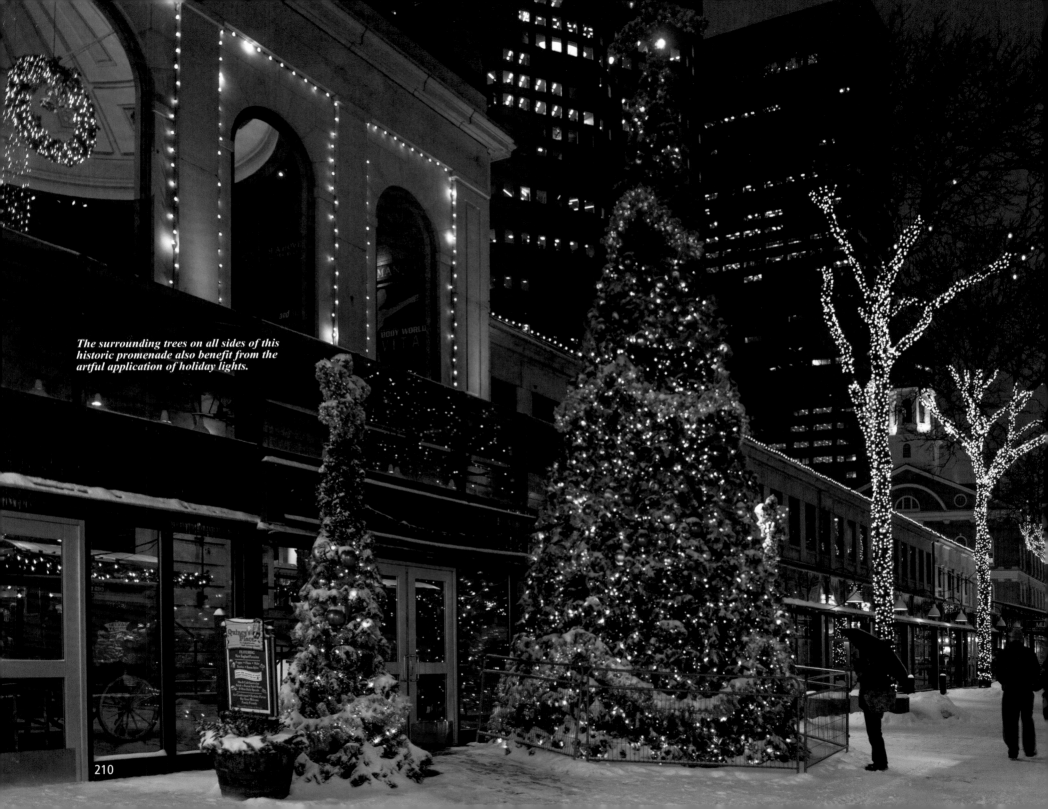

*The surrounding trees on all sides of this historic promenade also benefit from the artful application of holiday lights.*

210

For almost 30 years, over the Christmas-New Year's period, Faneuil Hall Marketplace sparkled with a magnificent display of holiday lights.

This spectacular 80-foot, 12-ton Norwegian Spruce (right) comes from Long Island. It takes 10 people to raise the tree, followed by 12 days to set up and decorate it with 30,000 lights and 1,000 strobes.

Beginning in 2012, the Marketplace launched a new holiday tradition in Boston called Blink! This "light and sound extravaganza" truly brings America's First Open Marketplace alive with the holiday spirit, using over 350,000 LED lights synchronized with the music of the Holiday Pops in a seven-minute spectacle each evening. The lights dance seamlessly to the music through every corner of Faneuil Hall, including the largest Christmas tree in the Northeast.

*Faneuil Hall Marketplace*

*Christmas tree standing near the east entrance to Quincy Market in 2014.*
*Another Christmas Tree can be found on the Tremont Street side of Boston Common (below).*

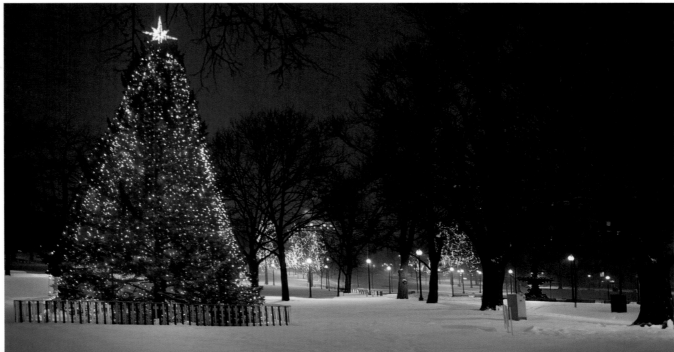

211

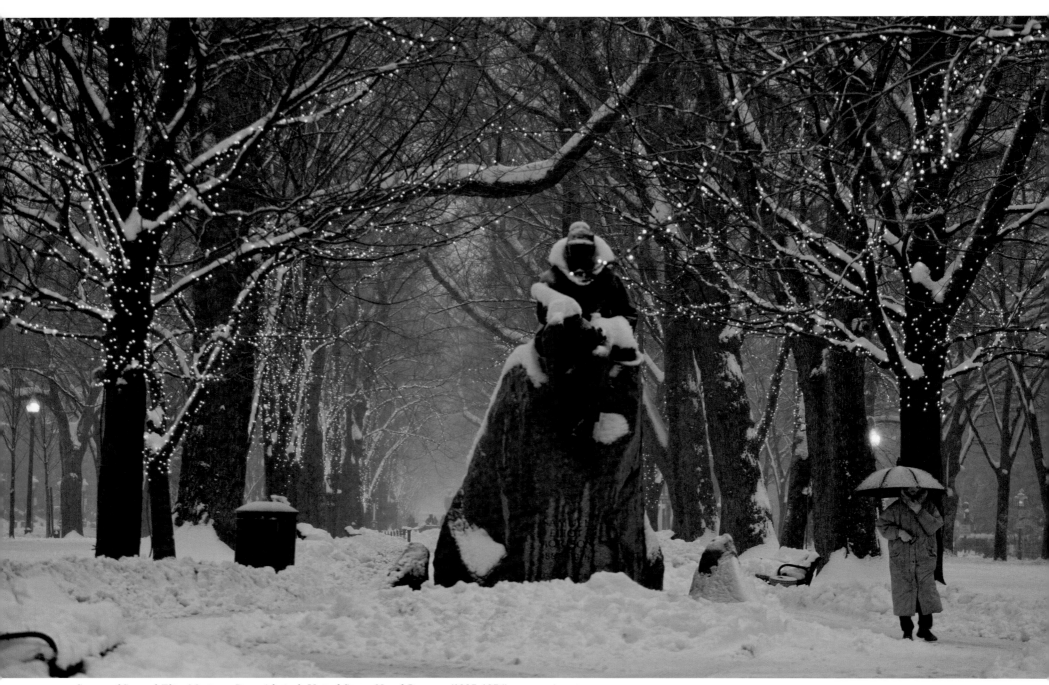

*Statue of Samuel Eliot Morison, Rear Admiral, United States Naval Reserve (1887-1976) was an American historian noted for his works of maritime history that were both authoritative and highly readable.*

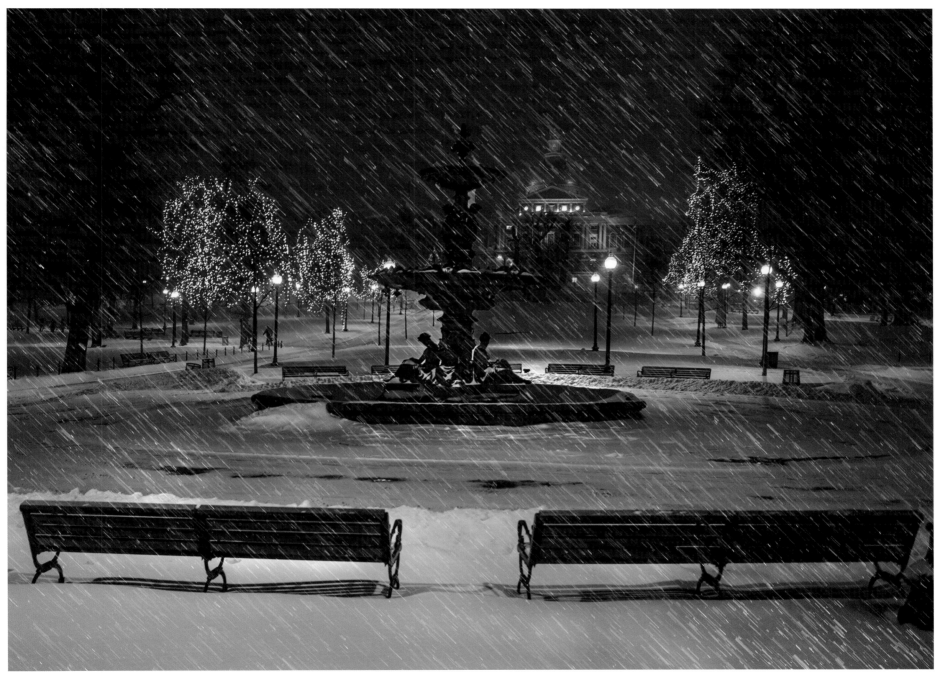

*Brewer Fountain stands near the corner of Park and Tremont Streets, by Park Street Station, A gift to the city by Gardner Brewer, the 22-foot-tall (6.7 m), 15,000-pound (6,800 kg) bronze fountain, cast in Paris, began to function for the first time on June 3, 1868.*

*It fell into disrepair and finally stopped working entirely in 2003. A major repair project began in 2009. After a year-long $640,000 off-site restoration led by sculpture conservator Joshua Crain., it was re-dedicated on May 26, 2010.*

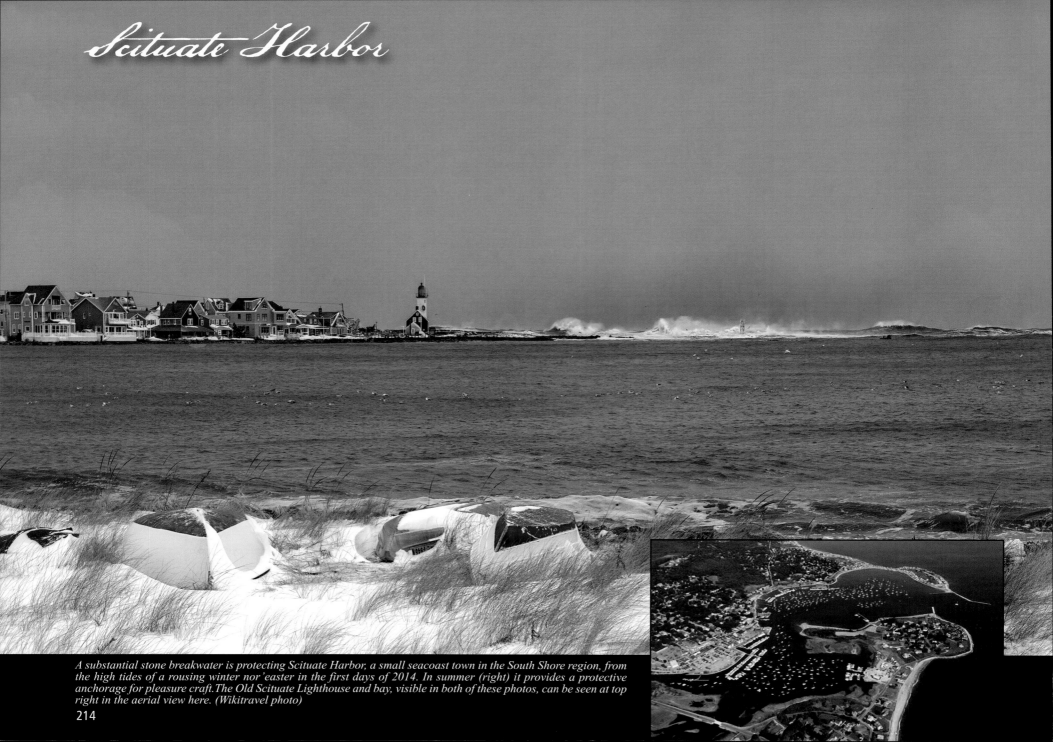

# Scituate Harbor

A substantial stone breakwater is protecting Scituate Harbor, a small seacoast town in the South Shore region, from the high tides of a rousing winter nor'easter in the first days of 2014. In summer (right) it provides a protective anchorage for pleasure craft. The Old Scituate Lighthouse and bay, visible in both of these photos, can be seen at top right in the aerial view here. (Wikitravel photo)

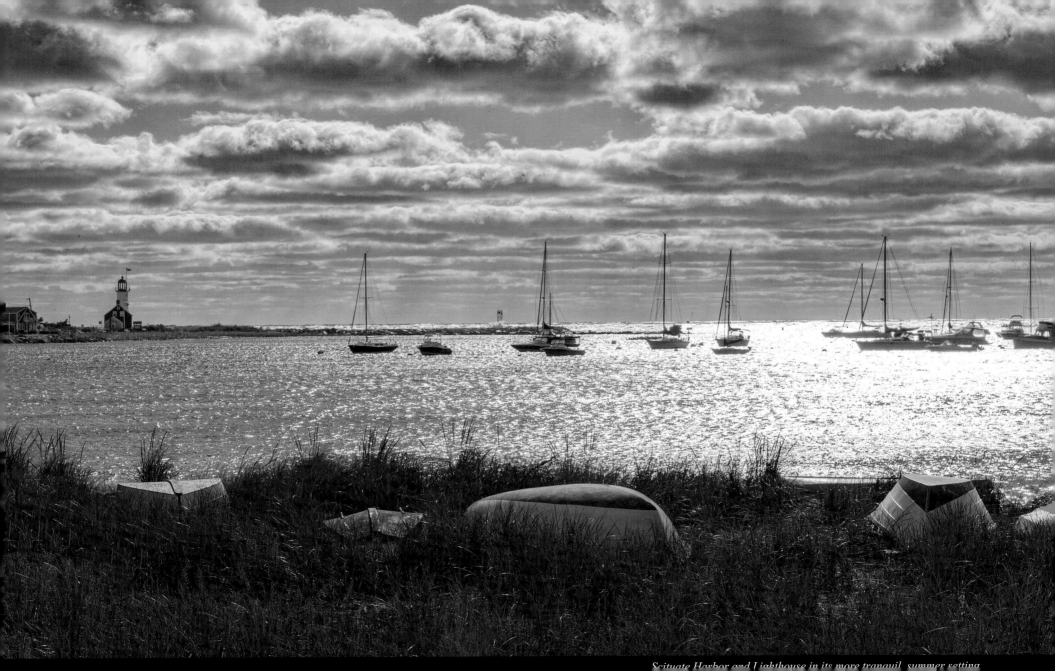

*Scituate Harbor and Lighthouse in its more tranquil, summer setting.*

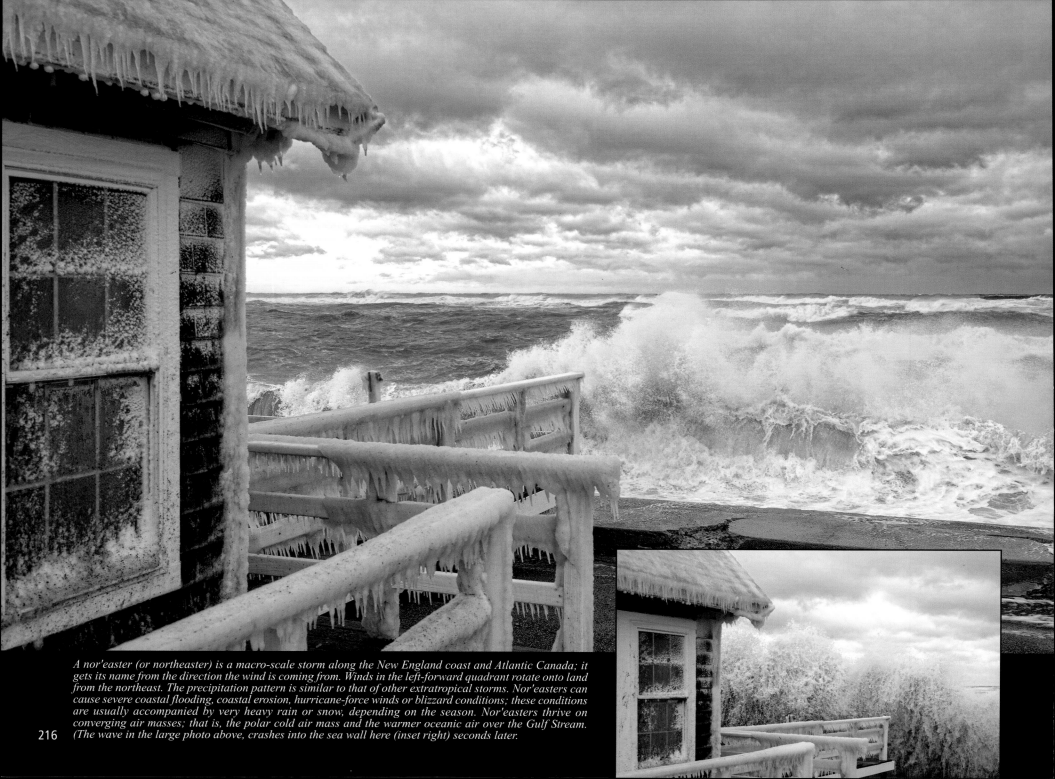

A nor'easter (or northeaster) is a macro-scale storm along the New England coast and Atlantic Canada; it gets its name from the direction the wind is coming from. Winds in the left-forward quadrant rotate onto land from the northeast. The precipitation pattern is similar to that of other extratropical storms. Nor'easters can cause severe coastal flooding, coastal erosion, hurricane-force winds or blizzard conditions; these conditions are usually accompanied by very heavy rain or snow, depending on the season. Nor'easters thrive on converging air masses; that is, the polar cold air mass and the warmer oceanic air over the Gulf Stream. (The wave in the large photo above, crashes into the sea wall here (inset right) seconds later.

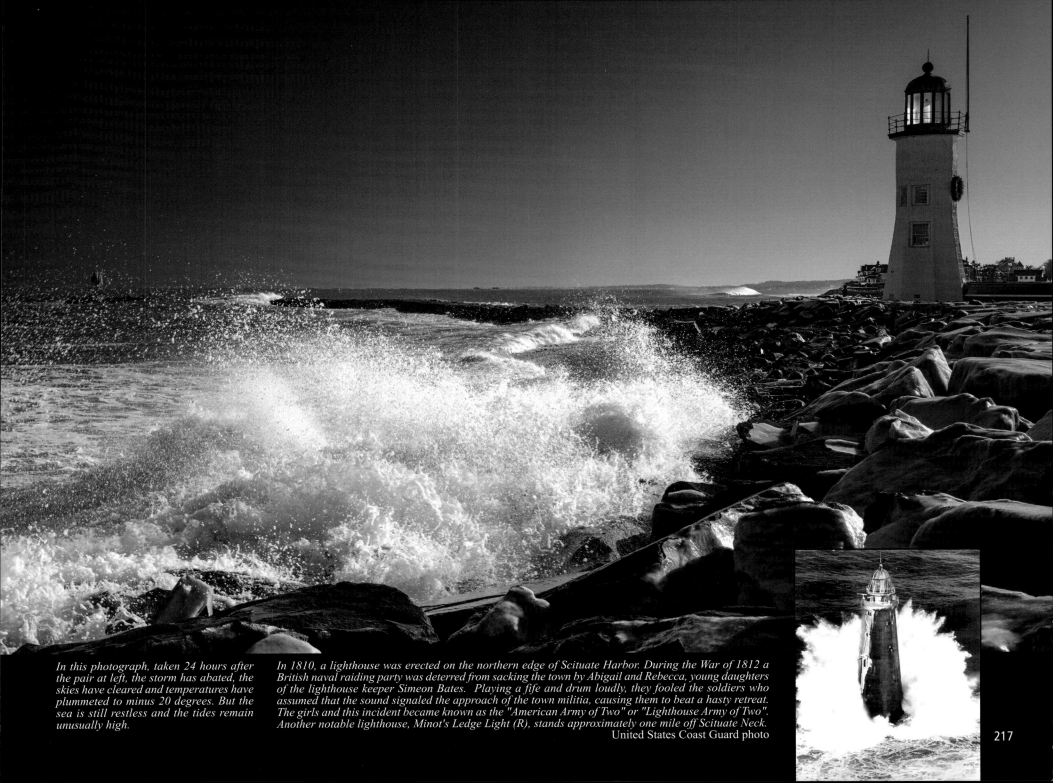

*In this photograph, taken 24 hours after the pair at left, the storm has abated, the skies have cleared and temperatures have plummeted to minus 20 degrees. But the sea is still restless and the tides remain unusually high.*

*In 1810, a lighthouse was erected on the northern edge of Scituate Harbor. During the War of 1812 a British naval raiding party was deterred from sacking the town by Abigail and Rebecca, young daughters of the lighthouse keeper Simeon Bates.  Playing a fife and drum loudly, they fooled the soldiers who assumed that the sound signaled the approach of the town militia, causing them to beat a hasty retreat. The girls and this incident became known as the "American Army of Two" or "Lighthouse Army of Two". Another notable lighthouse, Minot's Ledge Light (R), stands approximately one mile off Scituate Neck.*

United States Coast Guard photo

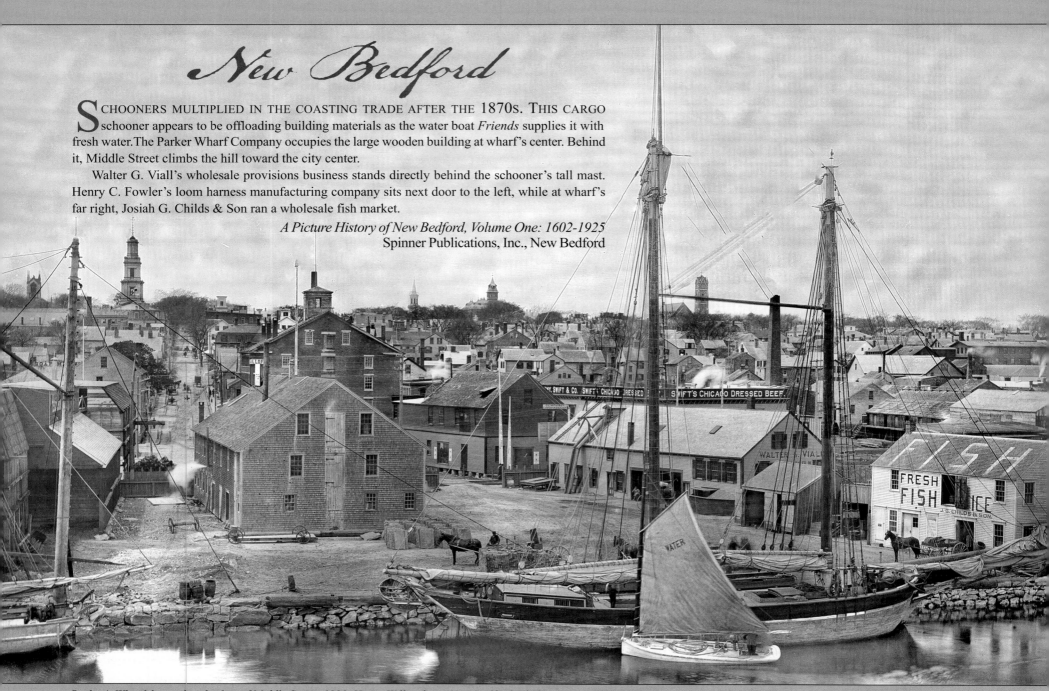

# New Bedford

SCHOONERS MULTIPLIED IN THE COASTING TRADE AFTER THE 1870s. THIS CARGO schooner appears to be offloading building materials as the water boat *Friends* supplies it with fresh water. The Parker Wharf Company occupies the large wooden building at wharf's center. Behind it, Middle Street climbs the hill toward the city center.

Walter G. Viall's wholesale provisions business stands directly behind the schooner's tall mast. Henry C. Fowler's loom harness manufacturing company sits next door to the left, while at wharf's far right, Josiah G. Childs & Son ran a wholesale fish market.

*A Picture History of New Bedford, Volume One: 1602-1925*
Spinner Publications, Inc., New Bedford

*Parker's Wharf, located at the foot of Middle Street, 1890. Henry Willis photo, New Bedford Whaling Museum (2000-1.100.363.2*
*Willis took this photograph from the upper floors of the William F. Nye oil factory on Fish Island.*
*This scene is near the present-day location of Crystal Ice and the small, color image opposite reflects this area of the harbor today..*

New Bedford's history has long been linked with the oceans beyond its fine harbor. Whaling was its premier enterprise but not every ship was a whaler. Even Joseph Rotch, a whaling pioneer, engaged in merchant trade. In December 1773, when the Sons of Liberty dumped tea into Boston Harbor to protest British taxation without representation, the Rotch family's *Dartmouth* and *Beaver*, whaleships were part of the tea fleet under charter to the East India Company. Another of Rotch's vessels, *Bedford*, sailed for London in 1783, with 487 butts of whale-oil in its hold. (A butt is a barrel-like container, which holds 130 US gallons.) It was the first ship to display the thirteen stripes of the new American nation in a British port.

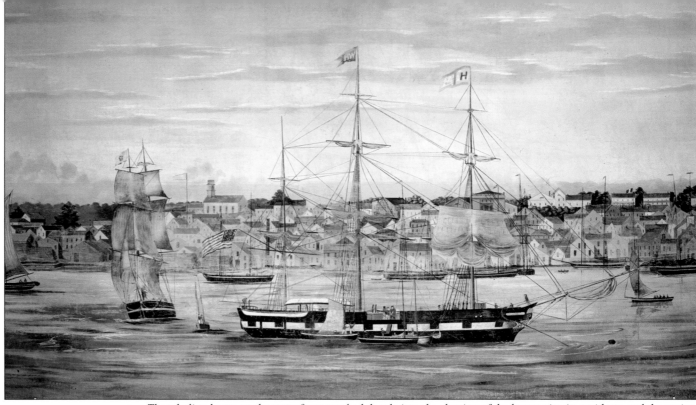

*The whaling boom on the waterfront reached deeply into the shaping of the larger city, its residents and the region. Whaling ship* William Hamilton, *Benjamin Russell, 1845 New Bedford Whaling Museum (1918.27.128)*

*New Bedford today has one of the largest fishing fleets in all of New England. This grouping of fishing boats is occupying the area of Parker's Wharf in the 1890 view opposite, and was shot from the New Bedford – Fairhaven swing truss bridge (right).*

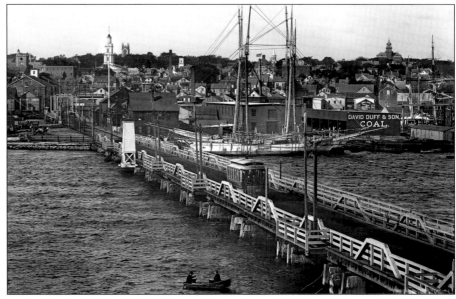

*View from Popes Island of a trolley crossing the original Fairhaven bridge prior to 1897, the year the present-day bridge was built. Clifford Baylies photo, New Bedford Whaling Museum (1000.100.363.2)*

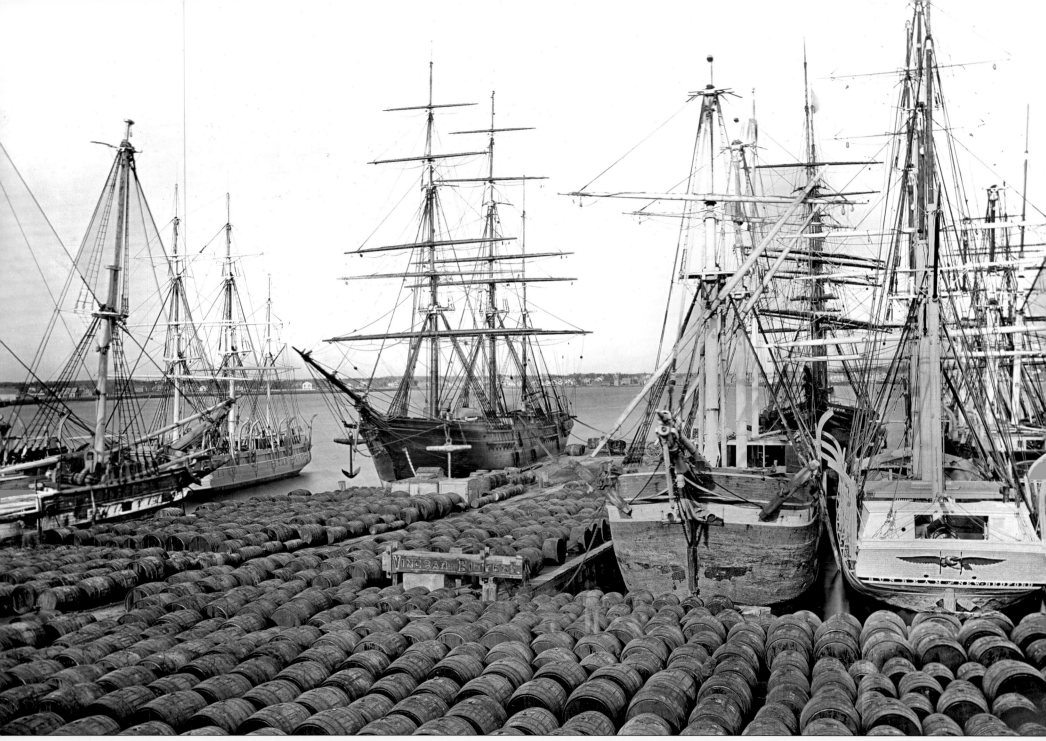

*Typical waterfront scene on New Bedford Harbor, with whaling brig* Meteor *alongside bark* Sunbeam *(with carved eagle stern board), 1862.*
*Joseph S. Martin Photo New Bedford Whaling Museum (1000.100.363.2)*

*The two vessels are berthed in the slip between Central (left) and Taber's wharves. Although the barrels are filled with oil, this is a time of war and the whaling industry is in depression Today, this site is occupied by the Seastreak ferry terminal with seasonal service to Vineyard Haven and Oak Bluffs on Martha's Vineyard.*

Sometime between 1815 and 1825, New Bedford became one of the largest whaling ports in the the world, due to its protected deepwater harbor, proximity to transportation routes, and the business acumen of its residents. By 1857, it harbored 324 vessels (half of all America's whalers), each crewed by approximately 30 men. Whale oil was vital in illuminating homes and businesses throughout the world, and in lubricating the machines of the Industrial Revolution. Baleen (the long cartilaginous strips that hang from the top of whales' mouths) was used by manufacturers to make buggy whips, fishing poles, corset stays and dress hoops. Whale products made New Bedford the wealthiest city in the nation.

Whaling's decline began in the mid-19th Century. By 1900 there were only a handful of whalers still operating in the city. The last successful whaling voyage from New Bedford returned to port in 1925.

*By 1857, whaling was the nation's fifth most valuable industry. Nothing cast a brighter light than sperm whale oil; nothing lubricated high-speed or delicate machinery better.*

*Catboat of Edgartown, Martha's Vineyard, sits in front of bark* Morning Star *drying sails. Catboats* Waif *and* Corrine *are partially visible to the right. Fairhaven can be seen across the harbor. New Bedford Whaling Museum (1998.64.11)*

The New Bedford Whaling Museum's half-scale model of the whaling bark *Lagoda* was built inside the Bourne Building in 1915-16, with funds donated by Emily Bourne in memory of her father, whaling merchant Jonathan Bourne, jr., who made his fortune with the original *Lagoda*. It is the largest ship model in existence. Visitors can imagine life on a whaleship by climbing aboard this 89-foot, half-scale model of the bark, which dominates its large gallery with sails set and gear rigged.          whalingmuseum.org

# Whaling

BEGINNING IN THE LATE COLONIAL PERIOD, THE UNITED STATES, WITH A strong seafaring tradition in New England, an advanced shipbuilding industry, and access to the oceans grew to become the pre-eminent whaling nation in the world by the 1830s.

American whaling's origins were in New York and New England, including Cape Cod, Massachusetts and nearby cities. The oil was in demand chiefly for lamps. Hunters in small watercraft pursued right whales from shore. By the 18th century, whaling in Nantucket had become a highly lucrative deep-sea industry, with voyages extending for years at a time and with vessels traveling as far as South Pacific waters. During the American Revolution, the British Navy targeted American whaling ships as legitimate prizes, while in turn many whalers fitted out as privateers against the British. Whaling recovered after the war ended in 1783 and the industry began to prosper, using bases at Nantucket and then New Bedford. Whalers took greater economic risks to turn major profits: expanding their hunting grounds and securing foreign and domestic workforces for the Pacific.

Early whaling efforts were concentrated on right whales (the 'right' whale to hunt) and humpbacks, which were found near the American coast. As these populations declined and the market for whale products (especially whale oil) grew, American whalers began hunting the sperm whale, which forced whalers to sail farther from home in search of their quarry, eventually covering the globe.

New England ships began to explore and hunt in the southern oceans after being driven out of the North Atlantic by British competition and import duties. Ultimately, American entrepreneurs created a mid-19th-Century version of a global economic enterprise. This was the golden age of American whaling.

Whaling became important for a number of New England towns, particularly Nantucket and New Bedford, Massachusetts. Vast fortunes were made, and culture of these communities was greatly affected; the results can be seen today in the buildings surviving from the era. Larger cultural influence is evidenced by former whaler Herman Melville's novel *Moby-Dick*, which is often cited as the Great American Novel. The town of New Bedford is experiencing a revival, since the 1996 establishment of New Bedford Whaling National Historic Site. This site, along with the Whaling Museum, capitalizes on the rich culture of whaling and the immigrant and free black populations that made up the "City that Lit the World."

Nantucket joined in the trade in 1690 when they sent for one Ichabod Padduck to instruct them in the methods of whaling. The south side of the island was divided into 3 ½-mile sections, each one with a mast erected to look for the spouts of right whales. Each section had a temporary hut for the five men assigned to that area, with a sixth man standing watch at the mast. Once a whale was sighted, rowing boats were sent from the shore, and if the whale was successfully harpooned and lanced to death, it was towed ashore, flensed (that is, its blubber was cut off), and the blubber boiled in cauldrons known as "trypots." Even when Nantucket sent out vessels to fish for whales offshore, they would still come ashore to boil the blubber, doing this well into the 18th Century.

But times were changing and after 40 years of growth and prosperity, the whaling business was about to fall into a downward spiral. Oil production was up, but kerosene began to replace whale oil in the late 1830s and prices and profits responded accordingly. Many vessels were lost during the Civil War, and in several Arctic disasters when ships were crushed by the ice. And the hardships of the hunt increased when sperm whales became harder to find and the long voyages became even longer. The golden era was soon to end—this time for good.

The California Gold Rush struck another devastating blow to the island's economy. The quest for gold was too tempting for islanders who could see the handwriting on the wall. In 1849, 14 ships commanded by Nantucket sailors headed for the Golden Gate.

Some islanders were still pursuing whales, but the profits steadily declined. There were few ships and fewer men. The last Nantucket whaling ship, the bark *Oak*, sailed out of the Harbor in search of sperm whales in 1869, never to return.

*This painting provides a romantic and animated view of activity at the entrance to New Bedford Harbor across a choppy sea. The city skyline forms the horizon, with church steeples, masts, wharf, and mills filling in the line. A port quarter view of a whaleship is seen to the left center, its main and fore topsails backed. Sloops and schooners surround the whaler in the harbor waters. Palmer's Island Light House is in the distance.*
*Albert Van Beest, 1854-1857, New Bedford Whaling Museum (1975-17)*
*Van Beest came to the city at the invitation of a local artist, William Bradford. Beginning in 1854 the two shared a studio and absorbed the best of each other's skills. This painting, signed only by Van Beest, shows the evidence of Bradford's hand in the precisely rendered whaler and small boats under sail.*

# Martha's Vineyard

MARTHA'S VINEYARD HAS ALWAYS HAD A STRONG TIE TO THE SEA through fishing, whaling, trade, and transport. During the 1800s, Vineyard Sound was one of the busiest shipping lanes in the world, second only to the English Channel. In 1859 the Gay Head light keeper reported 29,000 vessels passing his station. Countless vessels stopped in Vineyard Haven to take on provisions, ride out storms, or wait for tides and a fair wind.

Sailing from England in his ship *Concord*, Bartholomew Gosnold planned to reach Virginia and establish a trading post. However, his landfall ended up near Cape Ann. After rounding and naming Cape Cod, Gosnold continued south and encountered a group of wooded islands abundant with grape vines. On May 21, 1602, he traveled on to the northern side of the largest island and encountered a group of Wampanoag who seemed accustomed to meeting foreigners. Gosnold named this island Martha's Vineyard in honor of his infant daughter and his mother-in-law Martha Golding, a key financial backer of his voyage.

This colonial period was marked by prosperity as well as peace. The sea provided fish for both export and Island use, and the Wampanoags taught the settlers to capture whales and tow them ashore to boil out the oil. Farms were productive as well; in 1720 butter and cheese were being exported by the shipload. The American Revolution, however, brought hardships to the Vineyard. Despite the Island's declared neutrality, the people rallied to the Patriot cause and formed companies to defend their homeland. With their long heritage of following the sea, Vineyarders served effectively in various maritime operations. On September 10, 1778, a British fleet of 40 ships sailed into Vineyard Haven harbor. Within a few days the British raiders had burned many Island vessels and removed more than 10,000 sheep and 300 cattle from the Vineyard. The raid was an economic blow that affected Island life for more than a generation. The whaling industry did not make a real recovery until the early 1820s, when many of the mariners built their beautiful homes in Edgartown.

The Civil War brought an end to the Golden Age of Whaling. Ships on the high seas were captured by the Confederate navy, while others were bottled up in the harbors. Either way, it meant financial ruin for the ship owners and the Island. In 1835 a new and enduring industry was born when the Edgartown Methodists held a camp meeting in an oak grove high on the bluffs at the northern end of the town. The camp meeting became a yearly affair and one of rapidly growing popularity. Many found the sea bathing and the lovely surroundings as uplifting as the call to repent. The Methodist Campground meetings were the catalysts that transformed the Island from a simple farming community into an internationally known seaside resort by these first groups of tourists.

Many who came for a week or two eventually rented houses and later became property owners—a pattern that still occurs today. Summer visitors become seasonal or, as in the case of many writers and artists, year-round residents. These people, along with the many who retire to the Vineyard bring the world to the Island much as the far-traveled captains did in the great days of whaling.

*The Allen farmhouse and iconic stone wall that is a trademark of the Chilmark area of Martha's Vineyard. Jonathan Allen originally purchased the farm in 1762, and his oldest son, Tristram built this still standing, timber-framed home in 1770. It has been continuously occupied by the family ever since.  allenfarm.com*

In 1964, the schooner Shenandoah, a 108' square topsail schooner, was launched from the railway of Harvey Gamage Shipyard in South Bristol, Maine. Designed to maintain the excellence from "America's Golden Age of Sail", she brought the excitement and traditions of clipper ships to the public. The schooner Alabama, a living piece of America's maritime history built in 1926 to a design of Thomas F. McManus, a man widely regarded as the best designer of all the Gloucester fishing schooners, shares Vineyard Haven Harbor with Shenandoah (above).

In the mid-1990s, the Black Dog Tall Ships began offering Kids Cruise program on the schooner Shenandoah. Unlike traditional 'sail training' these programs focus on allowing the next generation of sailors to fully immerse themselves in the life onboard with the emphasis on FUN! During their week onboard, our young passengers learn their maritime heritage, and many other life-skills of the sea. They become part of the crew...

theblackdogtallships.com

Stone walled, livestock pounds like this one in Chilmark, were a common sight in the early days before fences became necessary. If you were missing a sheep or cow there would be a good chance one of your neighbors would have penned it here for you to pick up.

The earth here tells the story erased elsewhere in New England. The Aquinnah cliffs lay bare to geologists the history of the past hundred million years. The current, brick and sandstone Gay Head Lighthouse replaced a wooden one in 1856. It was automated in 1960. As with many lighthouses, the forces of erosion are slowly bringing the structure ever-closer to the cliff-edge and efforts are underway locally to fund a move in the near future.

Some of the earliest visitors to the area that became Cottage City and later Oak Bluffs were Methodists, who gathered in the oak grove each summer (1859 to 1880) for multi-day religious "camp meetings" held under large tents and in the open air. As families returned to the grove year after year, tents pitched on the ground gave way to tents pitched on wooden platforms and eventually to small wooden cottages. Small in scale and closely packed, the cottages grew more elaborate over time. Porches, balconies, elaborate door and window frames became common, as did complex wooden scrollwork affixed to the roof edges as decorative trim. The unique "Carpenter's Gothic" architectural style of the cottages was often accented by the owner's use of bright, multi-hue paint schemes, and gave the summer cottages a quaint, almost storybook look. Dubbed "gingerbread cottages," they became a tourist attraction in their own right in the late nineteenth century and today many are available to vacationers as weekly rentals. Cousins and best friends, Emma Pollard and Emma Keane's families are regular summer visitors to the cottages at left.

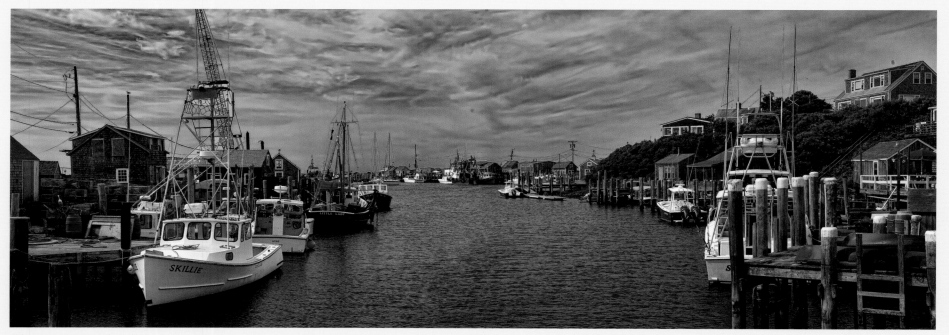

Edgartown was used as the main shooting location for the town of Amity in Steven Spielberg's 1975 blockbuster Jaws. Many landmarks and buildings in Edgartown that were filmed in the movie can still be seen today. This view of the fishing harbor in the town of Menemsha was the scene of Orca's cruising out to meet her fate in the jaws of the great white star of the film.

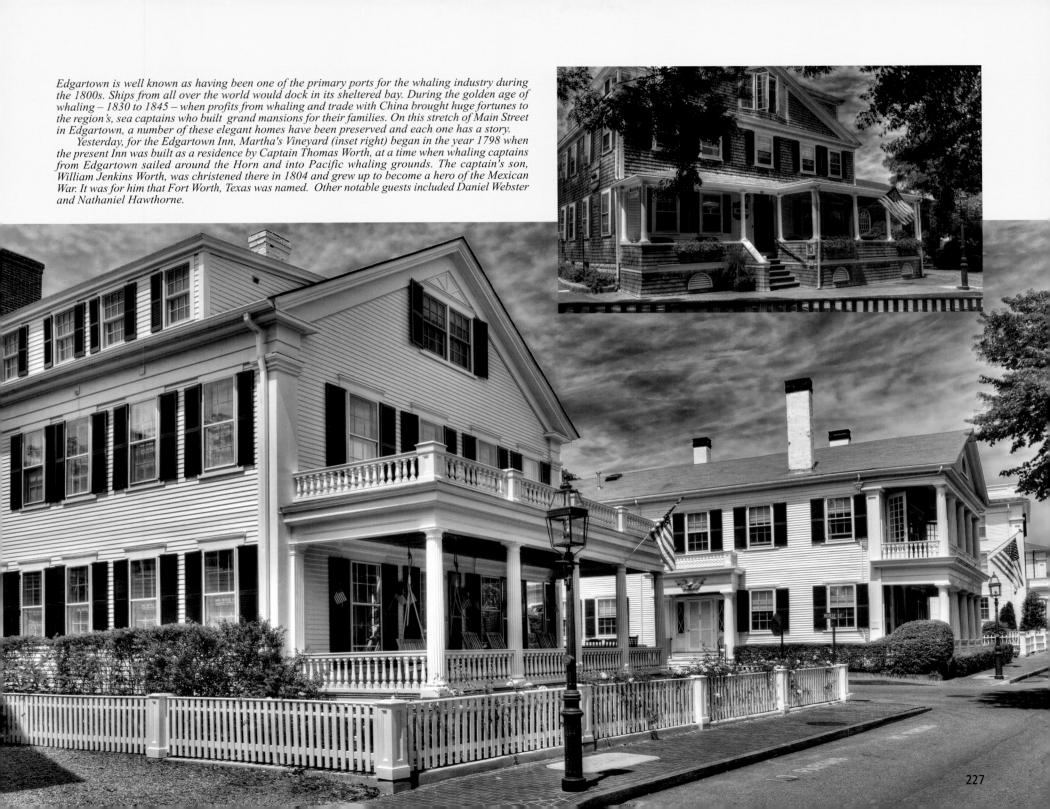

Edgartown is well known as having been one of the primary ports for the whaling industry during the 1800s. Ships from all over the world would dock in its sheltered bay. During the golden age of whaling – 1830 to 1845 – when profits from whaling and trade with China brought huge fortunes to the region's, sea captains who built grand mansions for their families. On this stretch of Main Street in Edgartown, a number of these elegant homes have been preserved and each one has a story.

Yesterday, for the Edgartown Inn, Martha's Vineyard (inset right) began in the year 1798 when the present Inn was built as a residence by Captain Thomas Worth, at a time when whaling captains from Edgartown sailed around the Horn and into Pacific whaling grounds. The captain's son, William Jenkins Worth, was christened there in 1804 and grew up to become a hero of the Mexican War. It was for him that Fort Worth, Texas was named. Other notable guests included Daniel Webster and Nathaniel Hawthorne.

The candle factory was built by the Mitchell family immediately following Nantucket's Great Fire in 1846 and close to the end of the island's whaling era. In 1929, the building was purchased and converted into the Nantucket Historical Association's (NHA) Whaling Museum, and remains as such to this day.

The Nantucket Whaling Museum features a restored 1847 candle factory, expanded top-quality exhibition space, a fully accessible rooftop observation deck overlooking Nantucket harbor, and the sperm whale skeleton. In 2008, the whaling museum received accreditation from the American Association of Museums, an honor bestowed upon fewer than one of every 22 museums in the country.

The museum houses a large collection of whaling artifacts and memorabilia, including longboats, harpoons, and scrimshaw, but the centerpiece is the complete skeleton of a 46-foot (14 meter) bull Sperm whale suspended from the ceiling. True to its original use as a candle factory, the museum also has exhibits regarding that trade as well. The exhibited beam press (used to extract oil from the spermaceti to make candles) is the only one in the world still in its original location. Other exhibits include an 1849 Fresnel lens used in the Sankaty Head Light and the restored workings of the Nantucket 1881 town clock.

Landlubbing vacationers might not see its appeal, but still, the Whaling Museum does well with history lovers and Herman Melville fans. There's also an impressive collection of scrimshaw art: whalers created these elaborately engraved (or carved) pieces out of spare whale bones and teeth to pass the time at sea.

While the museum's scenic rooftop deck is a big hit, it's the various educational programs that really win visitors over. One TripAdvisor reviewer says: "Make sure you plan your visit to coincide with the Whale Hunt presentation. The 40-minute talk was so engaging that about two dozen 13- and 14-year-old students were mesmerized -- no texting, posting or whispering!" Also popular is a storytelling presentation on the *Essex*, the local whaling ship that inspired Moby Dick.

*The museum houses a large collection of whaling artifacts and memorabilia, including longboats, harpoons, and scrimshaw.*

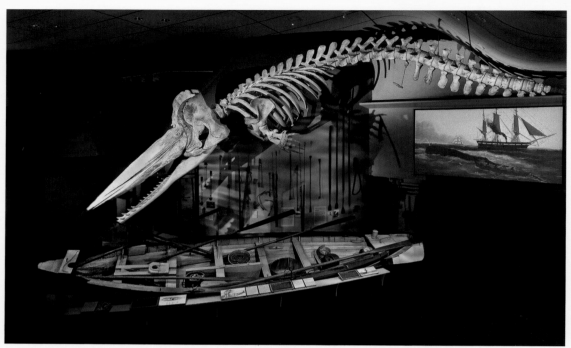

*A sperm whale skeleton measuring 46-feet in length hangs in the Nantucket Whaling Museum.*
*Photo: Peter Vanderwarker/Nantucket Historical Association*

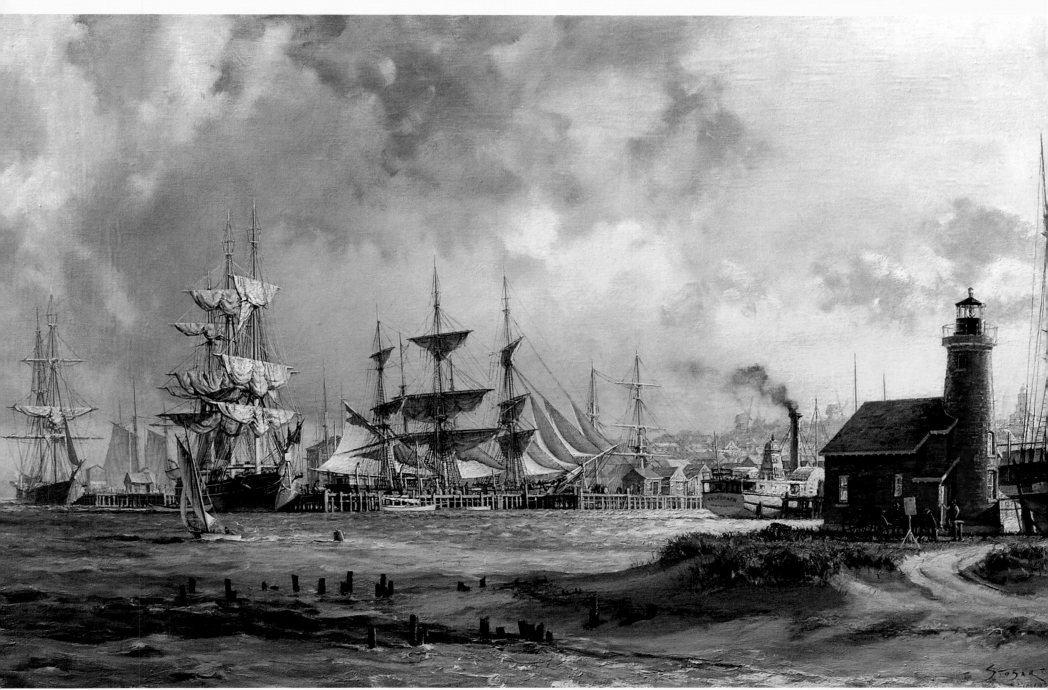

*Nantucket, The Celebrated Whaling Port in 1835  (John Stobart, Nantucket Whaling Museum)*

# Nantucket

I N 1795 THE NAME OF THE ISLAND WAS CHANGED TO NANTUCKET, WHICH IS believed to be Wampanoag for "faraway island." "Nantucket" was now the name of the town, the county and the island, which also became known as the "Little grey lady of the sea" for her preponderance of fog.

By the late 1820s, Nantucket was one of the busiest whaling port in the world. The entire island's economy was tied to the whaling industry, and the wharves and bustling harbor were scenes of never-ending activity. Hundreds of people worked in rope works, candle factories, chandleries, boat-building shops, sail lofts and warehouses. Others were employed in the food stores, grog shops, boarding houses, newspapers, banks and counting houses that supported the whaling business.

Fortunately, the hard times would prove to be short-lived. The growth and popularity of the railroads revolutionized travel and provided cheaper, faster transportation for people and goods. No longer having to depend on wagons or horses and buggies, mainland Americans began searching for summer vacations spots in places they would never have considered before the advent of the trains. With Nantucket's mild climate and amazing ocean views, its citizens determined to attract the wealthy vacationers to their island. Cottages, summer houses and elegant hotels were built and ads were placed in the Boston and New York newspapers. Vacationers responded, but getting to the island was still a bit of a challenge.

In order to draw even more visitors, ferry service was expanded between the Cape and Nantucket and an airport was constructed in 1920. Actors and artists were some of the first to respond. The island's remoteness, her quaint cottages, her breathtaking views and comfortable weather attracted a number of artists and actors, and the cozy little village on the bluff hosted many of the top stars of the American theater. But it wasn't long before historic Nantucket was drawing travelers from all over the world. Tourism became the mainstay of the economy, just as the whaling industry had been so many years before.

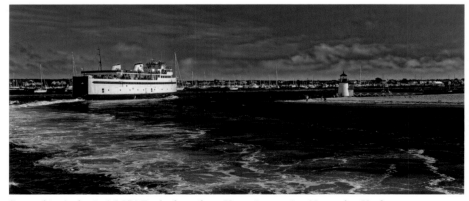

*Steamship Authority's* M/V Eagle *ferry from Hyannis entering Nantucket Harbor.*

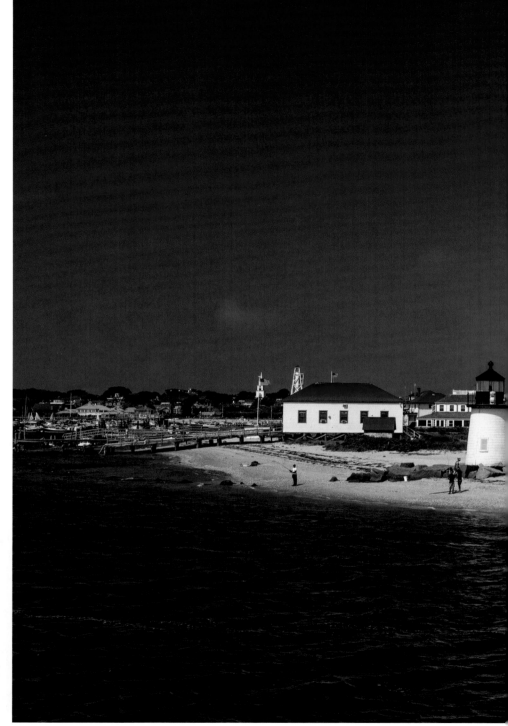

*Brant Point Lighthouse and US Coast Guard Station at the entrance to Nantucket Harbor.*

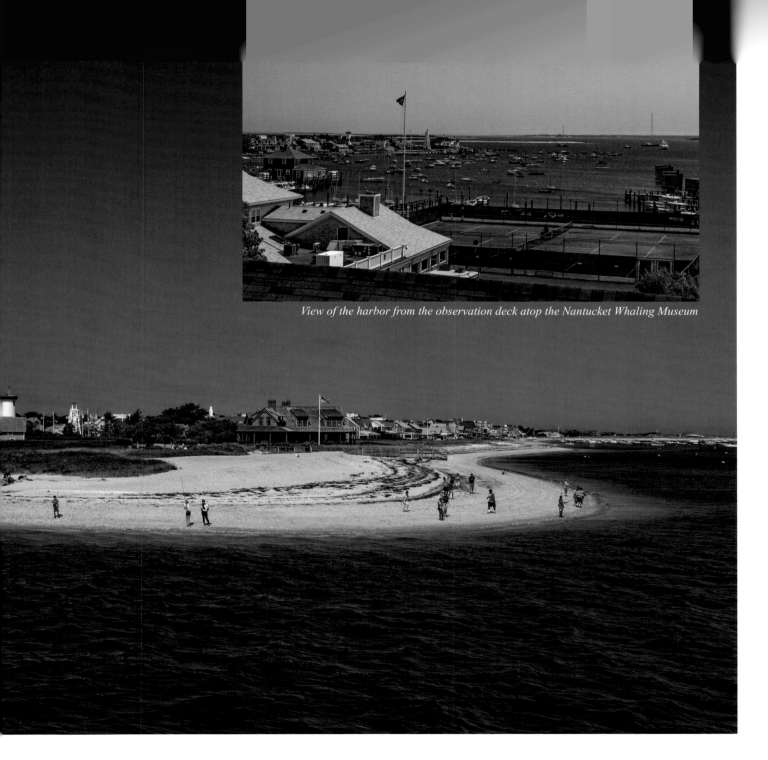

*View of the harbor from the observation deck atop the Nantucket Whaling Museum*

a short history of

boston

Robert J. Allison

If you want to learn about Boston history, here's the perfect place to start. And if you think you know it, here are some surprises. Robert Allison, chair of the History Department at Suffolk University, introduces you to the great characters, dramatizes the shaping events and takes you from the ancient Shawmut Peninsula to the Big Dig, from John Winthrop's City on a Hill to the Boston of today.

With economy and style, Dr. Robert Allison brings Boston history alive, from the Puritan theocracy of the 17th Century to the Big Dig of the 21st. His book includes a wealth of illustrations, a lengthy chronology of the key events in four centuries of Boston history, and 20 short profiles of exceptional Bostonians. Says the Provincetown Arts, "A first-rate short history of the city, lavishly illustrated, lovingly written, and instantly the best book of its kind."

# Cape Cod

**Robert J. Allison**
From *A Short History of Cape Cod*

FROM THE END OF LONG POINT, YOU CAN SEE TEN THOUSAND YEARS OF HISTORY. The Native people called the Cape's tip Meeshawn, "where there is going by boat." Stand here and you are surrounded by water, though the water is bound all around by land. Your eye can follow the curve of land west to Wood End, north to the shore of Provincetown, east to the Pamet River and the highlands of Truro, and then south again to the cliffs of Wellfleet. The land vanishes from sight southeast across Cape Cod Bay where off in the distance lie Barnstable and Sandwich and the canal.

Whales still feed offshore, and seals still surface, and diving birds reveal underwater schools of fish. Wind and tide have shaped the land much more than the men and women who have lived on this narrow stretch of sand. Native men and women built their canoes from the great trees that once grew here, caught whales, and gathered fish along the shore. Thorwald the Viking may have repaired his ship in this great harbor, which Bartholomew Gosnold wanted to call Shoal Hope. His men pointed to the fish teeming below the surface and told him to call the place Cape Cod.

*Old Harbor Life-Saving Station off Race Point, Provincetown*

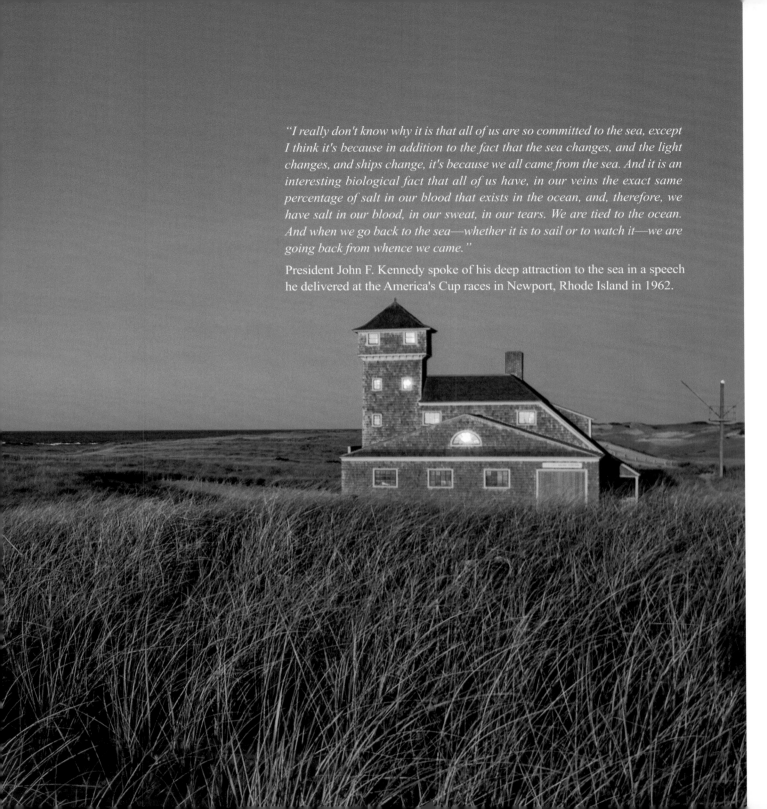

*"I really don't know why it is that all of us are so committed to the sea, except I think it's because in addition to the fact that the sea changes, and the light changes, and ships change, it's because we all came from the sea. And it is an interesting biological fact that all of us have, in our veins the exact same percentage of salt in our blood that exists in the ocean, and, therefore, we have salt in our blood, in our sweat, in our tears. We are tied to the ocean. And when we go back to the sea—whether it is to sail or to watch it—we are going back from whence we came."*

President John F. Kennedy spoke of his deep attraction to the sea in a speech he delivered at the America's Cup races in Newport, Rhode Island in 1962.

a short history of

cape cod

*Robert J. Allison*

Robert Allison's *A Short History of Cape Cod*," in a concise narrative, covers four colorful centuries. There's enough detail here to fascinate the historian and enough stories to fill an enjoyable day at the beach. Discovered by Bartholomew Gosnold in 1602 and visited by the Mayflower on its way to Plymouth, Cape Cod has been the site of confrontations between Pilgrims and natives, between Patriots and Tories. Salt works and windmills, lighthouses and shipwrecks, and characters as varied as radio pioneer Guglielmo Marconi and playwright Eugene O'Neill have given Cape Cod a unique landscape and a fascinating human community.

"Men once set out to hunt whales from Provincetown Harbor," Allison writes. "Today boats go to watch the whales and study them. The land remains though it continues to change, as the relentless tide and wind reshape the land and remove all evidence that any of Native people or Vikings, Pilgrims or Presidents, explorers, warriors, poets, painters, or entrepreneurs, ever set foot on this sandy beach."

Eighteen years after Gosnold's brief stay, the *Mayflower* brought the Pilgrims to this harbor. They agreed to be governed by laws they themselves would make. The British warship *Somerset* sailed into this harbor in the 1770s, trying to impose authority on their descendants who took this notion of self-government too far.

By the early 19th Century, the nation had become independent, the trees were gone, and the Pilgrim descendants had bought the land from the Native people. They built saltworks on the sandy beaches and windmills to harvest the one resource they could not exhaust. They built lighthouses: Stage Harbor Lighthouse was built in 1880, at the entrance to Stage Harbor to help the Chatham Light since Chatham is one of the foggiest points on the East Coast. An automated light on a separate tower was built in 1933 and the Stage Harbor Lighthouse was decommissioned. The light at the top of the tower, the glass enclosure and the roof over it (called the lantern room) were removed and the keeper's house and remaining tower are now in private hands.

The mariners, descendants of Yankees or immigrants from the Azores or Cape Verde, ventured out after cod, tuna, and whales. John Kendrick, a 47-year-old former privateer captain from Harwich, took ships to the Pacific in the 1780s, opening American trade with China; 100 years later, in the 1880s, Lorenzo Dow Baker of Wellfleet brought lumber from South America and Jamaica; he also brought back bananas, learning how to ship bananas from Jamaica so the fruit would be ripe when it reached the markets. His company became United Fruit. He built the Chequesset Inn, a luxury resort, on an old fishing pier in the late 19th Century that contributed to the development of a tourist economy in Wellfleet.

Theodore Roosevelt sailed into this harbor to lay the Pilgrim Monument cornerstone in Provincetown in 1907, and three years later his stout successor, Taft, came to dedicate it. The Atlantic fleet was here during the First and Second World Wars; in 1918 German submarines came close enough to shell Orleans.

During the tense war years, a vigilant townsperson reported a suspected spy in the dunes; he turned out to be Eugene O'Neill, seeking to put into dramatic form the interior tragedies of the new century. After learning he had won the Pulitzer Prize, he took a celebratory plunge into the cold Atlantic. Whereas O'Neil and others wrote, trying to put into words the world they knew, Charles Hawthorne and Blanche Lazzell tried to capture the world in images of oil and ink, creating an American art with the light of the outer Cape.

*Remains of Stage Harbor lighthouse, Chatham*

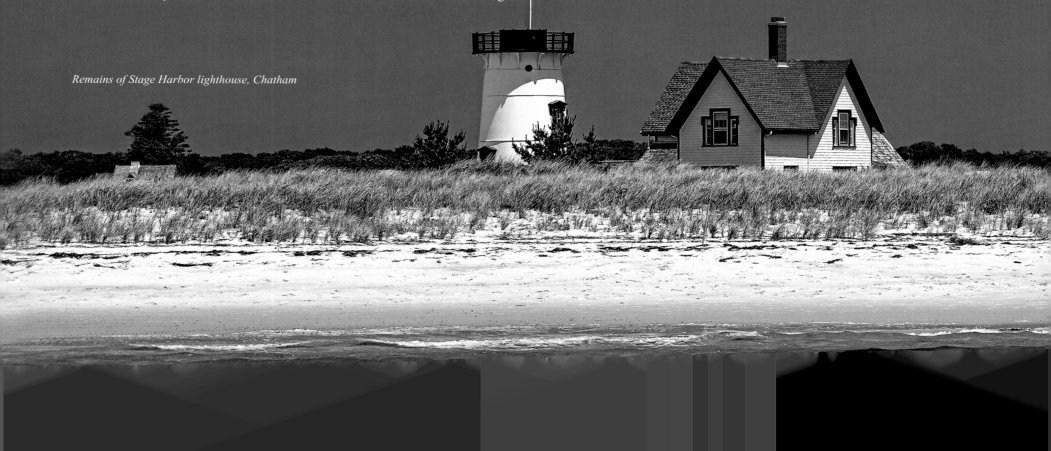

Today the harbor is tranquil, but it has seen turmoil and tragedy. Men once set out to hunt whales from this harbor, but today boats go to watch the whales and study them. The land remains, though it continues to change, as the relentless tide and wind reshape it and remove all evidence that any of us—natives or Vikings, Pilgrims or presidents, explorers, warriors, poets, painters, or entrepreneurs—ever set foot on her sandy beaches.

The National Park Service made preserving the Cape's outer beaches its top priority. Though privately owned, most of the outer Cape from Monomoy to the Province Lands was still undeveloped in the 1950s. Strong support to preserve the shoreline came from those with a recreational or artistic interest in the Cape.

After years of debate that pitted development interests against Cape residents devoted to maintaining the areas unspoiled beauty, Congress created the Cape Cod National Seashore, and President John F. Kennedy signed the bill into law on August 7, 1961. The Seashore today includes 27,700 acres of land, and 17,000 acres of water and wetlands. State parks, including Massachusetts' first, the Rowland C. Nickerson Park in Brewster, protect another 30,000 acres. In addition, many towns have conservation areas, and individuals have created private preserves.

*Morning mist on Great Pond, just off the Grand Army of the Republic Highway, south of Truro. Men like Daniel Webster and President Grover Cleveland came to get away from fashionable society, to fish or to hunt in the Cape's ponds or woods.*

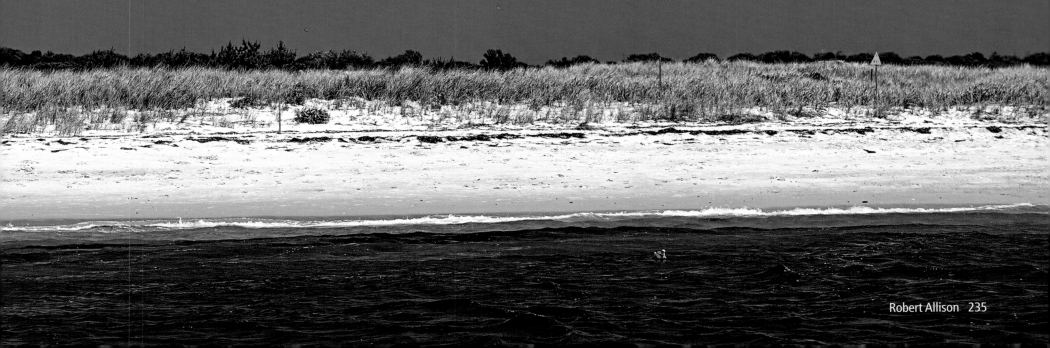

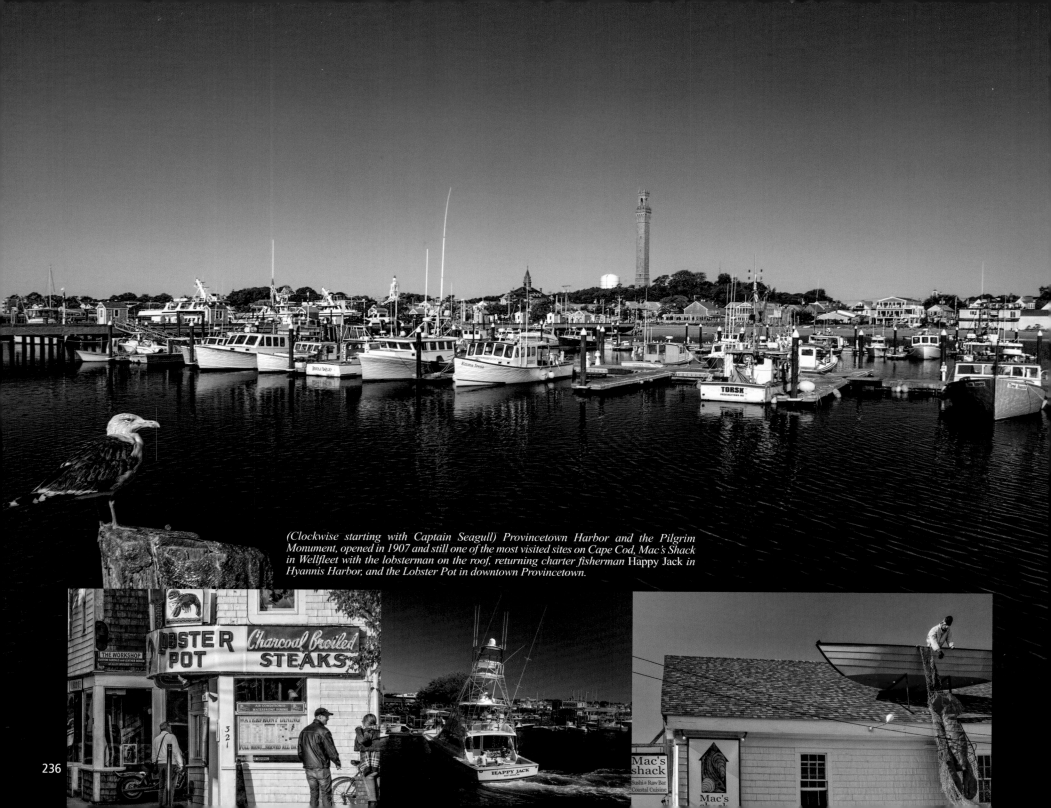

(*Clockwise starting with Captain Seagull*) *Provincetown Harbor and the Pilgrim Monument, opened in 1907 and still one of the most visited sites on Cape Cod, Mac's Shack in Wellfleet with the lobsterman on the roof, returning charter fisherman* Happy Jack *in Hyannis Harbor, and the Lobster Pot in downtown Provincetown.*

Over the years the images of the Kennedys at sea defined the family brand and gave birth to the Kennedy myth. Kennedys under sail were the picture of adventurousness, wholesomeness, vigor, and family. They commanded the elements and the political world. Jack Kennedy's navy experience in World War II became an epic tale of seafaring heroism, retold throughout his political career. A 1953 *Life* cover photo of Jack and Jacqueline on the bow of *Victura* (inset center below), along with their larger storyline, presented them as beautiful, privileged, sophisticated, glamorous, and destined for something great. Media forms like television were fast evolving and multiplying, their effects just being understood, and Jack and Jackie were well cast for the new era.

The story of *Victura*, more than the tale of a small sailboat, is a story of a steeled family and uncommon upbringing in a particular time and place, under specific circumstances, some created with deliberateness by parents who had the means, some shaped by world events and accidents of fate. All of these combined to deeply influence the lives of a few extraordinary people who, more than most, helped define America in the second half of the 20th Century. From these circumstances grew the Kennedys and all they became. Always integral to it all was a simple, small sailboat. *Victura*.

Excerpt from *Victura: The Kennedys, a Sailboat, and the Sea* by James W. Graham ForeEdge, an imprint of University Press of New England. www.upne.com

*The Kennedy Compound in Hyannis Port consists of about 6 acres of waterfront property along Nantucket Sound. In 1926, Joseph P. rented a summer cottage on Marchant Avenue in Hyannis Port. Three years later, he purchased the structure, which had been erected in 1904, and enlarged and remodeled it to suit his family's needs (large house at center of photograph below). In and around this house and several other family homes, the children spent their summers, acquiring a lifelong interest in sailing and other competitive activities.*

*John F. Kennedy and brother Edward M. Kennedy aboard "Victura", Kennedy's sailboat, at Hyannis Port, c1946 and JFK sailing* Victura *with fiance Jacquelin Bouvier, c. 1953. The family had many sailboats, but the favorite was* Victura. *They kept it the longest and sailed it most, over almost fifty years. About two hundred one-design Wianno Seniors identical to* Victura *have been built for families like the Kennedys who summer or live on Cape Cod's South Shore.*

*The family donated* Victura *to a museum and it now sits on permanent display behind the magnificent John F. Kennedy Presidential Library and Museum (below right) overlooking South Boston with the downtown skyline visible in the distance.,*

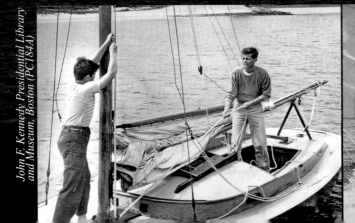

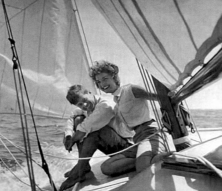

237

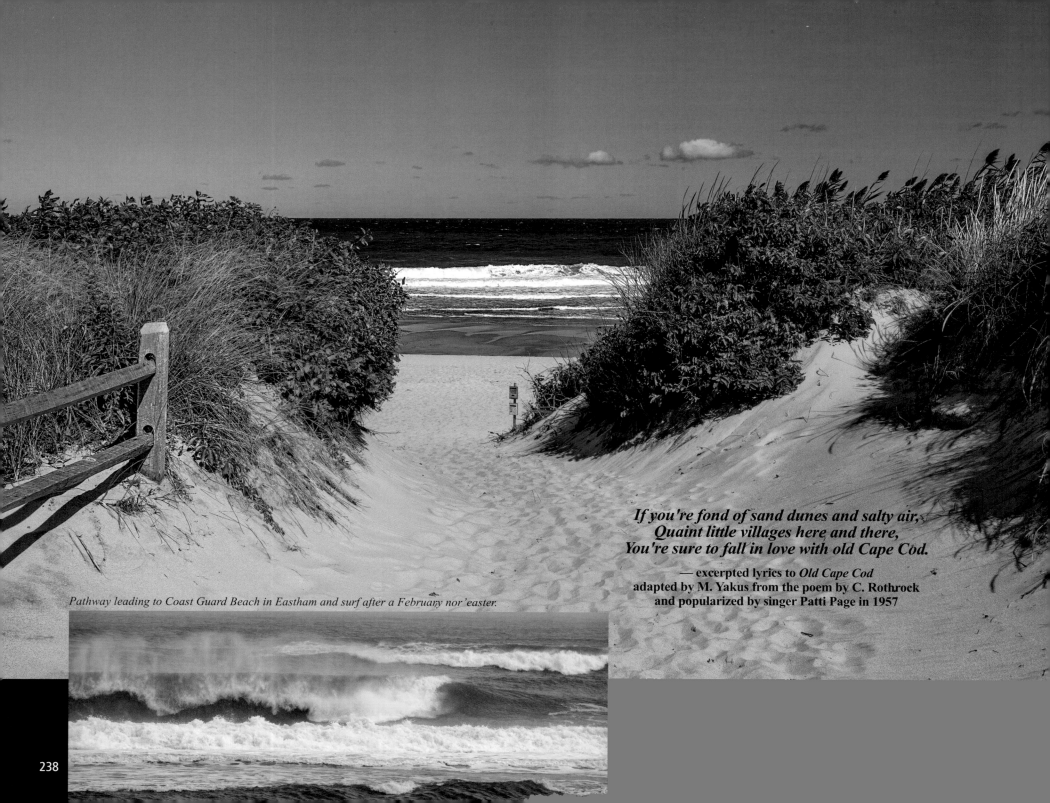

*Pathway leading to Coast Guard Beach in Eastham and surf after a February nor'easter.*

*If you're fond of sand dunes and salty air,*
*Quaint little villages here and there,*
*You're sure to fall in love with old Cape Cod.*

— excerpted lyrics to *Old Cape Cod*
adapted by M. Yakus from the poem by C. Rothrock
and popularized by singer Patti Page in 1957

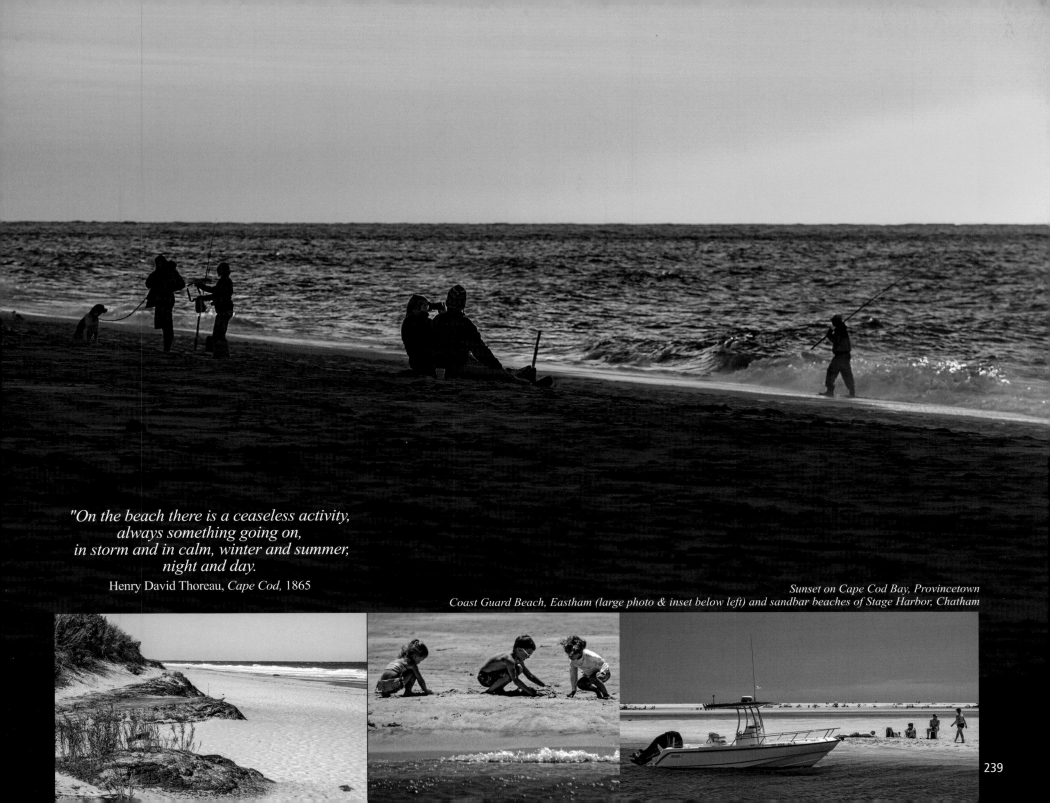

"On the beach there is a ceaseless activity,
always something going on,
in storm and in calm, winter and summer,
night and day.

Henry David Thoreau, *Cape Cod*, 1865

*Sunset on Cape Cod Bay, Provincetown*
*Coast Guard Beach, Eastham (large photo & inset below left) and sandbar beaches of Stage Harbor, Chatham*

239

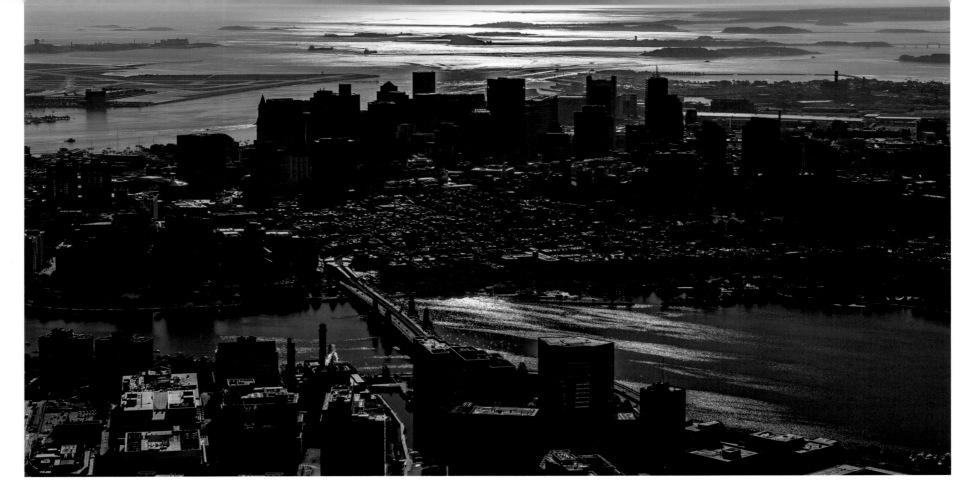

## Further Reading

Allision, Robert J., *A Short History of Boston,* (Commonwealth Editions, 2004)

Allision, Robert J., *A Short History of Cape Cod*, (Commonwealth Editions, 2010)

Beagle, Jonathan, *Boston, A Visual History*, (Penn Publishing Ltd., An Imagine Book, 2013)

Blauner, Andrew (Editor), *Our Boston, Writers Celebrate the City They Love*, (Houghton Mifflin Harcourt, 2013)

Boston Fire Historical Society, *Boston's Fire Trail*, (The History Press, 2007)

DiCara, Lawrence, *Turmoil and Transition in Boston*, (Hamilton Books 2013)

Linden, Blanche M. G., *Boston, Freedom Trail*, (Back Bay Press, 2012)

McNulty, Elizabeth, *Boston Then and Now*, (Thunder Bay Press, 1999)

Most, Doug, *The Race Underground: Boston, New York, and the Incredible Rivalry That Built America's First Subway* (St. Martin's Press, 2014).

Sammarco, Anthony M., *Lost Boston*, (Pavilion Books, 2014)

*Summer sunrise silhouettes the city.*